PRAISE FOR DOES THE NOISE IN MY HEAD BOTHER YOU?

"[Tyler] delivers the goods. . . . [His] surprisingly insightful and entertaining voice brings the familiar contours of this story alive. . . . Does the Noise in My Head Bother You? is much like Tyler himself. What on the surface seems clichéd, almost a parody of a rock memoir, manages somehow to rise above that and be a fun ride. And pulling off that trick, ladies and gentlemen, is what separates a Rock Star from a merely ordinary pop star." —Hollywood Reporter

"Strewn through the book . . . are dozens of patented 'Tylerisms' that can only come from his well-endowed motor-mouth."

-Houston Chronicle

"[Tyler's] forays into music theory are absorbing snapshots of what goes into making great songs.... Fascinating." —*Washington Post*

"Tyler's turbulently high-spirited cheer holds it all together." —New York Times Book Review

"At turns completely hilarious, surprisingly (perhaps, to some) coherent, poignant and sordid—a heart-rending read. Once you've started it, putting it down is not an option. It would be easier to ignore Tyler from the front row of an Aerosmith concert." —*Buffalo News*

"One of the book's charms is Tyler's lack of guilt or regret for anything in his life.... Music fans will enjoy Tyler's remembrances of the New York scene, dating from clubs like The Scene and Max's Kansas City." —Daily News (New York)

DOES THE NOISE IN MY HEAD BOTHER YOU?

DOES THE NOISE

BOTHER YOU?

A ROCK 'N' ROLL MEMOIR

STEVEN TYLER

WITH DAVID DALTON

An Imprint of HarperCollinsPublishers

Set of Tyler portraits by Steve Erle.

Insert One Photograph Credits

Pages 1–2, top of page 3, 4: Ernie Tallarico. Page 5, top right: Steven Tallarico; middle left: Ernie Tallarico. Page 6: Ernie Tallarico. Page 7, bottom: Robert Agriopoulos. Page 8, top: Joe Perry; bottom: Steven Tallarico. Page 9: Ernie Tallarico. Page 10, top right: Aerosmith; bottom right: Steven Tallarico. Page 11, top: Joe Perry; left: Steven Tallarico. Pages 12–13: Ron Pownall for Aerosmith. Page 14, top: Joe Perry; bottom: Ron Pownall for Aerosmith. Page 15: Susan B. Tallarico. Page 16: Ron Pownall for Aerosmith.

Insert Two Photograph Credits

Page 1: Aerosmith. Page 2: Ross Halfin. Page 3: courtesy of Gene Kirkland. Page 4, top: Kevin Mazur/WireImage/Getty Images; bottom: William Hames for Aerosmith. Page 5, top: Ross Halfin; bottom: Erin Brady. Page 6, top: Laurie Stark/Laurie Lynn Stark Photography; bottom: Ross Halfin. Page 7: Laurie Stark/Laurie Lynn Stark Photography. Page 8, top: courtesy of Gene Kirkland; bottom: Melissa Mahoney © Steven Tallarico. Page 9, top: Ross Halfin for Aerosmith; bottom: Melissa Mahoney © Steven Tallarico. Page 10, top and middle: Steven Tallarico; bottom: Keren Pinkas. Page 11: Erin Brady. Page 12, top: Erin Brady; middle: Ross Halfin for Aerosmith; bottom: Steve Erle/*Sports Illustrated*/Contour by Getty Images. Page 13, top: Ross Halfin for Aerosmith. Page 14, clockwise from top left: Liv Tyler, Chris O'Brien, Liv Tyler. Page 15, clockwise from top left: Liv Tyler, Chris O'Brien, Erin Brady, Steven Tallarico. Page 16: Kevin Baldes.

Additional permissions on pages 379-386.

DOES THE NOISE IN MY HEAD BOTHER YOU? Copyright © 2011 by Walk This Way Productions, Inc. All rights reserved. Printed in the United States of America. No part of this book may be used or reproduced in any manner whatsoever without written permission except in the case of brief quotations embodied in critical articles and reviews. For information address HarperCollins Publishers, 10 East 53rd Street, New York, NY 10022.

HarperCollins books may be purchased for educational, business, or sales promotional use. For information please write: Special Markets Department, Harper-Collins Publishers, 10 East 53rd Street, New York, NY 10022.

Designed by Mary Austin Speaker Photo inserts designed by Lucy Albanese

A hardcover edition of this book was published in 2011 by Ecco, an imprint of HarperCollins Publishers.

FIRST ECCO PAPERBACK EDITION PUBLISHED 2012.

Library of Congress Cataloging-in-Publication Data has been applied for.

ISBN 978-0-06-176791-3

12 13 14 15 16 OV/RRD 10 9 8 7 6 5 4 3 2 1

To the loving memory and the spirit of Susan Rey Blancha Tallarico

CONTENTS

	Semiprologue	1
1	PERIPHERAL VISIONARY	5
2	ZITS AND TITS	37
3	THE PIPE THAT WAS NEVER PLAYED	74
4	MY RED PARACHUTE	
	(AND OTHER DREAMS)	85
5	CONFESSIONS OF A RHYME-A-HOLIC	123
6	LITTLE BO PEEP, THE GLITTER QUEEN, AND	
	THE GIRL IN THE YELLOW CORVETTE	133
7	NOISE IN THE ATTIC (SNOW DAYS)	148
8	LADIES AND GENITALS I'M NOT	
	A BAD GUY (I'M JUST EGOTESTICAL)	170
9	THE HOOD, THE BAD, THE UGLY	
	HAMMERED WITH HEMINGWAY	198
10	FOOD POISONING AT A FAMILY PICNIC	212
11	GETTING LOST ON YOUR WAY	
	TO THE MIDDLE	247
12	WHERE YOU END AND I BEGIN AGAIN	
	(THE GODDESS)	256
13	TROUBLE IN PARADISE (LOSING YOUR	
	GRIP ON THE LIFE FANTASTIC)	265
13.5	THE BITCH GODDESS OF BILLBOARD	282
14	HOLY SMOKE, QUEST FOR THE GRAND	
	PASHMINA, AND THE BIG CHILL OF	
	TWENTY SUMMERS	302
15	TO ZANZIBAR AND BACK	329
16	FALLING IN LOVE IS HARD ON THE KNEES	356
17	TAKE A WALK INSIDE MY MIND	372
	Acknowledgments	377
	Index	387

SEMIPROLOGUE

If you're a hammer, everything looks like a nail. If you're a singer, everything looks like a song.

ife is short. Break the rules, forgive quickly, kiss slowly, love truly, laugh uncontrollably, and never regret anything that makes you smile." We're not quantified; there's no chart of desire. When the roaring flames of your heart have burned down to embers, may you find that you have married your best friend. Hunch, conjecture, instinct . . . a blind allegiance to anything can get you killed, and always remember . . . sing as though no one can hear you; live as though heaven is here on Earth. Here I want to say something deep and meaningless, like "To thine own self be true," but in truth, the first thing we have to do is KILL ALL THE LAWYERS.

When I was a kid and in a gang, my so-called best friend, Dennis Dunn, would slam me in the arm and say, "Pass it on, motherfucker!" So I turned to Ignacio and punched him in the arm and said, "Pass it on!" Ignacio turned to Footie and punched him in the arm, and Footie punched Raymond, who in turn . . . punched me again. It's all about fighting for position. Later on in life I was to find that being in a band was not too different. Only in my new gang, Brad punched Tom, Tom punched Joey, Joey punched Joe, and Joe punched me (in the mouth), and that's the sweetest way I can tell you what happens in every band that ever there was (at least those that lasted more than ten years and got the chance to manifest the light).

I remember once my mother telling me, when I said I wanted to be like Janis Joplin: "If you manifest the light, you will become a dartboard for others' fears, doubts, and insecurities. And if you can handle that, Steven, my little skeezix, you may have your Blue Army." And guess what? I got both barrels! I also wish to articulate at the outset here, neighbors and ne'er-dowells, that my life's journey has not taken me to a place to defile, demoralize, or damage *anybody*. . . . So all of YOU who have ruffled my feathers and done me wrong for being an inquisitive child or an oversensitive pain-in-the-neck artist, remember, just like they said about Mongo in the movie *Blazing Saddles*, if you shoot Steven, you'll just make him angry.

When you're young, you experience everything for the first time, and because it's happening to *you* so matter-of-factly, it just $is \ldots$ and you argue your way through it. In midlife, you question fucking everything, and so much energy is wasted questioning the *whys* of it all. You want to find that angel of thunderstorms that will put out your internal fire. You start to believe that you made it through six decades because there *is* an angel on your shoulder.

That's why I'm a songwriter—because I've lived through the changes of not knowing ANYTHING . . . to knowing EVERYTHING . . . and now at sixty-three I'm back to NOT KNOWIN' NOTHIN'. And when your mind is free of socalled knowledge, it is now set free to use its imagination. Like Albert Einstein once said: "Imagination is more important than knowledge."

Radio plays your song; the melody is so catchy that it crawls inside of the people listening and changes *their* Everything. *They* start singing it! You got into them. You made love to them. You got into their soul . . . and vice versa. It's like Vuja Dé, and that's when the miracle manifests . . . you're trading faces, places, spaces, and graces.

DOES THE NOISE IN MY HEAD BOTHER YOU?

Father of four children (loves of my life), a songwriter, got a doctorate at Berkeley and another one at UMass, Boston, a poet, a painter, a drug addict, and a person who learns something new on a daily basis, from the Malibu Home for the Recently All Right to having dinner with Sheikh Nion in Abu Dhabi ... and now . . . an author? You gotta be kidding! RoMANtics. SeMANtics. Exotic, neurotic, you got it! Does the noise in my head bother you . . . yet? Yeah, really? I'd say we're off to a good start.

S.T.

PERIPHERAL VISIONARY

was born at the Polyclinic Hospital in the Bronx, March 26, 1948. As soon as I could travel my parents headed straight out of town to Sunapee, New Hampshire, to the little housekeeping cottages they rented out every summer, kind of an old-fashioned bed-and-breakfast deal only it was 1950. I was put in a crib at the side of the house. A fox came by and thought I was a cub, grabbed me by the scruff of my diaper, and dragged me into the woods. I grew up with the animals and the children of the woods. I heard so much in the silence of the pine tree forests that I knew later in life I would have to fill that void. The only thing my parents knew was that I was out there somewhere. They heard me cry in the forest one night, but when they came up to where I was, all they saw was a big hole in the ground, which they thought was the fox's den. They dug and dug and dug, but all they found was the rabbit hole I'd fallen into—like Alice.

And like Alice I entered another dimension: the sixth dimension (the fifth dimension was already taken). Since then, I can go to that place anytime I want, because I know the secret of the children of the woods; there's so much in silence when you know what you're hearing—what dances between the psychoacoustics of any two notes and what reads between the lines is akin to the juxtaposition of what you see when you look in the mirror. My whole life has been dancing between these worlds: the GOAN ZONE, the Way-Out-o-Sphere and . . . the UNFORTUNATE STATE OF REALITY. In essence, I call myself a peripheral visionary. I hear what people don't say and I see what's invisible. At night, because our visual perception is made up of rods and cones, if you're going down a dark path, the only way to really see the path is to look off and see it in your peripheral vision. But more on this as we progress, regress, and digress.

When I finally got pulled out of the rabbit hole, my parents brought me back to the third dimension. Like all parents they were concerned, but I was afraid to tell them that I have never felt more comfortable than being lost in that forest.

In Manhattan we lived at 124th Street and Broadway, not far from the Apollo Theater. Harlem, man. If the first three years of your life are the most informative, then surely I needed to hear that music, and I was inspired by the noise coming out of that theater. It had more soul than Saint Peter.

A few years ago I was back at the Apollo, and saw the park where my mom had pushed me in my carriage. My first visual memory is from THAT PARK: trees and clouds moving above my head as if I were floating above the earth. There I am, a two-year-old astral-projecting infant. At age four, I remember going to get a gallon of milk with two quarters, walking with my mom hand in hand through passages and corridors of the basement of our building and through tunnels into the adjoining building where the milk machine was. I thought I was . . . God knows where. I might as well have been on Mars. Ah, it was the mysterious world of childhood, where someone is always leading you by the hand through a dark passageway and into a brand-new world just waiting for the child's overactive imagination to kick in. My mother lit the fire that would keep me warm for the rest of my life. She read me parables, *Aesop's Fables*, and Rudyard Kipling's *Just So Stories*. Children's tales and nursery rhymes from the eighteen hundreds, nineteen hundreds: "Hickory Dickory Dock," Andrew Lang's *The Nursery Rhyme Book*, Hans Christian Andersen, Helen Bannerman's *Little Black Sambo*. So great! Never mind the "Goose That Laid the Golden Egg!" My mom would read me all these stories every night at bedtime. But one night when I was around six, she stopped.

"You gotta learn how to read 'em yourself," she said. Up until then I'd been reading along with her as she pointed to the words. We did this for months until she knew I kinda had the idea, then suddenly there's no Mom looking over my shoulder. She just left the book by my bed and I became distraught. "Mom, I wanna *hear* the stories. Why won't you read to me anymore?!" I said. And then one night I thought to myself, "Uh-oh, now I gotta get smart." Naah. . . . I'll just become a musician and write my own stories and myths . . . Aeromyths.

Mom used to tell me of a man she'd seen on the *Steve Allen Show*, in 1956 when I was eight. His name was Gypsy Boots. He was the original hippie, a guy who lived in a tree with hair down to his waist and who promoted health food and yoga. Gypsy was *the* protohippie. In the early thirties he had dropped out of high school, wandered to California with a bunch of other so-called vagabonds, lived off the land, slept in caves and trees, and bathed in waterfalls. I was totally seduced by that lifestyle. Boots's message was this: As primitive as his world seemed, he wanted people to think that he would live forever. Hey, he almost did, dying just eleven days before his ninetieth birthday in 1994.

Next in my life came a bohemian composer named Eden Ahbez, who wrote a song called "Nature Boy" (which my mom heard on a Nat King Cole record). He camped out below the first L in the Hollywood sign, studied Oriental mysticism, and, like Gypsy Boots, he lived on vegetables, fruits, and nuts. My

mom sang that song to me before I went to sleep. I'll never forget how it made me think that I was her nature boy.

The song tells the story of how one day an enchanted wandering Nature Boy—wise and shy, with a sad, glittering eye crosses the path of the singer. They sit by the fire and talk of philosophers and knaves and cabbages and kings. As the boy gets up to leave he imparts the secret of life: To love and be loved is all we know and all we need to know. With that Nature Boy vanishes into the night as mysteriously as he had come.

Unfortunately the people who own the rights to "Nature Boy" won't let me publish the actual words to the song in this book (still, you can just Google them), but I promise it will be on my solo album come hell or high water.

Then there was Moondog. What a fantastic character, a blind musician who dressed up like a Viking with a helmet and horns and a spear to match. He hung out on the corner of Fifty-sixth Street and Sixth Avenue. I saw and smelled him every morning on my way to school. Oddly enough, he lived up in the Bronx, apparently in the woods, back behind the apartment buildings I grew up in. Was that a coincidence or was that God secretly telling me, "Steven, thou shalt become the Moondog of your generation"? Or at least the leader of a rock 'n' roll band.

What I heard about Moondog was that *he* wrote "Nature Boy," but what do I know? Maybe Eden Ahbez is Moondog spelled backward....

My mother's birth name was Susan Ray Blancha. At sixteen she joined the WACs (Women's Army Corps). She met my dad while they were both at Fort Dix in New Jersey during World War II. One night he had a date with a woman who was rooming with my mom. The roommate stood him up, and instead he was greeted by my mother, who happened to be playing the piano at the time. My dad walked over to her and said, "You're playin' it wrong." It was love at first fight! They got married and had lil ol' Lynda, my sister, and lil ol' me came two years later.

9

Ha-ha! That's my mom, that's my dad, and that's why I'm so fuckin' detail-oriented—and such a maniac. I got the traits that I don't want and the ones I do. Because you're an offspring, you pick up those traits unconsciously, in case you haven't noticed. You become your mom!

So that's how I happened, 1948, a rare mixture of classical Juilliard boy meets country pinup girl, who, by the way, looked like a cross between Jean Harlow and Marlene Dietrich with a tinge of Elly May Clampett. And if God's in the details—and we know She is—then I'm the perfect combination. I'm the N in my parents' DNA. So now, if anyone's mad at me and calls me a dick, I know they really mean Fort Dix. My daughter Chelsea always thought God was a woman from the day she was born. It was so nurturing hearing that from a child, that God would have to be a woman, that I just never questioned it. (No wonder I keep watching *Oprab.*)

Mom was a free spirit, a hippie before her time. She loved folktales and fairy tales but hated Star Trek. She used to say, "Why are you watching that? All the stories are from the Bible . . . just six ways from Sunday. Get the Bible!" And I thought, "Oh, boy, that's just what I wanna do after I've rolled a doobie and I'm smokin' it with Spock." And by the way, that's why teenagers today go, "Whatever!" But you know-and I can only admit this in the cocktail hours of my life-SHE WAS RIGHT !!!!! Isaac Asimov's I Robot, Aldous Huxley's Brave New World, that's where they got their inspiration. In the same way that Elvis got his sound from Sister Rosetta Tharpe (I dare you to YouTube her right now), Ernest Tubb, Bob Wills, and Roy Orbison. And they, in turn, begat the Beatles and they begat the Stones and they begat Elton John, Marvin Gaye, Carole King, and . . . Aerosmith. So study your rock history, son. That be the Bible of the Blues.

I was three when we moved to the Bronx, to an apartment building at 5610 Netherland Avenue, around the corner from where the comic book characters Archie and Veronica supposedly lived (I guess that makes me Jughead). We lived there till I was nine on the top floor, and the view was spectacular. I would sneak out the window onto the fire escape on hot summer nights and pretend I was Spider-Man. The living room was a magical space. It was literally eight feet by twelve! There was a TV in the corner that was dwarfed by Dad's Steinway grand piano. There's my dad sitting at the piano, practicing three hours every day, and me building my imaginary world under his piano.

It was a musical labyrinth where even a three-year-old child could be whisked away into the land of psychoacoustics, where beings such as myself could get lost dancing between the notes. I *lived* under that piano, and to this day I still love getting lost under the cosmic hood of all things. Getting *into* it. Beyond examining the nanos, I want to know about what lives in the fifth within a triad . . . as opposed to DRINKING a fifth! I've certainly got the psycho part . . . now if I could only get the acoustic part down (although I did write a little ditty called "Season of Wither").

And that's where I grew up, under the piano, listening and living in between the notes of Chopin, Bach, Beethoven, Debussy. That's where I got that "Dream On" chordage. Dad went to Juilliard and ended up playing at Carnegie Hall; when I asked him, "How do you get to Carnegie Hall?" he said, like an Italian Groucho, "Practice, my son, practice." The piano was his mistress. Every *key* on that piano had its own personal and emotional resonance for him. He didn't play by rote. God, every note was like a first kiss, and he read music like it was written for him.

I remember crawling up underneath the piano and running my fingers on top of the soundboards and feeling around. It was a little dusty, and as I was looking up, dust spilled down and hit me in the eyes—dust from a hundred years ago . . . ancient piano dust. It fell in my eyes and I thought, "Wow! Beethoven dust the very stuff he breathed."

It was a full-blown Steinway grand piano, not a little upright in the corner—a big shiny black whale with black and white teeth that swims at the bottom of my mind and from a great depth hums strange tunes that come from I know not where. 20,000 Leagues Under the Sea had nothing on me.

Later on, I went back to visit 5610 Netherland Avenue. I knocked on the door of apartment 6G, my old apartment. It had been years, and the man who answered was drunk and in his underwear and undershirt.

"Dad?" I asked. He cocked his head like Nipper, the RCA dog.

"Hi, I'm-" I started to say.

"Oh, I know who *you* are," said he. "From the TV.... What are you doin' here?"

"I used to live here," I said.

"Well raise my rent!" said he.

So I went in and looked around, and doesn't it always seem that the apartments we all grew up in are so much smaller compared to how they felt thirty years ago? My god, the kitchen was tiny, four by six! The bedroom I grew up in with my sister, Lynda, and my parents' master bedroom facing the courtyard you couldn't have changed your *mind* in there, never mind your clothes. How the hell did my father *get* a Steinway grand into that living room? So weird seeing this very tiny apartment with an even smaller black-and-white-screen TV on which I'd watched in wide-eyed abandon shows like *The Mickey Mouse Club* and *The Wonderful World of Disney*, which premiered on October 27, 1954. So between growing up at three underneath a piano and seeing my black-and-white television world turn into color by the age of six, that was enough right there to prepare me for life. I couldn't wait to jump into the middle of it.

My dad played those sonatas with so much emotion it vibrated into my very bones. When you hear that music from beginning to end day after day, it becomes embedded in your psyche. Those notes vibrate in your ears and brain. So for the rest of your life your emotions can be easily subliminally tapped into by music.

Most humans who are panning for gold—looking for that ecstatic moment—first find it in their own sexuality; then they have an orgasm and *whoops*, it's over. Now, imagine someone exploring, perhaps in search of their destiny. He stumbles upon a cave and out of sheer curiosity crawls inside and then looks up it's all glittering and sparkling, and for that first moment I was in Superman's North Pole crystal palace cave and the crystals resonated with Mother Earth's birthing cries.

I didn't know what I was hearing, and didn't understand then where it all came from. It didn't matter. I wanted to be a part of that. Little did I know, I was. It was pure magic. My dad manifested those crystal moments playing the notes of those sacred sonatas. It was like a mixture of Yma Sumac and the songs of humpback whales—these godlike sounds came showering down on me.

Just recently my dad came over to the house—he's ninetythree now! And I sat down next to him at the piano and he played Debussy's *Clair de Lune*. It was so much deeper than anything I have ever done or ever will do. It was so deep and invoked so much of that early emotion laid on top of my adult emotions that I wept like a baby. I remember that when I first heard it as a child I almost stopped breathing. Sometimes you can't appreciate how fortunate you are until you look back and get to glance into the *what-it-isness* and see how it all reflects off from whence you came. I started there, so now I'm here. I guess we're all here . . . 'cause we're not all there.

Sunapee, New Hampshire, was where I spent my summers as a kid. Driving up to Sunapee we'd go past Bellows Falls and Mom

would say, "Bellows Falls? Fellow's Balls!" There was so much to my mother. Like the way she'd get me to eat my peas. "Whatever you do, *do not eat those*!" And I gave her a frog smile.

A few years later, say around 1961, when I'd call for my mother from the other side of the house, my mom would go, "Yo! Where *are* you? Where'd you go?" Now I wonder where *she's* gone. She was a beautiful Philadelphia Darby Creek country girl who came to the city to bring us up, let me have long hair in school, argued with the principals, drove us to our first club dates, and loved and nurtured me—the whoever I was and/or wanted to be.

In the fifties, it would take us seven hours to go from New York up to New Hampshire because in those days it was all on back roads (there were no highways). But the ride up to Sunapee was filled with fantastic roadside attractions. A giant stone *Tyrannosaurus rex* on the side of the road, wooden bears, Abdul's Big Boy, and the Doughnut Dip, with a huge concrete doughnut outside.

Trow-Rico, our summer resort in New Hampshire, was named after Trow Hill, a local landmark, and Tallarico, my father's name, just smushed together. The cottages were on 360 acres of nothing but woods and fields. It was my grandfather Giovanni Tallarico's dream when he came over from Italy in 1921 with four other brothers. Pasquale was the youngest, a child prodigy on the piano. Giovanni and Francesco played mandolins. Michael played guitar. They were a touring band in the 1920s—it's where I get my on-the-road DNA. I've seen brochures for the Tallarico Brothers—they performed in giant hotels with huge ballrooms in places like Connecticut and Detroit. They went from New York by train to these hotels all over the country and played their type of music, to their type of people. Sound familiar?

My mother's father—that was another story. He got out of Ukraine by the skin of his teeth. The family owned a horsebreeding ranch. The Germans invaded and machine-gunned the

family down in front of my grandfather. "Everyone out of the house!" Bb-r-r-r-a-t! They gunned down his mother, father, and sister. He got away by jumping down a well and managed to grab the last steamer to America.

Trow-Rico is where I spent every summer of my life until I was nineteen. On Sundays my family would throw a picnic for the guests. My uncle Ernie would cook steaks and lobsters on the grill, and we'd make potato salad from scratch. We served all the guests—which came to what? eight families, some twentyodd people—in our heyday. After dinner, while the sun was going down, we'd fill in the trailer with hay, attach it to the back of a '49 Willys Jeep, and take everybody on a ride all over the property. We also had a common dining room where we served them breakfast and dinner, and guests would do lunch on their own, all for, like, thirty dollars a week. Sometimes six dollars a night. And when the people left, my whole family got pots and pans out of the kitchen and banged them all together—behold the origin of your first be-in!

As soon as I was old enough, they put me to work. First it was clipping hedges. When I snapped back, "What do I have to do that for?" my uncle said, "Just make it nice and shut up." He used to call me Skeezix. He'd spent most of World War II in the Fiji Islands, so he knew how to take care of business and anything else that gave us any trouble. I helped him dig ditches and put in a water pipeline over a mile of mountain and dug a pond with my bare hands. I washed pots and dishes at night and mowed the lawns with my father when I was old enough to push a mower. I cleaned toilets, made the beds, and picked up all the cigarette butts that the guests left behind.

We would rake up the hay with pitchforks and put it in the barn below the lower forty. The downstairs of the barn was empty except for maple syrup buckets and wooden and metal taps for the trees that some family had left before we lived there. It was quite an adventure going down there—full of spiderwebs, stacks of buckets, glass jars, and artifacts from the twenties and thirties—all those dusty, rusty things kids love to get into—me in particular.

Upstairs in the barn, there was a hayloft door with an opening where you'd load the hay in and out. I could climb up there and jump down from the rafters of the ceiling. I did my first backflip in that barn, because the hay was so soft, it was like landing on, well, hay. I always kept an eye out for pitchforks left behind. Land on one of those suckers and I would have learned how to scream the way I do now . . . twenty years earlier.

Before I could go to the beach with the rest of the guests I had to finish doing my chores. After a while I came up with a plan. It was called: get up earlier.

Every Tuesday, Thursday, and Saturday during the summer my father played the piano at Soo Nipi Lodge along with my uncle Ernie on sax. They had a trumpet player named Charlie Gauss, a stand-up bass player named Stuffy Gregory, and a drummer who will go unnamed. Soo Nipi Lodge—which today would probably be called Snoop Dog Lodge—was one of the classic old hotels, like the one in *The Shining:* all wooden and splendiferous and huge, with dining rooms and decks outside with rocking chairs and screened-in porches. Chill central by today's standards. They began building these resorts in the 1870s, when horses and buggies brought the guests from the train station to the hotels. The only thing missing was the musicians to play music and entertain the guests—and this is probably how the Tallarico brothers came to buy the land there.

During Prohibition, people would take the train up from New York to Sunapee, and the booze would come down from Canada. Some folks drank, some didn't. Maybe they came up for the weekend to see the leaves turn, but I have a funny feeling they got on the train for a quick weekend away—take horseand-buggy rides, stay at the big hotels, and cruise in the old steamboats. The ones in Sunapee Harbor today are replicas of the original ones from a hundred years ago. Very quaint. Ten miles up the road was New London, the original Peyton Place,

where, oddly enough, Tom Hamilton was born. But then again, it all makes perfect sense to me now.

On Sunday nights, Dad would give recitals at Trow-Rico. People from miles around would come over to hear him, and my grandma, my mother, and my sister would play duets. All the families that came up had kids, and Aunt Phyllis would holler, "C'mon, Steven, let's put on a show for them!" Downstairs from the piano room was the barn's playroom: Ping-Pong, a jukebox, a bar, and, of course, a dartboard. There was also a big curtain across one corner of the room that made a stage where my aunt Phyllis taught all the kids camp songs like "John Jacob Jingleheimer Schmidt" and the "Hole in the Bucket" song. I would pantomime to an old 78 recording of "Animal Crackers." It was an evening of camp-style vaudeville. For the finale, we hung a white sheet in front of a table made from two sawhorses and a board. Someone from the audience would be brought back to lie on the board, and behind them a giant lamp cast shadows on the sheet. My uncle Ernie would perform an operation on the person lying down, pretending to saw him in half and eventually pull out a baby-quite horrifying and hilarious to the audience. It was all very tongue-in-cheek but certainly the beginning of my career.

We must have done a hundred and fifty or more of those shows over the years. I was a serious ham. I'd do cute things kids can get away with—especially to adoring relatives. It was like something from a Mickey Rooney movie. I'd learned all the lyrics to that song "Kemo-Kimo."

Keemo Kyemo stare o stare Ma hye, ma ho, ma rumo sticka pumpanickle Soup bang, nip cat, polly mitcha cameo I love you

And then I'd add something like "Sticky sticky Stambo no so Rambo, had a bit a basket, tama ranna nu-no." What the hell was that? The beginning of my love for real out-there music and crazy lyrics.

Before I got involved in doing chores at Trow-Rico, before I discovered girls and pot and playing in bands, I had a great life in the woods with my slingshot and BB gun. As soon as we got up there, I'd be gone in the woods and fields. And I never came back till dinnertime. I was a mountain boy, barefoot and wild. I walked through the woods, looked up at the trees, the birds, the squirrels—it was my own private paradise. I'd tie a stick to a rope and make a swing from any tree branch. I was brought up that way, a wild child of the woods and ponds. But of course, nobody believes that about me. They don't know what to think when I say, "You know, I'm just a country boy."

No waves, no wind. If you go into a recording studio that's soundproofed, something just feels wrong to your ears. Especially when they close the door—that's sound deprivation, it's anechoic, without echo, without sound. Not so in the woods. In that silence I heard something else there, too.

I lost all that mystery when I was on drugs. Coming out of that din I was able to feel my spiritual connection to the woods again. Drugs will steal you like a crook. Spirituality, over. I could no longer see the things I used to see in my peripheral vision. No periphery, no visions.

I used to go up in the woods and sit by myself and hear the wind blow. As a kid, I'd come across places where the woodland creatures lived. Tiny human creatures. I'd see mossy beds, cushions of pine needle, nooks and crannies under the roots of upturned trees, hollow logs. I'd look around for elves, because how could it be *that* beautiful and strange and nobody live there! All of this tweaked my imagination into such a state that I knew there was something there besides me. If you could sleep on moss that thick it would be bliss. I'd smell that green grass. I would see a natural little grotto in the woods and say to myself, "That's where their house must be."

A few years ago I found a moss bed for sale at this lady's

little store in New London. The place was full of nature stuff and had a big wooden arch in front and giant bird wings. The bed is made of twigs, with a moss mattress, grouse feathers for pillows, a wooden nest, an ostrich egg cracked in half with a little message on it, and the prints of the fairies that were born on the bed. We kept it in the house so my two children, Chelsea and Taj, would see it and just know that fairies were born on that bed. They'd say, "For real?" and I'd say, "For real."

I bought the two fields I used to go walking in. I haven't gone out into the woods lately to see if they've been touched; I'm afraid to find out if it's all still there as I remember it. But I grew up with these creatures. I was alone in the forest but I was never lonely. That's where my first experiences of otherness came from, of the other world. My spiritual ideas didn't come from the Lord's Prayer or church or pictures in the Bible, they came from the stillness. The silence was so different from anything I would ever experience. The only noise that you heard in a pine tree forest was the gentle whistling sound of the wind blowing through the needles. Other than that, it's just quiet . . . like after a fresh snow. . . . It really quiets down in the woods . . . cracking branches . . . nothing. It's like when I took acid—I felt the wind brushing against my face although I knew I was in the bathroom and the door was closed. This was Mother Nature talking to me.

I would walk through the woods and walk and walk. I would find chestnut trees, fairy rings of mushrooms, bird's nests made with human hair and fishing line. I would imagine I was in the jungle in Africa and climb up on the gates at the entrances to the big estates and sit on the stone lions (until someone shouted, "Get down from there, kid!").

That's where my spirit was born. Of course I got introduced to spirituality through religion, too, from the Presbyterian Church in the Bronx and my choir teacher, Miss Ruth Lonshey. At the age of six, I learned all the hymns (and a few hers). I fell in love with two girls on either side of me in the choir. And of course they had to be twins. I remember being five and sitting next to my mother in a pew at that church, looking up at the altar that held the Bible and a beautiful golden chalice, with the minister looming over it. There was a golden tapestry that hung down to the floor with a crucifix embroidered on the front. I was all wrapped up in the tradition of getting up, sitting down, getting up, singing, sitting down, praying, singing, praying, getting up, praying, singing, and hoping all this would take me somewhere closer to heaven. I thought *for sure* God must be RIGHT THERE under THAT altar. Just as I'd thrown a blanket over the dining room chairs to create a fortress, a safe, powerful place, kinda churchlike, with the added bonus of imagination. WOW, all of this combined together in one beautiful moment of ME, feeling GOD. But then I'd met Her once before in the forest.

I would walk in Sunapee with a slingshot in my back pocket over the meadow and through the woods until I got lost . . . and that's when my adventure would begin. I would come upon giant trees so full of chestnuts that the branches would bend, bushes full of wild blackberries, raspberries, and chokecherries, acres of open fields full of wild strawberries in the grass—so much so that when I was mowing the lawn, it smelled like my mom's homemade jam. I would find animal footprints, hawk feathers, fireflies, and mushrooms in the shape of Hobbit houses that I was told were left by Frodo and Arwin from *Lord of the Rings*. Incidentally, those were the same mushrooms that I would later eat and that would magically force my pen to write the lyrics to songs like "Sweet Emotion." In choir, I was singing to God, but on mushrooms, God was singing to me.

I pretended I was a Lakota Indian with a bow and arrow— "One shot, one kill"—only I had my BB gun—"One BB, one bird." Me and my imaginary buddy Chingachogook, moving silently through the woods. I was a deadeye shot; I'd come back after an afternoon of killing with my slingshot and Red Ryder BB gun with a string of blue jays tied to my belt. That part wasn't imaginary. I had watched every spring how blue jays raided the nests of other birds and flew away with their babies. My uncle had told me that blue jays were carnivorous, just like hawks and lawyers.

I'd go out fishing with my dad on Lake Sunapee in a fourteen-foot, made-in-the-forties, very antique, *giant* wooden 270-pound rowboat that only a Viking could lift. The handles on the oars alone were thicker than Shaq at a urinal. You're out in the center of the lake, sun beating down like in the Sahara. You're burning, you can't go any farther. By the time we rowed out to the middle, where the BIG ONES were biting, we all realized we had to row back. *We being ME. A-ha-ha-ha!* I became Popeye Tallarico. Mowing the lower forty acres once a week gave me the shoulders to row back to shore (and to carry the weight of the world).

Up in the woods from the lake there were great granite boulders pushed there by glaciers during the Ice Age. There were caves up above the road I lived on in Sunapee with Indian markings on the walls—pictographs and signs. They were discovered when the town was settled back in the 1850s. The Pennacook Indians lived in those very caves. After killing off all the Indians, the whites built and named a seventy-five-room grand hotel after them, Indian Cave Lodge, the first of three grand hotels in the Sunapee area and the first place where I played drums with my dad's band back in 1964—also just a half a mile away from where I first saw Brad Whitford play.

In the town of Sunapee Harbor there used to be a rollerskating rink. It had been an old barn; they opened up the door on the right side and the door on the left side and they poured cement around the outside of the barn so you could skate around the barn and through the middle out the other side. As a kid, it was a great little roller-skating rink. And back then, you could rent skates on the inside of the barn along the back wall and buy a soda pop, which they would put in cups that you could grab as you skated on by. Later on they put a little stage where a band could play behind where they rented the skates. By the next summer, not only could you roller-skate, but you could also rock 'n' roller-skate to your favorite band. It was the first of its kind and it was called the Barn. Across the street was a restaurant called the Anchorage. You could pull your boat up and after a long day of waterskiing, sunbathing, or fishing-with-no-luck, get fish and chips... And speaking of chips, no one made french fries better than one of the cooks that worked at the Anchorage—Joe fucking Perry. I went back there to shake his hand and there he stood in all his glory, horn-rimmed black glasses with white tape in the middle holding them together. He looked like Buddy Holly in an apron. I said, "Hi, how are ya?" or was it, "How high are ya?" At the time I was with a band called the Chain Reaction and little did I know that my future lay somewhere between the french fries and the tape that held his glasses together.

At the end of each summer I'd go back to the Bronx, which was a 180-degree culture shock. A return to the *total* city-tenements, sidewalks-from total country-where the deer and the antelope rock 'n' roam. Haven't met many people who experienced that degree of transition. Where we lived was the equivalent of the projects: sirens, horns, garbage trucks, concrete jungle-versus the country-rotted-out Old Town canoe bottoms from the early 1900s, remnants from the last generation who once knew the original Indians. Holy shift! By September 1, all the tourists who made New Hampshire quiver and quake for a summer of fun had fled for the city from whence they came like migrating birds. Welcome to the season of wither. One was grass, green, and good old Mother Nature, and the other was cement sidewalks, subways, and switchblades. But somehow I still found a way to be a country boy, so even in the city I could be Mother Nature's son-but with attitude.

Kids would ask me, "Where'd you go?" I'd tell them, "Sunapee!" Sunapee was a great mysterious Indian name. It was like coming from a different planet. When I got back to the city I would invent fantastic adventures for myself: escaping from a

grizzly bear, attacked by Indians. "You've got a .22?" "You what?" And then I started the bullshit: "I got bit by a rattlesnake," showing them a scar I got falling into the fireplace that summer. It was kind of like believing your own lie; you tell a lie and it grows. "The thing came at me, it was drooling, it had blood on its fangs from the camper it'd recently killed." "You're kidding me?" "No, seriously, it was rabid, but I nailed it right between the eyes with my .22." Well, I didn't want to say I was mowing lawns and taking garbage to the dump. That didn't cut it with the girls, or the guys who wanted to beat you up if you didn't represent a Bronx-type attitude. I wanted to talk about how I killed a grizzly with my bare hands-I was Huck Finn from Hell's Kitchen. City people have bizarre ideas about the country anyway, so I could make up anything I liked and they'd believe me. Remember, this was 1956. And Ward Cleaver actually had a son, not a wife, named . . . Beaver.

I was about nine when we moved from the Bronx to Yonkers. I *hated* being called Steve. I was known as Little Stevie to my family and that's cool because that's my family. But being called Steve by anyone other than my family sucked. Getting moved from the Bronx to a place called Yonkers (a name almost as bad as Steve) took a little adjusting to. It was too white and Republican for a skinny-ass punk from the Bronx. My best friend's name was Ignacio and he told me to use my middle name, which is Victor, a-lika my poppa! This suggestion, coming from a kid whose name sounds like an Italian sausage, was perfect. So for a year everyone called me Victor and that's just how long that lasted.

Moving from the Bronx to Yonkers was okay because we lived in a private house with a huge backyard and woods everywhere. There was a lake used as a reservoir two blocks from my house, where my friends and I fished our teenage years off. It was filled with frogs, salmon, perch, and every other kind of fish. There were skunks, snakes, rabbits, and deer in my backyard. There was so much wildlife in those woods that we all started trapping animals, skinning them, and selling their fur for pocket money, a kind of backwoods hobby I learned from the 4-H friends I grew up with in New Hampshire. When I was fifteen I found a toy store that sold wading pools for toddlers in the shape of a boat. I bought one and humped it down to the lake, paddled out and picked up all the lures that were caught in the weeds. I wound up selling them to the same people who had lost them to begin with. I was a reservoir dog before it was a movie.

At fourteen I found this pamphlet in the back of Boy's Life or some other wildlife magazine, with an ad for Thompson's Wild Animal Farm in Florida. You could buy anything from a panther to a cobra to a tarantula to a raccoon. A baby raccoon? Wow, I gotta have one! I sent away and it arrived in a wooden crate looking up at me with eyes like a Keane painting or a Japanese anime schoolgirl. I gave him a bath, threw him over my shoulder, and headed down to the lake. It was there that he taught me how to fish all over again. I named him Bandit because when you turned your back he would either pick your pockets or steal all the food out of the refrigerator. After a year of his ripping the house apart, I realized that a wild animal kept in the house is not the same as having a domestic animal as a pet, so I had to keep him in the backyard. You've got to just feed them and let them be wild. If you take them in, they adopt your personality-and at age sixteen, I was full of piss 'n' vinegar, which is not what you want a wild animal to be. He ripped down every curtain my mom put up in the house. I loved Bandit and he changed my mind about killing animals. I wound up giving him away to a farmer in Maine where he grew to a ripe old age, huge and fat. Eventually chewing his way to freedom, he bit through an electric wire and burned down the barn. You can still see his face in Maine's Most Wanted. Way to go, Bandit!

Back in the Bronx, the kids would assemble in the courtyard every morning at good 'ol P.S. 81. "All right, class, line up!" at 8:15 A.M. sharp. One morning when I was in third grade, there was a girl in the courtyard and I must have grabbed a broken

lightbulb and chased her around—like any smart (ass) little boy looking for affection would do. This was *my* way of proving that there was more to adolescent courtship than snakes and snails and puppy dog tails.

Her mother went to the principal's office. "If Steven Tallarico's not thrown out of this school, I'm taking my daughter out! He chased my daughter with a LETHAL WEAPON (blah blah blah). He's an animal!" I was already Peck's Bad Boy, and this didn't help. They brought my mom in. They wanted to send me to a school for wayward lads and lassies, who are known today as ADHD kids.

"What? Are you kidding?" my mother said to the principal. My mom was soooo *for* me. "You know what? I'm takin' *him* out of this school. Fuck you!" She didn't say that, but her EYES did. And she DID take me out. I moved on to the Hoffmann School, which was a private school in Riverdale hidden in the woods, oddly enough, by Carly Simon's house. Unbeknownst to me, Carly also lived nearby in Riverdale. Thirty years later, when we did a concert toether on Martha's Vineyard, she told me that she also went to the Hoffmann School.

I was excited about the Hoffmann School, but I get to the place and find out it's full of "spaycial kids." Kids that go "Fuck YOU!" in the middle of class, who have some Tourette-type syndrome and scream their lungs out. A little wilder than public school, I would say: kids sniffing the glue during art class and writing graffiti in the hallways . . . kids *eating* finger paint and everyone shooting spitballs with rubber bands at each other. WOW, my kind of place!

These were kids like me, hyper, acting-out kids—real brats! Not that I was that *exactly*. I just had too much Italian in me, the kind of Italian who, you know, is loud, opinionated, in-yourface, with no brakes. But I knew that if I totally let go, there was going to be fucking cause and effect and it would end with a ruler across my knuckles. Still, I'd do anything I could think of. I remember once combing my hair in the lunchroom with a fork! That time I got off easy; setting a fire in a trash can was a different story.

So that was the Bronx, still somewhat wild. On my way to the Hoffmann School I cut through a field, jumping over a stone wall. Over the river and through the woods. There was a cherry tree that was so thick and fat, the size of an *elm* tree, and when it bloomed it was like an explosion of pink and white petals, like a snowstorm. In summer it was loaded with cherries.

I'd go around behind the apartment buildings looking for stuff to get into. I found this big, beautiful pile of dirt, which later I realized was landfill from all the apartment buildings in that area. A ten-story mountain of dirt you had to climb as if you were scaling Mount Everest. A kid's dream! To me that pile of dirt was a mountain—Mount Tallarico. "Let's go climb the mountain," I'd tell my friends. When you got to the top of it there was a whole *acre* of land with weeds and saplings—and praying mantis nests and all sorts of things that no one could get to. Of course I had to bring a praying mantis nest home. It looked like something from between my legs—all round, tight, wrinkly, and kinda figlike. I hid it in my top drawer because I thought it was so cool. I woke up two weeks later and my room was *full* of little baby praying mantises thousands of them! They'd just infested the place, all over our bunk beds, blankets, pillows, on the walls, and . . . "Mom!"

We opened the windows, ran out, and closed the door. Needless to say, I slept on the living room couch for almost a week. When we finally went back in they were all gone.

On the top of that mountain was a small tunnel that I'd seen but never explored. One day I crawled in a few feet, but it was dark and musty so I didn't go too far. The older I got, the farther I'd go. Finally one day I was crawling back in there and I said to my friend, "Hold my feet!" Because as a kid all you've got in your mind is that it's the rabbit hole, which I didn't want to know anything about at that age. Later on, I paid the Cheshire Cat a million dollars to be my roommate! How strange that after we moved in together, he almost cost me my life.

STEVEN TYLER

I was being really cautious, wriggling farther and farther in, shining a flashlight as I went, with my friend holding my feet. And what do I find there but an old M1 rifle that someone had used to hold up a liquor store around the corner from 5610 Netherland Avenue. So I took the rifle and walked through the streets to my building with it over my shoulder like General Patton. And I thought, "Wow, look what I got! I can't wait to show my mother." She eventually called the police and told them where I found it. I was written up in the paper the next day and I had my fifteen minutes of fame. Quite a change for the kid who was always getting in trouble. Okay, I became a hero while trying to *make* trouble, but still . . . a fabulous first.

Meanwhile, back at the raunchy, I mean the ranch (à la *Spin* and Marty) in Sunapee, Joe Perry lived on the lake just six miles from me, over in The Cove. It was, like, all our lives as kids, he was there and I was there and we never ran into each other. We did the same stuff. He swam all day and lived in the water—and the lake water's fucking freezing—any more than half an hour and your lips were purple. I'd get out of the water and lie on my stomach in the sand at Dewey Beach, stretching my arms out like wings and pulling the hot sand up to my chest, trying to warm up like a lizard on a rock. I can only imagine what my heart must have been doing, going through the hypothermia shuffle.

But it wasn't all purely idyllic up in Sunapee—there was racism, and we were Italian. The Cavicchio family used to put on water-ski shows in the harbor. They brought the show from Florida. They were the only ones who knew how to perform the water-ski jump, ski barefoot, and pull seven girls behind the boat, girls who would climb on each other's shoulders to make a human pyramid. Then one day they took the docks away at Dewey Beach to drive the Cavicchios off. An era was over. Now, no one could go to Dewey Beach and water-ski off the dock. My uncle Ernie, however, had a different plan. He knew that once anybody learned how to water-ski, it was more fun starting with your ass sitting on the dock instead of in the cold water. So he built a nine-by-nine-foot raft, put barrels underneath to keep it afloat and four chains on the corners that went down to four rocks that anchored it to the bottom to keep it in place. Whoever tore the dock down couldn't stop us, because the raft was far enough offshore that it wasn't in anyone's way. But someone got pissed that we had gone against the grain. One dark night they decided to take fat from the Fryolators at one of the harbor restaurants and smear it all over the top of the raft. It became so greasy and smelly that no one could or would want to water-ski off it. How odd is it that the fat from the Fryolator that Joe Perry used to make my french fries was the same shmutz that caused the first oil slick on Lake Sunapee? It was a countrified version of the *Exxon Valdez*... only it tasted a bit better.

I would hitchhike from Trow-Rico down to Sunapee Harbor on Friday night and meet up with the guys in town. The thing to do was to find someone to buy us some beer; then we would play this game of jumping from boathouse to boathouse, just like roof jumping in New York, only in New Hampshire, on the lake. The rule was you weren't allowed to touch land, and whoever made it to the farthest boathouse got the six-pack of Colt 45 and the girl that thought it was cool. Cheap thrills. The Anchorage Restaurant down at the harbor had three pinball machines that were lit up all night long, especially if Elyssa Jerett was there. Nick Jerett, her father, played clarinet in my dad's band. She was the most beautiful girl in Sunapee—and she later married Joe Perry. But back at the Anchorage, she was going full tilt all night long—she was a Pinball Wizardess!

My cabin up in Trow-Rico was tiny. It had a double-decker bunk bed, one bureau, and one window that pulled down with a chain. I slept on the top bunk, and in the morning my father would wake me up by throwing apples from the crabapple tree. Around 7:00 A.M. If I'd gotten any sleep at all, it was rise and shine no matter what. He didn't throw the apples hard, but it

STEVEN TYLER

was loud enough to wake me up. The sound and the rhythm of the apples hitting the side of the cabin was a muffled kind of music to me, kind of like the backbeat of a snare drum—it always reminded me of how loud a snare should be in a track.

Dad knew I loved playing drums, so he offered me a job playing with his band three nights a week, all summer long. What his band played was kind of like the society music you hear in *The Great Gatsby* tradition. We played cha-chas, Viennese waltzes, fox trots, and show tunes from Broadway musicals, like "Summertime" from *Porgy and Bess*. I was mortified when girls my own age walked in, turned around, and walked out. I so wanted to go into a rockin' version of "Wipeout" or "Louie Louie," instead of a waltz from Louis XIV, or so it seemed. We'd set up in the grand ballroom of the Lodge, and from 7:30 to 10:00 P.M. we played four sets, each a half-hour long. I had to pull my long hair back, slick it down with pomade and butch wax, and put it in a ponytail. I looked like a fourteen-year-old Al Pacino in *Scarface*!

I got two or three summers of that under my belt, playing every night for two months with my dad. The audience was older, but now and then some folks would bring in their daughters; it was a family affair. And while I was playing one night this good-looking girl in a white dress came in with her parents. I watched her from behind the drums, eyeing her up and down and fantasizing as little boys do. Her mother would look on while her father, of course, had the first dance with his little cherub. How cute! She had to be fourteen-plump, pubescent perfection, flashing her big green eyes, and hair down to her waist. "Oh, my god," I thought, and overcome with teenage lust, I let my hair down, though it made my dad very angry. I wanted to let my FREAK FLAG FLY! I'm sure that hearing the songs we were playing, if she weren't with her parents, any girl in her right mind would have been gone in two seconds! I could see her thinking, "I'm so outta here!" ... and so was I! The chase was on! During the break, Dad was in the bar with the band and I was drooling in the hallway, looking for the cherub in the white dress.

There was a guy named Pop Bevers who used to come and mow the fields when we got up to Trow-Rico in July. He chewed tobacco—big plug o' Days Work. I'd sit and talk with him while he rolled his cigarettes and taught me how, too. I'd make my own cigarettes using corn silk. I'd put it on the stone wall, dry it out, roll it up in cigarette paper, and smoke it. Corn silk! I tried chewing tobacco once and got *so* sick I blew chunks all over my sister Lynda.

Then came the drinking years. All summer long my family would collect large quart bottles of Coke. My mom would save empty pop bottles, beer bottles, and wine jugs during the winter when we lived in the Bronx and Yonkers, and we'd bring cases of empty bottles up to Trow-Rico. At the end of the year, when the guests would leave, it would be apple season, and my entire family and I would go pick apples at an orchard and bring them to a place that pressed the fruit. We'd take the juice and put it into the bottles and keep them in the basement of Trow-Rico where they would turn into hard cider. One evening after a show at our barn (where we played every Saturday night), my cousin Auggie Mazella said, "C'mon, let's go in the basement." We grabbed a bottle and drank the whole thing out of the tin cups from our Army Navy surplus mess kits. The top of the kit became a frying pan in which you could cook your beans over a can of Sterno. It had a couple of plates, a cup, and silverware—the coolest thing.

The hard cider was strong stuff. We drank it just like we were drinking apple juice, and with no clue that we were getting hammered fast. I stumbled into the barn where the band was jamming and began to entertain the startled guests in an altered state, one to which I would soon become well accustomed. The glow shortly wore off. I felt queasy, staggered outside, fell flat on my torso, and woke up with a mouthful of yard. I crawled back to my cabin. Had I learned my lesson? Yes! But not in the way you'd think.

One night at the Soo Nipi Lodge my childhood ended. I

went from sitting with Daddy in the bar, having a Coke and eating peanuts, headlong into the evil world of dope! I met some of the staff, the busboys who lived down in the bungalows. Went out there and somebody twisted up a joint. Now, back then, we're talking 1961, a joint was *thin*. They were *tiny*. Pot was *so* illegal I didn't want to know about it. Another night I went into town to see a band at the Barn and one of the guys rolled a joint in the bathroom. He goes, "Hey, you want to smoke this?" "Nope," I said. "I don't need that! I got enough problems." Plus I'd seen *Reefer Madness*, so I passed it up, but then I got curious. I don't know if it was the smell or the romance, but eventually everything that I did was illegal, immoral, or fattening.

Shortly thereafter I started growing pot, hiding it from the family—as if they would ever know what it was. I thought if I put it right there in the field, knowing my luck someone would probably mow it down. So I went up to the power lines and planted some seeds, thinking that maybe that was far enough away. I figured I could just go up there and water the plants whenever necessary. But first off, I took a fish-a perch that I'd caught in the lake-chopped it up in little pieces, and put it on the stone wall so the summer heat would ferment it. After two weeks, flies are buzzing around it. It's rotten, just stinky! I mulched it with dirt, put it in the ground, took my pot seed, and went up and watered it every day. Two months later, I have a freakish bonsai of a pot plant. It's had plenty of fertilizer, but for some reason it wasn't growing. The stems were hard like wood. What's wrong? I wondered. Maybe it was because New Hampshire's cold at night-that's it! Wrong. Turns out they'd sprayed DDT or some pesticide under the power lines that stunted the plant's growth. Hey, motherfuckers! I was pulling leaves off and smoking it and getting high anyway. But the plant only had seven leaves on it. Still, I loved getting high and being in the woods. I would trip and go up to the mountains and streams with Debbie Bensonshe was my dream fuck when I was fifteen.

I'd get high smoking pot with my friends in my cabin. We'd

lock the door, even though I never had to hide my pot smoking from my mom. I'd say, "Mom, you're drinking! Why don't you smoke pot instead?" I'd twist one up and say, "Ma, see what it smells like?" She never said, "Put that out!" mainly because Mom loved her five o'clock cocktail (or the contact high).

When I couldn't get a ride from Trow-Rico down to the harbor—which is what, four miles?—I walked. In New Hampshire at night in the woods, it was so dark, you couldn't see your hand in front of your face. All those terrifying stories I'd told to my friends back in the Bronx came teeming to life. Wolf packs! Black widow spiders! Silhouettes of the Boston Strangler! Blood-thirsty Indians! I knew there weren't any Indian tribes left up at Sunapee. We—the white man—had wiped them out. But what about the *ghosts* of the Indians? They would be really pissed off, rabid with unquenchable bloodlust. Or else I was trippin' on my mom's homemade hard cider.

When clouds went over the moon the road got pitch black and I went, "Oh, shit!" I tapped my way with a stick like Blind Pew from *Treasure Island*. Really lonely . . . and scary. Yonkers and the Bronx were always lit up. You could hide in the snowbanks and when a car came around the corner you could grab on to the bumper and ski along behind it. But in Sunapee I almost had to crawl on my hands and knees to follow the white line down the middle of a dark country road. Later on I'd be back on my hands and knees following another kind of white line down a different dark road.

When I lived up there and September came and everybody was gone, I'd feel abandoned. Rough stuff when you're young. I used to think, am I going to be that crotchety old fuck yelling at kids to get off of my lawn? No, that's not me. I was the kid pissing on the lawn. You know, at this point in my life, I'm still in the woods. There's still so much I'm not sure of, and I kinda like that. It's the fear that drives us.

"Seasons of Wither" comes from the angst and loneliness of those nights when I was walking down that spooky road. Fireflies dance in the heat of Hound dogs that bay at the moon My ship leaves in the midnight Can't say I'll be back too soon

They awaken, far far away Heat of my candle show me the way

Now something new entered my life, less scary in one way but in another, more terrifying since it involved girls—that was long before I figured women out. "Right, Steven. You never did figure them out, did you? Just became a rock star and that sort of solved the problem." Ya think?

Anyway, my cousin Augie and I had talked these two girls into going camping overnight with us. Two girls, a tent, daygives-way-to-night, booze. Oh, man, you never know what could happen with that scenario. We could get lucky. . . . We came to a beautiful, rolling hill. It looked so plush and soft at night: "Wow! Where are we?" "I don't know, man, but let's pitch the tent and, uh, heh-heh, y'know. . . ."We had a six-pack of beer, girls, what could be bad? I don't think we were doing the wild thing, but definitely making out and getting drunk. I wish I'd had the evil mind back then that I have now—but when you're a boy you're mortally afraid of girls! Terrified!

We wake up in the morning to someone shouting, "Four!" I will never forget that. We looked at each other. What does that mean? Four? Louder this time, and then a golf ball slams into the side of the tent. Oh, "Fore!" We'd pitched the tent on the third hole on the golf course. Naked and hungover, we grabbed our stuff and ran like hell.

When I was six or seven, I went to church and sang hymns. There was a table with candles on it, and I thought God lived under that table. I thought that through the power of song, God was there. It was the energy rolling through those hymns. When I first heard rock 'n' roll—what did it do to me? God . . . before I had sex, it *was* sex! The first song that went directly into my bloodstream was "All for the Love of a Girl."

Way before the Beatles and the Brit Invasion, when I was nine or ten, I got a little AM radio. But at night up in Sunapee, the wind howled and I couldn't get the radio stations I wanted, so I ran a wire up to the top of the apple tree. It's still there! And I picked up WOWO out of Fort Wayne, Indiana, and heard "All for the Love of a Girl." It was the B-side of Johnny Horton's "Battle of New Orleans."

"All for the Love of a Girl" was a slow pick-and-strum love song with Johnny Horton, curling his lips around the lyrics, twanging each word as if it were a guitar string.

It was very basic, almost the archetypal love song. It's kind of an *every-love-song-ever-written* ballad. It's *all there* in four lines. Bliss! Heartbreak! Loneliness! Despair! I sat in the apple tree and lived every line of it. The only thing missing was my *raging schooner*—the likes of which you could pup a tent with.

When I heard the Everly Brothers' "I Wonder If I Care as Much" and those double harmonies . . . I lost my breath! No one ever did that anguished teen love song better than the Everly Brothers. "Cathy's Clown," "Let It Be Me," "So Sad (to Watch Good Love Go Bad)," "When Will I Be Loved?" Oh, man, those heartrending Appalachian harmonies! Those harmonic *fifths*! I mean, God lives in the fifths, and anyone who can sing harmonies like that . . . that's as close to God as we're gonna get short of a mother giving birth. Behold the act of Creation . . . divine and perfect.

If you have any doubts, try this: Take a deep breath and hold one note with somebody—a friend, your main squeeze, your parole officer: *"Ahhh.*" When two people hold the same note and one person goes slightly off that note you'll hear an eerie

vibration—it's an unearthly sound. I think in those vibrations there exist very strong healing powers, not unlike the mysterious stuff the ancient shamans understood and used.

Now sing in fifths, one sing a C and the other a G. Then one of you goes off key . . . that's *dissonance*. Fifths in muscal terms are first cousins and in those fifiths there's a magical throb. If you close your eyes and you touch foreheads, you'll feel a wild interplanetary vibration. It's a little-known secret, but that's how piano tuners tune a Steinway.

God and sound and sex and the electric world grid—it's all connected. It's pumping through your bloodstream. God is in the gaps between the synapses. Vibrating, pullulating, pulsating. That's Eternity, baby.

The whole planet is singing its weird cosmic dirge. The rotation of the earth resonates a great, terrible rumbling, grumbling G-flat. You can actually hear the earth groan like Howlin' Wolf. DNA and RNA chains have a specific resonance corresponding exactly to an octave tone of the earth's rotation.

It all really *is* cosmic, man! Music of the fucking spheres! The third rock from the sun is one big megasonic piezoelectric circuit, humming, buzzing, drizzling with freak noise and harmony. The earth's upper atmosphere is wailing for its baby in ear-piercing screeches, chirps, and whistles (where charged particles from the solar wind—the sun's psychic pellets—collide with Mother Earth's magnetic field). Earth blues! Maybe some shortwave-surfing extraterrestrial out there listening through his antenna will hear our cosmic moan.

You can just about guess that anything can—is gonna happen, so long as we stay here on earth. In a Stratocaster, say, you use a pickup wrapped with a few thousand coils of copper wire to amplify the sound of the strings. The vibration of the nearby strings modulates the magnetic flux and the signal is fed into an amplifier, which intensifies that frequency—and blasts out into the arena. In the same way that you can take a note and amplify it, you could amplify the whole fucking planet. Planet Waves! Take a compass. It's just a needle floating on the surface of oil that's not allowed to float freely. The power holding that needle is magnetism. The needle is quivering, picking up the slightest frequencies. Now, if you could amplify that . . . In thirty years, they're gonna be able to do that, and I'll have been sitting here going, "You know, there's power in the needle of a compass and . . ." It's actually a magnetic grid, the earth, so if you could amplify the magnetic frequencies of a guitar string, you could *certainly* amplify the magnetic frequencies of earth and *beam it out there* . . . Then you'd have the galactic blues blasted and Stratocasted out to the farthest planet in the cosmos.

Right outside my house in Sunapee there's a big rock that my kids used to call "Sally." It was their favorite thing to climb 'cause it was big and menacing and it drew them in. I had a special mystic boulder, too, but I never named my rock. It was right behind Poppa's cabin. It's probably thirty feet around and seven feet high, its surface so slick and smooth you can't get a grip to climb it. But next to this rock was a tree, and using the tree I leveraged myself up and onto the top of the rock. I thought, "If I can get on this rock and stand where no other human has ever stood . . . I can communicate with aliens." This raised some eyebrows among the other eight-year-olds on the playground.

When I scaled the boulder, my first thought was *Holy shit*, *I'm on the top of the world! This is MY ROCK*. Then I ran down to the basement of Trow-Rico, grabbed a fucking chisel—an inch around, six inches long—got a big ball-peen hammer a really fat one that we used for chipping away stone to make stone walls—and I carved "ST" into that rock, so when the aliens come—and someday they *are* gonna come—they'll see my marking and know that I was here and needed to make contact, and that I was one of the humans who wanted to live forever. That was my kid thought. I visited that rock recently, wet my finger, and rubbed it on the place where I'd carved my initials—and

they were still there! I took some cigarette ash and put it in the *S* so I could take a photograph of it. *E.T. meet S.T.*

That was my childhood. I read too much. I fantasized too much. I lived in the "what-if?" When I read Kahlil Gibran I recognized the same alien shiver of wildness: *And forget not that the earth delights to feel your bare feet and the winds long to play with your hair.*

Trow-Rico went the way of my childhood . . . lost and gone forever, my darling Clementine. It stopped being a summer resort somewhere around 1985.

You can't go home again; you go back and it's not the same. It's all crazy, small. Gives you vertigo, trying to go back. Like if you went to visit your mom, walked into the kitchen, and she had a different face.

ZITS AND TITS

wo months before my eighth birthday—Elvis! "Heartbreak Hotel," "Hound Dog." It was like getting bitten by a radioactive spider. Elvis . . . the Extraterrestrial. But it wasn't Elvis who first turned me on to rock 'n' roll. I was too young to quite get it. But four years later, Chubby Checker and Dimah the Incredible Diving Horse came roaring into my life.

By the time I was twelve, Chubby Checker's "Twist" was *huge*. It was the only single to top *Billboard*'s Hot 100 *twice*. I went with my family in the summer of 1960 and saw him at the Steel Pier in New Jersey. It was such a big fucking hit even your parents wanted to see him. He was playing live that night *and* I got to see a woman on a horse jump off a thirty-foot diving platform into a tank of water. The announcer said: "Ladies and Gentlemen, Dimah the Wonder Horse is going to dive into this small tank of water. Her rider, Miss Olive Gelnaw, will guide Dimah during her thirty-foot drop into the tank. Now, we need you to be very quiet. It takes all of her concentration to get it right, or they will miss the tank and fall to their death."

Dimah and her rider made a perfect dive and landed in the tank. Most of the water flew up in a huge wave over the side

of the tank and the crowd went wild. And those two images— Chubby Checker doing the Twist and the sexy girl in a bathing suit on a huge horse in a death-defying leap—fused in my mind. And that was my introduction to the world of rock 'n' roll.

I heard sex in "Twist." I didn't know what sex was, I hadn't gotten laid yet, I didn't know how to do sex, I didn't know what blow jobs were-"and I'm supposed to put my thing in your what?" But I heard sex in the music. And that's what I loved. I loved that someone could allude to the most primal of instincts-what everybody wanted to do on a date-and put it in a song on the radio, and if the song came on and you were with your date, you ended up Doing It! Wow! And then there was the Fuck-All of it! All the things you couldn't say or do, you could do onstage or in your music. What about that Ian Whitcomb song? Where he sings like a girl and he's begging a girl. By singing it in that crazy falsetto voice he was able to convey unspeakable emotions that made girls blush and turned heads everywhere. And he nailed it, it was a huge hit. And they all had the same things in common: Little Richard's high falsetto screams that incited the Beatles' high harmonies, and then there was the end of Ian Whitcomb's "Turn on Song," which spoke to those who heard it like a breathy wet spot that climbed right out of the speakers and grabbed you by the neck and made your ears cry . . . and there was nothing you could do about it except dance or be the lead singer of a band and do it all yourself.

And then, later on, I went and saw Janis Joplin. Now that really was my world—pure emotion. Onstage she played the role of that gin-soaked barroom queen. With her gravelly Delta voice and street smarts she could have only gotten by going through all these experiences herself, she transcended all those who came before her. The way she sang a song it seemed like she'd been down that road one too many times and it wasn't going to happen again—not this time round. She had a brand-new kind of kick-ass confidence laced with a "superhippie," smart-ass, kinkykinda-sassafrassy strut to her vocals, the likes of which you'd

39

never heard before. After seeing Janis, it almost seemed like you'd come from a raise-the-tent, raise-your-spirit Pentecostal Holy Roller revelation-type thing. It was *that* kind of mind-altering sound. And it was like, oh, my god! There was such a raunchy matter-of-factness, a drug-induced-sexy-animal rush to the way she belted out "Piece of my Heart." I mean, that was the *shit*. It was almost as if she gave her heart away a thousand times and never did quite get it back.

Janis up there—Janis, what a grand dame, like someone's mom, but a cross between a stately old woman and a loud, brassy New Orleans bordello whore. That was the end of the sixties. That's what Janis was to me—a revolutionary spirit, someone who changed the emotional weather.

Chuck Berry, Bo Diddley, Eddie Cochran, Little Richard. "Roll Over Beethoven," "Who Do You Love," *Awopbopaloolaa-wop-ba-ba-bam-mboom!* Pure adrenaline rush. I'd been zapped by an alien tractor beam and it was pulling me toward the mother ship.

The Beach Boys! "In My Room." Oh, my god! All I can tell you is that my girlfriend got turned on just now hearing me say those words with such ecstatic glee. That song was the first time I got up from behind the drums and grabbed the microphone away from my bass player and said, "You know what, I'm singing that fucking song, pal!" And then—*abracadabra!*—I became a singer! I bought a gooseneck and put the microphone on it. "*Ladies and genitals, give it up for Steven Tallarico on vocals!*" But I'm getting ahead of my story...

By the time I was fifteen I knew what I wanted to do aside from getting high and trying to get into girls' pants under the aqueduct. Drums! A friend's big brother had a drum set in the basement. We snuck down there and when I saw that set of drums I was *in-fat-chu-ated*! I couldn't believe that something you banged on made *that much noise*—and it wasn't pots and pans. I sat down behind the snare drums, and that was the beginning of the end. I bought instruction records by Sandy Nelson, who introduced the drum solo into pop singles in the late fifties. His big hit was "Let There Be Drums" in '61. He would play these cool beats at the end, just on a snare. It sounded like ten snares doing a marching beat. That's funk *and* soul right there. Fucking everything! There was my card: I just landed on that fucking place in the great game of life. My pass-go card, my get-out-of-jail-free card. That was the magic. That's the funk the blacks knew. That's the soul that Elvis knew, right there, and now I had the key to it all, especially after attending the Westchester Workshop Drums Unlimited.

I went to lessons at the WWDU. A guy gave me a rubber thing with heavy sticks and I learned my rudiments . . . paradiddles and stuff. I listened to those Sandy Nelson records like the Beatles LPs when they came out. My head practically INSIDE the speaker, hanging on every movement, every nuance of soundage, REVELING in it. But at the end of one album, Sandy had this thing—like a cross between an 007 guitar and surf rock—a Ventures/Dick Dale *rata-tat-tat*, basically with accents. *It's all accents*. He took the drum beat but gave it a twist, and that one thing was the turning point . . . *the way he reversed the beat through the accents*. I fucking lost it! "I gotta know that!" screamed the mouth within. So, like I said before, I got under the hood and learned it.

The first time I got up onstage to play was at the Barn. It must've been the summer of 1963. A group called the Maniacs were playing, and when they'd finished their set, they let me up onstage. "I'd like to introduce . . . Steven Tallarico." I played the classic drum solo on "Wipeout." It was just a speeded-up version of a riff from a high school marching band beat but it sounded stratospheric—a pure sex, drugs, and rock 'n' roll rush. All right, now I *knew*. I was making a huge racket with this demolition-derby–driven surfer blast. Everybody loved it . . . *I* loved it. John Conrad, the guy who ran the Barn, was beaming—I was in the zone.

When I think about it now, forty-nine years later, I still

have the same rush of feeling, that same energy and joy of the endorphins flooding my brain. It's close to an addiction. I close my eyes and I just want to do it. To play that set and sing those songs—those songs were my way out.

I got into street fights in the Bronx all the time—an hour and a half they went on, I'd come home bloody as hell. I was made fun of quite a lot at high school. Jewish kids were constantly picked on—they got to see a side of life the other half doesn't see. Prejudice. I got spit on in school and called "Nigger Lips." The kids would snap my earlobes with their fingers, which was especially painful on freezing cold days. Being hassled at the bus stop, however, turned out to be my salvation. Initially I might have been offended, but as soon as I learned how to sing, I was right proud of that moniker, because I then realized that those were my roots, my black roots were in black music, and it was nothing to be ashamed of.

My family history—if you go back two hundred years ago the Tallaricos were from the boot of Italy, Calabria. And before that? Albanians, Egyptians, Ethiopians. But let's face it, in the end—in the beginning, actually—we're all Africans. You can't grow humans in cold weather. And before we were humans we were apes, and if *we* can't take the cold weather, how could a monkey, who doesn't even know how to buy a coat? So if you go back, you're black. It's so stupid to go around saying, "I'm Italian" (the way I do all the time).

My way of avoiding being beaten up at school was to play the drums in a band. My first group was the Strangers: Don Solomon, Peter Stahl, and Alan Stohmayer. Peter played guitar, Alan bass, Don was the lead singer, and I played drums. We would set up in the cafeteria and do a mixer after school. I played "Wipeout" and sang "In My Room." In high school the key to not being made fun of is to be entertaining, the same way that some fat people become funny, tell jokes, make fun of people, and then they get left alone. I was skinny and big-lipped and pinheaded. I grew my hair and played the drums in a band, and that was my key to acceptance. I knew about music from my dad, and so rock 'n' roll was a case of please-don't-throw-me-in-the-Briar-Patch!

I was giddily starstruck. At the Brooklyn Fox I ran up onstage and touched Mary Weiss, the lead singer of the badgirl group the Shangri-Las. With her long blond hair, black leather pants, and melancholy eyes, Mary Weiss was a teen goddess. She alone was reason enough for making rock 'n' roll your own personal religion, especially while she was singing "Leader of the Pack." She was a gorgeous tough girl who later got questioned by the FBI for carrying a gun across state lines. I was completely smitten with her. The next time I saw her it was a little more intimate-but not because Mary Weiss wanted it that way. In 1966 I went to Cleveland with one of my later bands, Chain Reaction, to do this teen dance show, Upbeat. I wanted to sing lead, so I got David Conrad (nephew of John Conrad, who ran the Barn) to play drums. There were no dressing rooms, so I went into the bathroom to change. I heard someone in the next stall. Thinking it was David, as a joke I hoisted myself up to the top of the stall. But when I peered over, there was Mary Weiss, with her black leather pants around her ankles and her patch showing. I got such the boner from that-I fantasized about that for weeks! It got me through a lot of cold winter nights up in Sunapee.

At our house in Yonkers, no one locked their doors, so with the advent of sex and drugs I had to figure something out to stop anyone from catching me smoking pot or rubbing one out or whatever else I was doing up there. A serious problem for a teenager. You had to put a chair in front of the door, but what a drag! From working with traps I knew how to rig things, and I came up with an ingenious way of locking a door. I drilled through the tongue—the metal latch that goes into the strike plate of the door—and put a coat hanger through it, leaving four inches sticking out like a pin on a hand grenade. If you turned the handle the door wouldn't open.

Then I devised a more fiendish plan. Through the mail I bought an induction coil, which is nothing more than a transformer for an electric train. On your train set you can turn the transformer up to ten, twenty, thirty, forty, so your Lionel train is just *whippin*' around the track until it's going so fast it falls off the tracks. I took the induction coil and attached it to the railing on the way up to my room so that if anyone touched that railing, they'd be zapped right off their feet. I'd be upstairs doing a girl, parents were gone for the weekend, those few, chosen moments when I needed serious warning. And YES, people did get zapped. But only my best friends! I'd go, "Touch that!" and they'd go "*Yeeoooow!*" Suddenly best friends were so well behaved. I don't know what happened.

Once I ran a wire all the way down to the basement and up under the couch and the pillows. I undid the wires, stripped about four inches off the insulation, spread them out—the positive and negative wires—and put them under the cushions so that whoever sat on the couch would get zapped. My best friend was down there eating peanuts. "Here, have this beer," I said. "I'll be right back!" I'm upstairs in my room, turning the train transformer on, and I get the door open and I switch it on. I'd hear the transformer buzz as it connected. I'm waiting there, listening to hear what happens . . . "Yow!" Just a little evil teenage fun.

When "The House of the Rising Sun" came on the radio, I thought it was the greatest record I'd ever heard. I saw the Animals perform it at the Academy of Music and was so overcome with raw emotion I jumped out of my seat, ran up the aisle, and shook the bass player Chas Chandler's hand. Then came the Stones. Rock is my religion, and these guys were my gods!

You don't need to go to the fucking Temple of Doom to find my banter on the Stones or the Yardbirds—what I thought about back then in my sixteen-year-old make-believe mind. It would have been the desire to write a song or be in an English

band when the first Brit Invasion came over and—more than *anything*—fame! Immortality! I wanted to inject myself into the grooves of the record. I wanted dreamy nubile girls to listen to my voice and cry. A thousand years after my death I fantasized that there'd be people in the outer galaxies listening to "Dream On" and saying in hushed tones, "It's *him*, the strange Immortal One!"

And then, briefly, I *was* touched by the caressing hand of fate when, sometime in 1964, I became Mick Jagger's brother, Chris. Mick Jagger was the baddest guy on the block, and of course I empathetically picked up on all his shit. Mick and Keith and all that—it hit me like a locomotive. "It's All Over Now" was like a fucking blues freight train coming straight at me.

In the summer of '64, I went to a lake in upstate New York, Bash Bish Falls or something like that, up near Utica, with a bunch of kids from Yonkers. Long hair, sixteen, no band, but somebody said, "Wow, you look like Mick Jagger!" And that was it . . . off and running! "You know what, I'm Chris, Mick Jagger's brovver. I am him!" And I went with it like mad. Shot off from there to this Limey planet and immediately lapsed into a Cockney accent. I was talking like "Bloody bleedin" poncey wanker, spot of Marmite, darlin? Care for a leaper, mate? Ghastly weather we're 'avin, innit?" It's called, you know, lost days of youth. When you're a kid you can jump into other people's personalities like a transmute. I can still relate to that.

In those days of the British Invasion you had to be a Brit to make it. First of all, you had to have a bloody English accent. That was number one. And that I could do. I still have those Strangers clippings at home: "Steven Tyler, his lower lip hanging like Jagger's, brought the front row to its feet." They wrote that in the paper. Bought my Mick impersonation lock, stock, and barrel. I couldn't believe it. But of course, I—more than anyone else on the planet—believed it. I *was* him. I was barely sixteen but in my mind already one of "England's Greatest Hit Makers." Even if the Strangers sounded more like a bad imitation of Freddie and the Dreamers than the Stones. *Yonkers* Greatest Hit Makers maybe.

In the early seventies I was embarrassed to say I was into Mick, because the press was already harping on the Mick Jagger and Steven Tyler thing and I wanted to get as far away as possible from those comparisons. I was hoping they would find something in my music that would have some merit other than making Aerosmith into some sort of tribute band with me as a mock Mick Jagger.

But yes, he was my fucking hero. There was actually a six- or seven-year period where I was afraid to tell the press that. I was, like, "No he isn't!" And then, of course, I came out of the closet and went, "Fuckin' A, he is!" To this day, to this minute, to this second, Mick Jagger is still my hero. I remember being at a club at One Central Square in the West Village in early '66, turning around and seeing Mick Jagger and Brian Jones sitting behind me. Not a word came out of my mouth.

I didn't become Steven Tyler all at once. I made him up, bit by bit. He kind of grew out of playing all the clubs in New York and doing acid and hanging out in Greenwich Village and tripping and going to *be-ins* in Central Park. All that stuff is where I come from. But more than anything I was shaped by the kind of music that I listened to in '64, '65, '66. The Yardbirds, the Stones, the Animals, the Pretty Things and their wild drummer Viv Prince—he was Keith Moon before Keith Moon became the maniacal drummer of the Who. Moon used to go down to the Marquee Club to watch him and pick up a few mad moves. And of course the Beatles, whom I saw at Shea Stadium. They were the musical G-spot.

I'd get all the Brit imports from a record store down in the IRT subway station at Forty-sixth Street. Those Yardbirds 45s: "For Your Love," "Shapes of Things," "Over Under Sideways Down." That's what I cut my teeth on—not that I was in any shape in 1964 to take all that stuff and run with it. I'd take speed and listen to the Yardbirds, the Pretty Things, the Stones. We

were what—sixteen? You couldn't drink till you were eighteen, so all we could do was grass and pills . . . red crosses, white crosses, Christmas trees, Dexedrine, Benzedrine. I'd go up to Sunapee in the winter and sit in the barn—four feet of snow outside—light a fire, and snort speed until I was vibrating at the same frequency as the fucking records.

The Strangers slowly began to get gigs. We played a lot of weird places at the beginning, like Banana Fish Park on Long Island. We even had a slogan: "The Strangers—English Sounds, American R&B." At Easter my mom drove the Strangers up to Sunapee to perform. We played stuff like "She's a Woman" and the Dave Clark Five's "Bits and Pieces."

My motto has always been: "FAKE IT TILL YOU MAKE IT." If you wanna be a rock 'n' roll star (like Keith Richards says) you gotta get your moves off in the mirror first. The *look*. Pick up a copy of *Rave* magazine, see what the cool cats are wearing in Swinging London this month. *Rave* was the midsixties Brit mag of immaculate Mod haberdashery. Check out Mick's houndstooth pants. And *green* shoes. Where'd Keith Relf get those wraparound shades, man? You gotta stay on top of this stuff, you know, if you wanna be a rock star. Gotta be properly attired in the latest Mod gear when the moment arises and the fickle finger of *Billboard*'s Top Ten touches you.

I scoured the pseudo–Carnaby Street boutiques of Greenwich Village for the genuine article. Collarless shirts, leather vests, and checkered pants at Paul Sargent's on Eighth Street. Beatle boots with Cuban heels from Bloom's Shoe Gallery in the West Village or Florsheim Shoes on Forty-second Street. They had the fuckin' greatest boots, high heels, tight around the ankles—those were the ones I wore onstage. Then there were the Mod shoes, brightly colored Capezio ballet shoes, flowered shirts, and satin scarves—well, okay, the scarves came later (inspired by Janis Joplin). Those I got along with my incense from Sindori (is that what the place was called?), an import store across the street from the Fillmore East. In the early days, I would put incense all over the amps and in front of the stage to mark my territory. I thought by burning exotic scents like myrrh they'd remember me by my smell, like God in their church. I wanted something other than our bad tuning and my ugly fucking Mick Jagger face to remember us by. It's like if I were a dog, I would go out to the tip of the stage, lift my leg, pee, and say, "I'd like to leave a little something for you to remember me by." Dogs piss on trees to mark their territory, so I marked mine with incense and banners—like old Scottish tartans that I found, the ones that held special family colors and crests.

It's so funny, the obsessive Limey mimicking that went on. Back in 1966, down on Delancey Street, where the blacks got their stuff, you could get a beautiful leather jacket for twentysix bucks . . . but who had twenty-six bucks back then? I'd hang around Bloom's Shoe Gallery just waiting to see who would go in. I bought all my shit there, you know, because they did. The Stones, the Byrds, Dylan. Mike Clark, the drummer for the Byrds, turned me on to this place in Estes Park, Colorado, where he got his moccasins, the ones he wore on an album cover. I asked him, "How could I get a pair of those?" He gave me the address and I got me a pair, which I later on brought into the studio where we were recording our first album. I got the rubber-stamp holder with all the different rubber stamps they used to mark the two-inch master reels. The rubber stamps would say "DOLBY OUTTAKES," "REMIX VERSION. SLAVE, MASTER"-all things that could be done to tapes. I rubber-stamped my moccasins, which I chose to call my recording boots, all over and I wore them till the soles fell off.

Bloom's Shoe Gallery was where I ran into Bob Dylan. Okay, he was coming out of there and I was walking in. I'd love to have a great story where I told him I was in a band (I wasn't). I wish I could've told him I loved his voice (I did). I used to go down and walk around Greenwich Village, all the time hoping to bump into the Stones, which of course never happened. I never got a chance to speak to Dylan or Keith or Mick to ask

them how the fuck they wrote their songs. I assumed they had to get their lyrics from their life experiences. I knew that drugs had something to do with it. I'd heard that Pete Townshend's stutter in "My Generation" came from leapers, some weirdass British speed. Tuinals, acid, and grass . . . I knew about those. And there was this drug called "coke."

I had been around the block and I'd done as much crank as anyone, but somewhere along the line I decided to do something else instead of using the speed to go and party in the Village. Fuck that, I think I'll stay at home tonight and channel John Lennon. I'll write a song based on my muddled understandings *and* my profound misunderstandings that'll change the world. But it took a while to get to that place.

New York City was filled with very odd folk—which I loved. I'd take my mother's car down to the city, park it on the street, get a parking ticket, throw it away, and drive home. I can't imagine how many tickets I got. I know I never paid any of them. A rock 'n' roll Dillinger in the making. Or I'd leave the car in the Bronx at the first train stop, which was past White Plains and Yonkers Raceway, get on the train, and get off at Fifty-ninth Street, Columbus Circle. The Fifty-ninth Street subway stop wasn't that far from where Moondog would stand with his spear and Viking helmet. He lived on the street, wore only homemade clothes, and thought of himself as the incarnation of the Norse God Thor. He was so noble and mysterious, like a character from mythology come to life on Sixth Avenue.

Moondog wrote "All Is Loneliness" (that Janis sang on Big Brother and the Holding Company's first album). He'd hang out with a bald-headed guy who would blow raspberries and yell "Fuck you!" at anyone who walked by. He had a ragged and gravelly street voice. Welcome to Freak City! There were freaks on the streets, in the clubs, on TV. There were magnificent misfits everywhere, and you had no idea what they were famous *for* but they were all famous for something. I loved them. Then I'd wander into Central Park, smoke weed, and catch a sweet Gotham buzz. On Friday afternoons me, Ray Tabano, Debbie Benson, Rickie Holztman's girlfriend, and Debbie's friend Dia would head for Greenwich Village because that's where the beatniks lived and we wanted to be beatniks. It was the summer of '64. I was a white boy from Yonkers, trying to get high, trying to get hip. We'd sit in Washington Square Park drinking Southern Comfort or Seagrams 7 (or whatever else we could mooch off somebody) until we were completely shitfaced on booze, pills, and pot. Then we'd go check out the clubs! The Kettle of Fish, the Tin Angel, the Bitter End, the Night Owl, Trudy Heller's, Café Wha? Those clubs in New York were my education. Later on we played *all* those joints. The smell of those bars was like a funky nostalgic patchouli. To this day I love the stale smell of cigarettes and beer that you got in those places.

One night we were wandering around the Village and saw a group advertising itself as the Strangers outside a club—they seemed to be a pretty established band and sounded better than us, so we decided to change our name to the mildly pretentious Strangeurs.

I'd go down there Friday night, come home Sunday. I loved it; I wanted that life so bad. I'd sit on a car in the West Village outside the Tin Angel with Zal Yanovsky from the Lovin' Spoonful and talk. He wore culottes, a Bleecker Street Keith Richards. And Josie the She Demon-a transvestite who paraded around Greenwich Village with no particular mission save her own sense of eccentric expression. It was just such a trip. Then uptown there was Ondine's, and Steve Paul's club, the Scene. Teddy Slatus was the doorman at the Scene, a runty little guy. You'd go down the stairs into a cellar. It was like the beatnik grottoes from old movies. Low ceiling, small, cramped, but magical. Everybody looked like Andy Warhol. Steve Paul in his turtleneck, tall, talking in a beat lingo so fast and clipped you could barely grasp what he was saying, but you knew it was hip and one day you'd be able to understand it. Late at night, Jimi Hendrix, Paul McCartney, or Brian Jones would just show up and play-they'd be on a tiny

stage about four feet away from you. I performed there early in '68, with my second band, William Proud, with Tiny Tim singing and playing "Tiptoe Through the Tulips" on his ukulele, a tall skinny Lebanese freak with long greasy hair, a high voice, and bad teeth. But that was the great thing about the Scene: he wasn't treated like a sideshow character—it was more like ... this is the artist in residence. *He* belongs—you've gotta get in tune with *him* if you want to fit in.

I would go see bands like the Doors at the Scene, and I couldn't believe the way the lead singer was acting. I thought, "Wow! What the fuck?" But maybe that's the reason people loved the Doors—because they really thought Jim Morrison was possessed. That club was seriously in your face. I can't tell you how close you were to the performers. You sat at a little table, and right there was the Lizard King three feet away from you.

I was Steve Tally, copying everything I saw, reading the poetry that Dylan was reading—Allen Ginsberg, Jack Kerouac, Gregory Corso. There were readings at the Kettle of Fish, where Dylan would show up and recite his incredible shit. I'd sit there slack-jawed and hypnotized.

In '65 the Stones had two monster hits: "Satisfaction" and "Get Off of My Cloud." We heard that they were staying at the Lincoln Square Motor Inn, so we got our friend Henry Smith to drive us down there in his mother's car with the excuse that we needed to go rehearse. I already had my mock Mick look down, and we got our bass player, Alan Stohmayer, who had blond bangs like Brian Jones, to come with us. When we got there, the streets around the hotel were mobbed with kids. Very cute, very hot girls—Stones fans. Well, how could I resist trying out my Mick impersonation on this crowd?

I leaned out the window and in a very loud, crude Cockney accent said, "I say, I see some smashing crumpets out there, mates. Wot you doin', later then, darlin'?" They went wild. "Mick! Mick!" "Brian, I love you!" Tears streaming down their faces. Lovely—except that they wrecked Henry's mother's car, tore off the radio antenna and the windshield wipers. It turned into a big riot and got on TV on the evening news. When we got back, Henry's mother was standing there with her arms crossed. "Have a good rehearsal, boys?"

Because we were too young to drink at clubs in the city, I took Tuinals and Seconals. I'd crush all that shit up and snort it. I was always fucked-up when we got into Manhattan. That same night we were at the Scene, we saw Monty Rock III! We all knew about him from watching the *Johnny Carson Show* on TV. On would come this very grand queen with a let's-tell-it-like-it-is name. He was high camp, a flamboyantly gay hairdresser/rocker or *something*—you didn't know what he did exactly. He was this outrageous person saying outrageous stuff. Who cared what he did?

He wore pseudomod clothes, and in person he was just as over-the-top as he was on TV. "Come on back to my house, darlings," he said. "I really got some shit goin' on there!" We get to his place and there's two Great Danes, a chimpanzee, and a defanged cobra—but it still bit you. Oh, and never mind the fucking freak folks that were there. Here we are, pubescent punks coming down from Yonkers. We hadn't a clue. Debbie Benson was gorgeous, we were cute kids, and here we were among these flaming *queens*. Someone starts passing around handfuls of Placidyls. "Here, have some of these!" They were fucking paralytic downers, sleeping pills. Monty had a hot tub in his living room. I ended up knocking the plug out of his tub. After the water drained out, I threw some pillows in and slept there.

"Jim'll be here soon," Monty said. Jim fucking Morrison was coming over? We all awaited his arrival like that of a god. He came late, and by the time he got there, we were so wasted we thought it was Van Morrison. We were in some place where words melted into sounds, and Jim was out there . . . even further! It scared the shit out of us. We were so terrified, we hid in the bedroom, then wound up getting under the sheets with a candle, just shaking because we were so fucking stoned. It was all

so freaky; we were scared what the chimpanzee might do to the Great Danes, let alone what Monty had in mind for Morrison.

We were in no shape to walk *or* talk. We took more Placidyls and fell out around two in the morning . . . totally zonked. Around 5:00 A.M. we woke up. Debbie was crying. "These aren't my clothes," she said. "What do you mean," I said. "You're wearing the same dress you had on last night." Her eyes were glassy. "But these aren't my *panties*!" Omigod! I looked down and thought, what the fuck? "You know what? These aren't my pants, either." We were running down the stairs, Debbie crying, "I've been violated! I've been violated!" Shit, we'd all wanted to take a walk on the wild side, but this was a little bit more than we bargained for.

The thing about the British Invasion bands is that they were like gangs—especially the Rolling Stones and the Who. Unlike the Beatles, they looked defiant and menacing, guys you wouldn't mess with. I'd like to attribute this insight about groups and gangs to the Stones with their collective leathery eyeball, but I'd already figured this out long before the Beatles arrived, when the gang I was in turned into my first band.

How do you get into a gang? You act tough—and I've always been good at the acting part, anyway. I wasn't tough. I was skinny and scrawny and into my own weird world. Acting tough is easy: you just try and be as obnoxious as you can and get the shit beaten out of you for it. Throw in a few stupid and illegal things—like running across Central Avenue naked, stealing stuff for the clubhouse—and if they're feeling kindly they'll let you in.

At Roosevelt there was this guy Ray Tabano who was to become my lifelong friend. We first became friends from my telling him to get the fuck out of *my* tree (the one he was climbing). "Stay off my vines," I yelled. I paid for that a couple of days later when he beat the shit out of me—but it was worth it because I eventually became a member of a gang, really more of a club, called the Green Mountain Boys. With membership in a gang you got protection from the more thuggish elements in high school. It also attracted girls, who are always into that kind of asshole.

When I was about fourteen, I hung out with Ray at his dad's bar on Morris Park Avenue in the Bronx. Not bad for a hangout. He would let us drink beer. A local Bronx R & B group, the Bell Notes, used to perform there, and between their sets Ray and I would sing their 1959 hit "I've Had It." We'd also do the old Leadbelly song "Cotton Fields," but in the collegiate folk song style of the Highwaymen, who had a hit with it in 1962. Later I would be in a band called the Dantes with Ray that evolved out of the Green Mountain Boys (while still playing with the Strangeurs). The Strangeurs were more Beatlish and pop; the Dantes darker and Stonesier. I played one gig with the Dantes.

How the Strangeurs got their first manager and how I became the lead singer of the group also came out of the gang in a way-through Ray and stolen merchandise. I'd been ripping off stuff from the little Jewish corner candy store where I worked as a soda jerk in Yonkers. I'd go down in the basement where I did inventory and grab candy bars and packets of cigarettes and give them to Ray to sell. I then progressed to the Shopwell supermarket on Central Avenue-bigger items, boxes and crates. Peter Agosta was the store manager, and to prevent me from moving stuff out of the back of the store and handing it to Ray, he had me collect the shopping carts, so he could have me where he could keep an eye on me. Why he didn't just fire me I'll never know. I told him I was in a band, and he said he'd like to see us play, so I said I'd invite him to the next gig we played, which turned out to be a Sweet Sixteen party for Art Carney's daughter. It was a gig my dad had gotten us (he taught piano to Carney's son). Peter Agosta liked the group, but he thought I should be the lead singer-oh yeah! We got Barry Shapiro to play drums.

This was the era of spacey rock. The Byrds' truly cosmic single "Eight Miles High" came out in March 1966. It vibrated in

STEVEN TYLER

your brain like you were tripping. It was blacklisted by radio stations because it was thought to be a drug song—duh!—despite Jim McGuinn's unconvincing explanations that it wasn't. I'll tell you what "Eight Miles High" was . . . a stratospheric Rickenbacker symphony!

Soon Ray Tabano and I moved on to other quasi-criminal activities. To support our pot-smoking habit, we began selling nickel bags: buy an ounce for twenty dollars, sell four, keep two for ourselves. This was a cool deal and a cheap way of getting high until . . .

They put an undercover narc (who will remain nameless) in our high school ceramics class. The fucking *ceramics* class! He popped us eventually, but first he was *selling* us nickel bags of good shit he got off some other poor fuck he'd popped.

On June 11, 1966, Henry Smith booked us to play at an ice-skating rink in Westport, Connecticut. We rehearsed that afternoon, did a sound check. I hoped some people in town would come, because we had a little following in Connecticut. I'd met Henry Smith, "the Living Myth," up in Sunapee in the summer of 1965—he became a close friend and a key person in my life. He was impressed with our sound when we played the Barn, where we did stuff by the Stones like "Everybody Needs Somebody to Love," the Kinks' "You Really Got Me," the Byrds' version of "Mr. Tambourine Man," and all the current hits. Slamdunk rockers like "Louie, Louie" and "Money." Henry and his brother, Chris, the band's first photographer, started getting us gigs in Connecticut.

Outside the rink, on the other side of the fence, was a trampoline center. I had been on the junior Olympic team in high school for trampoline; I could do twenty-six backflips in a row. Not such great form, but I could get height from hell.

For three dollars, you could jump in this trampoline park for half an hour. There was nobody there, and I looked around and snuck over the fence. I jumped from one trampoline to another, and on to the next one. Backflip. I'd probably got through the

first six trampolines and on to the next row when I heard, "Hey! Get the fuck off my trampolines!" "Listen, man," I said, "we're playing next door—you want tickets?" His name was Scotty. "Oh, you're in the band that's playing here tonight?" He loved that. "Why don't you come up to my house?"

I went over to Scotty's house. Nice pool and a fridge full of St. Pauli Girl. We're swimming and throwing back a few beers when these two guys come ripping into the driveway on the two sickest go-carts from hell. It's Paul Newman and *Our Man Flint*, James Coburn. Holy shit! "Scotty, what's goin' on?" I asked. "Oh, that's my dad," he said. "Which one?" "Paul Newman," he said. "I'm Scotty Newman, pleased to meet you." "You fucker! When were you gonna tell me?"

Paul Newman was very laid back and as cool as *Cool Hand Luke*. It was like being in a movie with him. I went into the sauna with Paul and Scotty. We're all sitting in there getting sweaty and Paul Newman whips out this bottle of fifty-year-old brandy he'd got from the Queen of England, which I downed immediately. I toweled off, put my clothes back on, and wandered into the house. There on the mantelpiece was Joanne Woodward's Oscar with its arms folded as all Oscars are. "Where's yours?" I asked Mr. Newman. "Well, I never got one, but my friend made that one up for me." It was a mock Oscar, only with its arms open wide instead of folded and with the guy going, "*Vat?*" Like, how could you have passed me up after all my great performances?

Twenty minutes later, I got a phone call from my mom, completely hysterical. "They found it!" she's yelling. "Mom, calm down," I said. "What's goin' on?" She starts explaining . . . and it ain't good. "The cops are here and they found your marijuana! It was in one of your books." Uh-oh, they found my stash so cunningly concealed in a copy of *The Hardy Boys and the Disappearing Floor*. "Get home right now!" I jumped in the car and drove back. I pulled into the driveway and saw a black unmarked car approaching from around the corner. My heart fell out of my ass. The cops handcuffed me and walked me to the car while

STEVEN TYLER

I protested my innocence. "What are you doing? Why are you arresting me?"

Ah, it never rains but it pours. My dad had come home early that day because it was his birthday. "Gee, Dad, Happy Birthday! I just wanted to make sure we're all here to . . ." You couldn't put that in a movie. *Action!* Have the dad drive up while you're being carted off to jail. It got in the paper. The shame! The Italian guilt! "Dad, is there a file in your birthday cake I can borrow?"

We were taken down to the police station. They'd popped a bunch of us, most of the kids in my class. We were giving them the finger through the two-way mirror. I'm sitting handcuffed to a bar when this fucking guy who had been smoking pot with us walks in flashing his badge: DEPUTY SHERIFF. The narc was very fucking pleased with himself. I was still playing the injured party. "How could you have betrayed us like that, you ceramic fuck?" I shouted at him. "You set us up!" "They're gonna throw the book at you, kid," he said as he walked away. Well, not the book, but maybe a couple of chapters. The narc who busted us was on a vendetta—his brother had died of an OD, and we were the unfortunate victims of his moral crusade.

At the hearing I asked if I could speak to the judge privately. I'd seen enough *Perry Mason* episodes to know about consultations in the judge's chambers . . . and once you're in there you can tell him whatever the fuck you like. I told the judge that this guy, this narc—not me—was the criminal. He'd infiltrated our ceramics class and turned us on to grass and then busted us for doing it. I said I'd never heard of grass before this, never once tried it. "He was handing out joints, I swear, telling us this was the latest turn-on. I'm Italian, your honor (conveniently, so was the judge), and I've always lived by my parents' moral code, by the sacred beliefs of the Catholic Church. . . ." Ferris Bueller had nothing on me.

I got a reprimand and was put on probation. You pay, that's how the system works. The good news is that the four misdemeanors I received put a YO, Youthful Offender, on my draft card—so no fucking Vietnam for me. The bad news is . . . we'll get to that in an upcoming chapter. I wouldn't have gone to 'Nam anyway. I was against it.

My whole life's been like that. Of course, I also got kicked out of Roosevelt High, but they let me be the guitar player in *The Music Man* at the end of the year. Yeah, there was trouble in River City—the trouble was me. Right before the performance, "somebody" set off an M-80 in the bathroom. It was at the end of the year, everyone was about to graduate, and had all these unfortunate things not befallen me, I would have graduated, too. I was devastated. As a memento I went off with the bass drum that I played in the marching band. That drum came back to life with a haunting vengeance at the end of "Livin' on the Edge."

I got sent to Jose Quintano's School for Young Professionals, 156 West Fifty-sixth Street. It was a school for a bunch of professional brats and movie stars' kids. There were actors, dancers, the girl who played *Annie* on Broadway, that kind of thing, but it was way more fun than Roosevelt High. Everyone there had this crazy spark to them of *fake-it-till-you-make-it-ness*. Steve Martin (same name as the comedian) was in my senior class. His full name was Steve Martin Caro. One day I asked him, "What're you doin' tonight?" "We're recording," he said. "You're *recording*? What? Where?!" "Apostolic," he replied. "Can I *come*?" I asked breathlessly. "Well, yeah, sure," he said. "You mean *the* Left Banke as in 'Walk Away Renee'?" "Yeah," he smiled. That's when I just freaked. *He was the lead singer of the Left Banke*.

The Left Banke were huge. Along with the Rascals and the Lovin' Spoonful, they were the other big New York City band that had hits on the radio at that time. "What's the song you're going to record?" I asked. "Dunno. They give us the lead sheets when we get to the studio." "Wait, you're in the Left Banke, and *you don't know what song you're recording*?" "No, our producer tells us," he

said. I couldn't believe it. "How the fuck can you do it?" I asked. "You don't even know what you're recording when you get there?"

One of the guys in the group had some Acapulco Gold. I had a thing for blondes, as all boys did, and this Acapulco chick was soon to be my new girlfriend. I got me a dime bag, which in those days came in a paper bag. A dime bag and I was on my way. We get to Apostolic Studios and it's huge. Eighteen-foot walls, and right up at the top were the windows of the control room. I went up there to watch. I remember listening to the string section and waiting for Steve to sing. The producer and the engineers looked down at the musicians in the studio and then hit a button and over the PA they'd say, "Hey, um, will you re-sing that?" There was sheet music on a stand. I was stunned. This wasn't like the Stones or the Yardbirds who wrote their own material, played their own stuff. They didn't even know how to tune their instruments. The only guy in the band who had a clue about music was the keyboard player, Michael Brown. His father, Harry Lookofsky, was a session musician and he controlled everything. He was the producer and arranger, and he hired the musicians. Michael McKean, who later played David St. Hubbins-the blond dude with the meddling girlfriend in This Is Spinal Tap-was one of the studio musicians. Hell, I still have a problem with that movie. That woman is too close to the truth I lived (look for elaborations on that point later). I sang backup on a couple of Left Banke songs, "Dark Is the Bark" and the flip side, "My Friend Today."

That was my introduction to recording, and I knew if they could do it, I could do it. They were *drunk* all the time, fer chrissakes. I hung out with the bass player, Tommy Finn, at his apartment. So here's me, a kid from Yonkers, hanging out with a bunch of guys that have hit singles *and* have great pot. I was beyond impressed—I was in seventh heaven.

Hendrix had been at Apostolic not long before. God himself. "Hendrix was here two months ago . . . and he used this mic," the engineer said. "Which one?" I begged. "This

Sennheiser pencil mic." And then, casually, he adds, "Yeah, he put it in this girl's pussy in the bathroom. He was fuckin' her with it!" And I went, "*Whaaattt?* Hendrix used that mic?" When the engineer turned his back, I sniffed it . . . which gave new meaning to the term *purple haze*. I guess I looked a little incredulous because he then said, "Yeah, listen to this tape! You're not gonna believe this!" Whereupon he claps a pair of headphones to my melon and . . .

You could hear the squishing noise as Jimi inserts the mic into her gynie. And you could hear him going, "Oh, that's goooood, man, that's cool." And you could hear the girl moaning, "Ohohhhh, ohhhh, ohhh, ohhhh. . . . "Then it shifts into an orgasmic octave higher, "O-ohhhhhh, o-oh-oh, oh-ooooooooh!" And he's done. That's when the Electric Lady's man says (no shit), "Hey, baby, what's your name again?" "Kathy," she purrs. I mean, talk about urban legends. With a gearshift! I was in a new league now.

The Strangeurs were the opening act for every kind of gig from the Fugs at the Café Wha? to the Lovin' Spoonful at the Westchester County Center to an uptown New York discotheque like Cheetah. Then, on July 24, 1966, the Strangeurs opened for the Beach Boys at Iona College. *Pet Sounds* had come out in May and blown everybody's minds. It was sublime and subliminal and saturated your brain. After you heard it you were in a different space. "Wouldn't It Be Nice," with "God Only Knows" on the flip side, had been out only a week before our performance and it was all over the radio. They had a competition to choose the band that would be the opening act. We played "Paint It Black" and sealed the deal. We got to hang out with the Beach Boys. Brian, even in those days, was on another sphere, vibrating his Buddha vibe.

I had my first out-of-body religious experience that day singing along with the Beach Boys. It was me and six thousand kids from Iona College, all singing "California Girls."

The promoter Pete Bennett (a pretty heavy guy in the business) knew me and my bands from watching us play around New York City. And I must have been radiating that glow of *Sufi*—I know I felt like one when he was done talking to me. He asked if we wouldn't mind opening up for the Beach Boys for the next four shows, there and around New York City. I said to him, "Let me think for a minute," and slam-dunked him a big fat "YES!"

Through Peter Agosta we got our first recording contract. Agosta knew Bennett, who eventually became promotional manager for the Beatles at Apple and worked with Elvis, Frank Sinatra, the Stones, and Dylan. Pete Bennett arranged for us to audition for executives at Date Records, which was a division of CBS. Back in those days you brought your equipment up in the freight elevator and set up in the boardroom and played. We did a couple of numbers, and then they went and got one of their producers, Richard Gottehrer, who eventually ran Sire Records with Seymour Stein. Gottehrer offered us a deal: six thousand dollars. Okay, we'll take it.

We did a song called "The Sun,"kind of Lennon-McCartney pop. It came out in '66 and got a little play, but didn't do that great here. It was a big hit in Europe: "Le Soleil," they called it. It was about staying up all night and watching the sun come up in the morning.

It comes once a day through the shade of my window It shines on my bed, my rug, and my floor It shines once a day through the shade of my window It comes once a day and not more.

It was definitely one of Don Solomon's finest moments. The flip side was "When I Needed You," a little harder rock, a little more experimental . . . our version of the Yardbirds. At this point we had to change our name again—CBS was concerned that our weird spelling, the Strangeurs, wasn't different enough from the other Strangers and we might get sued. So we became the Chain Reaction, which is a continuous, unstoppable flow of energy.

During this time, I moved out of my house in Yonkers to West Twenty-first Street, the only blue building on the block. There I lived with Lynn Collins, a gorgeous blonde whom I stole away from my guitar player, Marvin Patacki. In '69 I saw Zeppelin at the Tea Party. When the band came offstage, I went back to say hello to the guys, 'cause Henry Smith was working for Bonzo, and who do you think comes walking out of the dressing room on Jimmy Page's arm? Lynn Collins. She was a genuine, high-class girl-about-rock-'n'-roll-town. I thought to myself, "If I was gonna lose her, might as well be to a legend like Page."

Eventually, Henry became our first roadie (whom we could pay), and because he lived in Westport, Connecticut, a richer side of the tracks than I came from, he could get us betterclass gigs. Henry would book the Chain Reaction into these gigs we could have never booked ourselves, like opening for Sly and the Family Stone, opening for the Byrds, and the coup de grâce, opening for the Yardbirds. Jimmy Page was on bass, Jeff Beck was on lead guitar, and we were in seventh heaven. We drove up in my mother's station wagon with our equipment. The Yardbirds had a van. We pulled out our gear and put it on the sidewalk while they took theirs out. They had some fantastic equipment, so I made this little joke, like "Let's not get it mixed up." I saw Jimmy Page struggling with his amp and I said, "I'll help you with that." Hence: "I was a roadie for the Yardbirds." At least it gave me something to talk about while Aerosmith was getting its wings in the early days.

Oddly enough, three years later, Henry Smith, still working for us as a full-time roadie this time, gets a phone call from his old-time buddy Brad Condliff at the front door to the club in Greenwich Village called Salvation, asking Henry if he wanted to help out his old buddy Jimmy Page with his recently formed band, the New Yardbirds (always respect the guy at the door). Henry grabbed a ticket to London and his only possession at

that time, a large toolbox covered with stickers with only enough room for a pair of underwear, which he stuffed in behind his ounce of pot, and headed off to Europe to help his friend with this new band that over that summer became Led Zeppelin.

Everybody likes to overblow their past, including me—to squeeze out the relevance of what may or may not have really taken place. And when you're just starting out, any story will do. Beck was on guitar, Jimmy Page on bass—it was the Yardbirds' second incarnation (after Eric Clapton left), an unbelievable, unstoppable, funky, overamped R&B machine. "Train Kept a-Rollin" was bone-rattling . . . there was steam and flames coming out of it, and the whole place quaked like a Mississippi boxcar on methadrine.

Every morning before school I'd fill a plastic cup with Dewar's whiskey or vodka and down it. I used to dry my hair before school to "Think About It," the last single the Yardbirds did. I'd get the vacuum cleaner, take the hose, and stick it in the exhaust socket so it blew out . . . turn it on, go upstairs, and eat breakfast. By the time I got back downstairs, the vacuum cleaner was warm and I could blow-dry my wet hair to look like a Brian Jones bubblehead. Got to have good ha-air! I used to sew buttons to the sides of my cowboy boots, and at the bottom of the inside leg of my pants I would tie three or four loops of dental floss and attach those to the buttons on the boots so that my pants would never ride up. I loved doing that sort of thing! I was a rabid rock fashion dog. So I went to school, spending an hour getting ready every morning, and ended up getting shit for it. I wound up in the principal's office every day. "Tallarico, you look like a girl," the man would say. I'd tried to explain, "It's part of my job . . . rock musician, sir." That got me absolutely nowhere.

From winter '66 into spring '67, Chain Reaction continued to get good gigs—in part through Pete Bennett. We played record hops with the WMCA Good Guys. We opened for the Left Banke, the Soul Survivors, the Shangri-Las, Leslie West and the Vagrants, Jay and the Americans, and Frank Sinatra, Jr. Little Richard emceed one of our shows—the original possessed character always doing that crazy shit. He was so fucking out there. He could get so high and still function. I don't know how the fuck he did it! He was doing amyl nitrate. That's scary stuff. There aren't a lot of drugs I've refused, but with that shit I was, like, "I'm outta here!"

Pete Bennett wanted to get rid of the band and just represent me, but I wouldn't do it, even though Chain Reaction was already winding down. After three years I'd definitely had it with covering Beatles tunes. I was already thinking about a hard rock band. Our last gig was at the Brooklawn Country Club in Connecticut on June 18, 1967. We made one more single, which came out on Verve the following year: "You Should Have Been Here Yesterday" and "Ever Lovin' Man." And that was that—the Chain stopped a-rollin'.

In the summer of 1967 I found myself up in Sunapee with no band and wondering what to do next. I'd been a local star with records on the jukebox, but now kids were asking me, "Where you guys playin'?" Later on that summer I formed another band called William Proud, with Twitty Farren on lead guitar. Twitty used to play acoustic guitar and sing at the Anchorage with a guy named Smitty. Twitty and Smitty were a major thing in New Hampshire. They covered Simon and Garfunkel to the T, nailing uncanny versions of "Sounds of Silence." We played out in Southampton for the summer, and while we were there wrote "Somebody," which is on the first Aerosmith album. I collaborated with Don Solomon on most of the early Chain Reaction songs, but with the song "Somebody" (which I cowrote with Steve Emsback), I realized I could truly compose a good song. The inner voice was wailing, "Let's get cracking here!"

"When I Needed You," the flip side of the first Chain Reaction single, had a Yardbirdish tinge to it, but "Somebody" was straight Yardbirds. The Yardbirds were so strange and unpredictable. They could make a pop song like "For Your Love" (with its minor key) sound dirgelike and ominous. We're talkin' fucked-

up time-traveling R&B monks. Gregorian chants! Outlandish Australian wobble-board percussion! Harpsichords and bongos! *They virtually invented the rock solo as an end unto itself.* The Yardbirds used minor thirds and fourths like alchemists. They were really the first progressive rock band, with their use of Eastern melodies on "Over Under Sideways Down," the howling sirens on "Happenings Ten Years Time Ago." I loved their weirdness and their mystery.

When Henry Smith was working for Zeppelin, Jimmy Page would blow his speakers and Henry would send them to me. I had two huge deer antlers I got from New Hampshire from eight-point bucks, and I put one on the left headboard post of my bed and the other on the right. I'd put my speakers there and painted them with thick phosphorescent paint—five or six coats—so that when you held a lamp to them, they would glow forever . . . well for at least ten or fifteen minutes, but if you smoked pot or took hallucinogens, as we did in high school, that was enough.

I'd draw mustaches on the Beatles and Stones posters and put phosphorescent paint all along the drawers and the knobs of the dressers, so when I went to bed at night, the room was a psychedelic cave! I put *dots*, like, all along the edge of the chest of drawers and the molding. Dot, dot, dot (maybe *that's* where my... thing started), then a nice big fat one, and I did it all over the room with phosphorescent paint, six coats, so it was that thick—to hold the light.

In the middle of the room at the end of my bed, I had a twelve-foot span (from the door to the window) of fifteen thick rubber bands knotted together—which could really stretch out—and in the middle I attached a five-ounce sinker dipped ten times in phosphorescent paint, so it glowed like a fucking red-hot poker. When you let go of the sinker, the linked rubber bands would bounce like crazy...swinging in slo-mo, back and forth across the room ... and you'd be *Star Trek*-trippin'. By the time I was done, when I was, like, seventeen or eighteen and get-

ting ready to move out, my room was a masterpiece. You were in this realm of pulsing phosphorescent light between the speakers. I would smoke a joint, bring the linked rubber bands all the way over to one side of the room, and let it go back and forth, right? 'Cause it was right in the middle.

Then I'd crank up the Association, Pretty Things, Brownie McGhee, Sonny Boy Williamson, and all this weird early German electronica stuff. I'd invite my friends over and they'd get wrapped up in my phosphorescent audio wonderland.

I went up to the Woodstock Festival with Don Solomon and Ray Tabano a day or so early. We told them we were Ten Years After—you never know when that Brit accent is going to come in handy—and they let us in. We made our way through the woods to the Hog Farm. The Hog Farm was the name of Wavy Gravy's commune in Tujunga, California—the longest-running hippie commune of the sixties. It eventually became what they called "a mobile hallucinatory extended family"—now that's the kind of extended family I wanted to join. The Hog Farm got involved in the Woodstock Festival to make trails, dig fire pits, and provide a food kitchen. The trail through the woods was called Groovy Way, a quarter-mile path hung with Christmas lights.

When I went to Woodstock, I was tripping my brains out. Everyone always says, "Woodstock, Woodstock—were you there?" but the funny thing is . . . half the people who were there didn't know *where* they were. I walked over to the stage area from the Hog Farm through a strip of woods with multicolored holiday bulbs running through them. I was so high they were like the mother ship zinging messages to me. And we wouldn't just do *one* tab . . . I'd already snorted another. *Can* you snort acid? My friend Ray knew Owsley. He would call him on the phone with advice on how to improve the product: "Dude, more colors!" More colors!" As high as I was, I could've met the Buddha, Murf the Surf, and the Tooth Fairy, and I wouldn't have turned a hair.

Now, who I *really* would have liked to bump into walking down Groovy Way making her merry way down the path was Janis fuckin' Joplin! But it was enough just knowing she was there at Woodstock. When I saw Janis sing she blew my mind. Everybody used to think Mick was my real hero, but I'll confess now ('cause that's what a memoir is for, right?), *it was Janis*. The scarves on the mic, the howl . . . inspired and perspired by pure 180-proof Joplin. She's bone deep and still makes me weep. Cole Porter, Nat King Cole . . . the divine vibratos of my youth . . . but none finer nor more sacred than Saint Janis.

And then—this is so amazing!—who do I run into on Groovy Way but Joey Kramer! Joey had been in a band called the King Bees, which was a younger version of the Dantes. Something I'll never forget, ever, colliding at Woodstock...both tripping our asses off. I *loved* the hallucinations; I loved that vibrating, molecular trance. The molecules that are dancing through your body, your hands giving off sparks. Altered states? *Please!* Psychedelics take you places you can't go on the natch.

One of my literary gurus was Aldous Huxley, who wrote *The Doors of Perception* based on his experimentations with mescaline. He was hip to the whole cosmological, folktale realm that is under the radar of the, um, mundane world. Ah, how did spots get on trout? The Raven did it! Coyote laughed and it rained for twelve years. Those stories. As a youth, it was, "Wow, what a brilliant mind!" Some of those fuckin' guys—Coleridge, de Quincey—were on laudanum (Victorian smack), too! But really, any of these seekers and freakers, because their thoughts are out of the box, out of their heads . . . you know there had to be something wrong with them. There's always been something wrong with me, too. I've always been the designated patient, clinically speaking, and therefore the bad boy, even in fucking Aerosmith! *Especially* in fucking Aerosmith! But we'll get into deeper *diagnosis* of my condition later.

If there's a fifth, sixth dimension. . . . If? Oh, come on! Any-

way, it must be something like what you see on acid. Things would vibrate differently. . . . No kidding! What acid did for me was made me think about other planes and possibilities, contemplate things that I see and feel that aren't there. I've gone to the wall with that stuff, straight and stoned. When I got my new house, I went in, turned all the lights off, sat in a chair in the black, infinite not-wisdom, and said, "Bring it on, motherfucker! Come on! Come on! Where are you? I'm waiting. 'Cause if you're here . . . *be* here. And if you do show up later, I'm gonna kick your ectoplasmic ass!" You gotta talk tough to demons . . . you can't shilly-shally or they'll pounce.

After a couple of days tripping my brains out I was crashing into the deep dark pit of apocalyptic blackness. I didn't know anything about dope back then. How great would it have been to snort some heroin while you're coming down from LSD? You're going into a tailspin, the alien pods have drained your synapses, you're wildly thinking about the deaths of stars. Everything is profound and meaningless at the same time. The micros of the lysergic acid shrinking the whole universe to the size of a pea that's when you need a Valium! "TAKE ONE OR TWO OR THREE ... AFTER COMING DOWN FROM AN ACID TRIP." That's what it should say on the label.

The morning Hendrix played, Woodstock had become a war zone. We were walking about aimlessly, and then I heard *baa-baw-ba-ba-ba-ba*, the first notes of the Jimified national anthem. It was about three in the morning when he went on. Hendrix was so smart . . . he'd been up all night. I saw him walking around like a visitor from Xanadu. He played "The Star Spangled Banner" *knowing* he'd wake everyone up. That was brilliant! It was like an X-ray report from Alpha Centauri to the third stone from the sun.

After three days of peace, love, music, and massive amounts of drugs, Woodstock looked like Vietnam on acid. People were eating watermelon rinds; the helicopters were thrumming and

hovering everywhere. After everybody else had left, the fields all around looked like there'd been a war but with no bodies sleeping bags instead of corpses.

Somebody stole the gas cap to Don Solomon's car, and since it rained for two days, the gas tank got full of water and we couldn't leave. I still have a Coca-Cola cooler that I'd stolen, and I went around picking up everybody's pipes. There's a banner that hung behind us at Woodstock with a stick figure holding a cornucopia and with a dick, or a tail, between his legs. I stole that, too. I had Aerosmith's seamstress, Francine Larness, and her sister duplicate it and I still have them.

At Woodstock I sat and watched Hendrix and Joe Cocker and the Who especially. I had those deranged thoughts watching them up onstage: "Someday I could be that spectacular." The experience of the first Woodstock totally outweighed the second one that we played at in 1994. We had all those people backstage, and the press is coming to you. Every time I went out of my trailer there were millions of flash cubes in my face. It wasn't my idea of Woodstock. I would rather have been out there rolling around in the mud. Had I been there as a spectator, I'd have been fucked-up and had that experience again.

At the original Woodstock I was in a tent, and suddenly the tent was making this warping noise from the helicopter blades it was shivering—it was *alive*! I went outside, my brain on LSD. I was tripping my ass off. I was atomized, sparks were flying off me like a Roman candle, and fuck me if it wasn't raining frankfurters! *Incoming*! The helicopter was talking to me: "GET OUT OF THE WAY!" it said, like Jehovah out of a cloud, except it was army helicopters dropping six hundred pounds of hot dogs (and pots and pans to cook them) in huge nets. They would hover ten feet off the ground and let their payload drop. I went over and I picked up a pot . . . and started drumming. Then another guy came over and he did the same. Pretty soon, a dozen people banging on pots, then two dozen . . . three. Ken Kesey was there banging on a pot! The original bona fide hippie drum circle. And the beat would change as people dropped out and came in and dropped out and came in again. This went on for days . . . or at least hours that *seemed* like days.

The Vietnam War was terrible, but we made peace by smoking pot. That's something that we don't have today. It's all fucking Ecstasy and clubs and, er, fucking. Back then you passed a joint, and it was "make love, not war." Everybody was your friend. You'd make eye contact with someone and end up smoking a joint with them. You started talking sweet and beautiful shit. In the sixties everyone had a common ground . . . and pot and the drugs were a big fuckin' part of it. There's your triangulation: Pot, Rock, Vietnam (and civil rights).

We used to give the peace sign, and if someone nodded, you'd say, "Wanna get high, man? You got a joint?" And it was lovely. Today you don't know what somebody's thinking. Today, I see people in the street and don't know if they're going to hug me or mug me. You know, I don't really care if you get on the Internet, text, or Twitter . . . we were accessing the fucking cosmos! Okay, now I do sound like a character out of a Crumb comic—or Oscar the Grouch. But I just figured out why guys like me turn into curmudgeons . . . the world's going to hell in a handbasket, everybody has rolled over and given up, and there's no more afternoon baseball.

I'd drop acid and go into the city. You'd look down at the sidewalk and it was *melting*. I was walking on a great gray, sparkling snake. It shivered when you stepped on it. The sidewalk was *alive*! And then there was the Electric Circus in the East Village with the Rubber Room. I'd take acid and go in there. I *lived* there! The Rubber Room was this padded space made for people who were tripping, because they were going "YEE-HAA!" and they didn't want anybody to hurt themselves.

One Sheridan Square in the West Village—the Stones and the Animals would go there. I'd sit there listening to that

song "Judy in Disguise (with Glasses)" by John Fred and His Playboy Band.

It was the beginning of the disco era, and in that club they would play the music so fucking loud, and we were in there going, "Fuck, this is fucking great!" Clubs with bone-jangling loud music! That was the beginning of all of it. And no one sold T-shirts to the revolution. Think about that! No one was selling T-shirts in 1971! What were we *thinking*?

By the late sixties I was seriously into Haight-Ashbury. I'd way got over my Mod Mick phase—so had Mick. I was into—I don't want to say my feminine side, but the hipper women's stuff, the way Marianne Faithfull and Anita Pallenberg dressed those guys! They really had that motley, tatterdemalion medieval troubadour thing down. Eventually the hip King's Road shops began exporting that stuff, like the New York branch of Granny Takes a Trip. As soon as I began to refine my own personal style, I was immediately attracted to the Anita Pallenberg/Keith Richards gypsy look. But after I saw Janis—*she* became my fashion idol.

Eventually Anita and I became good friends. When I go over to England I always try to see her. Last time I met her where she works, at the designer Vivienne Westwood's boutique. Vivienne Westwood, now Dame Vivienne, designed clothes for the Sex Pistols and then brought her eccentric clothing into the mainstream—if you can call her wildlife outfits mainstream. I was looking around at the bizarre clothes in the shop when a woman came up behind me, covered my eyes, then put her hands around my neck, almost snapped my fucking neck off, and said, "Who is this?" "Uh, I give up." "Your best English fucking cunt!" It was Anita in her broken-English Cockney accent.

A few years ago, when Keith and Anita still lived in Bing Crosby's old house out on Long Island, I went to spend a couple of days with them. I'd bought this rare book in a weird little bookstore in New York. The guy kept it in the back room; it was about black magic and shit. I took it with me. A little light satanic reading for a weekend in the country. It was about the

derivation of the Seven Sacred Sins and all that dark stuff. When Anita found it under my bed, she had a fucking fit. She ripped the book up. When I asked her why she did it, she screamed at me in front of Keith, "How *dare* you bring this into my house? Are you here to cast spells on us?" Meanwhile we were all gacked to the nines on coke.

The sixties and us, we got away with it. And now, "fuck-all" lives on! You'd read R. Crumb and then these characters would be there right before your eyes. You'd go, hey, *he's* from R. Crumb. Oh, that was so great! A little lame and filthy, but what the hell, R. Crumb had Mr. Natural and, you know, Flakey Funt and Angelfood McSpade. Oh, it was just so good.

At the end of the sixties I lived at Sleepy Hollow Restorations, right before the Tappan Zee Bridge. I'd be so *high* coming from New York or Yonkers in my car, in my Volkswagen, from eating hash brownies and recording records, I would wind up missing the exit and drive over the bridge. Whoops! Forgot cash! I'd go over the bridge with no money! Problem is, there's a *toll* on the way back into New York. I'd drive up and go, "I just don't got—!" But I was scared to death. That happened quite a few times. I remember there was a tree there that had such a beautiful face against the sky at sunset.

At eighteen most kids think about becoming a man. Never did! The guy you went to high school with figured it out. Got a job, went to work every day. He became a man. But here I was at twenty-two. I was at a loss. What was I going to do? Tune pianos like my uncle Ernie or teach music like my dad did at Cardinal Spellman High School? I had that moment of angst.

"Perplexity," sayeth my man Kahlil Gibran, "is the beginning of knowledge."

Yeah, but he wasn't living in Sunapee and doing crystal meth. I loved speed, man! Remember the speed that burned when you snorted it and you had to keep it in the freezer? It was blue and

it had that terrible smell? "Oh! That tastes terrible!" It was an acquired taste, one that I acquired without too much difficulty. You could eat the paper it was wrapped in and you were fuckin' forget-about-it.

I *loved* Quaaludes, too. Especially when you got too high on speed or blow. Whenever I'd go to rehab, they'd say, "Well, you're always chasing the drug." And I go, "Yu-uh!" It's like having a fast car and you go really fast, but then occasionally you've got to stop and go get gas, but while you're getting gas all you want to do is get back in that fast car. It's like that time again! You have no blow, you run out, you go to your dealer and get some more, and then you're in the car breaking the sound barrier and your brains are pouring out of your ears and then someone goes, "Here, check this out!" It's like ethyl alcohol and you hit this button and your mind chills down.

The wildest places we played were fraternities. With Fox Chase I played Bones Gate—it was a famous raunchy fraternity at Dartmouth they based *Animal House* on. At those parties I used to sit under the keg, they'd turn the keg on, and I'd beat everybody out.

Fox Chase was the last band I was in before Aerosmith. Right before that, in 1969, William Proud went out to Long Island and I was with them there until that fell apart and I went back up to Sunapee.

I had no money. I was desperate, defeated, doomed. I didn't know what I was going to do with my life. William Proud had played every nightclub, grotto, union hall, gym, bar mitzvah, and VFW hall for a fifty-mile radius. We were burned out on the trail. Nowhere left to play. It all came to a head one night at the last incarnation of Salvation in the Village, way out in Southampton on Long Island.

At the Hampton gig, I practically strangled our lead guitar player, Twitty Farren, to death during a rehearsal. Top that, Alice Cooper! Midrehearsal, I look up and see Twitty—who was a fuckin' great guitar player, by the way—*yawning*. I asked myself, "Is it the heat or is it that his heart isn't in it anymore?" I was

high as a kite, and I jumped over the drum set to try and choke his raggedy ass, but I fell over my high hat and cracked my leg instead.

I ran out of the club, stuck out my thumb, and hitchhiked all the way back to New Hampshire . . . drumless, bandless, hopeless. But still telling my mom, "Mom, I'm going to be such a big star there's gonna be girls hanging off the rafters, kids coming through the windows, battering down the doors. We gotta batten the place down, put up six-foot fences, put shutters on the windows. We'll need an intercom and electric gates to keep out the rabid fans. Or else we'll have to move." "Of course, Steven." My mom always believed in me, she was a stone romantic.

William Proud—Peter Bover, Twitty Farren, Mouse McElroy, and Eddie Kisler—wasn't really working out. It was still fun, we still got gigs, but it was small potatoes and wasn't leading to anything. No road to destiny! I grew up in a family where we were all very close, and I was probably homesick or whatever they call that today.

Summer ended, the town was cold. No one to cop from, no drugs, nothing up here—everyone had left. Oil lamps, candles, winter, the wind whistling through the pines. No band, no plans, no future, and they were starting to roll the sidewalks up. It was my first season of wither. And then, *on the seventh hour of the seventh day* I heard Joe Perry play. . . .

THE PIPE THAT WAS

efore we get started, you're probably asking yourself, "Is this about that famous pied piper from that children's story or just another clever drug reference?" Read on . . . seek and ye shall find. . . .

I'm a great believer in moments arising. You'll miss the boat, man, if you're not ready for star time. Then at least you need a brother like the Kinks, Everly Brothers, and of course the Stones. And I was ready, ready as anybody could be. "Keith, gimme an E!" And the emcee is saying, "Let's hear a big hand for old Whatsisname and the Miscellaneous Wankers." Yeah, yeah, yeah . . . but I always thought I needed a brother to rock the world—and FATE would take care of the rest.

I'd been a rock star ever since I could remember. I came out of my mother's womb screaming for more than nipple and nurture. I was born to strut and fret my hour upon the stage, fill stadiums, do massive amounts of drugs, sleep with three nubile groupies at a time . . . AND endorse my own brand of barbecue sauce (oh no, that's Joe). All I needed was for the rest of the world to see who I truly was—Steven Tyler, the Demon of Screamin', the Terror (or tenor) of tin pan time and space. Recipe demanded a cookin' band, a few hit records, and, as alluded to a moment ago, my mutant twin. Was that too much to ask?

By the summer of 1970, sixties megalodons and heavy metal raptors still ruled the land—the Stones! The Who! Pink Floyd! Black Sabbath! Deep Purple! Led Zeppelin! All those poncey Brits with their bloody million-quid blues riffs, limey accents, Marshall amps, flaunting their foppish King's Road clothes. We didn't stand a chance, mate. Back in the USA little bands came and went. They huddled in the underbrush trampled by the passing Ledzeposaurs. If you heard a bustle in the hedgerow—that was us. I'd been in my share of these little bands, eking out a living gigging for sixty dollars a night (if we were lucky) in crummy clubs, gymnasiums, dance halls, and dives.

I was even the designated rock star of Sunapee (summer population, 5,400; winter population, 500). I had 45s on the jukebox at the Anchorage where we all hung out. I had a couple of singles out, the very pop and Brit Invasion–like ballad "When I Needed You" and the Beatlesque, Dave-Clark-Five-sounding "You Should Have Been Here Yesterday" with Chain Reaction. I was a local hero... a rapidly evolving legend in my own mind. But that was all. I'd burned through countless bands and come home a beaten child.

I started mowing lawns. I had a little piece of hash that I kept in my hash coffin and smoked in my hash pipe, which was labeled *The Pipe That Was Never Played*. A couple of tokes, get loaded in an old drafty house with little curtains that closed. I'd sit around with my friends. We'd talk about what we were going to do for a living. Maybe we'll become cops—I actually *said* that! Oh, I swear! I wanted to be a local cop like my best pal, Rick Maston, who carries a badge on the lake. I can drive around at night, I thought, at least have something to do, like Biff, the old cop in the harbor. What would we be doing when we're sixty? That was another topic of conversation. Ah well, we'll smoke cigars and sit on the deck. But as soon as the words came out of

STEVEN TYLER

my mouth I heard a high-pitched bat shriek in my brain. No, I don't think so.

Sunapee is not unlike Our Town-only smaller, a little more artificial (because it's a vacation resort) and on a lake. Sunapee Harbor is just like the postcards of itself: quaint cottages, souvenir tchotchke shops, colorful local characters, aging rock stars. . . . The masts of sailboats sway in the harbor. It's sooo picturesque. A perfect little stage set designed for tourists. Antique paddle-wheel boats docked next to an airbrushed little park. The crew wear Gilbert and Sullivan naval uniforms, and the captain narrates the cruise-the history, landmarks, and lore of crystal clear Lake Sunapee-as he indicates points of interest for the enlightenment and entertainment of the gawking visitors. "Now, over here, to your right, is the lighthouse where legend has it two star-crossed lovers would meet on moonlit nights . . . and over there is the summer home of degenerate rock star and control freak Steven Tyler [gasp!], who spent his summers here as a child mowing lawns and talking to elves...."

They actually do an *Our Town* bit (billed as Crackerbarrel Chats) where old-timers (playing themselves) sit around an old woodstove at the Historical Society Museum and share, first-hand, their memories, experiences, and photos of days gone by. I've signed up for next year. My subjects will be whittling, bird-call clocks, the size of Slash's cock, and how to throw a TV set out of a hotel window into a swimming pool so it explodes when it hits the water. (Hint: extension cords.)

Sunapee's quaint all right, but if your aspiration in life is to be a rock star, then you're in trouble. This isn't the place to be. I knew that in a few weeks the town would start to close up. Like Brigadoon, every September it all evaporates. They fold up the flats, strike the set, and overnight it's this deserted village—the kind of town you see in Stephen King movies where the place has been abandoned due to a supernatural fog. I'd stand in Sunapee Harbor all by myself and there'd be *nobody there*. It gave me

the creeps! No wonder the town is filled with alcoholics—there's nothing else to do.

Winters in Sunapee are brutal. Six months of howling wind and driving snow. A Siberian nightmare! And I'd spent plenty of winters in Sunapee, licking my wounds, getting high as a kite, brooding, regrouping, reassembling myself, and practicing my Jagger pout.

I'd spent too many winters up there doing that. I wasn't going to do it again. I said, "That's fucking *it*." I prayed to the Angel of Cinder-Block Dressing Rooms and Ripped Naughahide Couches, "Deliver me from this horror!"

And then one day—like an apparition—Joe Perry! Joe pulled up to my parents' place in Trow-Rico in his brown MG. There ought to be a plaque to mark the spot where that happened. God, I can see it in my mind's eye—the pebble retaining wall below the big house, the steps up to the house where I used to clip the hedges—it was such a Technicolor wide-screen moment. He got out of his little Brit sports car. He was wearing black horn-rimmed specs.

"Hey, Steven, we have a band and it's playing the Barn tonight. I wanted to invite you to come down and see us. You know Elyssa, right? She'll be there." Oh, yeah, I knew Elyssa, the pinball wizardess. She was Joe's girlfriend, drop-dead gorgeous.

Now Joe, Tom Hamilton, and a little kid called Pudge Scott were in a group called the Jam Band that played around Sunapee and Boston. I went down to see them play that night at the Barn. There was Joe, Tom Hamilton on the bass, Pudge Scott on the drums, and a guy named John McGuire singing lead. All of them totally disheveled, fronting that unbridled bohemian cool of the early Brit rock bands. Joe looking a little dorky with his black-rimmed glasses patched with masking tape and his guitar *way* out of tune.

John McGuire was the original shoe-gazer . . . an affectation later taken to a high art form by Liam Gallagher of Oasis and others in the postgrunge bands of the nineties like Adam

Duritz in Counting Crows. With these guys the lead singer looked down at his feet instead of out at the audience. Supposed to indicate authenticity, disdain for showbiz—but what the hell. I'm watching John McGuire looking down at his shoes and I'm thinking, God, no eye contact there, no connecting with the audience—what *is* that? Then I notice he isn't exactly looking at the floorboards. He had a couple pages of *Playboy* taped to the floor of the stage between his feet, and he was looking down at her tits, you know—how great was that? Wonder if Eddie Vedder had pages of *Surfer Magazine* taped to those early Pearl Jam stages?

Joe sings lead on the next song. I'm sitting down with Elyssa watching Joe sing "I'm Going Home," you know, the old Ten Years After song? Joe couldn't sing at all. He sings like the Brit blues blokes, like Alvin Lee. Those kind of songs where you don't have to hold a note (because you can't actually sing), doing the early rock stutter, the way Ray Davies does "All Day and All of the Night."

Next song. And then they went into "Weeeellll, beh-bee, if you gotta rock gong-gong-chick-gong, I got to be your rockin' horse." Joe's singing it kind of like Dylan, because he couldn't really hold notes back then—nor did he want to. Singing pretty, on key, was pop shit. Leave that to Dusty Springfield and Joannie Baez. The blues cats were aiming for the genuine Delta gris-gris growl.

They played only three songs the whole night—a lot of riffing, noodling—one of them being Fleetwood Mac's "Rattlesnake Shake"—the mojo-driven Peter Green version (rough and dirty, pre–Stevie Nicks and the megahits). Fleetwood Mac's *Live at the BBC*—we'd use that as our reset button. It's the Holy Grail, the kabbalistic shit, pure unstepped-on melodic sensibility. Get that record, it's all *in there*.

Joe couldn't carry a tune to save his life and I thought, Oh, my god, these guys really suck! Oh, shit, these guys are so bad, they're so out of fuckin' tune, it's embarrassing! I've got to get out of here! They were playing this great Brit fret-burning blues, but they were *horrible*. They were out of tune, out of time—and I'm an animal of the beat, I have the ears of a bat. If a drum beat is a hundredth of a second off, I become unstable. I rant, I rave, it has to be fixed or the world will stop spinning on its axis. I drive my band crazy with this shit.

I was sitting there in the audience right next to Elyssa looking at Joe play. He had his Keith Richards moves *down*. The menacing hatchet-face scowl and bent knees as if the riff was so heavy it was weighing him down. The cool-chop look slightly undercut by his horn-rimmed glasses, white tape in the middle, hair down to his shoulders.

Goes into the second verse. . .

He do the shake The rattlesnake shake Man, do the shake Yes, and jerk away the blues Now, jerk it

Then—and this is the moment—Joe lurches into the guitar break: BOOAH DANG BOOAH DUM. Fuck! When I heard him play that, ah man, my dick went sooo hard! He blew my head off! I heard the angeltown sound, I saw the light. I was having that moment—the moment. Remember the scene in the movie The Miracle Worker about Helen Keller and her teacher? For a million years they'd done the hand signal thing. Then one day, out by the water pump, she signs W-A-T-E-R. At that moment, the levee broke.

Then he played the Yardbirds number "Train Kept a-Rollin'," which became our *top-this-motherfucker* closer. Like me, an old Yardbirds fan—hence our mantras: "Train Kept a-Rollin'" and "I Ain't Got You."

My ear was a little more finely tuned than these guys', but what I saw was this rough, raw, uncut rock 'n' roll thing, the

X-factor, the wild thang that runs through rock from Little Richard to Janis Joplin. Now that's what was missing from the other bands. It's not something you learn, it's something you are. You play what you got. I'm thinking, with me make-believing rock star (which I could do *so* well) and Joe channeling Beck-Keith-Page, who could stop us? Who? They were in a very raw, rough state—but so what? If the horse doesn't want to be ridden with a fucking bit in its mouth the whole time, what the fuck, let it go. If you've got this monstrous animal, let it run.

It was so fucking great it made me cry, and then the thought came into my mind just like the midnight train steaming into the station: What if I take what my daddy taught me, the melodic sensibility I've got, with the broken glass shards of reality that these guys wove together? We might have something.

Oh, yeah! When they did "Rattlesnake Shake" the fuckin' energy coming off them was radioactive, they had the juice that all the bands I'd ever been in before couldn't touch. The sacred fire! With all the acid and Tuinals and crystal meth, we couldn't get to what they were doing *on the natch*. Right there what was beaming through was the white-hot core of Aerosmith. I went, "Ye-esss! YES!!!" I heard that high ecstatic voice, locusts were singing in my brain! And then I knew we'd have our day.

My whole life I'd been searching for my mutant twin—I wanted a brother. I didn't want to be in another band without a brother. I needed a soul mate who would go "Amen!" Someone I could say "Fuck yeah!" to when I heard a million-dollar riff. In all the bands I'd been in from '64 to '70 there'd always been that one thing missing, *the* essential ingredient. Joe was the missing link. I wanted that Dave Davies–Ray Davies (that was real blood), Pete Townshend–Roger Daltrey, and of course, Mick-Keith thing. I'd never had that.

We're polar twins. We're total opposites. Joe is cool, Freon runs in his veins; I'm hot, hot-blooded Calabrese, a sulphur sun beast, shooting my mouth off. JOE'S A CREEP . . . I'M AN ASSHOLE. He's the cowboy with the brim of his ten-gallon hat pulled down, the *Hell-it-don't-matter-none* dude. But goddammit, is he always going to win? Am I always going to be the one with egg on my face? Of course, contrariness is the way the great duos have always thrived. Mutt and Jeff, Lucy and Desi, Tom and Jerry, Dean Martin and Jerry Lewis, Shem and Shaun, Batman and the Joker.

Right off, there was teeth-grinding competitive antagonism. The internal combustion engine that drives us. It's in our DNA, part of our chemistry. The two-way thing going on . . . combination of the two. When I met Joe, I knew I'd found my other self, my demon brother . . . the schizo two-headed beast. Joe comes up with a great riff and immediately I think, "You fuck, I gotta top that motherfucker. I'm gonna write words that'll burn up the page as soon as I lay them down!"

But you know what? Antagonism, pure nitro-charged agro, fuels inspiration. Do I have to explain these things to you? And you can't control animosity, can you?

We've been chained together for almost forty years, on the lam, like Sidney Poitier and Tony Curtis in *The Defiant Ones*. Writing songs together, living next door to each other, touring, sharing girls, taping, getting high together, cleaning up together, splitting up . . . getting back together. There *is* a love there, no matter what. As soon as the anger gets resolved, we're bosom buddies, nothing can ever drive us apart, but something inevitably comes up and I say, "Whoa! Wait a fuckin' minute!"

Nobody can make me as crazy as Joe. No one drove me to the coffin for a reminder of *the pied piper dream* more often than Joe. Not ex-wives, not ex-managers—and you *know* how mad they can make me. Joe Perry is fucking Joe Perry—nothing I can do about that. Nothing I want to do about it. If he walked out onstage covered with vomit and shit and a needle hanging out of his arm, people would still applaud him and scream because he does the guitar god better than anyone. He's the real deal. Not that the real deal is always the best deal.

Also the doomed, self-destructive rock star thing . . . straight

STEVEN TYLER

out of the old *Rock Star Handbook*. Which is why I've got to keep my eye on him. Someone has to! Women love him; they have to live with his shit, his sniveling, smoking, and doping too much. I see him from the outside. Joe fucking Perry is the ultimate ... but I'm the one who can see the shadow over, under ... and inside him.

And there *is* a fucking Cloud of Doom passing over his head. My relationship with Joe is complex, competitive, fraught, really sort of fascinating in a hair-raising kind of way. There's always going to be an undercurrent, ongoing tension, periods of homicidal hostility, backstabbing jealousy, and resentment. But hey, that's the way the big machine works.

We'd joined that illustrious company of brawling blues brothers: Mick and Keith! Ray and Dave Davies! The Everly Brothers! That's us, the Siamese fighting fish of rock! Aw*right*! Bring it on.

But whatever happens, when we go on tour it fuses us together, we become the big two-headed beast. I *see* Joe every night and I go, fuck, that's it, I get it! This is why we do it! And why I *love* it. Everything kind of washes away. *All* of that.

After that night, the Rattlesnake Shakedown, I was ready to make it happen. Tom and Joe were still in high school when I first met them, thinking about going to go to college. I had already burned my boats. I was never going back. I said to myself, *Fuck it, I'm going to take a chance and move in with everybody.*

Now, I knew we could do it. I loved sixties music; Brit rock stars were the shit. I wanted that sound so bad. And almost as much as I wanted the band, I wanted that lifestyle. I wanted it more than anything. *I could taste it*. The band was going to be the sixties Mach II . . . the Yardbirds on liquid nitrogen.

We'd all move to Boston and get down to the serious business of becoming famous. We had everything else, now all we needed was the fame to go with it. And being that I'm a little more crazed than most people, once I saw the light, I went for it hell for leather. My bags packed, at the end of that summer I said good-bye to my mom and dad, going, "Okay, here we go, this is the shit."

The day we drove down—and here you have to stretch out the syllables—*d-r-o-o-o-ve* down to Boston from New Hampshire, I remember looking out the window at the trees and hills rolling by. I was feeling a little pensive (for me). I was a bit anxious about moving in with everybody; but at the same time I was ecstatic. It was a *good* anxiety, nervous and excited at the same time. And just then, the highway opened up—right at the junction, right at that spot on the highway where you see the skyline of Boston, and you go, "*What!?*" Because it suddenly goes from trees, woods, and crickets to cars flashing by and skyscrapers and apartment buildings. . . . Just at that moment, I went, "Oh, shit, *the city*!" I was sitting in the backseat. I grabbed a box of tissues from the back window of the car and asked if anyone had a pen and started to write on the bottom of the Kleenex box.

I'm in my bubble in the car. It's like a projection booth where I'm screening our future on the windshield, a wide-screen movie of coming attractions—I can see it! Joe's Les Paul gnawing through reality like a sonic shark, little pop tarts throwing their panties onstage, the high of fusing twenty thousand people into your own fantasy. The car's moving (it's also in the movie) ...images and words colliding, generating a kind of spell of what I wanted to happen.

At the moment that I saw the Boston skyline, words began flooding into my head: Fuck, we gotta make it, no, break it, man, make it. We can't break up, we gotta make it, break it, make it, you know, make it. And I began writing: "Make it, make it, make it, break it," saying the words over and over to myself as I wrote them, like a prospector panning sand in a stream, back and forth and back and forth—water and sand, water and sand—until a little nugget emerges out of the sand. And there in the back of the car I thought to myself, What would I fuckin' say to an audi-

ence? If we write songs, get up onstage, I'm gonna be looking the audience in the eye, and what am I gonna say? What would I want to say? I'm starting to pan for the gold: What do I say? What would I want to say? What's cool to say? All those ideas were beginning to gell into one fuckin' phrase... Whoops, here we go!

Um...good evening, people, welcome to the show...
[First-person, me singing to the audience...]
I got something here I want you all to know...
[The collective we, the band...]
We're rockin' out, check our cool...
[Um, no, no, that's no good, uh, talk about my feelings...]
When life and people bring on primal screams,
You got to think of what it's gonna take to make your dreams,
Make it...

Oh, fuck yeah! Now I'm scribbling like crazy on the Kleenex box.

You know that history repeats itself But you just learned so by somebody else You know you do, you gotta think the past You gotta think of what it's gonna take to make it last; Make it, don't break it! Make it, don't break it!

And there it was, first song, first record. Put that in your pipe....

MY RED PARACHUTE (AND OTHER DREAMS)

've been. . .

New Orleaned, collard-greened, Peter Greened and tent-show queened; woke-up-this-mornin'ed and givin' vou a warnin'ed, Seventh Sealed, cotton field; hollerlogged and Yeller Dawged; sanctified, skantified, shuck-and-jived, and chicken-fried; black-cat boned, rollin' stoned, and cross-road moaned; freight-trained, achin-heart pained, gris-gris dusted, done got busted; bo-weeviled, woman eviled; mojoed, dobroed, crossroad, and mo' fo'ed; share-cropped and diddley bopped, Risin'-Sunned and son-of-a-gunned; voodooed, hoodooed, and who do you'd; red-light-was-my-minded and baby why you so unkinded; Mississippi mudded and chicken-shack flooded; boogie-woogied, Stratocasted, blasted and outlasted; 61 Highwayed and I did it my wayed; Little-Willie-Johned and been-hereand-goned; million-dollar riffed and Jimmy Cliffed; cotton-picked and Stevie Nick'd....

STEVEN TYLER

The blues, man, the blues . . . the *blooze!* That achin' of 'heart disease and joker in the heartbreak pack, demon engine of rock, matrix of über-amped Aerosmith, and the soul-sound of me, Steven Tyler, peripheral visionary of the tribe of *Oh Yeaah!*

Now the blues is, was, and always has been the bitch's brew of the tormented soul. The fifth gospel of grits and groan, it starts with the first moan when Adam and Eve did the nasty thing and got eighty-sixed from the Garden of Eden.

"Once upon a time . . ." "In the beginning was . . ." That's the way it always starts off. Every story, gospel, history, chronicle, myth, legend, folktale, or old wives' tale blues riff begins with "Woke up this mornin'. . . ." The blues is soiled with muddy water, funky with Storyville whorehouse sweat and jizz, smoky from juke-joint canned heat, stained with hundred-proof rotgut and cheap cologne. It's so potent 'cause it's been in every lowdown, get-down joint the world has ever seen.

Everybody sucks on someone's tit, and ours was the bitch's brew of the blues.

My first sexual musical epiphanies came through the radio. They were all entangled together. I can't remember how old I was when I first realized they were separate things—but *are* they? That's the question. I used to listen to the radio as if these sounds and voices were coming from outer space. Deejays were magicians who talked to you through the air somehow and brought you these erotic sounds, songs about love, desire, jealousy, loss, and sex. Later on I'd listen to 1010 WINS, which was a New York rock station back then, and hear all these great crazy characters talking that buzzy deejay jive talk.

When I moved with the band at the end of 1970 to Boston, it had the greatest rock 'n' roll stations of all time, and believe me I heard them all. Radio at its finest.

When Aerosmith was just starting out I began dating a very

sexy deejay at one of those stations. I'd never known an actual disc jockey before, but I knew they were famous people who could get you famous—and thus get you laid. But until I met her I didn't know you could do both . . . on the air.

Of course me being in a band and trying to make it in Boston, what better thing than to be over there on the air making out with her while she was doing the dog and cat reports—that's when they announced the missing pups and pussies. She didn't have prime-time spotage so she had to do a lot of public service spots: the community center is having a dance; the local synagogue is throwing a picnic.

It was hilarious the things I did to that woman while we were on the air just to see if I could rattle her cage. I never really did. It was funny, though; we did the most incredible things. I'd give her head while she was on the air, take off her panties and have her sit on my lap and fuck her.

Such outrageous stuff, and we got away with it! Nobody knew, but let me tell you what . . . she got rave reviews! Not only were we getting very, very high—I was shoveling spoonfuls of coke under her nose—but we were really climbing under the covers, so to speak. All this while she's playing Led Zeppelin, Yardbirds, Animals, Guess Who, Montrose, Stones—tons of great shit. It was a graveyard shift, but regardless of what it was, big or small, we were still live on the air, and it makes you just want to test the water and see what you can get away with. I used to do shit like sing along with records—people didn't know that I was doing it, they must have thought she was playing some outtake or live track. I'd tell jokes, recite limericks, make up bizarre news items. God, that was heaven!

I would be all over the place: early Fleetwood Mac with Peter Green, Blodwyn Pig, Taj Mahal, the Fugs. In those days deejays would play the whole side of an album. Nowadays some of your best XM/Sirius stations play deep tracks. We should all be proud that our music, what they were inventing back then,

STEVEN TYLER

has lasted so long. Love—and the music of its time—is its own reward isn't it? And having sex with the deejay while she's playing "Whole Lotta Love" was the ultimate consummation of my radio sex music fantasy.

Joe Perry, Joey Kramer (we went to the same high school in Yonkers), Tom Hamilton, and I arrived in Boston and got an apartment at 1325 Commonwealth Avenue in the fall of 1970, entering the city like spies, ready to conquer the world overnight. It took a little bit longer than we thought it would.

With any of the bands I'd been in I'd always wished we could live together. I'd been dreaming of that since I was twelve, and now we could. We could write together, go to bed at night with the lick we wrote that afternoon fresh on our minds. The Island of Lost Boys.

Day one, I said to the guys, "This is so great that we're living together! I fuckin' love that!" It started out blissfully but soon turned into little skirmishes over chewing gum and toothpaste and petty psychological feuds. But that's what marriages are. And in the end the band really worked, and I think somewhere deep inside—and quite hidden even from themselves!—they really loved me for making them do that when we lived at 1325. Stealing the food and cooking! I would make breakfast; we'd learn those songs and really craft them, make them tight.

In his book, *Hit Hard: A Story of Hitting Rock Bottom at the Top*, Joey told the world that the reason he has a facial tic is that I abused him just like his father did. I used to yell at him. I'd say, "Don't play it like that . . . play it like this!" I know good things don't come without practice; if I was hard on him it was because we had to get it right. But because I had decided not to be the drummer in the band, I gained a right IN MY MIND to be able to live vicariously through Joey.

I had a dream. So in the beginning, Joey was my interpreter, and we sat and played together. I took my drum set and said, "Joey, today's the day." And he'd go, "What, man?" And I'd go, "Well, you set up your drums and I'll set up mine . . . right in front of you! And we're gonna play facing each other." He never understood. Later on, with Aerosmith records, he always thought that if I did a snare hit with him—or if I played the high hat while he played the drums—people would notice that there was someone else playing the drums. And I'd say, "Listen to Greg Allman's 'I'm No Angel' or the Grateful Dead stuff with two drummers. It's a *sound*. The Beatles sang in a room that had a voice . . . which means the room had an echo. They didn't have some ass fuck engineer try to get rid of it. They put it on the track like that. Once it's a hit, that echo is on there forever."

A room has its own sound and music. You can buy a machine and tune it to "ambience." When we were making *Just Push Play*, we recorded our empty room. If you record that hall noise and sing over it, it's like letting the hall embrace you. It has chairs and equipment and people. The room IS another instrument. The room is in the band.

So with Joey, we would play together, and in the beginning—what I'm getting at—is there'd be this Cheshire grin on both our faces. He loved me and I loved him. He couldn't believe the tricks I knew. And to this day, he can play what I could never play. But back then, in '71, it was all about "Hey, show me *that* again!"

Hence there was I, night after night, sitting near his drum riser, going, "Do a drum fill here," 'cause he really didn't know on his own that after the second verse—right after the prechorus, going into a chorus—one needs something exciting and . . . what would that be, Mr. Drummer? *A drum fill*! A prechorus means "Whoops, here it comes." A verse should be the storytelling, and the prechorus is the "Whoops, here it comes." And then a drum fill to go into it to show that it's *important* . . . *to mark its importance*! End of the song, maybe a prechorus again, and a middle eight (recapitulation), a little "tip o' the hat" to something you might have said in the beginning of the song

to remind everybody what it was about . . . and WHAMMO, right into your chorus and you're out. And during the chorus and the fade . . . come on, play the drums even more. These things I knew and learned and passed on to Joey. So he played, and for the last thirty-five years, I lived *through* him. I don't know how *not* to.

You know what one of my favorite albums of all time is? Stevie Wonder's *Songs in the Key of Life*, mainly because of what drummer Raymond Pounds decided to do, which was, in essence, *not* live up to his last name. There are very few drum fills on that amazing record. You can be good just holding down the fort. On Zeppelin's "Kashmir," listen to that drum beat. Simple. Straight. It gives the song legs—like the linemen who protect the quarterback.

Since I'm a drummer and a perfectionist, I rode Joey hard, admittedly. But in the process I made him a better musician. Like when we're sound checking in Hawaii, I sat down at the drums and wrote the drum line for "Walk This Way." You want the story now or when we get to *Toys in the Attic*? Hey, I never said this was gonna be a completely linear read. How could it be? (Ha!) But we're on DRUMS so . . . what the fuck?

One of the things I'm most proud of is "Walk This Way," and it's very *EGO* and all, but even after you read the press about Run DMC and Rick Rubin, I still think the song was a HIT in and of itself. And the proof of the pudding . . . "*Backdoor lover always hiding 'neath the covers.*" You can't SING that unless you're a drummer or have some major sense of rhythm.

So we're at the HIC Arena in Honolulu, doin' a sound check, and Joe was playing a riff and I went, "Whoa, whoa, whoa . . . STOP!" I ran over to the drums. Joey had not come out yet. He was backstage, and Joe and I just started jamming on the "Walk This Way" riff 'cause Joe's rhythm was fucking "get it!" *Bada da dump, ba dada dump bump (air)* . . . *bada da dump, ba dada dump bump*. I got on the drums and played to *that*, and that's where the "Walk This Way" drum beat came from. Joey wasn't the best drummer in the world when I joined the band, and I was a drummer, and it was my theory of how a real band rehearses that fused the band together—playing that line from "Route 66" over and over and over again—and because I wrote the song "Somebody." Eventually Joey achieved his independence as a drummer. He always had a hard time playing the rhythm at the end of "Train Kept a-Rollin'," but he worked on his independence—that's your ability to move all four of your limbs independently—and in the end he's turned into the greatest drummer in rock 'n' roll. He now has a right ankle that's like a bicep from playing the bass drum.

Joey says I drove him crazy, gave him a nervous breakdown. When we were in rehab together at Steps in Malibu in 1996, the class confronted me. "What's the big idea of bringing someone here who's an active addict?" I said, "What the fuck are you talking about?" "Your drummer, your drummer's on cocaine, he's got that tic addicts get from snorting coke." Then I had to explain but I had no idea *I* was the explanation.

Okay, so we're all living and working together and we're getting these early gigs. Sure, there's friction from time to time, but nobody in the band has doubts that we are going to make it. Everybody was totally committed. No band I was ever in had gone to that extent. Prior to moving to 1325 I would look at Tom and go, "You're not leaving, right?" "Are you a quitter?" "We're doing this, right?" Nowadays, there are fewer places for a young band to set up and play... and suck. Dare to suck! We did—you can, too!

Joey Kramer's the one who brought that funk and shit to Aerosmith because he was playing in black bands and he thought he was all that. Of course, he had no idea what he was going to blossom into. He's so dis-*tinc*-tive. Even his mistakes *fly-y-y-y*!

And then there was my old buddy and gang mate Ray Tabano. He was there from the beginning. Not the greatest guitar player on the planet but one hell of a crazy motherfucker. Crazy Raymond. And I wanted the sound of two guitars in this

band (eye, E . . . the Stones). After a year or so Brad Whitford would replace Ray (in 1971).

Like a lot of bands, we lived in the same house, played, got drunk, went to drug school together, stole to eat. We had no money . . . we were starving to death back then. I was stealing food from the Stop and Shop (rechristened the Stop and Steal). I'd go to the store and get some ground beef and shove it down my jeans to throw in with the rice. I'd make that Gravy Train shit that I could pour over some bread with brown rice and carrots. And then the six of us ate.

The psychological warfare began with milk—which is pretty funny, because it was over spilt milk that the band broke up in 1979. I'd get the milk in the morning and put it in the refrigerator; then I'd go to get a drink of milk and what the fuck, there's just a drop of milk left. "Well, at least we left you *something*!" they'd say. And there it is . . . there's the psycho*lacto*logical crux of the thing, and that's pretty much as humorous as I can get about our petty daily band frictions. I've gotten real mad, but I never actually *bit* anybody in the band. That nobody ever hit *me* is a testament to their forbearance. I probably drove everyone nuts.

But if you don't bring this shit out into the light it gets suppressed and festers. Bands try and avoid aggravation, but hell, it can actually inspire you to write better songs. One day at the very beginning of 1971 I wrote the basic track and lyrics for "Movin' Out" on a waterbed with Joe Perry in our living room at 1325 Com. Ave. I leaped up and shouted, "Guys! Do you realize what we just did?" Their enthusiasm was curbed. "Yeah, what is it, man?" "It's our firstborn!" I proclaimed. "The first *Aerosmithed* song! How great is that?"

We all live on the edge of town Where we all live ain't a soul around People start a-comin', all we do is just a-grin Said we gotta move out 'cause the city's movin' in

All this time the band is sprawled out watching TV, drinking Ripple and Boone's Farm, smoking pot. They wouldn't have been interested if I'd said it was the end of the world. "Move over, you're blocking the TV," they'd whine. "No, man," I said, "let's go write some more songs!" "*Bah!* Get the fuck outta here!" and they'd flick their joints at me. I got really fucking pissed off at these guys, went in the other room, sat down at the piano, and wrote another verse to "Movin' Out," finished up "Make It, Don't Break It," and worked on "Dream On." And just did a shitload of stuff. Love may be the best driving wheel, but anger is a pretty good second.

The albums that had a huge effect on me were *Taj Mahal* and *Deep Purple*—a mixture of Taj Mahal and the Yardbirds. That's what I brought to Aerosmith. I said, "These albums are gonna be our Bible, let's have at it." Taj Mahal. God, his album was so instrumental for me, leaving all those cover bands and doing Aerosmith. I named my son for Taj. It was Taj Mahal singing "Going Up to the Country, Paint My Mailbox Blue" right out in the open with his harmonica—that first album, I still listen to it.

We got "Train Kept a-Rollin" from the Yardbirds, but it started as an R&B hit for Tiny Bradshaw, who was a swing band leader. Johnny Burnette hillbillyized it in the fifties and the Yardbirds just *smoked* it. What did we have to lose? I always wanted to do "Road Runner"—my totem critter. Bo Diddley's version Britbluesisized by the Pretty Things.

The first thing you got to do is get yourself a blues Bible: Yardbirds, Led Zep, Stones. The old über-amped Brit blues shit. Pieces of the true cross, baby. Fiery holy relics! Peter Green playing on "Oh, Well" or "Rattlesnake Shake" on Fleetwood Mac's *Live at the BBC*. What the fuck? Hidden truths! Melodic sensibilities are embedded in that vinyl.

Now, any idiot can basically buy that kit. A bald-headed

accountant in a fright wig and tight spandex can do it and end up on the cover of a heavy metal mag. But in the dazed and confused days of yore, the mystic moves of Jeff Beck, Jimmy Page, and Peter Green were only revealed to true believers.

When Jimmy Page came to Boston on the *Outrider* tour in June of 1988 and dedicated "Train Kept a-Rollin" to "Steven and Joe from Aerosmith," that was like a blessing from one of our gods.

We rehearsed at Boston University, down in the basement of the girls' dorm. Jeff Green, the director of the West Campus One dorms, was a heavyset guy who loved the band and let us practice there for free. We rehearsed until four thirty and then hitched a ride back to the apartment so we could all watch *The Three Stooges* at five on Channel 38 and share a bong full of brown Mexican marijuana. Let's get stupid. Well, not everybody gets stupid. I actually think I wrote some good lyrics on pot, but meth, coke, and Tuinals were my drugs of choice.

In Joe Perry I'd seen raw power . . . but how to harness it? One day it dawned on me why Led Zeppelin was the shit. Jimmy Page figured it out, and it wasn't jamming. Everyone in that band knew what they were playing and played the same rhythm. I heard Joe Perry, Tom Hamilton, and Pudge Scott jamming back at the Barn in Sunapee. I was blown away by their unleashed fury, but I wasn't crazy about their rambling, indulgent noodling. "Hey, we're jammin', man," they'd say. They even called themselves the Jam Band. My answer to that was "Yah and . . . what? What??" There's nothing so great about three people jamming. It's all egotistical, all over the place. So I said, "How about instead of each of you going off on your own tangents, you all play in sync?" Now, there's balls! "You guys, we gotta play together. We can't jam and be a big fuckin' rock band. The foot's gotta play with the bass-then we'll have a serious fucking rock machine."

There are secrets to rock, just as there are secrets about making love to your wife or girlfriend. Do you come at the same

time? I'm not going to ask, but I will tell you that some of the finer moments in my life were making love to a woman and coming together. There's an ancient magic ritual to this: if right before both of you come, you make a pact or say a prayer and focus that thought, *"Sweet Jesus, I want you to send this light"* to cure an illness, to achieve some deep purpose in your life, it *will* happen, because there is no power on earth stronger than that. There's electromagnetic theory behind it. If I hooked up that energy at the instant you came to an electrode it would go *mmmmmnnbrrrrggggnnnnnn*. The little red needle would thrash like a rattlesnake's tail.

Now, what if you had a thought *while* your electricity was ramped up? What if your every thought had an electrical charge attached to it that got overamped during sex? When the two orgasms combine they have unbelievable psychic power. The English occultist Alistair Crowley based his ritual Magick on this principle. And it's an interesting fact that for a dozen years in the seventies and eighties, Jimmy Page owned Bolskine House, Crowley's old home on the shore of Loch Ness—so who knows what effect Crowley's Magick had on the serpentine rise of Led Zeppelin?

I've practiced that Crowley Magick so I know it works. I'm not saying that every girl I slept with came at the same time as I did or that I asked her to pray for the same thing I was praying for: namely that Aerosmith would become the greatest American band. But then I didn't have to, because that's all I ever thought about . . . or prayed for.

Every kid on every block in every city in America wants to be a rock star. But if girls, money, fast cars, houses in Maui, and skybox seats to Red Sox games are your only motivation—and that's *a lot* of motivation—then you're in trouble. Aerosmith has been together—the five of us—for forty years, with a short twoyear break, and you don't get to do that without some very strong

motivating force to counterbalance all the stupid fucked-up things that are constantly working to tear you apart. The psychic glue that held us together was *the music*. The collective sound that the five of us make. Peel back the layers of the onion (that's what it is) . . . and when it works, it's above and beyond your wildest dreams.

Like it must have been for Jimi Hendrix's band. His music was so heavy that when you hear the thunderous, orgasmic opening to "Purple Haze," you don't have to *say* anything. You can imagine Jimi's drummer, Mitch Mitchell, listening to that playback and going, "Oh, my god! *Oh, my god!*" The rush and din of it sucked you in, it pulled you under. It was magnetic, utterly addictive—you would follow that sound to the ends of the earth. It's not something you can walk away from. It's the sound of humping, pumping, grinding life itself—with a voodoo vibe to it.

I remember my first girlfriend, Geraldine Ripetti, saying, "I heard this song on the radio—I've never heard music that sexy."

"What do you mean?"

She goes, "'Purple Haze.'"

Gerry Ripetti had the biggest boobs—I couldn't even look at them while I was standing in front of her, they were so big, it so affected me, I was st-st-stuttering, be-be-be-because. . . . She was so beautiful. She said, "Steven, you've got to hear this record, this is the sexiest music I ever heard." And just hearing her say "sexiest music" I could feel the lump already arising in my pants. "Sexy? What do you mean by that?" She played me "Are You Experienced?" and, come on! She was so fucking right on, because when you heard those Stratocasting gears churning . . . that was sex as sound in its purest primal form.

No one had ever played like that. No one. So imagine being in his band and saying, "We just *played* that." Or the Stones creating that raunchy spooky blues vibe, that *energy*, that *tangible* force that could *not* be denied, it had to be reckoned with. A sound that would be the mouthpiece for a whole generation. When you think about rock bands that made it, why did they make it, *how* did they make it, what did they make it *for*—I can get really emotional about this stuff. Because the *music* that they made was so strong, so overwhelming that it was a prayer and an answer all at once.

The Beatles, come on, and what the fuck! It wasn't because they were all such great musicians. They knew. They knew. They were English and they had long hair when nobody else did and they said funny things, but it wasn't that, either. It was the alchemy they cooked up—Everly Brothers, Buddy Holly, Little Richard, Chuck Berry—and music hall numbers.

And they evolved, as did the Stones, the Who. Many groups came out, had a hit, and then took the ferry back across the Mersey. The Beatles went from "She Loves You" to "Help" within a year. In one year. Not ten. In two years they were at the trippy *Rubber Soul.* "Norwegian Wood," how great is that? So you can say what you want, but in one year they started out recording in a room where Paul and John sang together on one mic, took that vocal and dumped it down to one track, and added it to the next vocals. You know what that means? It means you can't go back. They had to be so sure of themselves. Plus, of course, they had George Martin as a producer.

We needed a name, so we all got together and tossed names around the table, like Stit Jane. I came up with the Hookers. No one liked that. "How about Arrowsmith," Joey suggested. "Arrowsmith? You mean like the Sinclair Lewis novel we had to read in high school?" And then, a minute later, I went "Aero: a-e-r-o, right?" And he goes, "Yeah." Now that was cool. The name evoked space—aerodynamics, supersonic thrust, Mach II, the sound barrier. I thought if we could stay together, that name would always work because we had nothing to look forward to except the future. I always imagined that when I was fifty, there'd be robots already, skateboards that floated and you could jump on. Everything that happened to me since I was ten came out of

STEVEN TYLER

comic books anyway. All the superheroes had that shit. Every bit of it—lasers, light sabers, phones that you could talk into. Dick Tracy had that watch on his arm. He was talking to it all the time. Watching *Dick Tracy* I used to think, "What if we all had one of those watches?"—but it was just a crazy kid thought. Now everyone has one with all the apps—check your e-mail, blog, Twitter me . . . and please, sit on my Facebook.

I'd thought of calling us the Hookers because I considered playing clubs a form of prostitution—I'd spent six years playing clubs in New York and knew how exhausting and frustrating it was. So with Aerosmith we avoided the club scene like the plague. It's a trap. The money's okay—a thousand a week would be a nice payday—but doing four sets a night (for fortyfive minutes each, even if the club was empty) for a two-week stretch playing other people's material will grind you down. No time to rehearse, write, develop new material. People shouting "Play 'Maggie May'!" "Hey, you fucks, know any Credence songs?" In any case we were too rowdy for most clubs and bars. We got kicked out of Bunratty's Bar in Boston because we started to incorporate original material and the club owners didn't like that.

Instead we focused on colleges, high school dances, ski lodges. We played around a lot, mostly weekends, rehearsing during the week. Playing high school dances out in the country, getting maybe three hundred dollars a night.

We played absolutely anywhere that fifty people would come see us. As the keeper of our gig calendar, I had to make sure we had at least three dates a month for around three hundred dollars to cover our rent and basic nut. We functioned like a guerrilla band: play a small town, establish a beachhead, develop a small fan base, next time through there'd be more kids and more and more enthusiastic fans.

Our set list was our Brit blues catechism. Real heavy metal to me is Led Zeppelin playing "Dazed and Confused." We got our roots the same place Zeppelin got theirs—and I don't mean from Jake Holmes, the guy who inspired Jimmy Page—I mean de blooze.

When we started out, there must have been five thousand rock 'n' roll bands in the Boston area alone trying to make it. But if you are going to separate yourself from the pack you have to develop your own identity and you aren't going to do that by playing other people's songs. In the very beginning we, too, did cover versions (we only had a couple of our own songs).

We never played in our street clothes. We always dressed up . . . put on a show. You're in a band, lads, we've got to get *flash*. The look is the hook. I got the band to strut their stuff, dress up, get their sartorial swagger on. I'd walk into Caprice, an antiques store on Newberry Street owned by my friend Barbara Brown. She said to come down to her store and she'd give us some clothes for our first album photo shoot. I had to ease the guys into the fashion thing. I was already having my leather pants done in flames from the girl who lived upstairs at Number 5, Kent Street. I brought the band to Caprice and told 'em to rummage around, pick their own stuff out. It was a free-for-all.

The store was opposite Intermedia Sound where we would record our first album. "Here, put this on!" I said. "Hell, no, I'm not gonna wear *that*." "Aw, c'mon, man, just do it for the pictures! Look at the Brit art school flash! Look at Jimmy Page! Look at Mick! Look at Jimi Hendrix, Jeff Beck! Look at Pete Townshend! The Union Jack jacket is the shit. Are they wearing jeans and army surplus? I don't think so." After a lot of yacking they got into the clothes that made the picture on the first LP cover explode . . . and they looked fucking great.

That photo was taken on the stoop in front of Barbara's store. Brad had one of her shirts on, Joey's got her jacket, I wore the hat and the belt. That's it, baby. We got the shot, and then some brain-dead police working at Columbia shrank it down and put clouds behind it—the beginning of my corporate hell.

We raided the closets of the hipoisie. A mad mix of King's Road medieval motley, pimp swagger, Stones gypsy gear and

Carnaby Street kitsch. Janis's Haight-Ashbury scarf-draped bordello exotica (god, I'm getting off just saying this!) and a touch of titillating androgyny for shits and wiggles. Anything startling, garish, glam, and over-the-top: jewelry, earrings, black lace, feathers, metal flake, eyeliner. All the stuff we need to look cool and out there. Whatever it takes to spark that outlandish rock star impudence. Anything that denotes snotty, defiant arrogance and beyond-the-pale chic. *Let your freak flag fly!* And a few Aerosmith tattoos just to underline the outlaw element. Find out where they are, folks!

We were perfect for the dandified Brit look. We weren't pumped . . . on the contrary, we were skinny and weedy, just like the English musicians. Anyway, our outfits paled beside those of the New York Dolls: hot pants, fake leopard skin, black nail polish, panty hose, bouffant hairdos, feather boas, and six-inch platforms.

Most of this band's early career had been spent making fun of me for what I wore—clothes and shoes—and then they'd wind up wearing it themselves. I'd put jewelry on the guys in the band and there would be a comment. Joe has said to me more than once about my style or what I was wearing, "Wow, I love those pants. Do they make 'em for guys?" At first—and for a very long time thereafter—Joe was *aloof*. When I'd point out that this is the stuff Mick, Keith, and Jimmy Page wore, he'd say, "What do I want to look like him for? I'm *me*." I just wanted to be a gypsy. Interestingly enough, whatever Joe's own thing is, your thing, anyone's thing, that's it. That's where the song "Make It" came from.

You know that history just repeats itself Whatchoo just done so has somebody else You know you do, you gotta think the past You got to think of what's it gonna take to make it last

I lifted those lyrics out of the creative ether . . . my inner voice. I live and stand by it. You've got to make up your own shit

out of what's already there. I always figured, "I don't know what I'm doing, but I know I'm doing it!"

I kind of got offended when Madonna came out with her thrift shop chic like she'd invented it. That's the way everyone dressed from 1966 to Woodstock. And then in the eighties, Madonna came out with "Material Girl" and her bangles and stuff and I went, "Yes!" Wow, what a fickle, fuckin' mass media! Because nowadays, everything's recycled. There's nothing new. Everything's in quotation marks. What *wasn't* before? Gypsy Boots, he was the *first* nature boy, living in a tree and dressing like it's 1969.

My dream had come true, but the second I said, "It's so great that we're all living together," Joey moved in with his girlfriend, Nina Lausch, and Joe moved out with Elyssa. Was it my breath? We were a unit, watching the sparks fly, day or night. Didn't they know that some of the best creative shit came in the midnight hour? In my other bands I'd seen how women led to a breakup look at the Beatles—and I didn't want that to happen to us. I pleaded with my *brother*. "Joe! You're Joe *fuckin*' Perry . . . you're the ultimate, the beyond-which-there-is-nothing—when I met you, I knew I'd found my guy. Come on now, man . . . you gotta stay. We gotta write together . . . that's the whole reason I moved to Boston." But to no avail.

I was angry at Elyssa because she stole my boyfriend, my significant other, my partner in crime! It was like losing a brother. So now there was jealousy, this dark undercurrent humming along. I felt that Joe abandoned me—that he cared more about Elyssa than he did about the band. After all these years, it's okay to admit it. I was really hurt that he would rather be with Elyssa than be with me, especially after we started writing songs together. Like I said earlier with "Movin' Out," Joe's sitting on the waterbed and I hear him strumming this thing and I go, "Hold on . . . whoa, what's that?" and a minute later, Joe's riffing and I'm scribbling . . .

STEVEN TYLER

We all live on the edge of town Where we all live there ain't a soul around

And it was in the afternoon, and that song wouldn't have happened unless we'd been living *together*. Writing songs *was* fucking. I took my anger and jealousy and eventually put it into "Sweet Emotion," which I pointed at Elyssa directly...

You talk about things that nobody cares, You're wearing out things that nobody wears Calling my name but I gotta make clear I can't tell ya honey where I'll be in a year

I used my jealousy and anger for lyrical inspiration. Looking back, I'm actually grateful that Joe moved out with Elyssa. It gave me something to sing about, a bittersweet emotion. My relationship with Joe is fraught to say the least. Even in the best of times we sometimes don't speak for months. On tour we're brothers, soul mates, but there's always an underlying tension broken up by moments of ecstasy and periods of pure rage.

Mutual animosity is a necessary part of a band's chemistry. It's all egos in a band, anyway. Would you want to be in a group who were all clones of yourself? Pretty much anyone who wants to be a rock star is by definition a raging narcissist—then just add drugs! It may be one for all and all for one, but each one of us is an egomaniac, we're all in it for gain and glory and showing the world how fucking great we are. It's *me*! And when you have five me's . . .

They say, "As long as you can keep that competition healthy, it's all good, dog. . . ." But just try to be that reasonable when you're eighteen or even twenty-six. The only way this actually works in a positive way is also out of ego, when, say, Joe or Brad comes up with a riff and I think, fuck, that's great, and I want to try and top it by reversing the melody or writing a lyric that will blow everybody away. Joe and I are opposites in many ways . . . and that's what fueled our creativity. So I knew if we were going to run like that, it would inevitably cause a lot of tension. The friction between us started almost immediately—when Aerosmith played their first gig, at Boston's Nipmuc Regional High School, on November 6, 1970. We'd barely gotten through the first number when I began shouting at him. "Turn your fucking amp the fuck down! You don't need to be so fuckin' loud!" I couldn't hear myself singing. I can't sing in the key of the band if I can't hear my voice. I need to hear my voice over the music to know if I'm in tune. Truth is, the energy was so *there* with the band, it didn't matter whether I heard myself or not. That was a private inside joke between me, myself, and I. I came from the club days before monitors and held my finger in my ear so I could hear myself. Like my dad says: "If you have bad ears . . . I sound pretty good."

I've had constant blowups with Joe about how loud his amp is. Remember in *Spinal Tap* when Nigel Tufnel shows the rockumentary director the *11* setting on his amp? Well, my guitar player definitely had his amp turned up to 12! I tuned Joe's guitar for him way back then because his ears were already damaged by the volume. They're still shot. Joe's had tinnitus for years. What he hears most of the time is a high-pitched whine.

You want opposites in a band, that's what makes the big wheel turn and the sparks fly...but when you have such widely differing personalities there are going to be some upsetting exchanges. Joey told me about the time we were on Newbury Street at Intermedia Studio. Joey was on one side of the street and Joe was walking on the other side. Joey crossed the street to be next to Joe and said, "Hey, Joe, how ya doin'? Can I walk with ya?" He was full of that *wow and wonder* of recording our first album and just plain being Joey Kramer, who happens to have the biggest heart in the band. And Joe says, "Yeah, sure." Pause. "So, Joe," Joey asks him, "why can't we be friends?" And Joe doesn't even pause before he fires back, "Why? Just because we're in a band, we gotta be friends?" Which was pretty harsh. Now, Joe

may say today, "Well, I was just fuckin' with him!" Really? Well, there was a lot of wounded silence hanging there as Joey walked away. He never forgot it.

In a group it's always about "who the fuck *you* think I am" because it's all mental, it's all *attitude*. If you're scared of the dark, then the devil's going to come out of that blackness. If you're afraid of the ocean, you're going to feel like something bit you on the toe. That isn't to say that if you're *not* afraid of the ocean, you won't get eaten by a shark.

At the beginning of December 1971 we got booked into the Academy of Music on Fourteenth Street in New York, third on the bill with Humble Pie and Edgar Winter's band. We packed all our gear in a bus and headed down there. We had no bass amps—we borrowed some to get on that stage and play. Steve Paul was the promoter. He managed the Winter Brothers, the two albino blues musicians from Texas, Johnny and Edgar. Johnny had just got out of rehab that night, but at that time Edgar was the bigger Winter. The Academy of Music was the biggest gig we'd had, where I'd seen the Stones some years before.

Right before the Stones came onstage, I could see Keith's boots and the high heels and I knew it was them and I just about fucking wet my pants. I was freaking, the audience was screaming, the lights were down, but you could see those boots. Then, years later, I'm sitting with Keith, shortly after his father died, at Dick Friedman's house (he owns the Charles Hotel on Martha's Vineyard) and we're smoking cigars, discussing life and shit. Talk about surreal, I felt my mind going back to that very Stones show and the image of those boots.

Anyway, I'm backstage at the Academy going, "Oh, my god!" On top of which Steve Paul was considering managing us. I knew Steve from his club, the Scene, on Forty-sixth Street. I played at the Scene with the McCoys, Rick Derringer's band. Derringer

was backstage at the Academy of Music tuning his own guitar by doing a method called "Octaves." You hit an E octave up and you get a harmonic, and when it stops *waving*, then you're in tune. I called the guys over. "Joe, Brad—you gotta see this! It's a way of tuning without me using the harmonica." I'd spent the last two years tuning the guys onstage with an E harmonica in my mouth. I would tune Joe's E string and they'd try and take it from there. Now the guys could tune their own guitars. Bloody hell! Genius. I saw Derringer play live at Klein's department store in Yonkers in like '67 or '68 doing "Hang On Sloopy." He had to have been sixteen years old. I was dazzled to death.

That night we were an opening act. We were meant to play three songs and get off. We did all originals: "Make It," "One Way Street," and "Major Barbara." For whatever reason, on "Major Barbara" Joe and I decided to sit down and play.

We weren't sure of really anything except making an impression and getting our songs right. The audience started chanting, "We want Edgar!" so I butted the songs up so close together; that way the crowd didn't have time to heckle us. We shouldered on and jammed. If we stopped playing for twenty seconds, we'd get a loud "BOOO" from the crowd. It didn't feel good. "Major Barbara," a song we've never released, had gone over quite well no boos, just a couple of shouts. Under that kind of pressure you don't know what you're doing . . . you just go with whatever you have and try not to give a shit, which we did. So we just launched into "Walkin' the Dog."

We could see Steve Paul in the wings getting apoplectic. "Get them off!" But we continued on and finished our set. As we got off the stage, Steve Paul pulled me to the side of the stage and gave me a lobe full. "Don't you *ever* sit down at a show that I book!"

Years later I was out at Steve Paul's house with my first wife, Cyrinda. "I have to tell you something, Steven," he said. "If it hadn't been for that stupid stunt where you and Joe sat down on the stage during 'Major Barbara,' I'd have become your manager."

Joke's on you, Steve! Looking back, it was a ballsy thing to do . . . sitting down. Nowadays, you call that an acoustic set. Unplugged. We just sat down so Joe could play slide on his guitar. It was very ahead of its time. And Joe played a great slide.

The apartment at 1325 was on the second floor, so when we came back from a gig we'd hump all our shit up the stairs. One night as we were unloading, I spotted a small suitcase lying against a telephone pole. I looked around, no one was there, so I snuck it upstairs real quick. Inside was a lot of dirty laundry, an ounce of pot, and eighteen hundred dollars. Wow! I grabbed the pot and the cash and took the suitcase back down and put it back in the spot where I found it. "No one will *ever* think I took it," I told myself. There was no one else around, but obviously someone was going to come looking for this stuff. And they weren't going to think it was the little old lady on the fifth floor who took it. Had to be the guys in Aerosmith unloading their van.

I took the cash, bought an RMI (Rocky Mountain Instruments) keyboard, and took it out on the road. I worked up "Dream On" on it and played it at our next gig. You know, the Sheboo Inn or whatever it was—the Fish Kettle Inn or the Fish Kitten Inn.

Eventually two thuggish guys showed up and demanded the suitcase, the money, and the pot. They had guns. Fuck! What now?! Out of the basement comes our biker super (and first security guy), Gary Cabozzi . . . who was something of a maniac, not to mention HUGE. Toothless, bald, 350 pounds of fucking flaming angry I-talian quivering flesh who would be delighted to kick the shit out of anyone who came near the band for whatever reason, waving a Civil War saber. "I've already called the cops," he says to the thugs. "So get out of here. The cops will be here any minute." And the guys put their guns down and ran . . . never to be seen again.

We were going to follow our quest to the bitter end, but by December of 1971 we were pretty much at the end of our tether and of everything else, too. No money, no food, no gigs, nowhere

107

to rehearse, and nineteen dollars in the bank. I'm always one for taking things to the wall, but occasionally you actually *hit* the wall. We were at a dead end, our last gasp—and then we got an eviction notice. And just at that moment an angel appeared unto us in the form of a well-connected Irish promoter named Frank Connally.

Through a guy who played in a local band, we heard about a rehearsal space at Fenway Theater on Massachusetts Avenue. John O'Toole was the manager there and gave us our first big break when the hard rock group Cactus canceled because of a snowstorm, and we filled in for them. John O'Toole put us in touch with Frank Connally, who had brought the Beatles, Hendrix, and Led Zeppelin to Boston. Frank was connected to the movers and shakers of Boston, and he believed in us in an epic way—in the same way we believed in ourselves. To wit that, as unlikely as it seemed at the time, we would become the greatest rock 'n' roll band in the world. And, as future superstars, he gave us a salary—a hundred a week each.

Frank wanted us to do it all over again. At first I was a little pissed off because I'd spent the last five years playing every club in New York and Long Island. But Frank knew that this new band was going somewhere, so he got us to play this new club in Massachusetts for a month to hone our chops and build a buzz.

Father Frank was a brilliant promoter and a visionary—he understood us—but he didn't have the connections we needed to get a record contract, so he became partners with two guys from New York, David Krebs and Steve Leber, who knew the record business. They managed the New York Dolls, the hippest, most outrageous band around, so we were thrilled—initially, anyway. They would arrange for us to perform at a showcase for the major record companies at Max's Kansas City. They also helped us out of a few jams. Frank died from cancer some years later and the voices inside me said he knew something was going on . . . so he passed us over to Leber and Krebs.

Probably through some other-world connection of Father

Frank's, we occasionally played seedy joints like Scarborough Fair, a Boston bar where you could get shot for saying the wrong thing to the wrong person. One New Year's Eve we were playing a gig there. The place was packed with bikers and local thugs. A great hairy biker chick came up to us and gave the band a nasty arm's-length fuck you. "Hey," I said, "I can see your string hangin'." A gasp went up from the crowd in the bar, and right then I knew we were in serious fucking trouble. She was the girlfriend of the president of the Trampers, a gang of bikers that were too lame to make it into the Hells Angels . . . a "menstrual cycle gang" I called them. The guys in the crew told us that I'd insulted the biker babe's honor and the Trampers were lined up outside and were going to stomp us all to death. I am, I admit, a foul-mouthed individual. None other than Chuck Berry dubbed us "full of soul-and full of filth." I was forced to make a groveling apology to the girl; then we called the cops and got the hell out of there.

We started out doing tours of clubs and colleges around the Northeast in an Olds Delta 88, amply fortified with drugs. Which makes the highway a little hairy. It was just around the beginning of Aerosmith, '71, '72, playing a gig in some godforsaken place, we were on the New Jersey Turnpike and the fucking cops pulled us over. They found some pot in someone's bag in the trunk. I had put a bag of pot down my pants. Brad had two ounces of pot stuffed in his right pocket, Tom had a couple of roaches in a film canister, and my hash coffin—that infamous tiny metal box—had some hash dust and a Nembutal in it. The cops saw us throw the pot out the window of the car.

So off to the police station. We were handcuffed to this bar that ran along a wall that looked like a dance bar. I still have the pot down my pants and am handcuffed to Joe, but I had one free hand. When the cops went to go book us they said, "You know, that's the Aerosmith guy." "Oh, really?" came the echo. We were kind of known, but not that well known. They left us in the hallway, and as soon as there was a moment where no one was around, I took the pot out really quick and threw it across the room. We wound up in Booking. They let us go one at a time. "What's your name? Stand there. Your weight?" And as they were taking a picture I looked up, and *right* on his desk is where the bag of pot had landed. The cop never saw it!

I thought, *that* is it! I went, "Hey, you guys, look!" And they went, "Shut up!" all nervous and shit. That's my band. Beavis and Butthead would have gone, "Heh-heh-heh, that's so fucking cool!" But my band was, "Shut up! You're gonna get us busted!" I think Joey had it down his pants. By some miracle . . . *misplaced evidence* . . . and help from our managers, Leber-Krebs, who got us the heavy-hitting lawyers—we were all slapped with misdemeanors and then released. Back on the road to ruin!

Early tours were very simple affairs. We had the two Joes limousine drivers from Buffalo who drove us around the Midwest—plus a station wagon for the bags. Both drivers were Italian and pretty dumb, but one of them was way dumber. Joe the Dumber won the Golden Sow Award for pulling this girl backstage in Terra Haute; she had a little sailor outfit on, white pleated skirt and the whole bit, a big healthy corn-fed State Fair girl.

One of the best things the band did early on was to use that billboard in Copley Square. Raymond came up with the idea. The billboard had had nothing on it for a while, so we worked out a deal with them to put the Aerosmith wings up. This was after we got the wings redesigned. The first Aerosmith backdrop cloth had the A logo with wings on it, but they look like bat wings, little stubby things.

The deal with the billboard company was that we could put our logo up and then when somebody wanted to come and rent it, fine, they could just cover it over. It was up there for a long time. Anybody that came in or out of Boston saw those wings before they even knew who we were. That was '72, '73. It was above New England Music City. Fenway Park is right there. You go over that little footbridge and you're in the park.

Those were the days. New England Music City was a record

STEVEN TYLER

store; it was about the size of probably the bathroom of a hotel suite. A tiny little corner store. It's probably a Cumberland Farms franchise or a Store 24 now. But that was where you'd go and flip through the records back in the day; you could read all about the bands on the back of the album.

After 1325 Com. Ave. we rented a house at 39 Kent Street in Boston with all these sailors. Back then we were lowlifes who didn't live anywhere and were just barely getting by. We made our first tapes at my friend Rick Smith's house—he's now a manager. Rick had a rich college friend who had tape recorders, so we got a chance to record things like "Walkin' the Dog" and shit like that before we made our first album. And that's where we began to start thinking seriously about making a record and saw that we could. They had a room that was all lined with cork so you could laugh and sing and play late at night, and no one would hear you.

At that time I was hanging out with Buddy Miles. He had this giant silver skull full of cocaine. The night I met the *skull*, David Hull and Charlie Karp (Buddy's guitar and bass player) joined us in the living room, where the drummer told all these wild tales. Buddy had been in a lot of famous bands. He'd played with Duke Ellington, Charlie Parker, Wilson Pickett, Mike Bloomfield's Electric Flag, and had been the drummer in Jimi Hendrix's last group, Band of Gypsys. I asked Buddy questions about what it was like to go on tour. "Where do you stay? What do you do? The girls, do they come to your room? Oh, you go down to the bar and find them there? Oh yeah!" I had never actually gone on tour yet. What we did in the early days was do one-offs. He told us what it was like to be on the road, the perks, so to speak, and I was flabbergasted. It was my first taste of what I wanted.

In my room on Kent Street I created my psychedelic cave. I went to the Army and Navy Store and bought a parachute, a big fucker, it would drape an entire ceiling. Then in the middle where there was a hole, I tacked it up around the light and draped the sides. The parachute was white, so I took four boxes of red dye,

111

put it in the washing machine on hot, and when it came out, it was a nice blood red. Then I strung Christmas lights, tacked them up along the sides, so my room resembled a big tent. I'd open the door and pull the parachute silk up and over. When you went in there, it was like being in the womb. It was like a *red cave*, a safe place . . . and the Christmas lights behind the parachute were on and blinking and you felt *hmm-hmm*. I'd pull the plug for the lights out and go to sleep.

I lived in black orchid oil—that intoxicating aroma. It's now illegal to make it because of how many orchids they have to smush to make the oil. At first I got the orchids from a friend, and then in the seventies I began to grow orchids myself. It has to be really hot and steamy for orchids to thrive, so I always had two vaporizers going in my room. Oh, it was sticky sweet and she's my girl. Everything was wet and dense like the Amazon... the Matto Grosso.

That room inspired my singing and writing because when I went in there, nothing else existed. I guess normal people can do that without creating an Amazonian rain forest in their bedroom. They can go to the library and write their essays and stories, bury their face in a book, they're so into it. But I was pretty much so ADD that I had to live in a psychedelic cocoon. Not that I minded distractions from appliances. If the TV was on when I was studying, I loved it. And all the kids today, every one of them can study with the TV. I look at my daughters Mia and Chelsea and they can cram for finals to Pharrell while applying nail polish at the same time. *Holy multitasking, Batman!* But that orchid-oil drenched parachute cave was for me a really safe, warm womb to work in ... a sanctuary so hot and humid, seeds would sprout in there, spontaneously evoking the demons I danced with to write my lyrics.

Nineteen seventy-two was a much better year for us. We played Max's Kansas City, the legendary New York club, three times that year.

STEVEN TYLER

I spent the hour before the gig looking out the window thinking, My god, what are all those limousines doing out there? And then a mad thought came to me: Oh, my god, John Lennon's here! But of course he wasn't. It was a paper house, which means it was all corporate, all executives. People in the business coming to see us. I didn't know that David Krebs had called up record company executives and stirred up a competitive frenzy. Clive Davis, the president of Columbia, and Ahmet Ertegun, the head of Atlantic, were there to go Monster to Monster. Godzilla vs. Mothra! They all came, so we knew that however well we did, there was going to be some serious bidding... and there was.

I told a couple of jokes, introduced the band, made the audience laugh, and we played our set. I couldn't hear my voice—no monitors—so I had to scream out, "You got the love," over the din of the band. But I'd learned how to do that by playing the clubs in New York all those years. There was Clive Davis clapping enthusiastically after every song. We'd unfortunately run through all our numbers when he shouted, "Encore!"

We finished the set and ran offstage. Frank came running backstage. "Get back up there and play something," he said, and I said, "But we don't know anything else," and he said, "Just do a jam!" And I said, "Okay, we'll do a thing called 'Wit's Tip,'" which was a jam we'd do every night at the end of a set . . . something I could get cute with: "We're Aerosmith, ladies and genitals. We'll be back in fifteen minutes . . . and don't forget to try the beef tips."

Frank goes, "Just tell 'em the name of the song is 'We Don't Want to Fuck You, Lady, We Just Want to Eat Your Sandwiches." The room roared and the band played hot . . . I made up the lyrics as I went along. Clive Davis lost it—he just *lost* it. After the gig he came backstage and said, "You guys were great. You're going to make it big. And you, son," he said, putting his arm around me and looking me straight in the eye, "are gonna be the *biggest* star in America." And then *I* lost it.

Clive inspired me to write the lyrics to "No Surprize."

Nineteen seventy-one, we all heard the starter's gun New York was such a pity, but at Max's Kansas City we won We all shot the shit at the bar With Johnny O'Toole and his scar And then old Clive Davis said he's surely gonna make us a star Just the way you are But with all our style, I could see in his eye That we were going on trial It was no surprize

Aerosmith got signed to Columbia Records in 1972 by Clive Davis for \$125,000. We stayed up all night celebrating, but we knew that just getting a record contract wasn't the be-all and end-all of our career. When we finally woke up and saw what was in it, the smell didn't seem so sweet. The contract said we had to deliver two albums a year—which would be impossible on account of the fact that we were out on the road touring nonstop, fast and furious, to support the singles the radio stations were playing. That's the way you did it.

Frank Connally was smart enough—and rich enough—to know that the band needed to go off by itself and write without the women around. And he obliged me. The motherfucker knew . . . he *knew*. If Joe and I could write songs, we would take the group to a whole other level. And to do that we needed to live in a house together, rent a place for two weeks. Let's go.

First he put us into the Sheraton Manchester, north of Boston, and then in a couple of suites at the Hilton near the airport (where I wrote the lyrics to "Dream On"), and then in a house in Foxboro, where we lived the week before recording the first album. I'd wake up in the morning and say, "Tom, let's go and see if we can play this song." I'd play a few bars of "Dream

On" on the piano and say, "Well, what if . . . Tom plays these notes." I sang them; he played them and it was fucking perfect . . . *perfect.* That's where "Dream On" started to come together. The other guys followed my piano. I said, "Joe, you play what my right hand's doing. Brad you play the left hand." When we did that—hello, synchronicity!

So, the band did go out to Foxboro alone, but . . . there are exceptions to every rule. Joey brought a girl, his girlfriend, and one night says to me, "She wants to *do* you and you can have her." And that was the best Christmas present Joey ever gave me.

We'd been together about two or two and a half years when we got ready to record the first album. We were poised to strike. I had nine years of being a hippie behind me, smoking pot, going to the Village, reading Ouspensky, and wanting to bust out of my own placenta, eggshell, or wherever the fuck I came from.

When I wrote the music to "Seasons of Wither" I grabbed the old acoustic guitar Joey found in the garbage on Beacon Street with no strings. I put four strings on it, which is all it would take because it was so warped, went to the basement, and tried to find the words to match the scat sounds in my head, like automatic writing. The place was a mess, and I moved all the shit aside, put a rug down, popped three Tuinals, snorted some blow, sat down on the floor, tuned the guitar to that tuning, that special tuning that I thought I came up with . . .

Loose-hearted lady, sleepy was she Love for the devil brought her to me Seeds of a thousand drawn to her sin Seasons of Wither holding me in

One of the highlights of my career was being in Greenwich Village with Mark Hudson and coming across a guy sitting on a rag playing a guitar. His feet were black from the streets he'd walked. He looks up at me and starts playing "Seasons of Wither," note for note, exactly as I wrote it. Someone was looking at my painting.

"Mama Kin" was a song I brought with me when I joined Aerosmith. The lick for "Mama Kin" was from an old Bloodwyn Pig song, "See My Way." If Mick can say, "Oh, we got 'Stray Cat Blues' from 'Heroin' on the Velvet Underground's first album," I can cop to a little larceny on our part.

Keep in touch with Mama Kin. Tell her where you've gone and been. Livin' out your fantasy, Sleepin' late and smokin' tea.

"Route 66" was our Stones mantra, a way of finding our groove. It was the riff I asked the band to play again and again in the basement of BU to show them what *tight* playing meant. When I started rehearsing with the jam band, we *jammed* as good as anyone, but to survive the rock 'n' roll world, we'd have to write songs and get under the hood . . . that's why I had Aerosmith play that lick from "Route 66" over and over and over until we were as tight as a midget's fist.

We played it so many times it eventually morphed into the melody for "Somebody" on our first album. "One Way Street" was written at the piano at 1325 with the rhythm and harp coming from "Midnight Rambler." On "Movin' Out," the first song I wrote with Joe, you can hear him quoting Jimi Hendrix's "Voodoo Chile." He quotes the Beatles and the Stones elsewhere on the record. The rhythm of "Write Me" (originally "Bite Me") came from something Joey was playing. But the intro comes from the Beatles "Got to Get You into My Life," because at that point we didn't know how to write hooks.

"Dream On" was the only song I hadn't finished by the fall of '72, so I moved to the Hilton at the airport in Boston while

we were doing sessions at Intermedia Studios for the first album. I just buckled down one night and wrote the rest of the lyrics . . . and I remember reading them back and thinking, "Where did I get that from? It's strange rhymage." I loved Yma Sumac, the Inca Princess with the staggering five-octave voice. "Look in the mirror, the paaaaasst is gounnnnnnh." That's the Yma Sumac vocal swoop. Singers generally don't go from the bridge to the chorus with a bridge note like that, but it worked melodically for me. It's like the Isley Brothers singing "It's Your Thing," where after the solo the first line of the verse is sung an octave higher, then slides down an octave for the next.

I would sing along with Yma Sumac, that eardrum-piercing banshee shriek, beginning in the highest register. She sang these strange, otherworldly songs in movies like *Secret of the Incas* and looked like an over-the-top Hollywood version of an Inca queen. Sam, Dave, and Sumac—an inspirational trinity.

In October 1972 we started work on our first album at Intermedia Sound. It took only a couple of weeks to record because we'd been playing many of the songs—especially the covers—for over a year. Adrian Barber, an English engineer who'd worked with Cream and Vanilla Fudge, produced the album. It was recorded on very primitive equipment—sixteen-track to AGFA two-inch oxide tape.

The band was very uptight. We were so nervous that when the red recording light came on we froze. We were scared shitless. I changed my voice into the Muppet, Kermit the Frog, to sound more like a blues singer. *Kermit Tyler*. I would unscrew the lightbulbs so no one would know we were recording. One of my favorite things to say before we recorded a song was "Play it like you would if no one's looking, guys."They'd be recording and we'd be so nervous, making mistakes and hesitating, and I'd go, "Fuck being nervous! Just play!" We would run through the song live a couple of times and then Adrian would shout. "Yes! It's got fire; it's got the bloody fire!" As soon as we'd cut that first song, "Make It," upon listening to playback, I knew we'd nailed it. I'd done "Sun" at some studio in New York and all that shit. "Sun" was stiff and forced, but I knew that with this band, once we got out of our own way we were going to ace it. And with a great guitar player like Joe in the band, if we stayed true to our *fuck-all*... everything would sound like Aerosmith.

I used an exaggerated black-speak voice on all the tracks except "Dream On." I thought it was really cool. The only problem was, nobody knew it was me. "*Ah say-ng lak dis*" because I didn't like my voice and it was early on and I wanted to *put on* a little. To this day, some people still come up to me and ask, "Who's that singin' on the first album?" I was into James Brown and Sly Stone and just wanted to sound more R&B.

"Dream On" deserved strings, but we couldn't hire an orchestra on the kind of budget we had for our first record, so I used a Mellotron to fill out the sound. It was like an early sampling device employed by the Beatles. I used it to add strings and flutes to "Dream On," while doing lines off my keyboard. I thought the Mellotron would do the trick, coming in on the second verse.

In the end we decided not to use "Major Barbara" and did Rufus Thomas's "Walkin' the Dog" (via Stones) instead, which was tighter than a crab's ass from doing it in the clubs for so many years. On the first ten thousand copies of the album they spelled it "Walkin' the Dig." If you happen to find a copy, it's worth about five thousand dollars. You'd figure with all the cash and power the labels had, they'd learn how to spell. That, coupled with the fact that "Dream On" didn't come out until after the second album, made me think . . . *if things didn't go down, we wouldn't go up*. I believe in life imitating art, but who is art and why is he imitating me anyway?

Of all the songs I wrote on that first album, "One Way Street" has some of my favorite lyrics:

STEVEN TYLER

You got a thousand boys, you say you need 'em You take what's good for you and I'll take my freedom

The original title was "Tits in a Crib." That's what I wanted to call it, but that was forty years ago and things weren't as loose as they are today. I wrote it about this girl I was seeing. I'd talk her into coming over because she was such a trip . . . did me sooo good. She had a baby, and when she came over she'd bring the kid and his crib, saying, "I have no babysitter tonight." She used to fuck me to death in that crib. The line "You got a thousand boys, you say you need 'em" came from where we were living at the time, in Needham, Massachusetts. I'll do anything for a rhyme. I can't think of that girl's name now, but god, she was the skinniest, cutest little trollop.

The style of the first album was raw, filled with relentless attitude. We were a bunch of boys who had never seen the inside of a recording studio. You can practically hear our hearts racing on every track. Barber's atmospheric technique resulted in tracks that were so *open* you could literally *feel* the tracks breathing . . . it was almost transparent.

We knew the road was where we could conquer. Sure it was sex, drugs, and rock 'n' roll, but we wanted to add one more word to the equation . . . *gynormous*. We needed to get to the people, so we did it ourselves. Played every small town and went to every station in the fucking country. Sure it's old school, but it worked.

Aerosmith was all about sex . . . music for hot chicks and horny boys. Loud, bone-rattling rock for chopped and channeled cars and customized Harleys. If you're driving along and you hear "Movin' Out" you're gonna go, "I wanna get the fuck out of here and *dance*!" Roll the window down and let the world in on your little secret. Well, the gist of Aerosmithism is: cars + sex. Booty-shake music. We rocked like a bitch. *Creem*, April 1973, wrote "Aerosmith is as good as coming in your pants at a drive-in at age 12. With your little sister's babysitter calling the action." Okay, at least somebody out there was getting us. We spent the whole of the 1970s on tour. It was just one long endless road trip. We'd stay out on the road for a year and a half. The only time we'd come off the road was to record an album. We went out with everybody: Mott the Hoople, the Mahavishnu Orchestra, the Kinks. We toured the Midwest that debut LP summer in a couple of limos with the two guys from Buffalo and Kelly, our new road manager: Robert "Kelly" Kelleher. Our first real tour was opening for the Mahavishnu Orchestra. John McLaughlin, in his white robes, burning incense. Spreading *his* transcendental six-string scent . . . sweet. We opened for the Kinks in the Northeast and Midwest; Ray Davies called us Harry Smith, after the hair on Kelly's back. We were opening for bands that were our heroes—Ian Hunter from Mott sang like no one else did. Groups that were beginning to fade a bit . . . and whose audiences we wanted.

We used to do out-of-town shows with Mott the Hoople. We'd make up to five hundred bucks a night, with them. To save on getting there, we'd use these bogus DUSA—Discover USA—tickets that were, like, 50 percent off. You were supposed to be a non-American passport-holding tourist to get them, but we found this travel agent who helped us out. Then I'd go up to the counter with an English accent: "Hallo! We'd like to preboard," or whatever the fuck it was. That's how we were able to do that.

Then we'd come home and play every high school in the area and little neighborhood colleges. We'd throw a thousand dollars at the athletic fund, and we'd do everything else. And they'd give us the four walls—meaning we'd make all the money. It soon became a little status thing: "Oh, Aerosmith played at our high school!" And then Wrentham High and then the Xavarian Brothers out in Westwood and everybody wanted to have Aerosmith play at their school and we pretty much did.

We did it at our high school, too, and at BC, Boston College. At the Q Forum at BC, that was when I knew the band had made it, the crowd was so huge and out of control. (Meanwhile,

our Father Frank is in the hockey team dressing room with Father So-and-So, getting him drunk. Oh, those were the days!) Because there were so many people that we were almost afraid to go on, we went into the bathroom with a security guard, Johnny O'Toole, outside the door. The kids were throwing chairs through the bathroom window and climbing in the window! Ripping the back doors off the arena, just blowing the windows out of the place, trying to get into this hockey rink, which they did. So we ran out of there and went down a hallway. Boston College, 1973. There were so many people, a real freak show.

Sometime in '73 this guy Tony Forgione said, "I'm going to open a club"-it was the old Frank and Ike Supermarket where Eric Clapton and Joey Kramer had played years ago-and asked us to headline. Al Jakes was around, and all those goofy guys from Frank Connally's old crew in Framingham. We had Billy Squire and the Sidewinders open for us. The fire department was there and they'd posted a certain capacity. "Here's how we're going to do it," I said. "We're going to fuck 'em up tonight." When you've got that many people coming in, you estimate the crowd by the median between three clickers. We had three different clickers between us. But the count is always jive because someone somewhere is always on the take! When we were doing it, we'd count every third person coming in. We stuffed that club. We opened one night and the fire department closed us down the next night. The club never opened again. And we took all the money! Steamroll.

Elyssa Jerret, who married Joe Perry, remained unbelievably gorgeous. Everyone was in love with her. She'd been Chicago guitarist Joe Jammer's girlfriend, had gone to England, worked as a high-fashion model, had dinner at Jimmy Page's house at Pangbourne on Thames . . . and all that. She felt this patina of über-hipness had rubbed off on her.

On the road, we played "Dream On" every night. I thought that was the song that defined me. But not everyone shared my passion for that ballad. Every time we started to play "Dream Me, six years old, with my sister, Lynda, and cousin Laura at Dewey Beach. I look like my son, Taj.

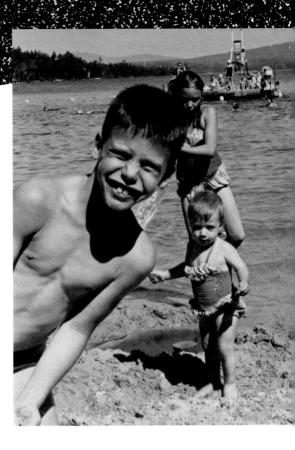

Trow-Rico Lodge and the lawn I was mowing when Joe Perry drove up, summer of '69.

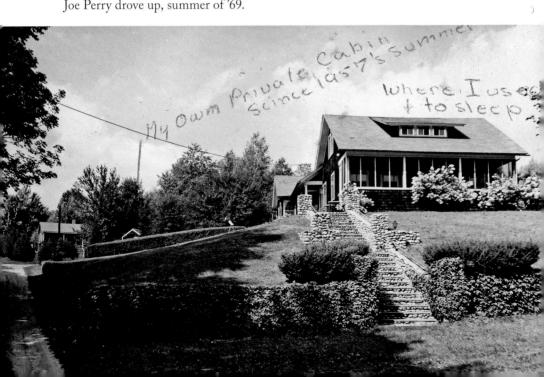

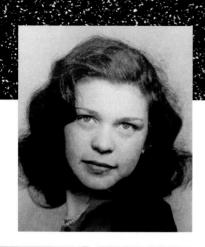

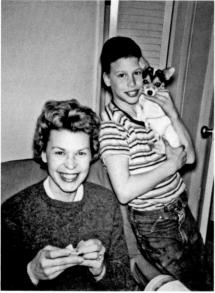

TOP LEFT: My mother, Susan Rey Blancha, at eighteen in 1932.

тор віднт: My father, Victor Tallarico, 1956.

ABOVE: Happy days—Mom and me and Crickett, my Toy Fox Terrier, 1954.

RIGHT: Me and Dad, 1958. It *did* snow more back then.

TALLARICO BROTHERS QUARTETTE

PASQUALE

FRANCESCO

MICHELE GIOVANNI

New York, September, 1902.

To Music Lovers.

AS LEOPOLD MOZART in the year 1762, took his children, the little Wolfang and his sister, on a tour through Europe to show people these wonders of God, with a like feeling SIGNOR GIOVANNI TALLARICO has come to New York to show music lovers his two talented brothers, PASQUALE and FRANCESCO. SIGNOR GIOVANNI TALLARICO has been, for the past two years, a Mando-in, Guitar and Banjo teacher in the Kimball School of Music at Waterbury, Conn. During this time he has devoted all his money and spare time to the education of his two little brothers, who have now achieved great merit as mu-sicians. The youngest is PASUTALE, her years of same PLAYERT the other is France.

Scilans. The youngest is PASQUALE, ten years of age, PIANIST; the other is FRAN-CISCO, fourteen years, MANDOLINST. The attention of music lovers is called to them, not because of their youthful age, but because of the proficiency they have attained in so short a time. Both have seemed, since their infancy, to pos-sess a natural disposition for music, and being fatherless, Signor Tallarioo had them come over to America, two years age, to get here a musical education at his expense. Thus both boys commenced to study music the 25th of October, 1990, and although two years have not yet elapsed, they have completed the course of Harmony, and are now able to play at sight, any music. Everybody who heard them play has been amazed to see how they had reached such a pro-ficiency in so short a time. A glance at the press notices and specimen pro-ficiency in so so hort a time. A glance at the press notices and specimen pro-ficiency in so short a time, and how York because it is the place where one can get a complete musical education, and he hoyes, whilt the money he may get, to be able to help his brothers in their musical career, and without doubt, these two boys, by studying as they are doing daily, will become shortly, artists of no small reputation.

ABOVE: At twelve, my first band . . . me, Ignacio, and Dennis Dunn.

TOP LEFT: 1961—we all gotta start somewhere. . . .

LEFT: Where it all began . . . or, why I must love to tour.

TOP LEFT: My cabin where Dad threw apples at me to wake me up.

ABOVE: Me and Ray Tabano, aka Rayzan the Apeman, around the time we played "I've Had It" at his father's bar, 1960.

RIGHT: Lynda, 1967. Vargas, look out. . . .

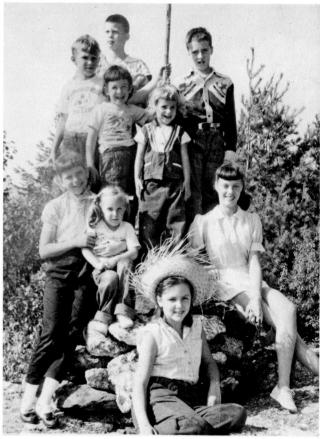

LEFT: Summer of 1954 at Trow-Rico. I'm at the top on the left, Lynda is in the straw hat, and Sylvia Fortune, my first girlfriend, is on the right with her legs crossed. I was infatuated with her. . . .

BELOW: Dad at the Cardinal Spellman High School graduation in the Bronx, 1965.

ABOVE: Debbie Benson, 1968. O, how I loved her. . . . RIP.

BELOW: Busted for smoking pot imagine that. I'd be nineteen in eleven days.

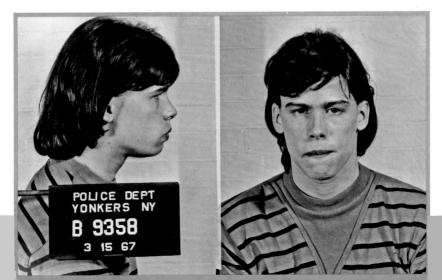

ABOVE: The Chain: me, Don Solomon, and Frankie Ray, 1968.

LEFT: The Chain Reaction opening up for The Byrds in 1967 at County Court, Yonkers, White Plains, New York. Me, Alan Stohmayer, and Peter Stahl. (Not pictured: Barry Shapiro and Don Solomon.) RIGHT: My life four years before Aerosmith . . . with The Strangers.

BOTTOM: At Barbara Brown's store with Joe Perry. . . . I brought the band here for clothes for the first album in 1972.

::

: :

: :

:::

: : :

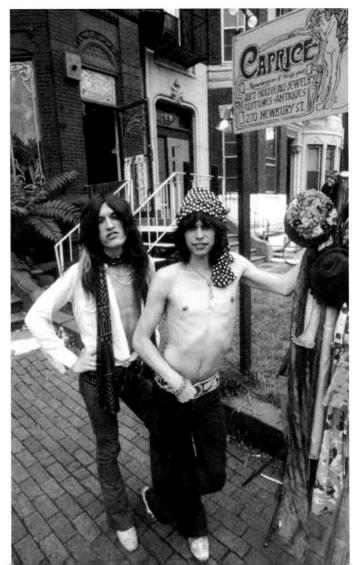

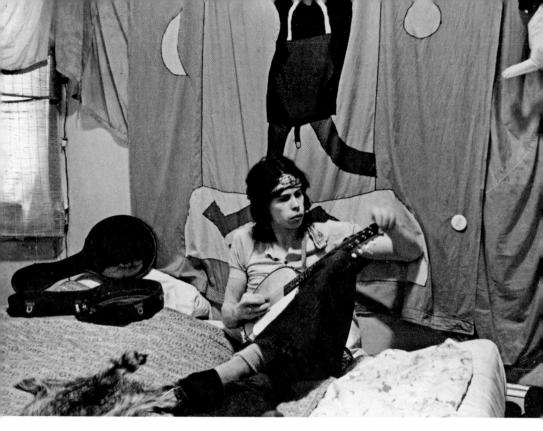

My room at Kent Street in Brookline, Massachusetts, 1971, with my red parachute and our original backdrop that I stole from Woodstock. It was the original Shroud of Tourin'.

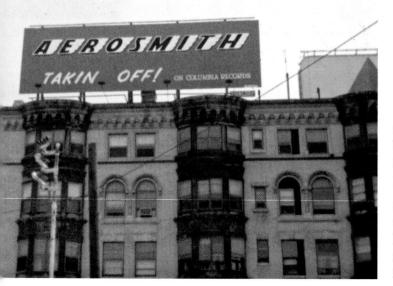

LEFT: Our first billboard, Kenmore Square, Boston, 1972.

RIGHT: Our first tour book.... I put this together from this show in 1972.

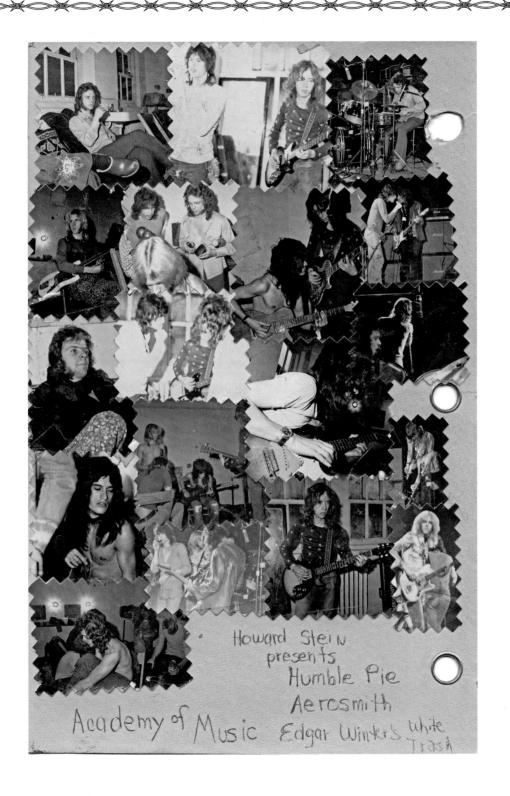

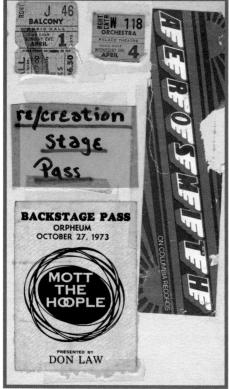

ST

C

TOP LEFT: We stickered every tollbooth from Boston to NYC to L.A. with our first Aerosmith sticker, 1973.

TOP RIGHT: In the head on a jet going to England. I guess life's a pisser when you're a-peein', 1975.

RIGHT: Tom, 1974... so I could hold him hostage. Not anymore...

TOP: Me at the Record Plant recording our second album, 1973.

ABOVE: Mark Lehman, our first tour manager, 1972. Joe and I wrote "Movin' Out" on his water bed.

RIGHT: First song Joe and I wrote. . . . My dad transposed it, 1971.

MOVIN' OUT

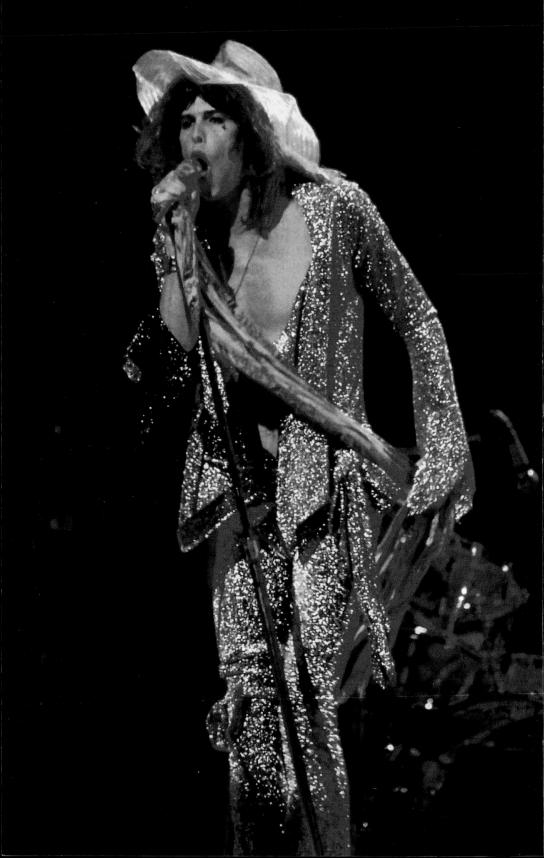

LEFT: Glitter Queen, 1972. (Outfit was designed by me and Francine Larness. I love you, girl!)

RIGHT: Back in the saddle, getting my rocks off on tour for *Rocks*, 1976.

BELOW: Me in the macramé shirt I wore until it rotted off and I hung it from my mic stand, 1972.

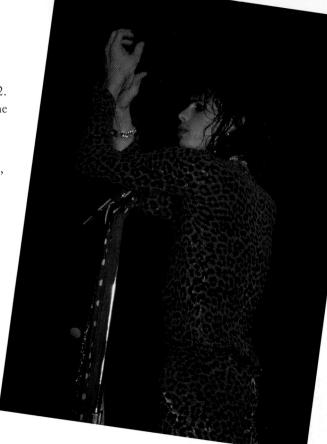

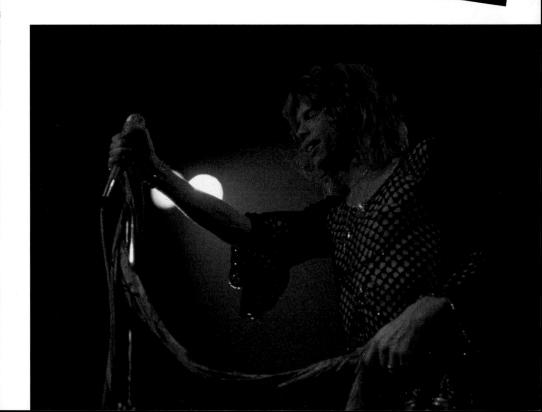

Me and Rick Derringer backstage at the Academy of Music, 1973. "Hang on, Sloopy."

Me and Mom, 1976.

Me and John Belushi, 1975, at Studio 54.

How we won the war by reaching out, 1976.

On," Elyssa would roll her eyes and go, "Oh, fuck! Not *this* song again! God! Let's go snort some blow!" She'd make sure I saw her. And all the guys in the crew followed her into the bathroom. While she was cutting up lines, it cut me to the core—it broke my heart. It was the song that hurled us to wherever we are today and beyond. Born somewhere between the red parachute and my dad's piano, that song took this band to places where we could only dream on.

Back in the early days before we'd had a hit on the radio, we made our reputation playing live and loud. As an opening act we'd only get to play three or four songs, so if we wanted to strut our stuff, slow songs weren't what we'd play. You do the hard and heavy down and dirty to get your ya-yas out. Joe didn't like "Dream On" from the start, didn't like the way he played. He felt we were a hard rock band, and here we were staking our reputation on a slow ballad. And to Joe, rock 'n' roll was all about energy and flash. When it was first released in 1973, "Dream On" only made it to 59 in the Hot 100 charts. But, you know, the song got bigger and bigger and I got my "*taa-daa!*" moment. When it got rereleased in 1975, it went to number 6 in the charts. I got a Grammy for it, but I would gladly have traded any gold album just to have my brother love that song. Wait a minute, I take that back!

The concerts were getting more rowdy and outrageous. We opened on August 10, 1973, for Sha Na Na at Suffolk Downs racetrack near Boston. Thirty-five thousand kids showed up and got so rowdy they had to stop the show. Awright! Now that was more like it.

Aerosmith had been big in Detroit from the beginning. We had a loud, flashy, gritty, metallic vibe. *Rolling Stone* called us greasers, "Wrench Rock," which was strange because we looked more like medieval troubadours. We were hardly grease monkeys—mechanics of ecstasy, maybe. But they did love us in the rust belt towns: Toledo, Cincinnati, Cleveland, Detroit. The only part of us that was heavy metal was the clang of steel... the body

shop, assembly-line, car-based clamor. We're a people's band. Judy Carne—the English comic who starred in the iconic TV show *Laugh-In* and dated Joe for a stint in the early seventies thought we were the voice of the mills and the malls. And those working-class towns were the places that embraced us early on.

We had to get out there, however we could, to the fans. We knew that the energy we had was contagious, that we would infect the whole colony. Evidence that we were getting through came when we started pulling Mott the Hoople's audience. Kids started jumping over the barriers, climbing onstage, and grabbing at us. Detroit was the turning point for us. We played Cobo Hall three times in '75. After that, we exploded. There's a ton of bands out there competing for the hearts, minds, and bucks of the sacred rock fan, but Aerosmith has managed, for better or worse, to get to the ear (and various other organs) of a lot of them.

Still, our core audience was always the Blue Army—the hard-core kids from the Midwest. They were the Blue Army because they all wore denim jeans; the place was a sea of blue. Just like when you go see Jimmy Buffett and his Parrothead contingent . . . look out, it's Q-Tip Nation. Everyone's fucking gray and they love it. And we all got to ride that Aerosmith train to the outer reaches.

Our interest was the same as the kids': rocking out, getting them off . . . getting *us* off! Like I always inquire, "Was it as good for you as it was for me?" Inspires a quick verse . . .

Was it as good for you as it was for me? That smile upon your face makes it plain to see What I got, uhuh, what you got, oo-wee So was it as good for you as it was for me?

CHAPTER FIVE

CONFESSIONS OF A RHYME-A-HOLIC

hen I was in my late teens, seventeen or eighteen, I used to come home from onenight stands with local New Hampshire bands like Click Horning and Twitty and Smitty and crash at Trow-Rico, fuckedup on trashy skunk New England weed. I began to write a song on an old Este pump organ about alienation. The ancient Vic-

torian instrument, made in Vermont in 1863, lived in the studio where my dad practiced piano four hours a day. In order to play on the pump organ, I'd have to sneak time

In order to play on the pump organ, Id have to sneak time during the day while the guests were swimming at Dewey Beach. The song started with a melody in my right hand that rocked back and forth hypnotically, out of the ether. That was "Dream On."

I began it in F-minor with a C, C-sharp dischord. That gave it a haunting, Edgar Allen Poe kind of feel. I wrote much of the body of the song in Sunapee, where I knew I had something. The verses were composed at the Logan Hilton when we were working on our first album. I've always said it's about hunger, desire, ambition—a song to give to myself. Something about it was nostalgic and familiar, as if it'd been written by someone else years before (but if no one has, then you know you're into something), or perhaps like I had written it years later and was looking back on all the things that have happened to me over the last four decades. "Pink," off *Nine Lives*, felt that way, like it was somebody else's. However interpreted, my primordial thought was that maybe I wasn't put here on earth just to mow lawns.

Every time that I look in the mirror All these lines in my face gettin' clearer The past is gone . . .

Stream of consciousness mixed with the Grimm's fairy tales my mother read to me from the crib till I had to read them to myself.

Sing with me, sing for the years Sing for the laughter and sing for the tears Sing with me, if it's just for today Maybe tomorrow the good Lord will take you away

The lyics to "Dream On" came in a thought . . . and my train of thought stops at every station.

By pure crazy chance last summer I found the very organ on which I'd written "Dream On," in a house on the lake road near where I live. That road has become for me a kind of metaphor for my life. Beginning in the woods near my house, I remember the days I'd be up in Sunapee at the start of winter, really scared in the dark and not knowing what to do with my life. Then farther on, the road winds down to the harbor where Joe and I used to hang.

The road forms a loop, a three-mile jog that meanders past houses quaint and grand, beside grassy green fields, up and down

125

grades. I would make the trek every morning for two months to prime myself for any upcoming tour. Nobody would ever guess that I get the breath to sing "Don't Want to Miss a Thing" in fucking Russia from running this friggin' loop. If I could make it up Heartbreak Hill down into the harbor and back up to the house still in one heart-pumping, breathless piece, I'd be ready for the campaign. Sometimes I'd run right off the end of the dock into the water, anointed by the waters of Mother Nature, baptized by freezing Lake Sunapee.

In live performance, before I go and sing that high note in "Dream On," I do a little hyperventilating. I look down (like this—use your imagination) and I breathe in and out, in and out, rapidly . . . then I go, "*yeaahhh*," and I hold my breath where anyone else if they were underwater would be going, "I gotta come up for air!" I learned how to go past that in part by making those treks around the lake . . . for the sake of holding the note.

Over the last ten years, as the condition of my feet has deteriorated from stomping stages since the seventies, the loop has become more and more challenging, but more on the wounded rock warrior later.

One night, during a nonaerobic stroll on the loop, I passed a house that was glistening with a flickering flame inside. The house was called "Witch Way." Outside there were gargoyles and mannequins and twisty limbs from trees. I'd seen this house many times before, and every time I went past it I'd go, "I'd love to meet the person who lives there." I'd stop out front and yell, "Hello, I love you in there!"

This time I shouted a little louder, and a sweet middleaged couple, Sherry and Philip, invited me in. Philip's a contractor; Sherry is a sculptor. Amazing bizarre stuff she's made is all over the house. "Oh, my god," I say, "can I look around?" A sculpture made out of a cello, another one—I can barely describe it—made out of gourds. And dried sunflowers. It looked like *The Wizard of Oz*. Meanwhile, on a huge flat-screen TV, *America's Got Talent* is on the tube. Twenty girls that any guy would love to do.

In the front room, there's an old organ, just like the one on which I'd written "Dream On." I began playing and I felt like I was levitating. The organ felt very familiar. I was transported back to Trow-Rico all those years ago when I grabbed a few chords out of the air. Turns out, it was an Este pump organ made in Vermont in 1863—the exact type we had up at Trow-Rico.

"Where did you get this?" I asked.

"There was an old antiques store down at the harbor right across from the community store and the organ was sitting out on the porch," she explained.

So they'd bought it in the eighties, which would have been about the time my dad sold Trow-Rico. Talk about serendipity! I'm called by my muse into a house that I'd never been inside, and there's my old friend, the "Dream On" pump organ. Was it possible? I sat down, laid my hands upon the keys, and pulled out all the F-stops as I did thirty-five years ago. As I started pumping the organ, I could feel her start to breathe. We made musical love right then and there.

Sherry said she bought the organ at an auction in Sunapee the fall after my parents sold Trow-Rico and that it's most likely the same organ. "I think the organ has a poltergeist in it that's somehow attached to the crystal vase," she told us. "I'd always kept this little crystal vase on top of the organ, but after we moved I decided to put it on the bookshelf. One night I was sitting on the floor drawing when this vase came off the shelf and hit me in the back, you know, but since I put it back on the organ, it hasn't done it in nine years."

I made Sherry promise me that if she ever sells that organ, she'll let me make the first offer. It's the shit. It really truly is a pump organ with all the stops. A strange thing about antiques they had another life before we get introduced to them. It's like an ancient string of beads that you might find in Mesopotamia.

127

You don't know who they could have belonged to. They tell you only "These are beads from the ancient lands, found in the ruins." Or they were found in a barnacle-encrusted chest off the coast of the Holy Land. Did they once hang around Mary Magdalene's neck?

When a song comes to you and you write it in ten minutes, you think, *There it is. Dropped in our laps like a stork dropping a baby. It was always there. The song. On the inside*... I just had to get rid of the placental crap that was around it. Because at the end of the day, who really wrote that? If Dylan were here, he would tell you in his laid-back Bobness, "Well, now where would it come from?" Out of the blue, lines come to you...

You think you're in love like it's a real sure thing But every time you fall, you get your ass in a sling You say you're in love, but now it's "Oooh, baby, please," 'Cause fallin' in love is so hard on the knees

You see it floating there and say, "This should be caught." It's like those Native American dream catchers. I look at those and go, "Oh, my god, that's my fuckin' brain!" I would see something or hear Joe playing, I'd yell, "*Whoa, whoa!* What was *that*?" Or a passage in a Beach Boys song where they go to the bridge and I'll hear an entire song in there.

When I was a kid, my mom would read me all these stories and poems, Dickens and Tennyson and Emily Dickinson. That's where I got my rhyming from. I'm a rhyme-a-holic. It made me curious in life to wonder why, when you look out the back window of your car and you stop for a red light, the world seems to be coming back at you. Everything you pass catches up to you; poems from the past can turn into songs in the present through curiosity and imagination.

But it catches up to you, like when I had dreams about flying or floating up to the ceiling and then out the window and over a city. I'd have a piece of wood, be on a hill, slap it to my chest, and I'd catch winds like a sled does snow and start lifting up and I'd fall and roll down the hill and I'd grab it again and catch the winds and be afraid I'd fall down again and get back up and those winds would blow me out to sea. I'd go so high and find myself in a tree. And I'd wake up going, "Are there cars that levitate?" I'd feel that sensation in my chest like when you fall. The stories inspired the dreams, so thank you, Mom, for the stories.

I was twizzling the little skull I have twined in my braid and went, *hmmm*, *hmmm*. I started off with something that everyone's familiar with, like a line from "Dream On."

Every time I look in the mirror All these lines on my face getting clearer Sing with me, sing for the ye-ears.

I'll grab a little of that and throw it in like yeast. It's 2010, and if I was to connect the dots from "Dream On" till now, I would say:

All the lines on my face as I sang for the years was the skull in my braid barely down to my ears? I could deal with the screamin', you know how that goes when the skull in my braid hung down to my nose.

And you get the rhythm going and in no time at all it's writing itself.

I'll have had me a pint and be hanging with Keith when the skull in my braid's grown down to my teeth.

If I'm not on tour, well, you'll know where I've been when the skull in my braid's grown down to my chin.

When the agents and labels get round to a check, that old skull on my braid will be down to my neck. And I'll take that old check and I'll rip it to bits by the time my old skull has grown down to my tits.

With my girl in the sun and I'll maybe get faced when the skull in my braid's grown down to my waist. I'll be rippin' it up with a mouth full of sass when the skull in my braid's lookin' down at my ass.

And life'll be good and life will be sweet if that skull in my braid makes it down to my feet. It's been second to none, that no life can compare, when that skull in my braid gets cut out of my hair.

Yesterday and today I was thinking about the timelines between the verse and the curse (chorus) and how it all works together. There are four elements to writing a song, or as they say in comic book land . . . the *Fantastic Four*. If you break it down, there's melody, words, chords, and rhythm—put those down in any order and you've got something you can play to piss your parents off.

When I was married, I used to think of myself in the third person. I would say to my wife, "Well, I can't believe you're married to this guy in a band," you know. "How could you *do* that?" Then a couple of years ago my daughter Liv called me up and said she was marrying Royston, another guy in a band. There it was again, like a shadow, you know.

My ex-wife called me last night and I thought, *Well, you know what? I love her*, and she's picking up my son and I'm thinking about my girlfriend Erin and the girlfriends I've had in life, where I've been, two divorces and stuff. All fodder for the

passionate pen. If you have a child with a woman you'll understand that when you write a song with somebody it's like having a child with them. You're birthing, you're evoking the spirits of a moment in time, specific moments, seconds, so for better or worse I'd come up with a scat. Trying to make sense of it all.... First it's *"Hey, jaded!"* which later on in a magic moment turns into *"Hey, ja-ja-jaded,"* which puts it in a very rhythmic meter with a four-four time signature. It's a picture of my temperament set to music.

Once you have a melody, that's your hat rack, a hat rack that can hold many hats—the hats are the words you throw on top of it. Or you can *scat* and by scatting, summon up lyrics. Once you have lyrics, you can let the words come up with melody. Those lines "*back when Cain was able way before the stable*" from "Adam's Apple," you know where those came out of? Scatting.

I would listen back, along with the rough of the song, and I would *hear* lyrics. Every time. Tapped right into my own subcontinent. It would jump right out at me from the scat. I could play you scats and if you listened close enough, you would hear the lyrics that I wrote. Not unlike psychoacoustics. If two people are playing, you hear things in the middle. If two notes are played or people are singing . . . there is a tone on the *in-between*. *Hamonics-slash-psychoacoustics-slash-vibe*. The scat *kink* became *Pink*. The scat to the Beatles' classic "Yesterday" was *scrambled eggs*. Fucking magic.

You take off from there. . . . You don't know what you're singing or what chord it is. It's all done as if you're in the middle of a desert with two long poles and a lot of little sticks. The people from the town come out and they're wondering how you got up there, how you climbed up the palm tree on the rungs of your own voice and the lyrics you wrote. "Oh, my god, look at that! He's singing! How'd he get up there?" You build a ladder. A song is a kind of ladder, too, but that you've got to build without little sticks. Never mind the melody, never mind the chords—no, no, no. You start with infatuation, obsession, passion, anger, zeal, craze, then take a handful of notes, sew them into a chord structure, create a melody over that, and then come up with words that fit it perfectly. "Oh, my god, what *is* that? He's up there singing and he climbed up on air, on his vocal chords." Well, yeah, I got up there on my own nasty scat... *O-uh-OH-EEE-uh-ee-yeehn! O-uh-OH-EEE-uh-ee-yeehn!* It's a deep-dish apple pie, baby.

You know right away if a song has that magic. It has to have those extremes—the one thing it can't be is *okay*. Okay is death. Okay is a jingle or a ring tone—not even that! You look at the person you're writing with and say to yourself, *God*, *this is gonna be either great or suck*. *Dare ya!* Those are the only two possible choices you got! There are a lot of musicians that are schooled and learned and playing piano in the bar at the Four Seasons or Days Inn, and they're *really good*. Their problem is they never learned how to be really *bad*. See, when I go and sing a song with an artist like Pink, I say, "Oh, man, I can fuck that song up *good*." It's a figure of speech for me . . . kinda my mantra. Because that's what *I do*. I know I'm going to *rip* it a new asshole and I'm going to take it big into the passionate pool. That's what I know how to do.

Tom Hamilton (bless his fat strings and good heart) wasn't sitting in a room with the insight and forethought of going, "Fuck! WHO wrote those Kinks albums?" I had that thought because I knew that they—*he*—Ray fucking Davies—wrote those records. Where did the invention come from, the flash from wherever to write a song and get together a bunch of guys to just start playing and maybe make a mistake and take that mistake, save it, and turn it into something you're proud of? Own your mistakes! Write something, sing something—as bad or good as it is—that no one has come up with. I sat with Joe and went, "OH, MY GOD"; we wrote a song after that riff he was playing and I jumped on it and it naturally became "Movin' Out." And that's how "Dream On" came to me . . . natural. The voice inside never stops asking, *What am I gonna sing about?* Questions upon ques-

tions. *Why* has Janie got a gun? What's my first verse? What's the third verse? What's the chorus and the prechorus gonna sound like? How will the end go?

What did her daddy do? It's Janie's last IOU She's gonna take him down easy and put a bullet in his head

Oh, my god! Now's she's done it! *Now it makes sense from the beginning*. Sometimes I think I've given more forethought to *that* than to getting married, having kids, getting a driver's license, going to school, college. It transcends the Everything because it *is* the Everything.

Songs are never in plain sight, they're under your skin; if anything, the best are peripheral and then they pop out like a baby. Did I want to get that song out with its head crowning out of the vagina of the music? YES! And in some cases, like "Jaded," those breech-birth songbabies caused so big a disruption in my life that I endangered my marriage, squandered the time I should have spent with my children, just to get that song out.

CHAPTER SIX

LITTLE BO PEEP, THE GLITTER QUEEN, AND THE GIRL IN THE YELLOW CORVETTE

id women get backstage and offer themselves to us on our altar of lust? Take off their clothes, do tricks, satisfy our aching needs? Not in the beginning. Stuff like that doesn't happen on a regular basis until you become really, really famous. But still, were there ass-shakin' trollops in the audience who defined our existence and made our minds go into Glory Hallelujah mode? Absafuckinlootley! Hell, that's what it's all about!

Now, I'm not saying these girls didn't come backstage after performances—of course they did. Isn't that why they showed up to begin with? Music was one thing, but *my* thing was the other. I'd run back and get Kelly... "Kelly—the girl with the red dress in the front row have her shaved and oiled and brought to my tent!" And she'd be there. As dirty as my mind is, my body's pretty clean. Kelly always made sure the girls were in the shower when I got in the room. I liked my pulchritude pristine! I can't kiss a girl that's been stage diving with five hundred other guys. I'm very oral and I like clean. Back then, sure, you could've gotten gonorrhea, but with one shot of penicillin . . . see ya. Unlike today, STDs were a dime store a dozen in those days. How do you avoid 'em? Screw 'em through Saran Wrap? Nah, if they washed, they were clean. As someone once said, "You ain't seen nuthin' till you're down on a muffin"—and I'm no different.

After we became more famous, girls began coming backstage without having to be coaxed. Soon they started getting inventive, printing their own backstage passes for the price of a little backstage ass!

But early on, there were no girls doing backflips, no limos, no private jets—just the occasional girlfriend of a band member who acted like the only thing they ever blew out was their hair. Of course, there were other pleasures of the road. Like . . . the girl in the yellow Corvette.

Rewind to the summer of 1972 when we used to drive to our gigs in this truck that Mark Lehman owned, our original roadie and road manager all wrapped up in one. These days it's probably moldering in the woods with vines growing through it. Anyway, that's how we got to the gigs in the early days. And who wants to ride in a fucking van with the guys in the band? Sure, it's okay to ride together when you're on your way from Connecticut to New York to do a show. That's a mere two hours, you're all in the van together, and you're psyched. You're getting buzzed from breathing in the "eau de low tide" of the night before mixed with the sweet smell of sensimilla, stale cigarettes, and flat beer. To this day, it's an aphrodisiac like no other to me. But the long, endless road trips in that van with guys farting, telling lame jokes, pissing in pop bottles . . . that was murder. Somewhere in the grain belt between Indianapolis down to who knows where, I fell asleep on the top of the amps in the back of the van with my head staring out the window and my mind on Mars. I woke as the wheels rolled over half a deer that'd been sliced in two the night before by a semi. We were doing fifty-five in our International Harvester truck, christened the Good Ship Aerosmith, when I spied something yellow—it looked like a giant sour lemon drop—moving in retrograde in the next lane. My curiosity was instantly tweaked. I shouted to the driver, "Mark, slow down, and let that car we just passed catch up to us!"

Suddenly, I'm staring at a yellow Corvette bearing a blonde with gigantic orbs and a smile from heaven. I crawled up over the top of the amps like an infantryman on the beach at Iwo Jima and landed on Joe's lap in the front seat. Joe goes, "What the fuck are you doing, Tyler?" "I'm just lookin' for a kiss," I say. "You ain't gettin' that from me," said Joe. "That's not what you said last night," I quipped. You can't ever really get back at a guitar player. They'll just crank their amp up to a million and drown you out.

She worked at the motel we'd stayed at the night before and was out on the highway doing a bit of her own randy reconnaissance. You can't always get what you want, but she knew if she tried hard enough she could get her heart's desire—and that was lucky me! She took me to a room and fucked my brains out. It was like three in the morning and she rolls over and caresses my back. What, *again*? Oh, baby, I thought, but what I said was "You know what? I could do this all night *and* the next day but I gotta get up really early to catch this goddamn flight."

"Well we can take my Corvette," she says. "And tell ya what ... I'll sit on your lap and grind you till the middle of next week or you can ride my face all the way to Chicago or wherever the hell we're going!" It didn't matter. Time becomes meaningless in the face of creativity. Was I dreaming? Or the luckiest guy on earth? "That sounds okay to me," I said with all the casualness I could muster.

"But first," she says, "I gotta go back home for a few minutes to put out some feed for the horses." Oh yeah, I'm not in New York anymore. I end up back at her house, riding horses bareback all night, naked. Right out of a storybook. Is this really happening? Am I dreaming, or am I being dreamed? Around 5:00 A.M., she says, "Put your clothes on, we're going. What the hell, I wanted to see the show anyway." If this ain't something I already put in a song, it sure as hell's gonna be.

Well, the next gig was in Davenport, Iowa, and damned if we didn't drive that little Corvette all the way. Four beautiful hours, with mysterious fields of corn flashing by, rusty old gas stations, grain elevators, clapboard churches—and the sun's coming up.

Two months later, she's still on tour with me. The guys in the band, of course, are royally pissed. Why wouldn't they be? They're up there reading their in-flight magazines, drooling stewardess dreams, while I'm out there getting my kicks on Route 66. I swear to god—or General Motors—I never traveled so sweetly ... to this day.

I only wish we were on the radio right now, or on *Oprab.* I would say, "If you're out there, please call this number. I want to know how you are, what you're doing, and what you look like now!" Of course, sometimes you don't wanna know. You'd rather remember them the way they were—the way we all were.

Later on, when fame comes, things change. We're in all the pop magazines and gossip columns, we're fuckin celebrities, and we've got an impressive entourage of haute coke dealers and purveyors of other things for the discerning drug addict. Everybody wants to be my baby, everyone wants to kiss my ass.

"But isn't that what you always wanted, Steven?" my guardian angel in a pink bustier asks. Hell yeah, baby. Whatever you say.

But Fame is a bitch. You've probably heard that somewhere, but only because it's goddamn true. It's a riderless horse, it's a two-headed dog sniffing its own butt, a one-eyed cat peeking in a seafood store. And . . . it's the absolute greatest generator

137

of creative fiction there is. You make it up, then *they* make it up. And as soon as you get well known enough for people to want to make stuff up about you, they will. It's not up to you anymore; the demon is on the loose. Everybody you work with, buy a car from, hire as a babysitter; everyone who fixes your computer. Each becomes, overnight, a writer of short stories, a chronicler of mouth-watering scandal.

Remember who we're talking about! Famous people. Why, they're capable of almost anything you can imagine. They're degenerate, ruthless, heartless, and disgusting, so pile it on. Anyone who's worked for Paul McCartney, believe me, has a story to tell.

"I saw Macca massaging her stump!" "Get out!" "No, really!"

Of course, that's all we ever wanted: to be famed and acclaimed, but be careful what you wish for, because fame is the bitch goddess of rumor, innuendo, slander, and gossip and the perverted purveyor of tabloid trash. She'll say anything to anyone anywhere. "Pssst! Wanna hear some real hot stories about Steven Whatsisname? *How he got there* and what he did to whom when he got there. It'll make your hair stand on end—and that's not all that'll stand on end, baby. Wanna see some Paris Hilton–type sex tapes? Wanna hear some nasty shit secretly recorded by his babysitter—I swear!" Oh, yeah . . . that shit goes on. Tapes of the babysitter overhearing every private conversation you ever had with your children, band mates, accountants, ex-wives, even your fucking proctologist. In the end, even the babysitter's story makes you look like an asshole.

Once you become a rock star—something you've prayed for fervently since you were sixteen, making promises to sleazy saints and strange goddesses of the night—all bets are off.

After you're famous, it's all simple and brutal: you're either loved across the board for things you *did* do . . . or sneered at for things you *didn't* do—or vice versa. Either way, you become a dartboard for other people's fears, doubts, and insecurities, and right there in the bull's-eye are the two terrible tabloid twins: sex and drugs. Now, of course, the good stories—we claim proud ownership of those. As for all the rest, well, we don't read our own press . . . wink wink. But that's horseshit. One way or another we eventually get to hear all the news that'll blow a fuse. If we don't read it, we're sure to hear it from girlfriends, mothers, fathers—or our best friends. Then there's the occasional "Tyler's in Room 221" written in smoky letters across the sky by a stunt pilot who found that we were staying at the Four Seasons in Maui, who got his info from the concierge who got it from the bellboy who got a phone call from the airline steward who sent the call the second he saw your ugly face getting off the plane. "LEND THE FAM-ILY PARROT TO THE TOWN CRIER!"

No matter what you do, there's someone putting together a little bag of anecdotes in which you're prominently featured doing nasty stuff. If I get gas down at the corner, the woman who pumps my gas is going to be telling all her friends the next day. And the story will grow: not only do I get my gas there *all* the time, but I get my car serviced there, and, as matter of fact, I had dinner over at her house the night before and watched *American Idol* with her and made popcorn. And if she happens to be goodlooking and your wife finds out, then you've automatically had an affair with this girl. That Stevie! The kind of things he asks you to do!

So, go on, make it up! By now Steven Tyler is pretty much a fictional character anyway—I have absolutely no control over the little fuck. I read about him and I don't know who it is.

Just the other day, I open a book and what do I find? A former Aerosmith accountant, a perfectly reasonable, rational person—someone who adds up columns of figures, divides them, amortizes them, collateralizes them—has turned into a writer of bodice-ripper romances. She's telling a lurid tale featuring little old me. The woman's become an authority on my sex life: *My dear, there's a little-known fact I'll share with you about Steven Tyler* ... Something that few people know. By this point we're all holding our breath, we're spellbound. In a hoarse whisper, she continues: He makes his groupies put on kinky costumes. Oh, yes, he designs them himself. He makes them recite nursery rhymes while he fucks them. He can't get it up unless they're dressed up as Little Bo Peep, Little Miss Muffet, Little Red Riding Hood....

What a perv that Steven is! And that was my accountant!

Back to our story already in progress.... The band hits warp speed in the Midwest. At the helm our driver, Mark Lehman, a one-man hump-amp, rig-lights, set-up-sound-system wizard. When I saw *Almost Famous* I said, "Holy shit, is this sideways Aerosmith or what?" We were on that bus, in that plane, diving naked off rooftops into the way-out-o-sphere along with fellow demon Ted Nugent. The hallways were crowded with bad girls, seedy characters, and a waiter named Julio delivering groupies on a room service cart.

Now, one night after our show at the Paramount Theatre in Seattle in late November 1973, we're all in this big room backstage, and our very considerate promoter had invited these girls there for us. "I've got a little surprise for you boys." My, my, my, what do I spy with my little eye? Six nubile young chicks, one cuter than the next. They curtsy and introduce themselves to the band. One says, "Hello, boys, we're the Little Oral Annie Club." Well, beam me up, Scotty, says I.

Then she says, "Well, sir, we've taught each other how to give great head, so when we meet rock stars . . . we blow you like no man has been blown before." To have two girls come up and say, "Hi, we'll do each other, wanna watch?" is mind-boggling. Six hot girls and one of them whispers in your ear, "I can eat her pussy right here and now better than anyone on the planet." I think I can safely speak for all males of the species . . . this moment would have changed your religion.

All these girls were dressed up fantasy style in sexy costumes. Guys are very predictable creatures. We *all* like schoolgirls in plaid skirts, women in high heels and fishnet stockings.... Strawberry Fields, as she called herself, was their den mother—kind of heavyset and a little older, but she knew what

rock stars—hell, what all boys—wanted. As for the *me* that I thought I knew? He'd left the building! This woman *knew*. She knew how to take care of her girls and how to please the boys.

Speaking of which, remember a little group of nasty girls called the Plaster Casters? There were originally two Plaster Casters, but soon more were needed. If Led Zeppelin were in town, say, and the first two girls were busy . . . well, that night they would send another couple of girls over to do the Allman Brothers. Eventually there were more girls involved at each session: a plethora of plasterers. One cooked up the plaster, the second one did the fluffing, and the third one would cast the mold and put it in her Easy-Bake oven. I never had my plaster casted, 'cause I always believed in mystery meat. I figured if I got the cast, it would wind up on someone's mantelpiece somewhere, and people would be going, "*That's* Steven Tyler's dick?" We'd lost half our audience right there.

The girls are parading around in their outfits, and I'm talking to Strawberry Fields—she's got my attention—and other parts of my anatomy, too, by now—and she's telling me all the stuff they do. Groupie Geishas! I wanted to say, "As long as I've got a face, you'll always have a place to sit," but it came out, "Igloo boffrim modden ginsky"... but what I meant to say was "Blahimi auhfern koofnard gynolia?"

"So, uh, you girls, you dress up in different outfits?" I asked.

"Well, of course, we have any kind of costume you want," chimes Ms. Fields. "Just tell me. We're here to please." This was way before you could call a service and say, "Send over a couple of hookers dressed up like Jack Sparrow and Whoopi Goldberg." Strawberry Fields had the costumes made to order for your particular perverted fantasy—any fucking fantasy your twisted little heart desired. Out of this entire erotic circus, there was one day where seven girls showed up dressed like Joe Perry with tits. No one got laid *that* night.

Penny Lane, the groupie Kate Hudson played in *Almost* Famous, could easily have been based on sweet . . . hell, I'm not

even going to give the girl a pseudonym, but that *was* her, my girlfriend to be, one of the six girls in the Little Oral Annie Club we met that night. She was sixteen, she knew how to nasty, and there wasn't a hair on it. With my bad self being twenty-six and she barely old enough to drive and sexy as hell, I just fell madly in love with her. She was a cute skinny little tomboy dressed up as Little Bo Peep. She was my heart's desire, my partner in crimes of passion.

Early on in the band when I was still Jung and easily Freudened, I'd blurt out my sexual fantasies. I thought I was just being honest and saying what was on everybody's mind, but I made the mistake of talking this stuff in front of the band's wives. You know, stuff like how I liked doing it with two girls—twins, preferably. "You're disgusting, Steve!" one of the band wives blurted out (I hate it when people call me "Steve"; always a tinge of squinge attached to Steve). I'd say, "What? Boys don't like threesomes? Don't *all* boys dream about that?"

And did I expect my band mate to say, "Oh, yeah, I'm sorry, baby, that *is* my secret fantasy. And, honey, while Steven's brought up the subject of sexual fantasies, did I ever tell you I've always wanted you to dress up in a Nazi uniform and order me to goosestep on your great white plain?" What was I thinking? No man is going to tell his wife what he really likes. Because when he gets home, she'll Lorena Bobbitt his ass and he'll never find his licorice nib again.

Any cop will tell you that the things people lie about most are sex and drugs—and in that order—so hypocrisy is the order of the day. I would just sit there, flabbergasted, going, "Oh, really? You mean boys *don't* like girls going down on each other?" I think I'm on firm theoretical grounds in saying this, but I always welcome other points of view.

Of course, nowadays, in every fuck club or strip joint, it's fashionable—hell, it's mandatory—for two girls to kiss and jam out with their clam out. Why did it take so long? That's how they get your attention; now they *know*.

Can I help it if I was ahead of my time? Back then, I used to say, "Aw, c'mon, all guys like a close shave." In the year 2011 it's become fashionable for girls from sixteen to sixty to be cut to the quick. It's waxed, smacked, and shellacked. Do we need to do a survey? They may have a landing strip, so flight attendants, please remain seated until my face comes to a complete and full stop. I remember one night on the road when Joe and I were sharing a bed with two girls and woke up in the morning with a seafood blue plate special. Crabs for . . . everybody! And I'm the last guy on the planet to use that little Barbie Doll comb that used to come with a bottle of A-200 that would burn the critters out. At one point, I had so many crabs, I used to say good night to them.

My little oral Annie came back with me to the hotel, the Edgewater Inn in Seattle, where we sat in the tub for two hours, naked with no water, when it dawned on me there was an emergency cord in the bus we'd taken to the hotel. So I went down (on my way knocking on Ted Nugent's door), cut the cord with a pair of pliers I had in my bag, brought it up to my room, attached a fish hook from hell to it, ordered ham sandwiches-which is all you could get after midnight—put the ham on the hook, and dropped it out the window. We pulled up mud sharks and codfish for the next four hours and proceeded to clean the fish and gut the two sharks. Then Ted says, "Check this out." And lays the two hearts on the sink. "Okay, now go to bed," orders the madman. Next morning, my phone rings and it's Ted. "Steven, go into the bathroom and check out the heart." I touch the sea critter with my finger and I'll be damned if the heart didn't start beating . . . nine hours later! Which only proves one thing . . . which I can't remember just now. "You can't kill a lawyer," could that be it?

Nugent suggested we have a fish fry at the gig. So we filleted the cod we caught, put 'em in a cooler, and took 'em to the gig that night with us. I offered him my crabs, but he politely declined.

I was so in love I almost took a teen bride. I went and slept

at her parents' house for a couple of nights and her parents fell in love with me, signed papers over for me to have custody, so I wouldn't get arrested if I took her out of state. I took her on tour with me. My Sweet Eeee. . .

Standin' in front just shakin' your ass, Take you backstage you can drink from my glass. Talk about something you can sure understand 'Cause a month on the road and I'll be eatin' from your hand.

That was her. I lived with her for three years. She was a sweet, mysterious creature . . . very smart, and she knew what she liked and what I liked. We took baths together. She wore skirts with no panties. We did it on the red-eye from L.A. to Boston . . . that kind of stuff. All the things that guys dream about.

We made love in public, in private, and tried positions the *Kama Sutra* has yet to come up with. One time we started out in a hot tub on the roof and wound up in the lobby. We got out of the hot tub naked and into the elevator and dared each other we couldn't make it all the way down to our room without being seen. We hit every floor starting with the lobby . . . unfortunately, it went there first. It was so erotic and romantic that by the time we got to the lobby, we were coming and going all at the same time. When the doors opened, there was an Amish family staring at us like figures in an oil painting. The door closes, then it opens again, and someone says, "Can I have your autograph?"

That sweet girl used to recite poetry and constantly sing songs to me like my mother did when she put me to sleep. It was an inspiration to my heart. One of the songs she taught me was "We Are Siamese," which I'm sure you'll all remember from the movie *Lady and the Tramp*.

Like I said, so sweet. Not like me.

At the end of the tour I brought her home to Boston. We got on well for a while . . . we were best friends and did everything together. She even knew how to mow a lawn. That impressed me.

There's a picture of us in *People* magazine sitting on my tractor. But toward the end things started to derail. We got so messed up on drugs and were so out of control that the dark side started taking over. And while I was on the road, our apartment almost burned down and she wound up in the hospital with smoke inhalation. I went to see her in the hospital and that's when reality slapped me in the face. When you love somebody, set them free. And I just had to let her go. She went back to her parents, but I can still see her in the songs we sang together. And the greatest thing she taught me . . . that *love is love reflected*.

So much to be dealt with when you fall. And I fell hard. And I fell heavy. And I fell so in love. Was it from songs? From my Italian family? From heaven or hell? I'm a breeder. Been married twice. They say never trust a rock musician? We can write songs about love but we're not allowed to be in love. "Oh, yeah, that's right. I fell in love with you from the side of the stage, surrounded by other women," your significant other would say if she were honest. But they don't think that. You get married, and sometimes you fall from God's grace. You're sitting there saying to them, "Yeah, but sweetheart . . . you see the girls screaming at me every night. I don't sleep with them, I just make love to them through my music. And that stage is my mistress. Why are you angry at me?" And, actually, I liked it. When I was younger and easily impressed I watched my heroes and I was enticed by that . . . the crowds, the adulation, the sexuality, and the girls that loved rock guys. It certainly wasn't the money.

You know, guys in rock bands aren't the only devils. Wives can be just as bad. I've known some wives that cheated on the guys while they were on tour and the husbands never knew it! And they said I should be wearing the genital cuff?

I came up with the second album title, *Get Your Wings*, after reading a book on the Hells Angels. Getting your wings is a Hells Angels thing. If you give a girl head when she has her period, you are definitely one of the guys and, my friend, you've got your wings. The album came out in March 1974—and we were on the road again. We toured like gypsy possessed. We opened for Mott the Hoople, Black Sabbath, Blue Öyster Cult, the Guess Who, and Kiss. We were on tour continually and endlessly. We made as little as five hundred dollars a night in places where they didn't know us and almost four grand where they did. *Get Your Wings* was bubbling in the Hot 100. And as a result of our never-ending road juggernaut, it got us our first gold record the following year.

That spring we opened for Hawkwind (the Brit sci fi rockers) at Alex Cooley's Electric Ballroom in Atlanta. Every night there'd be a girl in the front row, very scantily clad, silver glitter spray all over her body, and little nipple cups. And really *hot*. Stone gorgeous. She was the Glitter Queen and she came to every show we ever played in Atlanta.

We did a great show at Cooley's one night. I was up in the dressing room afterward . . . the backstage was full of people, along with a couple of girls in the dressing room, naked. My old childhood friend Ray was there. He was working his ass off with the band and had a bag of blow. Ray had the greatest connections—the red Lebanese hash with a camel embossed on the bag, same as the stuff he'd scored for Led Zeppelin—oh how they loved that shit!

One of my band mates took a look at the Glitter Queen and he was *gone*! She disappeared and so did he. I think she swallowed him up a couple of times.

The girl standing there in front of me was *hot*, not to mention very ambidextrous. She could bend over backward—my kinda girl—and she had a flat head where I could rest my beer. A little-known quality in those who bend. Later, Ray had this same girl in the toilet stall, she's standing on her head with her feet up against the wall, and he's pretending to pour Jack Daniel's into her 'gynie...but actually pouring it into a shot glass and sticking the shot glass into her coo-ha and drinking out of it with a straw.

STEVEN TYLER

When Ray was done, he poured Jack on his schvantz 'cause he thought it would kill the herpes he was about to get. One snort leads to another, and pretty soon it's two hours later.

My band mate—who will remain nameless—is hiding backstage, ramming the Glitter Queen with the silver paint all over her body, while we're getting gacked to the nines on blow (which we called "krell") in the dressing room. Mötley Crüe says they coined that term for coke in the eighties after the Krell, the people who lived on the *Forbidden Planet*.

"Hey, where were you?" I inquire, when said band mate returns. But when he gets close enough, we know. We all fall down laughing because his face and shirt are covered with silver glitter paint. There's silver paint in his hair, glitter all over his mouth—his penis looks like the Tin Man. And up behind him comes the Glitter Queen herself with all the silver paint rubbed off her breasts and her pussy. Oh, man!

We'd come offstage just shy of midnight. They'd shooed everybody out of the club and closed up. By now it's 3:00 A.M. I go downstairs and I can't get out so I run back up. "Omigod, you guys, we're chained in! There are chains across every door." What *were* we going to do! Locked in with a pile of blow, Jack Daniel's, and a bunch of hot naked chicks? The only way to get out was to force open the door a crack and then you could climb up and over—which I did. I got out, made a phone call to Alex Cooley, and it took an hour before anybody came . . . for the fifth time. I know, I know. We were younger then.

Upon returning to the hotel I recited my nightly prayer . . .

Now I lay me down to sleep, I pray the Lord my soul to keep You keep my soul, I know it's taken Hope you don't mind if I stab my bacon.

All these girls had to do was look on the back of the album and see what the tour manager's name was—and if you're in Chicago, call up every hotel that Aerosmith might be staying at,

147

which would whittle it down to maybe four, call the front desk and say, "I'm looking for Kelly, he's my cousin, he'll be coming with Aerosmith." It took the fans twenty years to get hip to this and me twenty-five years to figure it out.

That is assuming, and it's quite a lot to assume, that the tour manager would have even been available or would have given a fuck about my aching needs. Tour managers, I found out later, had other things on their mind, such as hobnobbing all night long with people they knew from the last time we'd played there, people with primo blow.

So many nights I went to sleep dreaming that two gorgeous, nasty twins were going to knock on my door, cover me in rose petals, and perform an after-midnight rectal examination. . . . But no way, they never arrived. Perhaps they didn't know I sometimes used the name I. K. Malone when I checked in. The chick at the front desk had a field day with that. "I'll be right up," she would say.

You get into a hotel elevator in a place you played the night before, and you know the last fucking person you want to meet is someone going, "Oh! My god! It's *you*!" in that Valley Girl accent. This person in the Hyatt House elevator is having a God experience and you haven't had coffee yet. By the time you're through your fifteenth or twentieth person having a religious experience, you wish you were a gasket salesman from Omaha.

You get home that night, the next day you wake up—it's your day off!—and step outside and what do you see but the three-hundred-pound guy in sweatpants you'd run into in the elevator the day before. He's camped outside your door and he's drying his clothes on your lawn. Perfect!

NOISE IN THE ATTIC (SNOW DAYS)

The buzz that you're gettin' From the crack don't last I'd rather be ODin' in the crack of her ass STEVEN TYLER AND JOE PERRY, "FEVER"

hose were the days when AIDS was not yet in the world. You couldn't die from getting laid. Those were different days. And cocaine! Doctors said it was not addictive . . . it was *habituating*. They didn't know at the time that the drug would eventually take a sharp turn after a certain day. Blow, once the life of the party, became the stuff of fear and loathing, the source of devious and secretive behavior, and the mother of all lies. "What, me? No, I don't have any!" "Sorry, ran out, bummer, man!" "Nope. Hey, I gotta go to the bathroom." And that's where the rock 'n' roll bathroom came from. That's when people started keeping stuff in *two* pockets—you had your courtesy bindle you'd share, so people didn't do too much, and you had your main stash in your sock. And thus sin and doubt entered our happy world.

Fame derails people—not to mention the drugs. But drugs were nothing new to me. I'd had a lot of practice with drugs; I'd been getting high since I was sixteen. I was getting high *all* the time back then. It was part of my education. Ray and I would set our alarm for four o'clock, drop acid, go back to sleep, and then wake up at five thirty or six just slammin'. It really started before that with speed, so much so that I wrote a poem . . .

Set your alarm, it'll do you no harm to get off while you're asleep You'll get off so fast, with the next hit you blast You'll do in a day what you could in a week

With speed your brain knew you took it and you were up. But acid, you could take it and go back to sleep. We'd get up and go to high school tripping our brains out. I used to smoke pot and listen to the Beatles, trying to decipher their lyrics. With grass you could read between the lines . . . with acid there was nothing *but* between the lines—both essential talents of the times. "Norwegian Wood," now what could that possibly mean? Today, it would be as obvious as the balls on a tall dog. Smoking pot was so much better than drinking—which I also did, of course. God, a couple of drinks and you go to that same old place, but smokin' the good stuff and you're up in your fucking way-out-o-sphere.

The great red hash was hard to come by, as were Thai sticks and Nepalese temple balls . . . real round ones. It had such a sticky, resiny, sweet, tangy taste. It's a real dream-inducing high. People would tell you it was laced with opium, but why would anyone lace a common drug like hash with something as expensive and rare as opium? Another urban legend gone wild. Not too different from the one where the girl supposedly fucked herself to death on the gearshift knob. That one we wanted to believe.

STEVEN TYLER

My mom used to ask me, "If you're already on such a high from finally having made it, why do you *need* to get any higher?" But I did, anyway. When you grow up doin' drugs, chances are you're gonna spend the rest of your life doing drugs. They were never to put out the pain. I would drop acid and run up the hill to the ski lodge. I'd drop and go to Bash Bish Falls, upstate New York, and stay in the woods all day. I would drop acid and go from Friday to Sunday night trippin' on the aqueduct, riding my minibike with Tommy Tabano, Ray's brother, who just passed away last year. Bless his heart. He was a big part of my yesterday.

So we were all off and running, all in bed with the same girl . . . Mary Jane. I was good onstage so why not be high, too? I was already addicted to adrenaline, so why not get higher, as Sly Stone preached? Using in spite of adverse consequences. Certain things happened in this band that weren't drug induced, although there haven't been many. I've always felt that we couldn't take one step forward without two or three back.

But let me don the Devil's Drug Advocate hat for a minute . . . a sociocultural rant, if you will. Why are drugs eternally attached to unpleasant hippie references? For those who OD'd ... drugs are bad! Yes. But some of us could do them. Great seekers-writers like Carlos Castaneda and Aldous Huxley. Did they take trips (like I did) up the side of a mountain to a ski lodge in the summer just to smell the wildflowers and watch the foxes run and stare as the clouds hypnotically floated by? Are all drugs bad just because some of them took over my life from time to time? I wrote some beautiful songs under the influence, just as jimson weed inspired Carlos Castaneda when he was writing his Don Juan iconic novels. By the way, I was getting the cues when I was eight years old. Sinatra's "Come Fly with Me." Even then, I didn't interpret those lyrics as come fly with me on a big old jet airliner. It was metaphorical, and guess what? A lot of us kids back then picked up on those things. Santa Claus, the Easter Bunny, Alice in Wonderland. If anyone has ever tripped on acid, in their heart of hearts and mind of minds they have experienced

what it's like to truly fall down the Rabbit Hole. And when the drugs hit full on, you *are* in Wonderland.

Life is something to be reckoned with. Winter has to be reckoned with. For the cold, find something warm. Baby's birthing? A shot of Jack Daniel's to celebrate. Wine . . . Christ's blood. But to me, it's always been EUPHORIC. Why? Euphoric recall isn't just drug based. It's thinking back to your childhood and the best memories of those times-that's euphoric recall. It's wonderful. Aerosmith did drugs . . . drugs, drugs, and more drugs. Can it take you down? Yes. Did it take me (us) down? Well, we're still here. But it's also what life is all about. Watching whales breech; holding a baby bunny; getting a new puppy for Christmas . . . that feeling of GREAT. It's all humans really want. They say in every moment, you have a choice to make between fear and love. I believe that. But all we really need at the end of the long and winding day is to be petted, to climax, to make love, and to be happy. And that is euphoric . . . with or without the hash coffin.

By the time we were getting ready to make the second album, we all flew solo. We didn't share drugs anymore; everyone had his own godlike, capable-of-anything-we-put-our-mindsto attitude. We storm trooped across America—three shows in a row—meet-and-greets every night (where the band quick-chats and shakes hands with fans who've managed an after-show pass thanks to a local radio station promotion), doing TV and radio interviews in every town we passed through. It was around this time that things started to get seriously out of control, but no one noticed because we were having too much fun. In the beginning, drugs seemed positively essential. We had to get high to get by, because no human had that kind of unworldly stamina and enthusiasm.

When it came time to start recording our second album, *Get Your Wings*, in 1973, Bob Ezrin, Alice Cooper's producer, was going to be our producer—which meant we were now in the big leagues—as the title of the album implied. So we were about to

get ours....Then Bob Ezrin came and saw the band and wrote, "They're not ready." I saw the note; I've got it somewhere. I take it out every once in a while and look at it and a little steam comes out of my ears. But Jack Douglas, who was then Ezrin's assistant, also saw us and loved the band. He told Ezrin we were the long-foretold Great American Band. Jack Douglas, a fucking visionary!

So Ezrin said, "Well, Jack, you want to do'em, you do'em." That's how Jack Douglas got the job—us—isn't that great! Naturally we were a little resentful at first when we met Jack. I was thinking, "Ezrin doesn't think we're ready, well, fuck you guys!" *I knew we were because I knew what we had.* Actually, who knew back then, right? But when you win in the end, you can always go, "You know? I *knew.*"

We relied on the drugs for recording, touring, partying, fucking—anything at all, really. But we already knew there was a dark side to all this, as in the lyrics to "Same Old Song and Dance."

Gotcha with the cocaine they found with your gun No smoothy face lawyer to getcha undone Say love ain't the same on the south side of town You could look, but you ain't gonna find it around

It's the same old story, same old song and dance, my friend It's the same old story, same old story same old song and dance

Fate comes a-knockin', doors start lockin' Your old-time connection, change your direction Ain't gonna change it, can't rearrange it Can't stand the pain when it's all the same to you, my friend

"Pandora's Box," from that album, is the one song I wrote with Joey Kramer. It was inspired by a friend's house in Woodstock, New Hampshire. A river ran through the property with

153

giant rocks on either side. The girls that hung out there would bronze their naked bodies on the boulders like a string of candied pearls. We'd always get to the water hole late, knowing they'd be posing like girls in a Vargas calendar. Now, you're probably expecting some huge erotic revelation from me, but that's not gonna happen. I will tell you this—if I had an extension cord long enough, I would have recorded the entire album right then and there, and in the heat of love, I would have screamed every vocal from the mounds of their Venus.

Meanwhile, back at the garage, Joey's strumming a guitar we found in a garbage can and starts playing this cool riff he'd gotten from the black soul bands he'd played with before Aerosmith. The riff was so inspiring, I wrote these lyrics . . .

When I'm in heat and someone gets the notion I jump to my feet and hoof it to the ocean We find a place where no one gives a hoot Nobody never ever wears a suit The ladies there you know they look so proud That's 'cause they know that they're so well endowed.

I nailed that verse in an hour. Joey, you're the man.

"Seasons of Wither" was a song that had been germinating in my head for a long time, but the other more sinister tracks, like "Lord of the Thighs," came from the seedy area where we recorded the album. "Lord of the Thighs" was about a pimp and the wildlife out on the street . . .

Well, well, Lordie my God, What do we got here? She's flashin' cross the floor, Make it perfectly clear. You're the bait, and you're the hook, Someone's bound to take a look. I'm your man, child, Lord of the Thighs.

STEVEN TYLER

You must have come here to find it, You've got the look in your eyes. Although you really don't mind it— I am the Lord of your Thighs!

Get Your Wings came out in 1974 and got us a couple of hits on rock radio—"Same Old Song and Dance" and "Train Kept a-Rollin"—and it was back on the road again.

I love going out on that stage. You come out of your dressing room, head down that gray cinder-block corridor with bodyguards and road manager flanking you, up a ramp, onto the stage, and there you are—twenty-five thousand Blue Army Aerosmith faithful out there waiting for you to light the fuse. It's a high that I'm not sure ever goes away. After some *doot da doot* started waving that .45 around during a Ted Nugent set, the threat of some moron taking a shot had me worried I'd be next. But if I keep moving, no way they can hit me. That's when I adopted a Tigger mentality and I've been dancing my ass off ever since.

Ray Davies knew how to work a stage. The Kinks are the most underrated band of the sixties British rock invasion and to this day everyone knows who they are. Never mind the Bible, that one song, "You Really Got Me," it *was* the Bible! Oh, my god, it was the shit! And then they were smart enough to follow it up with "All Day and All of the Night," which was "You Really Got Me" on steroids.

You know why they sang it like that? Shel Talmey, their producer, thought that Ray Davies couldn't sing, so he told him to blurt it out in short little telegraphic outbursts. That way you don't have to *sing* the *melody*. Fucking genius, because every word hammers at you, every word is *percussion* in that song. I love that. If you can't think, don't speak in long sentences. . . . And if you can't sing, don't try to carry a long melody! But of course the Kinks did all these other things, too. What a ballad, "Waterloo Sunset." Then they went off into all those crazy operas and concept records: *Lola vs. the Powerman & the Money-Go-Round Pt. 1, Preservation: Act 1* and *Preservation: Act 2*...100-amp fuse-blowing arena rock.

Shit happens between bands on the road. We played a show one time at Harrisburg Arena in Harrisburg, Pennsylvania—it was one of those places where they usually sell horses and cattle, so the place stunk of manure—and Queen would not go on because we were the headliners. They refused to open for us and the show was canceled.

Another time we were opening for Bachman-Turner Overdrive and they sabotaged the scrim that would fly the Aerosmith wings. Their roadies rigged the cables holding up the flag of the Blue Army so that when Kelly pulled on them, the fucking pipe bent and the wings crashed. We learned that the best way to beat sabotage on the road was to just kick ass every night . . . and that's just what we did.

Marko Hudson told me a great story about David Coverdale when Whitesnake was opening for Ozzy Osbourne. Coverdale supposedly showed up at the venue on more than one occasion with a pair of hookers wearing white fur coats and toting two Afghan dogs. Ozzy hated it. He called him a "prat." The crew was instructed to lay down silver duct tape that would lead Coverdale to his dressing room. One night, before Sir David arrived, Ozzy took the tape up himself and redirected the trail to the boiler room.

We were playing in Lincoln, Nebraska, one time. That's where Joey and I got busted for throwing firecrackers out the window of a Holiday Inn. The bill was Aerosmith, Kansas, and the Elvin Bishop Group. Elvin Bishop had that hit single "I Fooled Around and Fell in Love." Crazy Raymond or "Ray Gourmet" as we called him at the time, had it in our contract rider that we had to have a *turkey-on-the-bone* dinner every fucking night backstage after the show. Not turkey loaf, not turkey roll, not pressed turkey, but a fresh fucking turkey-on-the-bone

dinner, even though we never ate it because everybody was so out there all the time and just wanted to get out of the venue and back to the hotel. Nine out of ten shows, we'd get turkey roll with bubbles in the meat or some mystery meat that looked like hockey pucks and tasted like a Frye boot. And that's just what we got in Lincoln. I lost it. We gave the stuff to Kansas. They ate it and loved it. I guess that *futuristic* meat was one of the reasons why they were a great prog band.

Speaking of meat, I found out years later (through a crew member confessional) that when the techs would get pissed off at the band, they'd wipe their ass with the bologna and put it back on the deli tray. Come to think of it, I always thought the bologna on tour had an anal tinge.

Being on tour with Jeff Beck was one of the highlights of my career. One time we were performing in Chicago at Comiskey Park and Jeff Beck came out and played "Train Kept a-Rollin" with us. It was incredible. Then the stage manager comes running right out onstage and yells, "You're burning the building down!" We thought he meant that the band was on fire. Joe and Brad have been known to rip some pretty hot leads. But the building was really burning. The asphalt and tar on the roof caught fire and the place was going up in flames. That night, we burned the house down . . . twice.

We always knew that our old manager, Frank Connally, was hooked up with some shady characters. But now Frank's old business partners were coming home to roost. A big boxing promoter (we'll call him "Tony Marooka") claimed he wasn't getting his share and came to collect. "Frank told me I'd be taken care of," he said. "I'll break fuckin' Steven Tyler's legs if you don't do right by me." David Krebs went into the Celtics dressing room with Marooka and there was a powwow. Krebs took care of it by laying some dead presidents on him. I had no idea this was going on; one of those rare transactions where I was glad to be out of the loop. January 1975 . . . in the midst of a spine-chilling, ball-freezing New York winter, we began work on our third album, *Toys in the Attic.* I came up with the title because of its obvious meanings and since people thought we were fucking crazy anyway, what did it matter? I wasn't hip to the 1960 Tony Award-nominated Broadway play of the same name or its 1963 Oscar-nominated film adaptation. Didn't matter if I had been. This was Aerosmith's *Toys in the Attic* . . . singular, sexy, and psychosensational.

My creative chi ebbed and flowed from tongue in puss to tongue in cheek. I've always been tactile and oral. Maybe too much love from my mother? But it became obvious to me in later years that the passion I had was unlike that of other males, and unfortunately, on various occasions, that passion wasn't shared by other members of the band.

I've been misquoted as saying that I'm more female than male. Let me set the record straight—it's more half and half, and I love the fact that my feelings are akin to *puella eternis* (Latin for "the eternal girl"). What better to be like than the stronger of the species? I mean, women are the superior beings, are they not? Sure the male brings the food home, but can they birth children and feed them from their breast? Woman has compassion, which man lacks. I feel I was born with those same feminine compassions.

People wind up stashing their memories in the attic, a traditionally nostalgic place—your old teddy bear, *Archie* comic books, Slinkys, family heirlooms, a favorite moth-eaten sweater, photos of childhood, your old roller skates, tickets to a Stones concert, Mia's crib...

The other reason I came up with *Toys in the Attic* was that I knew we'd made it. I was the kid who put my initials in the rock 'cause I wanted the aliens to know I was there. It's a statement of

longevity. The record will be played long after you're dead. Our records would be up there in the attic, too, with the things that you loved and never wanted to forget. And to me, Aerosmith was becoming that. I knew how the Beatles, the Animals, and the Kinks did it—with lyrics and titles. I saw reason and rhyme in all the lunacy that we were concocting.

Leaving the things that are real behind Leaving the things that you loved remind All of the things that you learned from fears Nothing is left but the years

Joe was jamming a riff and I started yelling, "Toys, toys toys. . . ." Organic, immediate, infectious . . . fucking amazing. Once again, the Toxic Twins ride off into the sunset . . . this time, the sunset of the attic. Joe's been my inspiration on more songs than I would ever tell him. Sometimes, just his presence in the room is enough to inspire lyrics to the greatest melody. It's proved itself on every record we've ever done. I'm friends with some of the best . . . but I'm partners with almost none. He's so much more than the real thing. Coke has nothing on Joe Perry. Like leaves on an artichoke, the more layers you peel off, the closer you get to the heart. Guitar players jam

Toys, toys, toys . . . in the attic!

I just started singing and it fit like chocolate and peanut butter. Joe plays his ass off on that song. He used to sprawl across the couch with the TV on and play guitar at the same time. I'd come in and say, "What are you doing?" and he'd say, "I'm just watching TV." "No you're not. You're writing a song," I'd fire back. And all I can say is, Thank you, Thomas Edison for inventing the tape recorder. Joe played stuff unconsciously. It didn't matter what key or tempo. That came later. Just playing; just feeling; just being Joe fuckin' Perry. Tom Hamilton—same thing. He's come up with these slippery, slimy, melodically delicious out-of-the-blue bass lines from practice. He'd play stuff so down and dirty just from warming up, and it would turn into a song. Like "Uncle Salty," actually written on *his* guitar. Movie stars wanna be rock stars; guitar players wanna be lead singers; bass players wanna be guitar players.

Now she's doin' any for money and a penny A sailor with a penny or two or three Hers is the cunning for men who come a-runnin' They all come for fun and it seems to me That when she cried at night, no one came And when she cried at night, went insane

Here I was thinking about an orphanage when I wrote those lyrics. I'd try and make the melody weep from the sadness felt when a child is abandoned. I pretended to know the headmaster to get inside his head and what I heard was

Uncle Salty told me stories of a lonely Baby with a lonely kind of life to lead Her mammy was lusted, Daddy he was busted They left her to be trusted till the orphan bleeds

Inside was hell or barely tolerable, but she sang, "*It's a sunny day outside my window*..." because I'm a sucker for a happy ending.

The song title "Walk This Way" came from the Mel Brooks film Young Frankenstein . . . secondhand. Jack Douglas was discussing how Marty Feldman's scene went, where he utters the (now) immortal line. It was hilarious and it stuck. I'd actually finished the song the night before our recording session and kept it in a bag that had all the other lyrics I'd written for the *Attic* LP. Arriving that day at the studio at 4:00 P.M., I got out of the cab and realized that I'd left the bag in the car! Gone. Two hours later, I went upstairs. I sat down on the steps with my pen and wrote

STEVEN TYLER

the words to "Walk This Way" on the wall. As I rewrote each line, the words all came back to me. Never saw the bag again.

Backstroke lover always hidin' neath the covers Till I talked to your daddy, he say He said, "You ain't seen nothin' till you're down on a muffin Then you're sure to be changin' your ways" I met a cheerleader, was a real young bleeder Oh the times I could reminisce 'Cause the best things of lovin' with her sister and her cousin Only started with a little kiss Like this!

Walk this way!!!

Toys in the Attic came out in April 1975 and went gold. The rest of the year we spent on the road. This was the year it all changed for us. The album got good reviews and people started taking us more seriously—about fucking time! We toured with Rod Stewart and Ted Nugent. Ted is the definitive Paul Bunyan with an SG guitar—a man's man. His music is in tune with the times, but his values are as old-fashioned as Davy Crockett's coonskin cap. He's so far to the right, he runs over his left! And if looks could kill, his wife would slay us all.

Tour managers had it good back then. We didn't know it, but every person they let in the back door, they got a gram of blow from. "You wanna come in? Cost you a gram, man! Ounce of coke! An ounce of coke'll get you up close and personal! Yup! I'll give you all the tickets you want. But make sure you got an ounce. And dude, it's gotta be just like that last shipment."

The Aerosmith crew were ruthless extorters of blow. I met

these guys later on—we'd go back to the same cities ten more times and they would all come out of the woodwork and go, "You know, when I used to come here, Kelly would charge me in coke. The last time I saw you it cost me a fucking eight-ball just to get me in!" First it was a gram. Then it went up. Even among hustlers and dope fiends, there's inflation. And that's what they did; that's why Jimmy, Kelly—whoever—were nowhere to be found. And the more famous a band got, the more blow. And who did we buy our blow from? Kelly!

We drank a lot because of the blow and we got blown a lot because we drank a lot. My favorite cocktail was a Rusty Nail... Drambuie mixed with the finest Scotch and a twist of lemon. I found out later on that Eric Clapton and Ringo Starr were fellow Rusty Nailers. It's a good thing we set that glass down or it would have been the rusty nail in all our coffins.

Kelly had a monstrous appetite for coke, and I say that from the point of view of one who had a pretty ferocious appetite himself. He was a human vacuum cleaner. Fort Wayne, Indiana, we got into town and the crew would introduce the infamous Kelly to the local stagehands. "Listen, sons . . ." Kelly could snort a week's worth of their blow a foot from the baggie through midair. The guy would go, "What the fuck, man?" And Kelly would look at me and go, "Aaaahh—coke etiquette, Jack." He had so much residue in his nostrils, he made it into Ripley's Believe It or *Snot*!

I once owned a Cessna Riley Conversion turbo, bought it in New Hampshire—twin-engine turboprop, safest plane in the air. My friend Zunk would fly it with his father. I'd be at the house and call him up, "Let's go flying, Zunk," and I'd swing over, pick up a gram, and we'd go up and do parabolics . . . where we'd pretend to go up around (and over) a clock: 10-11-12 (woeeee) . . . 1-2-3 and between 11-12-1-2 and 3, you are truly *weightless*. There's nothing on the planet Earth like this. You can simulate it, but up there—*flying around the clock*—that's the real deal.

So one day our flight was canceled and the band had to

get to Indiana. We're flying from New Hampshire . . . just me, Zunk, and Joey. Zunk wants to show off for Joey so he goes into a parabolic. And I've got an ice chest in there. The ice chest goes up in the air and it's hovering in front of Joey's face. "What the fuck?" He's freakin' out. But even better, another time, we're on the band plane and we happen to hit some nasty turbulence. I whip out my vial of coke, put a line on my thumb, grab a straw, and start to snort. Just then, the blow begins to *float* up in the air . . . hovering like fairy dust in front of my face. I shove the straw up my nose and *sniffff* the powder right out of the air! A gram of coke floated out of my bindle and into the air! I was known from then on as the human DustBuster—which turned into Dirt Devil, which turned into demon of screamin'. And then at one point, the demon o' semen—but that's another chapter.

For a while we had a guy in the crew who was an ex-cop. Having worn a badge himself, he'd get friendly with the local cops in the towns we played, hang out with them, and they'd give us the stuff that they had taken off the kids. Fucking cops in uniform! They'd say, "Put your hands out," and they'd put bags of weed and little dime bags of whatever in tinfoil in them. He could also buy guns from various people. So one time he goes, "Come here," and pulls the bay down from the bottom of the bus. I look inside and there's what I thought was an AK-16 and this shotgun with a huge clip. The clip was round. I'd never seen anything like it. You can't even get one anymore. It's known now as a weapon of mass destruction.

I took the AR-16 up to Henry's house, went into his backyard, loaded it up, and said, "You know, this doesn't look right." I walked into his woods, pulled the trigger, and it went, *rattttatttatttttt....* I had never shot a machine gun up till that point. I freaked! Then I ran back to Henry's house, rolled it up in a blanket, went back to my house, took my boat out to the middle of Lake Sunapee, and threw it in the water. Rambo, I am not.

Whenever we wanted to snort blow together backstage, we'd say, "Let's go have a production meeting," and disappear into some little room and pack our beaks. There wasn't anything subtle about it. It was, like, "Production meeting!" We'd take over an office and have a cop stand guard for us outside. We called it the "money room."

We were all gacked to the gills back then. *Gacked* is when you've done too much blow and your jaw starts moving like a robot, there's white on the side of your lips—you're babbling, speaking in tongues . . . *rattling* on about *nothing*. It doesn't matter what it is. You'd get to the end of some insane rant and go, "Wait a minute, did I just say that?" That was the norm back then. You're so stoned and speeding, thinking about what to say while the other person's speaking. You're just *gacked*. That's the best part. The worst part is . . . nothing's funny. You could make a joke like "What's the difference between pink and purple? Your grip!" and the room would look like an oil painting. Not a laugh. And then you think you're the phallic mentor on this shit, but when it comes to doing the deed, it's like pushing a rope uphill, or stuffing an oyster in a slot machine.

Drugs were already getting to be a problem onstage and off—but it was a problem we wanted, and there were plenty of people to help us go down the road to perdition. Sometime along the way we'd met this character Brimstone—what a perfect name for a dealer.

We were playing the old Michigan Palace in April of '74. One of the roadies says to Raymond, "Someone wants to talk to you." And there he was, the devil himself. Brimstone was five feet four, big curly hair, big lips. He pulls out a bag *filled* with drugs. Raymond tells him, "Here's the deal. Party afterward, if you want to come, it'll cost you an eight-ball to get in the door. Walk in the room, don't say a word, take the shit out, put it on the table, then we'll talk." With that he became the band's regular dealer; he traveled with us, followed the tour with his own money. As we made more and more bread we bought bigger and bigger amounts until eventually we gave him twenty thousand dollars for a pound of coke. Two o'clock in the morning, there'd

be Brimstone. Always had two six-foot blondes with him. Came to a bad end. *Brimstone became tombstone*. In fond memory, I will say this . . . that man knew more about R&B than Joe and I put together. He'd sit on the floor with us like the Beatles did with the Maharishi, talking about music. As in the rest of my life, there are no coincidences. I feel blessed for knowing him.

Eccentric characters always found us. We're playing the Cow Palace in San Francisco in '93. Night before the show, we're invited down to the O'Farrell Theater, the infamous sex club owned by the Mitchell Brothers. *Rolling Stone* writer Hunter S. Thompson is in command central . . . the office upstairs with the pool table. "Steven, come here!" he shouts. "I want you to see this!" He proceeds to introduce me to two blondes that were . . . no shit, 11s out of 10. The first girl has her lip pierced with a four-foot chain hanging from it that's connected to the other girl's pierced clit. Right through the poor thing. "Couldn't you have done that after I got to it?" I said. "How you gonna feel my mouth?" The question was, at best, rhetorical. "Oh, I will," she smiled. They climbed on top of the billiard table and we commenced to play. Gave new meaning to the term *pocket pool*. Left ball in the side pocket!

When the drum riser starts harmonizing, you know you are either too high or some mystic Pythagorean force is at work. After the band stopped playing, the sound waves from the stage would vibrate the drum riser and out would come this *perfect note*. A booming E-flat. It was wild! What was that? The stage was haunted! The note would come out through the holes we'd cut into its side so that we could move it. It was feedback, but it was freaky, especially on a few lines of blow, to hear this otherworldly foghorn sound emanating from it.

Like I said earlier, I was a drummer, so I'd share all my tricks with Joey. Back when I was with Chain Reaction and no one could hear me, I put a pillow in my drum, ripped the front head off, placed a Shure 58 mic in there, and hooked that into two

Colossus amps. I put 'em on either side of my drums when I played, which pissed off Don Solomon no end, but he knew it accentuated what he was playing.

I told Joey that story later on, so he, having to outdo me, got a twelve-inch speaker that someone built for him that he stuck behind his head to enhance our show. It would get miked for sound, the bass would get miked for slap. And we were off and running. One day I look at Joey and I hear the stage talking to me, humming this note. Little did I know it was his fucking bass amp feeding back. Joey is a good drummer, but I'm the one that showed him foot foot, foot foot—high hat, high hat—foot and high hat playing the same thing . . . snare in the middle. He fuckin' practiced that and he got it.

I showed Joey the egg on my foot. The egg is the muscle you get on your foot from playing the foot pedal. I showed him because I was so proud of it. He looked at me and I could see in his eyes that he loved the whole thing, the romance of it. Joey became one of the greatest drummers ever, which made him two feet taller than he was when he started. Now he's taller than me! But he still wears spandex, with a little teeny nub. You've no doubt heard the expression "I know it's small but it's fat like a beer can." Most men dress to the left or the right; Joey dresses straight out. Far as endowments go on the other members of the band, two are hung like a Sopwith Camel, one's got a licorice nib, and one has a *big ten-inch*. I won't say who that is . . . but his first name is Steven.

Joey was one of the reasons why I wrote the song "Big Ten Inch Record." I guess it was always wishful thinking. And when it comes to rumors, while we're on the subject of phallic nobility, here's one more. . . . I've come to find out, as the years roll by, that everybody seems to think that in the middle of "Big Ten Inch Record," I say, "Suck on my big ten-inch." I can't tell you how many people I've heard this from—engineers, producers, disc jockeys, and, of course, fans . . . from all over the world. Well, I hate to burst your bubble, but the song is about a big ten-inch record,

STEVEN TYLER

and in the middle I say, "'cept" (like *except*) for my big ten-inch. How do you get *suck on* from '*cept for*? Again . . . wishful thinking.

B.J. (aka Billy Joe Reisch), who was one of the crew in the seventies, used to make jokes on the backstage passes. He'd print them up in the dressing room and laminate them. Like: THIS BACK-STAGE PASS AUTHORIZED BY MONDO. Or DEATH BY VALIUM... with a drawing of Kelly crucified on Joe's amp stack. There's an old blue Aerosmith backstage pass somewhere showing me pissing on it.

I kept my medicine cabinet onstage, in a fourteen-inch drum head, the bottom of which contained Jack Daniel's and two Dixie cups: one Dixie cup with a straw and blow in it and the other with Coca-Cola and Jack Daniel's. From behind the amps, I'd put the towel over my head and put my nose over it. The straw would be sticking out of the cup, as if it were a drink.

I wanted an onstage dressing room where I could snort drugs. The idea was a small movable sentry box that we could put at the back of the stage. The towel over my head routine was starting to get risky and a bit obvious. So, sometime in '76, we ordered a small dressing room from Tom Fields and Associates, a theatrical lighting company that also builds sets. We gave them the plans and the size: thirty-six inches deep by thirty-six inches wide by six feet tall. But when it showed up it was thirty-six *feet* by thirty-six *feet*. They called it "Mondo's Condo." It was such a monstrous-sized fucker it showed up on a huge flatbed truck. It was like the Stonehenge prop in *Spinal Tap*, only in reverse. We sent it back. We wrote on it, "Sell it to the Stones," and I think they did.

Joe had vials of coke with straws in them at the back of the stage, and when the lights would go out he'd go over there like he was checking something or making a guitar change and Kelly would put the straw in his nose; he'd take a hit, then the lights would come on again. The coke bingeing got so bad and blatant to where we just laid out lines on top of the bass amps on the left side of the stage.

167

One of the things we always put in our riders was that the promoter had to provide in the dressing room a full-length, sixfoot-long mirror. I would take the local promoter's rep into the dressing room and he'd say, "Well, there's the six-foot mirror you requested, Steven." And I'd say, "I can see the mirror all right, but where the fuck's the three-foot razor blade?"

The crew used to strew the stage with bizarre, arousing, and strange objects to startle, amuse, and titillate the band. For a while they put a scale model of the Starship *Enterprise* onstage and moved it around. Elsewhere, they'd scatter Polaroids of naked girls from the night before across the floor, and then there was the pièce de résistance: Nick Spiegel's artificial vagina.

Nick Spiegel was an Aerotech, and we made fun of him when we first caught him playing with a latex pocket pussy. Kelly decided to get him a deluxe model. He went to this porn store, waited until nobody was around, and pointed to this top-of-theline artificial vagina . . . a realistic-looking latex rubber job with a receptacle inside and some plastic pubic hair on the outside. It looked like they'd taken the sweepings off the barber shop floor and glued them on with Super Glue. But this was definitely the item, so Kelly said, "Let me see that one." "Will that be all?" the clerk asked. "That's okay, just wrap it up." So on the way out, the guy's going, "Oh, have a nice night, sir!" And Kelly says, "Oh, it's not for me...."

Unlike the other bands I'd been in, with Aerosmith the band members were willing to go the distance. The thought that we might not make it never occurred to any of us. When a band has doubts or thoughts that they have other options and tell themselves they can become accountants and Realtors and carpenters and whatnot—they're going to fail. And when the guys in those bands give up, they become bitter. They're all schoolteachers and cops on fucking meds.

I think this is a good time to address a matter of great political and social import, that being the scaly truth about LSD (no,

the other LSD) . . . otherwise known as *Lead Singer Disease*. Jimmy Page allegedly coined the term in less-than-endearing homage to *his* raspy-throated front man. LSD is a not-muchtalked-about syndrome defined in the *Mondo Manual of Psychiatric Disorders* as "Bone-gnawing, spleen-curdling jealousy of the lead singer in a rock band on the part of other members of the band, erupting in violent blaspheming and tantrums by such members whenever the lead singer's image appears on the cover of popular magazines."

Being the lead singer of a successful band, there's jealousy up the wazoo. And my big mouth just makes it worse. I will just come right out and say shit that people would never utter on their own because they'd either get fired or they weren't *asshole* enough to do it. I am definitely known for not being the shrewdest fox in the forest.

Jealousy, animosity . . . the lead singer is the dancing bear, the cash cow, and sometimes that's hard for band members to handle. They know that there's no getting by without the front man. They sure have had fun making fun, but every time they point a finger at me, there's three of them fingers pointed right back at them. As Terrible Ted says, "They can roast marshmallows out of the flames of my ass." As long as they share 'em with me! Musical s'mores . . . a rectal delicacy.

And *what about* the LI3? That's how Tom, Brad, and Joey referred to themselves in a *Rolling Stone* article . . . initials proudly standing for the *Least Interesting Three*. Well, let's go there for a moment. Take Tom Hamilton, for instance. Three years ago, we're on tour, and one night I go, "Tom, it's been thirty fucking years. Have you ever talked into a mic?" The answer was a resounding . . . never. "Don't you think you should break the silence? Just go over and say anything. I'll introduce you. Just do it so you can say you did." And he did it. And never mind the night I took a black marker and went behind Tom and outlined his fucking shoes and when he came to the front of the stage, I said, "Guess where you've been standing for the last thirty minutes?" And he fires

back, "Where?" So I point to the floor. "There!" And Tom, like his legendary predecessors, Bill Wyman and John Entwistle . . . never moved from his spot, like a stoic still life. But he did move twenty thousand fans that night with his magical intro to "Sweet E." Or what he could do to a fretless bass in "Hole in My Soul."

I live on the tail of a comet, and I must admit that with all the *me* that's me, I know in my heart of hearts that I would not be HERE if it weren't for those around me. *They* called themselves the LI3, I didn't. I took a risk and decided to be the poster boy, the magnet for other people's fears, doubts, and insecurities. It's all part of a delicious statement that all those people in my life do have something to say about me, but they aren't me and they don't know where I've been or what it took to get to that nasty, mean, maniacal behavioral place that everybody hates.

When you're in a band, fans are always giving you presents, yeah? At customs, when the gent in the uniform says, "Sir, there seems to be a packet of tinfoil in your luggage containing a contraband substance and we'll have to throw you into one of our dungeons for ninety-nine years," you can say, "What's this, then? Never touched that stuff in my life. Oh, one of our overzealous fans must've put it there." That's how we transported our rocket fuel. Throw a half ounce of coke in an envelope and on the outside write in big scrawling Crayola crayon letters, "You ARE THE SHIT! AEROSMITH FUCKING RULES! THIS IS JUST A TOKEN OF MY AFFECTION. [SIGNED] DWAYNE," and slip it in the drum kit. How we do love our fans.

CHAPTER EIGHT

LADIES AND GENITALS . . . I'M NOT A BAD GUY (I'M JUST EGOTESTICAL)

JON CRYER: I just wanna say, I'm a huge fan. Um, I lost my virginity to you. STEVEN: Really? Well, you know, there's a lot of the seventies I don't remember. FROM TWO AND A HALF MEN. SEASON 4. EPISODE 2

> • ow, it's funny, you look back now and the New York Dolls had that reputation for being over the top? Sure the Dolls were in the *way-out-o-sphere*, but we were in our own orbit. My mind was on

the dark side of the moon, as Clapton said in his Bangladesh documentary. But back then everyone in the rock elite was livin' on the edge and right out of Zap Comix, except for Zappa, who may have had one foot in the way-out-o-sphere, but the other was firmly planted up the ass of the Carl Sagan school of reality.

I spoke to Frank once on the phone, having heard he was sober. Talk was he'd take out a whole floor of rooms for those on his crew who shared his passion. "What the fuck are you talking about, Steven?" he said. "I don't have a problem with drugs; I've never done drugs!""What?" I said flabbergasted. "But seriously," I said, "vou've never even smoked pot?" An emphatic no followed. Who would have ever thunk that the Mother of Invention had no intention of dancing with Leary, swapping spit with Kesey, or ... If Ever However I'm Hearing He Never ... EVER ... made sweet love to Don Juan, the Yaqui warrior of the peyote button tribe, then how the fuck did he ever write Over-Nite Sensation or Weasels Ripped My Flesh? This was a wake-up call to a guy whose Alice B. Toklas imagination sprouted from the same soil as the trippin' troubadours of the sixties. I thought he was one of us-the lost, the damned, the terminally unique ones. He was. He just didn't use.

But why was it so wrong for me to think that Zappa wrote such euphoric musical prose . . . and that it wasn't based on some euphoric narcotic substance that might have helped get him there? And even if he never took a drug (in the literal *snort, puff,* or *swallow* sense)—he felt love. Love IS a drug (I knew that even before Bryan Ferry told me). Frank felt pain and anguish and sadness, and those are drugs of sorts. In fact, when you get scared out of your mind, your body releases drugs—endorphins and adrenaline—and just look at the molecular structure of adrenaline. It's about four notches away from what cocaine's made of. Endorphins four notches from heroin.

This was a new truth for me. Frank was only high on music. Is it Lao Tzu's belief that it's not the walls but the *space between the walls* that defines the room? WOW! Or my belief that it's not the notes but the *space between the notes* that defines the song?

In 1975, the year *Toys in the Attic* came out, we played with the Dolls at Max's Kansas City. I knew something was going on when we were received at Max's like Broadway Joe at the Super Bowl. There was so much magic in air, Lou Reed looked like Houdini. Aerosmith and the New York Dolls—it was the perfect marriage. David was *me* on steroids and nine-inch heels. The Dolls were OTT (over the top!). What I took from Johansen was his flamboyance and a wise mouth full of sass. But don't gimme no lip . . . I got enough of my own. I never wanted to wear lipstick onstage or high heels. Maybe I should have worn heels—my feet wouldn't have gotten so fucked-up 'cause I couldn't have moved around as much. I loved playing with the Dolls and the *wow* factor they possessed. The punch, the titles of their songs. But I thought that there were more toys in our attic. They would flame out magnificently while we were still setting a fire.

When you're a teenager, masturbation is more about doing it fast and not getting caught and less about doing it right and making it last. Later on, I'd cum to find out that the best thing about masturbation is that you didn't have to look your best. The Dolls were wearing Glam to the Nines. That described the smoky din of Max's on any given night. It was musical socialism: there was no formal headliner. The bathroom was full of blow, and the lineup of bands was whoever got their line first got to go onstage. Aerosmith, the Dolls, and Wayne County. And oh yeah, those fuckin' chickpeas they put on every table. They were more of a weapon than an appetizer. Wayne would have a toilet onstage where he'd reach down and grab a handful of dog food from the bowl between his legs and rub it all over himself like he was smearing his body with shit. We only played for one thing back then, and we all played for the same reason. We came to fly our freak flags. I called it Veni, vidi, vici, veni redux. Latin for: "We came, we saw, we conquered-and we came again."

I'd get so hammered when I hung with the Dolls. Johnny Thunders, who was one of the guitar players, used to go out with a twin named Lisa whose sister, Teresa, was very sweet. She and I dated long enough to eventually marry and have two beautiful children. Twins again. Ain't it funny?

Johnny Thunders was so out there. His addictions took him to graffitiing the ceilings of his hotel bathrooms with his own blood. His girlfriend had stories about walking into hotel bathrooms and seeing his initials on the ceiling. I call that dancing with the devil. He's died since, as have quite a few members of the band—they were hell-bent on self-destruction. Unlike the Dolls, we came up for air once in a while. At least early on.

It took us a few more years to implode, but even then we kept on going. Music was our fuse, and drugs were the match. Like a Roman candle that would shoot out seven flaming stars, each one an album for us, we were used to living and surviving the cosmic sway. Drugs to me were like a black hole . . . I was attracted to it and wasn't afraid to have it take me to the other side.

Around this time an unearthly creature came into my life. I first met Cyrinda Foxe when I was cruising the streets of the lower Village with David Johansen. She was gorgeous and glamorous, white hot (with a whisper of Norma Jean) with candyfloss blond hair. She was married to and consumed by David but devoured me with her eyes. I would sit there and watch her and wonder, "What the fuck is going on with these two?" This insatiable fox named Cyrinda was best friends with Joe's wife, Elyssa, who knew exactly what was going on between us and invited her on tour with the band.

While all this was going down, Cyrinda played lovely Lolita and we played cat and mouse for months on and off tour. She wouldn't let me near her. You want it? Can't have it! She was interested in my rock star catnip.

As the fame got more chaotic, we needed to get more organized. We used to keep all our expensive equipment in our Mr.

Natural truck and leave it out on the street, which wasn't such a great idea. After a while, Ray found us a building for forty thousand dollars and we bought it to store our equipment, record in, and turn into Mission Control. Ray ran all the merchandise and mail order and fan club stuff out of there. It was in Waltham, Massachusetts, right next to Moe Blacks, and we called it the Wherehouse. Raymond was always thinking ahead, perhaps sometimes with the wrong head, but a head nonetheless.

On Halloween, he put a party together for the grand opening of the Wherehouse and invited everybody who was anybody and anybody they knew. We set up the loading dock like a Moulin Rouge street scene. . . . French maids waiting on tables in fishnet stockings, berets, and long black cigarette holders and an entourage that included a midget in a skunk suit claiming he was Pepe Le Pew, just to piss off the party crashers. Ray's office, upstairs, was ground zero. In that room alone, we snorted half of Peru.

The Wherehouse was so big you could park cars in it, which all of the band did. It was big enough to house a tractor trailer, which is exactly what we did. We brought in the Record Plant's mobile unit, and that's where we recorded *Rocks*, our fourth album.

During the recording sessions, a guy from Columbia Records always had to be there. He wore a white jacket and was supposed to be like an engineer. The union forced us to have him there for the sessions. "Nobody's Fault" from that album was one of the highlights of my creative career. If you listen really close to the front of "Nobody's Fault," there isn't an intro to the song. I suggested to Joe that he turn his amp volume to 12 and the volume on his guitar off. Since the key of the song was an E, I suggested he start by fingering a D chord, and then turn the volume knob all the way up slowly. I told Brad to play an A chord, same dealio as Joe. Then Joe played a C, did the same thing—Brad played a G, Joe played a B-flat, Brad played an F, Joe played an A-flat, Brad played an E-flat, and then Joe and Brad both played a D chord. And when they played that D together, rolling the volume knob up with their pinkies—and holding it for a second—then the band came in on a crashing E chord like Hitler was at the door. I looked over and Jack Douglas was internally hemorrhaging with bliss.

I was in the middle of the room with my headphones on (which we called "cans") and a live mic in front of me, because I loved singing live vocals as the band tracked. It always seemed to incite a little riot inside of everyone. Right before the band came in on the downbeat, the union engineer from Columbia marked his presence for all time by opening the door right in the middle of that sweet silence. He had a clarinet in his hand that wound up on the front of "Pandora's Box," but that's another story. You can actually hear the door opening in "Nobody's Fault" to this day and it somehow seems to get louder and louder with each play, only 'cause you know it's there now. Joe and I always loved to leave in spontaneous mistakes—that was our credo. Jack loved them, too.

While you were making an album you'd find out things the Beatles had done on their records, sound effects and distortions, and how they got those effects by slamming a trunk or playing tracks backward. Jack and I were really into that. We put our amps in the hallway for "Train Kept a-Rollin'" and "Seasons of Wither" and stole the audience sound from *The Concert at Bangladesh* at Madison Square Garden.

For "Back in the Saddle," the first track on *Rocks*, I had a bunch of ideas. Jack and I thought of marching boots on a bigass piece of plywood. I wanted to bring in the cowboy boots I used to wear with the buttons on the side from high school. We got the plywood and I was about to put the tambourine on my boots for that extra-added special effect when David Johansen appeared and proceeded to help me gaffer-tape the tambourine to my boots, and I became "Mr. Tambourine Man." Thank you,

Bob. David was cool, but I couldn't help sitting there thinking, God, your wife is as fine as wine!

You can hear the stomping after the verse . . .

Riding into town by the light of the moon (stomp, stomp, stomp) Looking for ol' Sukie Jones, she crazy horse saloon (stomp, stomp, stomp)

After those lines I would stomp with my feet on the plywood. In the prechorus you'll hear "*I'm BACK in the saddle a-gaiain*" with the sound of my tambourine boots on the plywood. Jack and engineer Jay Messina double-tracked it, then tripletracked it so it sounded like an army marching . . .

Peelin' off my boots and chaps, I'm saddle sore Four bits gets you time in the racks, they scream for more

The next line went "Fools gold out of their mines." I figured people would just think it was "Fools go out of their minds." Then comes . . .

The girls are soakin' wet, no tongue's drier than mine I'll come when I get baaaaaaccckkkkkk...

And then, if you listen really carefully after the next verse, you'll hear a whip sound . . .

I'm calling all the shots tonight, I'm like a loaded gun Peelin' off my boots and chaps, I'm saddle sore Four bits gets you time in the racks, I scream for more

The title of the song evoked riding a horse into the sunset, so I wanted the sound of a lariat and a whip. I set up two Neumann U80 mics and placed them twenty feet apart, got in the middle, grabbed a guitar cord, and said, "Turn on the mics," whereupon I whipped the cord around my head letting it out ten feet, eleven, twelve, thirteen . . . till it got out as close as it could to the mics without hitting them. So in the mix, Jack panned the whip from the left speaker to the right speaker. I'd call that ear candy.

At the end of the song, you hear the clomping sound of horses' hooves galloping. I used two coconuts I stole off a mermaid's chest. Actually, they were part of a percussion kit I got from SIR Studios. When we did "Sweet Emotion," I asked for that same kit but they forgot the maracas. So if you listen to the front of "Sweet E," you hear that *chicka, chicka, chicka*? That's not maracas. Some guy at the studio left a packet of sugar on the console. I took the packet of sugar, held it up to the Neumann, Jack said, "Go ahead," and I shook the sugar. And that's the opening of "Sweet E."That *was* sweet!

"Back in the Saddle" I hoped would be nostalgic, hearkening to the spirit of every Spaghetti Western I ever saw. The band played like the gods they were. Jack mixed it with Jay in the way you hear it today.

I wrote "Rats in the Cellar" as a tip of the hat, or an answer to "Toys in the Attic." Rat/cellar—toys/attic. Meanwhile, in real life, "Rats" was more like what was actually going on. Things were coming apart, sanity was scurrying south, caution was flung to the winds, and little by little chaos was permanently moving in.

Goin' under, rats in the cellar Goin' under, skin's turnin' yellow Nose is runny, losin' my connection Losin' money, getting no affection

New York City blues East Side, West Side blues Throw me in the slam Catch me if you can

Believe That you're wearing Tearing me apart

Safe complaining, 'cause everything's rotten Go insanin', and ain't a thing forgotten Feelin' cozy, rats in the cellar Cheeks are rosy, skin's turning yellow Loose and soggy, lookin' rather lazy

See my body, pushin' up the daisies

As time goes by, everything gets more chaotic: three shows in a row, one meet-and-greet (we called 'em "press the meat") after another, every night, as the fun of it all came crashing in. It felt like the band was traveling a million miles a year, stopping at every galaxy, leaving our cosmic fingerprint and celestial scent as a little something for everyone to remember us by.

The stadiums we played were getting bigger. Backstage setups became more elaborate. When we performed at the Cow Palace in San Francisco, there were pinball machines and ridiculously slammin' naked mannequins that lined the hallways from the stage to our dressing rooms. You could only imagine how the wives loved that. In May '76 we played to eighty thousand fans at the Pontiac Metropolitan Stadium in Pontiac, Michigan. The drugs were becoming more serious, too, and not just among the band and the crew. We rocked the Motor City for a little over ninety minutes. It seemed about one fan a minute got taken out of the stadium from an OD—Quaaludes and booze mostly.

June 18, 1976. Mid-South Coliseum, Memphis, Tennessee—the infamous Memphis bust. I'm onstage, going, "Motherfuckin' this and motherfuckin' that," my usual stage rap, but on this particular eve in this particular southern city, the cops didn't like it one bit. Apparently there was a law against profanity. Who knew?! They told me to stop swearing or else. Or else *what*? Don't they know that's only going to *encourage* me? I was told, "If you cuss one more time. . . ." I said, "Like what?" And they said, "Well, *shit* and *fuck*." And I said, "But *those are lyrics in* our songs!" The cop didn't really like us a whole lot, so I said, "All right, I'll do my best." He goes, "Do your best? If you cuss, we're throwing you in jail. And if you think we're fucking with ya, try us out. We'll *lock you up for a month*. We ain't like the way they are up north!"

I couldn't help myself, so I laid it down and said a few more choice words. . . . Our tour manager came up in between songs and said, "The cops are waiting for you. After the show, you're gonna get arrested." I was sufficiently drunk, to say the least. "Okay, no prob . . . tell 'em I'll meet 'em in my dressing room." And we went into "Mama Kin," and before the song was over I told our tour manager to "Give me a blackout at the end of 'Mama Kin.'" I waited for the right moment, and during the blackout I jumped off the front of the stage, ran all the way up the aisle and into the lobby, and they came from everywhere, four directions—here, there, and everywhere. Guns a-blazing . . . all to my head. Knocked me to the ground. "Boy, you're under arrest! We gon fuck you up. You try to run, we're gonna . . . "I was frozen in my tracks and scared shitless.

One of the white cops said, "You ain't getting away with it like some of the niggers around here." And I said, "How dare you fuckin' say that! Don't you know the word *nigger* was invented by white folks that *hate*?" Thrown to my stomach, foot on my neck, and with a gun to my head, he said, "Now you're gettin' double for saying the word *fuck*." They grabbed me and threw me into the back of the car, and I wound up in a cold, dank cell for three hours. My lawyer called up and found out they set the bail for ten grand. Later, back at the hotel, smokin' a bone, I thought to myself, *Sweet Jesus, I'll never do that again*, then looked in the mirror, smiled, and said to myself, *Oh, yes I will*.

After my short-term incarceration, I got back to my room and as usual it was party central. We threw the girls out of the room and the TVs out the window into the pool. If you kept the extension cords on the TVs, when they hit the water they exploded like depth charges. We sent down our security guy to make sure there were no people in the pool who might get fried. No soup for the roadies that night.

I don't know if I can remember all the times I was arrested. There was a bust in Philly, there was a bust in Memphis, there was the time Joey and I were busted for setting off firecrackers at the Holiday Inn in Lincoln, Nebraska. And then there was the bust of Bebe Buell. She was a gorgeous model that caught my eye and ear at a club one night in New York City. Her reputation (like mine) preceded her. Mine being a rock star . . . hers, *dating* rock stars. And what a roster she had. The thought that I could make her Top 10 made my Dick Clark.

Bebe's best friend, Liz Derringer (tuning-ax prodigy Rick's wife), was chewing my ear off at a club. Liz mentioned that Bebe didn't have a composite sheet—that being an eight-by-ten glossy proof sheet of her beauty that would open doors and hopefully land her in the big time. Overhearing that, I wrote her out a check on the spot for three grand to cover the composite and with hopes a kiss would follow. Liz let us stay at her apartment on a double-sized pullout bed in her living room where we proceeded to cause the first New York blackout. But even that didn't stop us from sucking the juice out of Manhattan. I had never been in that much love in my life. I didn't know what to do with it all. But God did. She gave us a love child from heaven above, my beautiful Liv. We were on fire, and I got to tour Germany—with Bebe Buell on my arm.

I'd been on the exhausting flights to Europe many times before, but because I was with Bebe, I actually arrived before I took off. It was the shortest flight ever, in the sweetest kind of way. When we arrived, the press and the fans were so there, we had to get whisked to a back room to clear immigration. They searched Bebe as if she were Marlene Dietrich. I, on the other hand, a skinny-assed rock star, was the poster child for all orifice checking at every border. I had Bebe draw a W on each of my ass cheeks in red lipstick on the plane prior to landing so when they checked me and asked me to bend over, it would read "WOW" in any language. There I was, finally figuring out I had the power to communicate beyond my music.

Unfortunately, Marlene and my WOW wound us both up in the interrogation room, surrounded by blue-eyed blondes wearing white rubber gloves. Unbeknownst to them, my hash coffin was stashed in my sock. The border cop said, "Vot eese dees?" I replied, "What the???" Raising his voice, he put it closer to my face. Again, "VOT EESE DEES?" And I fumbled back, "Whatinthewhatthe?" Then, even closer to my face, at which time . . . I blew into the hash coffin as hard as I could, and the hash went flying everywhere! I was grabbed by my scrawny neck and handcuffed, and we wound up in a local slammer but were soon released for fear that we might apply for German citizenship . . . and the promoter's terror that the festival would break out in riots, because we were headlining—and you can't headline without a lead singer, no matter what country you're in.

Bebe was with us when we saw Paul McCartney and Wings at the famous Wembley Stadium in London. Backstage, Paul and Linda are in this tiny dressing room. Bebe walks in and had some nickname for Linda. "Sluggo," she says. "Sluggett," fires back Mrs. Beatle. Then they fucking went at each other and started wrestling on the floor. When they finished their friendly skirmish, I went to the bathroom. I'm peeing when I look to my right and eight stalls down is Paul McCartney, who looks at me and goes, "I like your music, man." I haven't pissed right since!

I'd like to think it was because of my Cherubic Behavior that I landed on the cover of *Rolling Stone*, but I . . . semimodestly digress. WE got on the August 24, 1976, cover of *Rolling Stone*

STEVEN TYLER

because Aerosmith had pulled Excalibur out of the stone. I was in a bungalow at the Chateau Marmont just below the Sunset Strip. Annie Leibovitz-bigger than big and soon to be biggershowed up to shoot "moi." If my daddy could see me now! Well, maybe not. It had to be five in the morning and I was out of dope. I'd had two hours of sleep from the night before. Annie promised that as soon as she got her shot . . . I'd get my shot. I told Annie, "Look, we need to go out and cop some shit right now so I can get straight." "Okay," she said, "but look, just take your shirt off and lie down on the bed for a second. Just do this for me. It'll take five minutes, come on, honey! And then we'll go get it. I know someone that's got some really good shit. They know Belushi and they're right around the corner." By now, I'm like Pavlov's dog, salivating with a raging schooner. I leaned back on the bed and she got her shot . . . raw, razzled, and real. She was beyond good. Annie knew what she wanted and got it. And I didn't. Nope . . . no dope for Stevie. I went home with my tail between my legs.

Please, I just got to talk to you Please, get yo' head out of the loo Please, you long, long way from home Please, you'd turn a young man's heart to stone

Sick as a dog, what's your story? Sick as a dog, mmm . . . Cat got yer tongue?

Next stop, Japan . . . Reminiscent of the sixties Beatlemania, we were welcomed with hysteria. As soon as we got off the plane, there were hundreds of screaming fans in the terminal, so many that we had to be lifted over their heads, like Cleopatra's arrival at the bedside of Marc Antony. Their screams were almost deafening at the airport as at the Budokan where we played four sold-out shows in a row. If only management had had the fore-

sight to tape those shows instead of rolling up dollars and getting laid on our dime, we might have beaten Cheap Trick to their Budokan punch. Which, by the way, was a great record. A live vinyl classic.

We were terrified to get high in Japan, and drug desperation set in. Elyssa's mantra was always "Let's go shopping!" So Joe, Elyssa, and Henry Smith went out to see what was out there and ended up in an antiques store. In the window of the shop was an old clay pipe with a curved stem. Well, that looked promising, ancient drug paraphernalia, and Elyssa said, "I want that!" So Joe bought it for her and brought it back to the hotel. Joe handed it to Henry. "You do it first," says Henry, because he didn't know what might be in it. Joe turns the pipe upside down, lights a big bunch of matches all at once, and proceeds to inhale. Holy Edgar Allen POEpium! It *was* opium.

He exhaled and the whole neighborhood got high. I even got a buzz and I was six floors above Joe!

Joe then slams the pipe on the table and, using his instinctive drug-user expertise, he digs out the black residue from inside the pipe. Like the fine artisan he is, he exhumes every smidgen to leave nary a trace of opi-yum in the ancient artifact. The room reeked from the unique, sweet smell of opium. They got a contact high from the countless lips that had kissed that pipe before. Within the hour, they were all projectile vomiting. "That's some good shit," Joe said. And they all pipe dreamed till dawn's early light.

The drug drought had been severe overseas—people's eyeballs were squeaking, and if there was any white substance on the corner of anyone's mouth it was left over from a week-old Dunkin Donut. It created maniac cravings for everyone; so on the way back we decided to stop in Hawaii and refresh ourselves. Kelly orchestrated with Krebs to accommodate the band's so-called well-earned needs. We had somebody go to Boston to pick up a slope's worth of snow and fly it to Hawaii, straight to the room we'd booked at the Holiday Inn. At the airport there was a mountain of bags from the Japanese tour. Somebody's job

STEVEN TYLER

was to stay and be on bag duty, but with bag drag and in a coke frenzy . . . it was like, "Fuck the bags." They made a beeline for the hotel, where Kelly took the mirror off the wall and put it on the bed. We laid out the ounce of blow and with an ace of spades playing card proceeded to chop out the names of everyone in the room. Ed got a weak bump. But Tulio Eppa Galucci can't feel his nose to this day.

In the spring of 1977 David Krebs had this bright idea that for our next record we should be insulated from the big, wicked city, away from temptation and drugs. Dream on! A geographical cure? Fuck me! Drugs can be imported, David . . . we have our resources. Dealers *deliver*! Hiding us away in a three-hundredroom former convent was a prescription for total lunacy. Perhaps it was their *plan* to drive us crazy. Not a chance.

Jack and the band designed every nuance for our own type of Deep Purple *Smoke on the Water* album experience. Rebuild a Studio A inside, out of the Record Plant mobile studio outside. Bring in the Grateful Dead's culinary entourage—cooks at our beck and call (not that anyone was eating—sniff sniff) and dealers at every doorstep. It was called the Cenacle, an estate near Armonk, New York, and what got the band members into the idea was that it was pitched to us as a castle. But the only thing remotely resembling a medieval castle was the large fieldstone water tower. Other than that the Cenacle was just a big institutional building with lots of tiny rooms, covered in cobwebs, and probably haunted. What a fiendish plan.

The Cenacle, a reference to the upper room where the Last Supper was held. Holy shit! I held court in my own mind up there. I was judge, jury, and instigator of all the lunacy that took place within the dysfunctional band family paradigm and the prayers left by the nuns unanswered. The silence was deafening, not even a face in a jar by the door. Just my own mind trying desperately to decipher the leftover realities of an abandoned nunnery. Quick—

185

see if you can find some rhyme and reason to that, Steven.

I fantasized about being Keith Richards in the south of France playing slide with a freshly broken-off bottleneck from a slammin' vintage Lafite Rothschild that I'd just guzzled in homage to a vibe that I so fucking badly needed—to intimately feel like I was recording at Chopin's mansion where Elton John birthed his classic *Honky Chateau*. I needed to get drunk on the placentic creative juices of my own musical imagination. A paradox of Creation—with delicious contradictions to create a fertile mind-set that I needed to embrace in order to occupy my own mental Cenacle and make this record real.

A stoned-out rock star in his tattered satin rags lying on the ancient stone floor of a castle—slightly mad, but still capable of conjuring up a revolutionary album that would astound the ears of the ones who heard it and make the critics cringe. Still, that medieval fantasy must have seeped into my subconscious one enchanted evening when I wrote "Kings And Queens"...

Oh I know I Lived this life before Somehow know now Truths I must be sure Tossin', turnin', nightmares burnin' Dreams of swords in hand Sailing ships, the viking spits The blood of father's land Only to deceive

The Cenacle was Aerosmith at its most extreme in its high middle period—it was just over the top! We mentally and physically took the place over. Long before cellulars, we hard-wired phones in every room. We had a huge kitchen, a dining room, a place for the crew to sleep and work, and our massive Studio A along with smaller rooms for Jack to get sounds in. We ran a hundred feet of barbed wire to microphones in the chapel, where Joey's drums were set up on the altar. And Jack Douglas exorcised Joey's ass into the middle of next week working on drum parts to, of all things, a song called "Critical Mass."

Some of us lived and breathed the Cenacle, and some of us simply went home at the end of the day. That never sat well with me. So if the recording day started at 4:00 P.M., Joey wasn't done till six in the morning anyway. To snort or not to snort? That wasn't even a question. *Blow* and more blow to the point of *krell meltdown*. Joey achieved critical mass the night he hit a guardrail at 4:00 A.M. in his black 308 GTB Ferrari, foolishly passing up the blow we had offered him so he could stay awake. He was still totally burned, totally stoned, and when he totaled his car—by some miracle—he was all right.

It was an incredibly creepy place . . . very poorly lit. There wasn't much to whatever lighting was left in the place, so it was a lot of big dark living rooms and a lot of long hallways—a cavernous, grim place, especially at night. And then there were the little tiny rooms where the nuns had slept. I would walk into each room and go, "Rrrrrright," cause there was a bed, a chair, a window—and that's it. Methinks frequent visits were made to one's next-door cubicle. Fast and quickly in the wee hours of the morning, methinks. And the *freakquent* flier miles the sisters ran up . . . God only knows! If you marry divinity and deny your humanity, something's gonna give. They were there before us and I waited patiently for divine intervention so I could tap into some of their sacred ether. And I thought to myself, THE THINGS THAT COME TO THOSE THAT WAIT MAY BE THE THINGS LEFT BY THOSE WHO GOT THEIRS FIRST.

If you ever had to go get something in the kitchen in the middle of the night, it was a trip across the Sahara, never mind finding your way back. So we put little fridges in each guy's room, but to go to the kitchen to get something, you had to go into this dark, dank basement. It was like the setting for a Roger Corman movie . . . and then the vampires settled in. All in our minds, of course, but what an hors d'oeuvre for the main course to come.

187

It's always interesting the way other people—those outside our coven—see us in times of extremes. The cartoonist Al Hirschfeld came up while we were there and drew the caricature of the group that's on the cover of *Draw the Line*. He really nailed us. We look like freakish botanical specimens pinned under glass. *Draw the Line*—it was the perfect title for the way we were living. I always went too far and was often reminded that I never knew where to draw the line. I hated to hear that, but that's how it was. Say "Don't do it," and we would do it. 'Cause I knew that if you don't know where to draw the line, then your choices become infinite.

Joe had this lick he wrote on a six-string bass that was so definitive, the song just about wrote itself. It reached down my neck and grabbed the lyrics out of my throat. The way the band played that track was off the Richter scale as the energy of *that* song defined our very existence at that time.

Checkmate, honey, beat you at your own damn game No dice, honey, I'm livin' on an astral plane Feet's on the ground, and your head's goin' down the drain Oh, heads I win, tails you lose, to the never mind When to draw the line

All this and the Grateful Dead's cooks in the kitchen! There were two or three girls crafting midnight munchies on the big old stove while growing pot in the basement. That's all we knew about them—that they had cooked for the Dead. It wasn't very good food . . . and it was dosed. They'd put assorted drugs in our dinners. We never knew what was coming. One time they made pot brownies and Joey got so stoned he couldn't record that night. We started buying our own food. Man must choose his poison . . . not be surprised by it in his soup.

Every other day Henry would take my Porsche and go to Happy Town, New York City, or Westport, pick up an ounce of blow, drive back, split it up among the gang. And when our vials got to the bottom, everybody hit on Tom, 'cause he always had some stashed in his sock. The next day, it was, "Fuck, we need more." One of the road crew would borrow a car, go back to Let's Make a Deal, cop the shit, and come back to the Cenacle. Ground Hog Day kind of defined our lives, minus the alarm clock and Sonny and Cher. Every now and then we'd have a guy deliver. Room service personified. I'll have a cheeseburger and a side o' blow, please. He'd show up, we'd play him a track to wow him, snort a Buick, and send him on his way.

We were all on different floors to keep each of our selfindulgent secrets to ourselves, wrapped in the shroud of "I need my privacy." In the attic of the mansion, Joe had set up a shooting gallery, but this one was with guns. Joe had a single-action .22 rifle and I had the sister pistol, a Walther PPK 380; I'd given the brother gun to Keith Richards in New York in the guest bedroom of Freddie Sessler's apartment on Keef's thirty-sixth birthday . . . along with a giant gratuitous four-way horse tab of methadone.

I would hide lines under ashtrays and various places in the room so nobody would find them. Rabbit and Henry Smith, our two trusted roadies, knew that Ray would sneak into my room and vacuum the floor with his schnoz. He could snort a jockey off a horse and suck the Formica off my kitchen table. So one day, after finding that even my bed had been Hoovered, I laid a line of Ajax on the kitchen sink under a doily left behind by one of the sisters. I was downstairs recording a vocal of "Draw the Line" when he screamed loud enough to be heard all the way back in Peru. We left it on the album, it was such a shriek; we comped it and mixed it into one of the guitar player's feedback tracks. It was E to the Z... EW TWEEDLE-E-DEE.

And then there was cocaine's nasty stepsister—BORE-DOM. In my more crazed phase at the Cenacle—in the space between my mind and where rumors lived—I began to secretly tape people who were saying shit about me behind my back. Fuck looking through the peephole of your apartment and seeing the CIA, aliens, and J. Edgar Hoover in drag (HOLY SHIT, THEY'RE OUT THERE!), they were talking about me. I had bought some wireless bugging devices in Japan with transmitters that had voice-activated microphones. I'd strategically strewn them everywhere and soon was listening to them talking about how she'd screamed the night before (instead of me on "Milk Cow Blues"). The crew called them Tokyo Spiders; they would find them all over the place—they were usually pretty obvious. I thought I was paranoid thinking they were talking about me. Just imagine how paranoid I felt when I heard that story. Well, it's a he-said-she-said kinda story, because I never planted anything! And the only time I saw Tokyo Spider, she was blowing Ping-Pong balls out of her gynie in a strip club.

Just how shattered we got lives in the tracks of "Bright Light Fright"...

Livin' on Gucci wearing Yves St. Laurent Barely stay on 'cause I'm so fucking gaunt

Best lyric Joe Perry ever wrote. It was the truth, it was clever, and it described us to a tee.

We had a hard time making *Draw the Line* because of all the mountains of blow we had climbed with backpacks full of heroin and Tuinals. And when that becomes more important than the music, that's when I should have drawn the line. I was up to four or five Tuinals a day, and David Johansen was bringing the Mexican black tar for Joe. It was all for one, one for all . . . and me for myself. Everybody was waking up at different times. We were told to get to the studio at noon, but the band wouldn't show up till seven or eight in the evening. Sometimes I wouldn't get there until much later. I might show up at five in the morning and want to start recording just as Joe was leaving. For the crew it was a tag team—and someone always got the graveyard shift. That's when I did my best vocals with Jack. There was no sense to me being there for Joe's recording hours. He never wanted to

record his tracks until I was finished with my vocals anyway. And they called my shit LSD! Talk about Lead Singer Disorder? Joe, knowing it would take me weeks to write the lyrics and sing the vocals, would use that time to get lost in Elyssa.

Me? I did my fair share of Houdini. I would disappear into my Bela Lugosi boudoir, like Boris Karloff and the bride of Frankenstein. I wouldn't come out until an angry mob arrived with pitchforks and burning torches. I didn't realize until ten years later that it was Brad, Tom, and Joey. Days went by without anybody recording, or even playing. I was used to writing to riffs, but now there weren't any riffs to write to.

With *Draw the Line* we were trying to do the album we started at the Cenacle and tour at the same time. It took six months to do and cost half a million dollars. We'd go to, like, AIR Studios in London and do a session and then we'd go to Germany and do a concert. The crew would drive all night to a session at some other studio and we'd show up burned to a crisp in the wee wee hours of the yawn. "Hurry up and wait," it seemed.

All the big worms in the Big Apple came out to help us Draw the Line . . . from Johnny Thunders to John Belushi to John Lennon. One night, looking for some rock in a hard place, Belushi and I went panning for gold after a twelve-hour session. We were so obsessed with copping that night, when the cabdriver asked Belushi, "Where ya headin'?" he answered simply (and loudly), "Cocaine!" I'd get in the cab with him and the drivers would say, "Hey, aren't you—?" Belushi was beyond famous for being the Samurai guy on Saturday Night Live. But all we wanted to do was chop out lines with that sword.

The negativity and the drama sucked the creativity out of the marrow of my bones. I was down and Jack knew it. What drugs couldn't fix, maybe a change of scenery would. "Come stay at my house and we'll finish the album together." Even that was like pulling teeth—when you don't have any. When you're that high, inspiration can be like standing in the middle of a rainbow,

writing lyrics you never thought you could write, and blaming it all on the buzz. But then the day comes when you come to realize that even rainbows get the blues.

You wake up in a dead-end alley having committed the ultimate sin, letting the right ones out and the wrong ones in, and even with a royal flush, you can't win.

Going on the road with an unfinished album. Oh, it must be my fault. So now I'm on tour with people J Don't Even Like (including myself).

So how could someone so broken not fall so in love with David Johansen's main doll, Cyrinda? What a beautiful name, Cyrinda Foxe, and what a fox she was. I was on the chase for four months after we met in the Village in '76. I was wounded and beaten from the band, the drugs, and the road, and in a hopeless romantic moment, I borrowed from Humphrey Bogart . . . "Are you guys getting along? Are you two really in love? Do you think you could fall for a guy that doesn't wear lipstick? If I told you you had a beautiful body, would you hold it against me?" What a grouch I was. She looked at me and blushed. "David's a different kind of guy. Heee's &#^^@^)@&%@\$!*&, and not only that, he's #&^#!%^& up. . . ." My "in" was that Cyrinda was really close with Elyssa and Joe. The triangulation between those three was like playing hockey in a sandbox, but once Elyssa invited Cyrinda on tour, I was on the road to Casablanca. Joe was against it, Elyssa was all for Cyrinda's cock teasing.

But she was a strange bird, that Cyrinda. She was a Warhol girl . . . had a part in his film *Bad*. She could Marilyn my Monroe one minute, and the next, Cruella my Deville. And then out of that love came the sweetest love of all, Mia. The rumor mill was cranking out bullshit in overdrive. She was on the cover of *Life*, and I loved her to Death. She worked for Warhol; I was an ass-hole. She was always too dramatic,

and I was known as a drugged-out addict. The one thing they couldn't write—and didn't even think of—was what *we were*, and *that was* In Love.

I knew that because we were both on fire was why the rumors kept burning. The "I'm going to take him for all he's worth" type shit melted by the wayside. Cyrinda was trying to be the wisecracking, gum-chewing, Lolita-type blonde—but she wasn't born yesterday. Sometimes a lost childhood can erode your innocence. By the time Cyrinda was twelve, she was already twenty-five. She could be bittersweet, wouldn't let you get away with anything; sharp as a tack and ferociously to the point. So to the point, they called her "Syringa." She told me that when she was thirteen, she'd walk along the beach in L.A. with needles stashed in her bobby socks and sell them to speed freaks.

Where do you go from there? I know I've developed obsessions . . . but I'm not obsessed. But I'm not obsessed. But I'm not obsessed. But I'm not obsessed. . . . I'm not sure whether I'm obsessive-compulsive, but I'm definitely obsessive-*im*pulsive. In courting Joan Jett while on tour with her, I would strip bare naked, put on a robe, pull the chair from near the elevator all the way over to the end of the hall, pushing it to right in front of her door. I'd then take my robe off and, sitting spread-eagled, ring the doorbell and wait for her to open it. She'd open the door and her jaw would hit the floor as I said, "I hate myself for loving you." She gave me that look that I really wanted to see and responded in her best Mae West velvety growl, "I'm not into the big ten-inch, honey," and slammed the door.

But as all-consuming obsessions go, Cyrinda was my greatest. Why? you ask. 'Cause she was a good bad Catholic girl. And she laid it on heavy. God knows, I thought, I wanted it so bad, but she wouldn't let me have it. "Don't touch me there, God is watching." Okay. "You can't kiss me there, I'm still married. God is watching." Okay. "Can I put my finger in your holy water?" Smack! I guess not. Now, you guys might not believe this, but God knows that we actually held out and waited to make love

until her divorce with David was finalized. The waiting was beyond worth it . . . and actually Divine. Because that was the night Mia was conceived.

We were still working on *Draw the Line* when, in August of '77, we went on tour to Germany. It was a Mudfest run by Mama Concerts. At Bilzen Jazz Festival in Belgium, the promoter showed up in a horse-drawn caravan, and as soon as the show began he took off, like the coachman in a Dracula movie. The backstage catering was roast pig. If you wanted cream in your coffee, they tied a goat to your table and said, "Milk away, *svine-hunt.*" Eighty thousand people with mud up to their knees! We had to get the fire department to pull our bus out of the bogs. To make matters worse—after we were promised the world, our road crew wound up getting a stein of beer and a cold bratwurst. One of our crew guys climbed into the promoter's trailer and took a shit on his desk. Leaving a little something for him to remember us by. It gave new meaning to the term . . . Mudfest. Holy SOURbraten.

To make matters bratwurst, I ran out of dope, and Joe conveniently said he didn't have any. That's an old story that goes deep with this band, and I know you can't always get what you want, but you'd think . . . brother, I'm fronting your band, can't you fucking front me some dope???

The Lorelei Festival was one of the worst gigs I'd ever done and almost put an end to the tour. Over there, it was our first introduction to a German audience, which in this case was half American servicemen. We went on at two o'clock in the morning. It's on the banks of the Rhine—and it was cold, dark, dank, Eastern European kinda weather. The word *Lorelei* comes from the German river muse whose singing lured men to destruction—and *destroyed* just about described my voice after singing for two hours in the freezing cold rain. I started spitting up blood and damn near passed out onstage

STEVEN TYLER

that night. Oh how I wished I had a roadie to change my strings and a fraulein to rub my gooseneck. I lost my voice, and we had to cancel our show in Sweden and go back to London. We were going to hell in a handbasket . . . without a handbasket.

Sometimes, being on the long and winding road for what seemed like forever, we'd be in the middle of nowhere, in our rooms and out of our minds from the endless days and sleepless nights surrounded by girls with low tooth counts, missing *anything* American. So like the rock stars we were beginning to think we were, we'd bring the U.S. to us. Wherever we were, we'd send out for egg creams from a deli in New York to be flown to Czechoslovakia, but so much got lost in translation that when they arrived, they weren't egg creams at all. It was like receiving a box of monkey nards dipped in tapioca from a country that hadn't been discovered yet.

At this point in our careers, we checked into hotels under pseudonyms. If you used your real name, you'd have a tribute band delivering your room service or a girl larger than your whole family trying to climb through your window. Mentioning the name Aerosmith brought nothing but pain and penicillin. But then what else do you give a band that's got everything?

So we checked in under names like the Shakespearean Players, Upchuck and the Hurlers, or, my favorite, Six Legs and Four Balls (I stole that one from Peter, Paul and Mary). We'd arrive at the Holiday Inn and they'd say, "Welcome, Shakespearean Players!" We would say stuff like "Thank thee, sire" and "Will thou showest us-eth to our roometh?" (Try saying that with crackers in your mouth.) It was out there, but you know, at four in the morning, anything goes.

I'd lose more than my mind on the road—like, for instance, in Europe I once left the rock of Gibralter stashed in the curtain of the hotel we were staying in. I kept it there knowing that if we got busted, no one could pin it on me. Any hotel

is transient. Could have been the guy from the night before. Don't blame it on the American. Blame it on some wandering Gibralteronian.

The band always stayed at their favorite bungalow at the Beverly Hills Hotel when we were in L.A. Mine was Bungalow 12 where I knew Marilyn Monroe had made sweet love to the likes of Arthur Miller, Joe DiMaggio, President Kennedy, and probably his little brother. I heard this from an off-duty officer who drove the doctor away the infamous night she passed. The hotel was a trampoline for the Who's Who of Hollywood all the way down to the Tinseltown trashy. Sure, there were a few folks that got a decent night's sleep at the reclusive retreat . . . but it wasn't me. On any given night the Polo Lounge could be a jumping-off spot for a movie deal, a drug deal, or a cop-a-feel deal. Bunaglow 12 was attached to another room that Joe and I booked as a suite. The only way you knew what bungalow we were in was by the caravan of room service trays lined up outside our door stacked with champagne, fifty-year-old brandy, and enough Beluga and Sevruga caviar to embarrass the Great Gatsby.

The place was always good for freakish and exotic sightings, like Michael Jackson having lunch with his chimp, Bubbles; or David Geffen with Cher skipping up the cobblestone path like Dorothy and the Scarecrow. Here I was, the big-time big-mouth rock 'n' roll singer of Aerosmith, becoming speechless in the face of Lucille Ball, Joni Mitchell, and Lauren Bacall . . . all in the same night on the same path on the way to Bungalow 12.

We were the most decadent, lecherous, sexiest, nastiest band in the land, and yet from time to time I would wonder, *Where are all the beautiful women*? It finally dawned on me twenty years later, after road crews' stories floated to the surface, that those clever fellows were "protecting" us from the hot chicks, blaming it on the wives of the only two guys that were married. "We couldn't let them see her, Steven. But *here's* a girl for you." She, unfortunately, looked like Ernest Borgnine. Gee, thanks, fellas. With friends like that, who needs herpes? Brings us fittingly

back to the first single from *Rocks*, "Last Child," which I wrote with Brad Whitford.

Yes, sir, no, sir Don't come close to my Home sweet home Can't catch no dose Of my hot tail poon tang sweetheart Sweat hog ready to make a silk purse From a J. Paul Getty and his ear With her face in the beer

It's true that we were trying pretty hard not to get any on us and, even more important, that we'd make it home with lust in our eyes. This was the band's rule: you didn't have sex for ten days before the end of the tour. But the reason was so that you'd be sure to go home (sweet home) with a full cup of chowder. You could pull off the lusty eyes bit, but you could never get away with blowing a cup of wind.

June 21, 1977. Fort Wayne, Indiana. Two nights at the Coliseum with AC/DC. First night, I walked from my dressing room down a long hallway with handrails lined with wheelchairs. The second night, walking down that same hallway to a second slammin'sold-out show, instead of fans in wheelchairs, there were a hundred fans handcuffed to the railing. Some were crying, some were screaming. I couldn't believe my own eyes. It was like an Aerosmith concert gone police state. I screamed for Kelly. He told me that they'd all been busted for smoking pot an hour before Aerosmith took the stage. So the first thing I did after the opening number, I walked up to the mic and I said, "I just saw a hundred of your brothers and sisters handcuffed backstage and the cops are getting ready to haul their asses off to jail for getting high." I started calling the cops "scumbags!" and "Gestapo!" It was fucked! The cops told me, "You do any funny business up there, we'll throw your ass in jail, too, for inciting a riot!" And I go, "But, man, that's *my job*!"

The crowd went fucking nuclear. "We're not gonna let that happen."They screamed even louder. "So here's what we're gonna do. We're gonna pay for their bail.... Throw me a joint [it rained pot like a Cheech and Chong thunderstorm] and they'll all be back here before the encore. I promise. We ain't gonna let this happen. Not no more, no more!" As Joe played the intro and I sang...

Blood stains the ivories on my daddy's baby grand Ain't seen the daylight since we started this band

Twenty thousand kids answered with the chorus . . . NO MORE, NO MORE [even louder], NO MORE, NO MORE, NO MORE!

THE HOOD, THE BAD, THE UGLY . . . HAMMERED WITH HEMINGWAY

CHAPTER NINE

al Jam II was held at the Ontario Motor Speedway, sixty miles east of L.A., on March 18, 1978. It was the biggest gig Aerosmith ever did. The thing was Woodstock *huge*. Half a million people if you include the crashers. I knew we were to make history when I looked down from the helicopter five hundred feet up in the air and I couldn't see land—just a sea of people on a two-and-a-half-mile oval track. A small town. Evel Knievel's company painted all the vans that we used to get from the hotel to backstage with the *Draw the Line* album cover on the sides.

We were spread out all over the place. The band was at the Beverly Hills Hotel, the crew was at the Hyatt House, and stagehands were at motels in Ontario. But when we all met in the middle—which was the stage—we were like the United Mistakes of America. Powerful, free, and fucked-up. By day's end, there were seven hundred ODs on angel dust, one rape, and two dozen robberies. Two babies were born the night we played, during what song I'm not sure, but strangely enough, they both resembled Joey Kramer.

We headlined the festival with the top rockers of the day ... Bob Welsh, Dave Mason, Santana, Heart, Ted Nugent, Foreigner, and Mahogany Rush. We'd observed that if you knew what time the sun went down and it wasn't cloudy, as the sky got darker, your lights onstage got brighter and more magical as the set went on. If you played it right—and threw in great songs to go along with God's light show—it was like nothing short of a deity showing up at your gig. All the nuances that a lighting director could never get, that movie crews wait for all day. They call it the "magic hour." We called ours the "witching hour."

So let's for a moment talk about the Scam at Cal Jam. Here I was, waxing on about Mother Nature's klieg lights, when Murphy's Law comes along and says, "Hey, Steve, what a great idea. Do you mind if I fuck it up for you?" Ted Nugent has to have an encore; Foreigner gets two. And don't forget Santana—he gets an encore, too. So by the time Aerosmith got onstage, it was 12:08, eight minutes into the next day. It was so late, even God had left. And the next day a far worse fate befell us—Kelly, having tried to snort every spec of blow at Cal Jam, left Aerosmith.

Rewind to 1977, Aerosmith goes Hollywood!! "They're gonna put me in the movies, they're gonna make a big star out of WE." Thanks, Ringo . . . I mean, Buck. The movie was *Sgt. Pepper's Lonely Hearts Club Band.* To be involved in ANYTHING that was slightly related to the Beatles was a dream come true. But with us, dreams were never quite what they seemed—they were either wet or a nightmare.

"We'll do it!" I said. Then I read the script. And here it comes: I get killed at the end? And by Frampton?

I talked with the film's producer, Robert Stigwood, in his office and had to put on my skis just to get to his desk. After

three hours of me telling him "I'm not gonna be Framptonized," they blew smoke up my ass by telling me I wouldn't die in the movie. They would set my clothes on fire and I'd melt like the Wicked Witch of the West. That was how it was supposed to be.

The most fun I had doing the movie was when I was strangling Strawberry Fields (played by Sandy Farina) with my microphone scarves and she kicked me off the stage and watched me plummet thirty feet into an airbag. Of course I had to do it twenty times . . . just for shits and giggles, 'cause I loved it. Not to mention, as I fell, I could see up Strawberry's shortcake.

The movie was a Hindenberg at the box office. Wait, the dream come true I left out . . . is I got to meet George Martin. We talked about recording "Come Together" at the Record Plant . . . fifteen minutes about the track and fifteen hours about the Beatles. He said he loved our band and was looking forward to working with us in the studio. We did a badass version of the song. I would have believed anything George Martin said. However, he wasn't just charming, he was brilliant and beautiful. I could see all that in his eyes. And I must admit that when I was singing the first verse of "Come Together" and I looked through the glass at Studio A, Record Plant east, it was like for that one nanosecond in time . . . I was John.

In 1978, still waiting for Cyrinda to surrender, I was dating Gretchen, a wild blond mama who later on married one of the guys in Blue Öyster Cult. She was feral and perpetually aroused. She would have at it with herself and me in the back of the limo, which shocked even Rabbit, who was pretty unshockable (and by the way, fucked like the critter that inspired his name). There was a party for the *Sgt. Pepper* film at Studio 54. Ray and his ex-wife Susan were there and at one point Susan came over to Ray and me and said, "You're not going to believe this, but Steven's girlfriend, Gretchen, is flashing her cooha in front of everybody." I said, "What the hell are you talking about?" She said, "Yeah, she's walking around with her dress up, and she's flashing her fish kitten in everybody's face." I couldn't believe it. I went over and confronted Gretchen. She flat out denied it. Gretchen called Susan out. The "fuck you's" went back and forth like Connors and McEnroe at Wimbledon. Meanwhile, Susan's brother, Richard Sanders—who started working for Aerosmith and wound up running his own record label—showed up with a copy of a magazine from the East Village, with a picture of Gretchen—GUESS WHAT?—with her dress up! When I saw that I was so pissed off at her that I broke up with her. You know, looking back on that, I can't believe I left because of her flashing ... when here I am, humping Joe's monitor during "Back in the Saddle" every night.

Outside Studio 54, there was such a mob waiting to get in ... that I jumped up on Kelly's back and rode him to the limo. The paparazzi were flashing their asses off, and a month later the quasi-photo was there with a caption that read, "Being rich means never having to walk again."

This kind of story seeps into the Aerosmithsonyian. You know you've made it when all your friends have the same story, which goes: "I carried him out . . . No, I carried him out! No, we carried him out! Nooooo . . . wait a minute! He carried us out. Paid for our drinks and nailed us all in the ladies' bathroom!" Such was the life at Studio 54.

Cyrinda and I got married on September 1, 1978, at the summit of Trow Hill in Sunapee, after dating for a year. We trudged over the river and through the woods through blueberry wishes to the very top of the mountain. We were up so high that the altitude got us straight. Zunk Buker—the pilot for the plane I owned—had a brother who happened to be a priest. We said our nups, gasped our "I do's," and hightailed it over to King Ridge ski lodge in New London. The reception was fairy-tale perfect. Lilacs and gardenias hung from the rafters as my dad played romantic music from the 1940s. The food, my family, my friends—I'd never kissed so many women with mustaches. The

Italian and Armenian cultural collision was a success and the honeymoon had already begun.

I'd bought a house the year before and a piece of property right on the lake in Sunapee. On that heavenly body of water, I fell so deeply in love with Cyrinda, I felt for the first time in my life that all my dreams had come true. Three days before Christmas 1978, our beautiful daughter, Mia, was born. I could have wished for nothing more in life.

The winter before we married, I'd taken her up to the family digs at Trow-Rico. Got in the Willys Jeep and drove her down to the lake to show off and show her the house. It was ten below and the lake was frozen solid. I headed for Sunapee Harbor and drove right off the dock and onto the ice. It was dusk and almost dark. A half a mile out into the middle of the frozen lake, Cyrinda's screaming like she was on the *Titanic* and it was going down. I spun the Jeep around five times and headed for the shore. When we pulled up in front of the house, I turned on the headlights, and when she saw the house sitting on the water like a Christmas card, she started to cry.

She was a city girl With no responsibility A pretty little city girl All fired up and what's Ah what that girl could to do me

We sat there till the battery went dead, and I said to her, "This will be our house." Then *I* cried.

I know there have been (and I'm sure there will be) more books written about me—from Stephen Davis's *Walk This Way* to Bebe Buell's *Rebel Heart* to Cyrinda Foxe's *Dream On* and Joey Kramer's *Hit Hard*. Sometimes I feel compelled to read parts of these memoirs so I can remember things about me that I don't remember. But on occasion when I read on, I find stories that are so outrageously absurd and blown out of proportion for their own benefit and some insulated truth, I have trouble believing these people ever really blew me . . . oops, I mean knew ME at all. Now I'm not saying that I'm a saint, but I do know some things. And the *me* that I ain't! Probably when I finish writing my memoirs, there will be a million and nine people saying, "I didn't say that! I never did that! **He's crazy!** He used me! He abused me! *Ilove him!* **I hate him!** And I wonder if he could loan me some money!" (No wonder Hemingway drank.) In a book, if you want the truth . . . read between the lines! And in music, it dances between the notes.

Cyrinda wrote a ton of fuckin' things about me—some of which were true, and some of which were lies and kvetching . . . nothing in there that said, "I grew up selling drugs on the beach (I don't know what I was thinking) . . . my mom had sixteen boyfriends and I wound up in a closet crying till I found speed and I shot up."That's what's too bad. But I'd be the first to admit that I would not be who I am without the good, the bad, and the ugly.

Those were the sweetest and the roughest years of remembrance as far I'm concerned: 1977 to 1979. By late '78 the band had begun to disintegrate. Joe and I were fighting more and more. We fought backstage, we fought on the plane . . . we even fought onstage, like good brothers from the Everlys to the Kinks to Oasis. Joe could torment me to death by being so stoned and looking so good. But most of all by playing his guitar on fucking 12. He'd play so loud, even Helen Keller could sing along . . . so loud, in fact, that in order to hear myself, I had to STICK MY FINGER in my ear. Making me so angry, I wanted to SHOVE MY FIST up his ass. From Freddie Mercury to Rod Stewart, they'd all agree that it's just how we'd want to be seen. On the cover of Rolling Stone . . . with our middle finger in our earhole. FUCK ME! That's why God created monitors, In-Ears, and acoustic guitar players. Thank you, Crosby, Stills and Nashville. LS fucking D . . .? In-Deed.

A little-known secret about lead singers with LSD: our disorder comes mainly from not being able to hear ourselves. My job is to sing dis thing called the melody. So in ORDER to sing the melody, I NEED TO HEAR MYSELF sing it.

So then I'd wait and go over and push him around while he was playing, and he would hit me with his guitar. The scuffles didn't start intentionally, but once we got into it, they became an excuse. "You tried to fucking hit me, you fuck." If I got too close and Joe thought I was upstaging him, that's when the games began. Then he'd really try to do it back to me. But you can't reason with somebody when they're that drunk or high-we would play games. I remember once coming really close to punching Joe, but I'm not that kind of a guy, I don't punch people. I never even understood the concept of that. Joe and I really did come close to it a few times—three or four times maybe—but we never deliberately hit each other. One time Joe stuck the end of a guitar string through my lower lip. I spat blood all over him and ended up with a little hole in my cheek. I honestly don't know if he did it on purpose or not. You'd have to ask him on his deathbed. Who knows if he'd even tell you then?

There were times when Joe was not in the best of shape. He would run behind the drum riser when he'd have to sing harmony with Henry—which, with Joe, isn't an easy thing to do. You have to watch Joe's mouth and try and figure out what words were going to come out. Sometimes he'd just make up words; sometimes they weren't even words. Like anybody who sings the same words day after day, month after month, he'd get tired of singing the same old shit. Or a thought would come into his head while he's singing and he'd just spit out a wordlike *sound*.

Somewhere there's a picture of a firecracker going off at the exact moment it hit the stage. A fan mailed the photo in. The flash was going off right between Joe and me at the exact second the M-80 blew up. It was as we were just coming back onto the stage for the encore. I got a singed cornea from that one and Joe cut his hand. The wound on Joe's hand was the shape of a smile,

so Joe drew a face on his hand and he would wiggle it and make it talk. There was the smashed glass bottle at the Spectrum in 1978, which stopped the show. Fans get excited, they get demented. They don't believe we're entirely human and do this stuff to find out if we bleed the same way they would. One time we found a *shuriken*—a fucking ninja throwing star—on the stage.

These are war stories. When you're on tour, short of loss of life and limb—or actual death—you have no time to get sick like a normal person. There are no days off. You're working yourself to death. The only thing that got us through was the cocaine.

For the whole of the seventies we were all nicely fuckedup and deep-fried. There's a photo of me somewhere snorting a huge rail of blow off a picture of myself in a Japanese magazine. What a great way to get high; I snorted my own face.

Blow was our rocket fuel. In the end it takes you down, but it's probably one of the reasons we got as far as we did. We never stopped. We would just blaze through it and fall apart when we got home. You're going home, you hit the ground, your mind tells your body what to do. It knows it's off duty and then chooses to get sick. Bands just don't get sick on the road in general—you're not allowed to.

After a while our off-tour lives became "At Home with the Draculas." We were zombied out on Tuinals and smack. Kelly used to send the security guards to wake us up, one to Joe's house, one to mine. Knock on our doors and if we didn't answer break them down. If we'd been up all night or up all week, okay, go in. If there's no clean clothes, scoop up all the ones on the floor, throw them into a bag, throw us over their shoulders, and put us into the limos and out to the airport . . . that's how we used to get Joe and me on the road in the bad old days.

Kelly'd be out there at the airport waiting. "Oh, shit! Where are they now? I don't see them on the horizon!" One time when Henry was trying to delay the flight, he told the rest of the crew, "Look, do whatever you've got to do . . . start a fight, tell them there's a bomb on the plane, anything you've got to do, because

the band's not here yet and this is the last flight leaving today" for wherever we were going.

All the ticket agent heard was the word *bomb* and he alerted the authorities. We all get on the plane and the door closes. Henry had an ounce of blow on him. It was Allegheny Airlines—they used to have tables on their planes, and we were just about to move up to the front and do the blow on the table. We would snort blow right in front of people back then because no one knew what it was yet. But just then the plane door opens again and airport security, FBI, CIA, everybody else with a badge in the world comes on the plane with this ticket agent and hauls Henry off the plane. Henry also happened to have a suitcase with an ounce of pot in it. Kelly claimed it was his and they never searched it.

They took Henry into custody. The day he went to court we had the band's lawyer, Norman Jacobs, there to represent him. Henry shows up in court early in the morning. The judge looks down at the docket, he's going down the list of cases, and when he comes to Henry's he goes, "Case is dismissed." Turns out the cop who was in charge of the case got shot the night before. He was murdered by a Harvard football player. For a while Henry looked like a desperado who'd had this cop knocked off so he wouldn't go to jail.

By 1978 we'd gone from being nobodies to being a multiplatinum band with four albums in the space of three years. We'd played to as many as half a million people at one time. And we had addictions to match. In the early days we were seen as cash cows—we were worked to death. We did three shows a week, and we were kept going on blow. Do you know what a treadmill is? Well, we spent the whole of the 1970s on one. It was tour—album—tour—album—tour—album. No breaks. Everybody knew what we were doing, and we were a mess. No one ever said, "You guys had better take a break." I was having seizures and passing out on stage. At any time I could've had a heart attack, and people would've looked away and said, "Well,

we didn't know what they were doing." Bullshit! There was so much money floating around that no one cared.

The promoters at our concerts were awash in cash; they had trunks full of money. We sold tickets like crazy. As a present, our accountants framed all the tickets we sold. We must have grossed at least 140 mil, but the members of the band ended up walking away with no more than 3 mil each. I have no hard feelings, but may they roll over in their graves a billion million years from now! That's all I have to say. I look back and I think, "God, man, all we were doing was writing songs, making records, touring." I have a pirate's chest of horror stories of things they've done to my brethren and my band. Unconscionable shit! I look back at that and, in front of Jesus Christ above at Heaven's Gate, I say, "Thank you and fuck you!"

All our tours had official names—and *our* names for them. The Aerosmith Express Tour became the WTB Tour—for Where's the Blow? But as things got worse the crew began giving dire names to the tours: the *Grab Your Ankles* tour, the *Lick the Boots That Kick You* tour. Kelly made up a T-shirt with "Why Can't I Fart Anymore?" on it—meaning we'd all been royally fucked in the ass.

By the time we got to late '78 we were all a little burned. And things started to go awry. We were so fried, we could hear our synapses crackling when we went to sleep. The band fell apart when the crew fell apart. The crew fell apart first and then the band began to unravel. The core rock road dogs began slobbering and howling at the moon. The crew had everything to do with keeping us together. Everyone knew everyone's personalities and how we functioned in our own quirky, dysfunctional way. The sky darkened and we prayed for rain but no rain came—it just all worsened. We were a complex mix of utterly unreasonable people, and the momentum revolved around Kelly, who had left after Cal Jam. That's when I began to wonder, *Why does my house have wheels and my car doesn't?* Aerosmith's core group—Kelly, Rabbit, Henry, Night Bob—kept the band rolling during those crazy times. Rabbit left in '78 and Henry left in 1980.

The roadies started leaving Aerosmith's interstellar probe like rats leaving a sinking ship. Henry Smith said he had to leave the band to keep being friends. Night Bob left to keep his sanity. It was better to step away and remain friends than to stay and work in that infernal mix. It ended up being the better choice, because otherwise I think some of them would have been dead by now.

But we never canceled dates. I'd be in the dressing room freaking out, throwing shit around, and Kelly—designated point guy—would be asking, "What the hell is going on now, you fuck?" I'd be screaming at him, "I want to charter a helicopter *right now*! Call David." David Krebs would be at home making his 15 or 20 percent asleep in his penthouse. He didn't have a clue what was going on while we were banging our heads against the wall, losing our minds. *Everybody* needed time off. But it never occurred to me to cancel. I was Captain Ahab in a mad quest for the Great White Quark. So the gears just kept grinding on.

It just got worse and worse. Too much money. If you want to control people and you know they're weak, you give them money! Trust me when I tell you that. Then drugs took everybody down. It was real bad. Nick the roadie died of cirrhosis, another crew guy hung himself, our dealers were being garroted, stabbed, and given hot shots. I was the crazed lead singer . . . too high for my own good. There were car accidents every day. I broke a Porsche in half up in New Hampshire. Drug demons got inside everything and wrecked everything. Drugs even speeded up the band's rhythm.

And then one night . . .

Between Joe and me there had always been a certain amount of friction due to the biological fact that we're such different personalities. But whatever stories you've read or Joe and everyone else has told—the eighty-thousand-dollar room service bill, the spilt milk, the solo album—the truth of the matter is that after nine years of playing, writing, and recording together I still couldn't get through to Joe. He was in his bubble and I couldn't reach him. He was insulated—by heroin, by Elyssa, by his own fucked-up lack of self-confidence, his inability to see that the band was bigger than his girlfriend, more important than his problems, his drugs. He has a great front, Joe . . . he seems *so cool*—but then don't we all. He needed his woman, Elyssa, who was cool and gorgeous and poisonous.

Elyssa was very caught up in that whole fashion thing, a model wannabe kind of girl, coming back from England with beavers and the black nail polish and all that kind of stuff. Joe was into role-playing as well, and they fed off of each other, they were always into each other's games.

She was so into herself and was easy to provoke. The coup de grâce came when I began to confront Joe about the wall he'd built around himself. I'd had enough: "Joe, do you know who you are?" "Yuh," he mumbled. "There's a hundred girls tonight that would have sucked your cock until a million o'clock! Are you kidding?" I said. "Well, Elyssa loves me," he mumbled back. "Okay, okay, okay, and no one else does?""But Elyssa I can trust." "Wow. All right. Okay. And that's it? That's the end of the story?" Joe didn't know his own self-worth. He didn't get how strong a personality he was onstage, a character right out of rock mythology—the electric god who wants his guitar to sound like a dinosaur eating cars. How great is that? And together we were the Terrible, Toxic Twins. But he could never see that—so in the end he left with her.

The straw that broke the camel's back came on July 28, 1979, at the World Series of Rock at the Cleveland Stadium. We were the headliners on a bill with Ted Nugent, Journey, Thin Lizzy, and AC/DC. Backstage in the trailer Elyssa and Terri Hamilton got into a flaming fight. Elyssa took a glass of milk and chucked it all over Terri. I wasn't there. I heard about it after the show. "What's going on?" I said. Then I got into a fight with Joe.

Joe and I weren't there when the Big Bang occurred . . . we didn't *physically* see it. We came offstage into this Winnebago parked in the back of this hall. I walked in, panting and dripping,

soaking wet, and Elyssa and Terri were screaming at each other. "Get the fuck out of here," I yelled. "Can't you see we're working in here?" That's when I found out that Elyssa had thrown milk at Terri and Terri just wouldn't have it. Elyssa would take no shit from anybody and got off on being that way. And neither would Terri. Tom was *spewing*.

Joe walked in and started stickin' up for Elyssa, but when I saw Terri's clothes all soaked, I got into it with Joe. "Man, can't you come over here and control your woman?" Why does it always have to be like this? Worse than me, and I'm the KING of that. Always startin' fights and bullshitting, but she did that and it's what broke up the band that night. Joe was acting like it was Elyssa's right to do what she did . . . *and* he's saying as much while *Terri's still in the room*. Didn't care. He *liked* that his wife was a troublemaker; he got off knowing that Elyssa could morph into a flaming bitch at the drop of a Mad Hat.

I was *so* drunk (as I was every night after a show), but I remember clearly being on the steps of the trailer, walking down and yelling at Joe, "You're fucking fired!" I don't even know where that Chairman of the Board voice came from. Never spouted off like I was the leader of this band! We were a gang, a unit. But I was just *so* angry! That was the only way I knew how to get Elyssa to stop it. "You're fucking fired, Joe!" You can get into a crazy head space where all you want to say is "Fuck you!" I could have just said, "I'm outta here," but I didn't; instead I said, "You're fired!" Those were the words! I've never actually punched Joe, but that night I came really close.

It was a mess. So much of this is just so radically true. We *completely* fried ourselves. But again, unlike Sid Vicious or the Dolls and other bands that were systematically sabotaging their careers and lives, if one was to spell it out clinically—we were going down that road unconsciously, we were just getting fucked-up and, *incidentally*, sabotaging ourselves. Joe and I had that mulish Italian strain of *stick-to-itiveness;* Joe's not actually Italian, but he's from that island off the coast of Italy, or is it

211

Portugal? With the exception of his guitar volume, he sure the hell doesn't know how to be loud . . . and who the fuck knows how happy he was that night? I sure wasn't.

And thus ended Aerosmith Mach I. It was an insane thing to do after all we'd done to make it. But I had gotten so enraged I'd now destroyed the one thing that had made Aerosmith so powerful, that fine tension that created Aerosmith's feral howl. It didn't matter to Joe that he and I were a team. He didn't care that we'd been together for almost ten years! All he cared about was getting high and being with *her*.

I was that angry with him, so I went, "Fuck you! You're fired. I'm gonna find a new guitar player." And I did. Jimmy Crespo. At least he wasn't Joe Perry . . . the cocksucker.

FOOD POISONING AT A FAMILY PICNIC

t's the fall of 1979—just after the Fall of Aerosmith Mach 1, the departure of Joe fucking Perry. I'm ready to time travel with my carry-on bag of goodies. Into the great unknown, baby. Yep, we're gonna get under the hood. I'm going to tell you the way it was: unexpurgated—that means nothing censored, nothing gained!

Aeromythology was built on the glamour of self-destruction. Self-destruction was great fun—still, I wouldn't want to do it again. Like the old joke about the Viking: "Fuck, not another night of rape and pillage, mate!" Of course, in rock 'n' roll we don't classify debauchery as bad behavior—that comes with the territory. Bad, shameful behavior would be turning up for shows in no fit state to play... and there was plenty of that, too. Don't worry, with this band there was at least another ten years of wretched excess, drug abuse, and hell-bent selfdestruction to come.

Every once in a while, I'll hit on something useful to tell you, especially if I'm talking about a subject that I'm kind of an expert on, like roasting marshmallows. How long the stick

213

should be and how long to leave it in the fire. See, I come from a long line of fact-based, overbearing people.

I was living with Cyrinda in that gray house up in Sunapee, had my Porsche and the Jeep. Mia was a brand-new baby. Scoring drugs had become our principal activity. Cyrinda, my friend Rick, and I would all drive down to Marshfield outside of Boston to get dope. Joe Perry had thrown me onto this dealer before he split the band. Back then in '79, '80, two blocks from Joe's house lived this guy named John we got all our dope from. A three-hour drive! I now live in Marshfield, I moved there in '88. When I go home I get off at the same exit—Exit 12—the same one I used to take when I was scoring dope. Ironic or just moronic?

Alas, I had kicked Joe out of the band in the middle of *Night in the Ruts*, our new album due out fall 1979, and Leber-Krebs were putting pressure on me to finish it. Joe played on "No Surprize," "Chiquita," "Cheesecake," "Three Mile Smile," and "Bone to Bone (Coney Island Whitefish Boy)"—the song I wrote about Joe. A Coney Island whitefish is a rubber. Brad Whitford, Neil Thompson, Jimmy Crespo, and Richie Supa handled guitars on the remaining tracks.

Even before we started I knew what I wanted the title to be: *Night in the Ruts.* I was into switching the initial letters of names and words, like Johnny Ringo into Ronny Jingo, so *Night in the Ruts* is code for *Right in the Nuts.* Back then you couldn't have an album title like that, the censors were all over you. You'd get blipped no matter what . . . you couldn't even sing "Goddammit!" For the cover I'd thought of filling a room with nuts. Twenty or thirty big burlap bags of nuts would cost you, what, eighteen dollars a bag? We'd be standing there up to our waists in nuts. And nobody could argue about the title because we *were* nuts. It was a takeoff on the cover of *The Who Sell Out*, where Roger Daltrey is sitting in a bathtub filled with beans and a surprised look on his face. I ran into Roger later on and asked him, "Were you really sitting in a tub full of beans? What was it like in there? Was it really full to the top or—?" "Nah, they, like, filled it with cloth," he said, "and then the beans on top. I didn't have to sit in all that." Damn.

But in the end we shot the cover in the entrance to a coal mine. It was black with coal dust. I rolled in it for a couple of minutes. And then I went over and rubbed the coal dust on everyone's face. It was a dark and gloomy cover, but we were in a bleak and doomy state.

Writing songs had gotten harder and harder, and now I had to write them without Joe. Joe's riffs were the engine . . . and the engine had stalled. I had tried writing with a bunch of different people. In the spring of '78 I flew up to Sunapee with Bobby Womack (who'd written "It's All Over Now") to work on songs, but nothing came of it. Just a lot of blow and blowing lines.

Sometime in the midseventies, David Krebs had introduced me to Richie Supa. He was a singer-songwriter signed to Columbia, also managed by Leber-Krebs. I was coming out of a meeting one day and he was going in and Krebs said, "You guys should hook up! Richie's a great songwriter, blah-blah-blahblah-blah." We started talking and one thing led to another, as it always does. Richie told me he had a studio at his house and all kinds of instruments, so naturally I had to go over and check it out. I think David gave me a copy of some of his songs, and I thought, "Yeah, this shit ain't bad!" When I was in L.A. I dropped in on Richie's session and sang harmony on a song called "Chip Away the Stone," which wound up going on the Cal Jam album.

Richie also wrote "Lightning Strikes," our first MTV video. Then later on there was "Amazing" and "Pink." He was my ally when shit would jump off in the band and I was fighting with Joe Perry. I always had Richie to collaborate with. After the band broke up in July '78, he came up to Sunapee that fall and helped me with lyrics. He was also my sounding board and played some guitar tracks on the album.

DOES THE NOISE IN MY HEAD BOTHER YOU?

Richie Supa had been in the Rich Kids. He came out with me on my first tour without Joe, along with Joey, Tom, and Brad—just before Jimmy Crespo came in. Richie played guitar and keyboards because he knew the material so well. Given all the drugs on the road, it was incredibly insane.

"No Surprize," the opening track on *Night in the Ruts*, was a miniautobiography of the band inspired by the night we were signed by Columbia that I rambled on about earlier. A brief encore . . .

Nineteen seventy-one We all heard the starter's gun New York is such a pity but at Max's Kansas City we won We all shot the shit at the bar With Johnny O'Toole and his scar

And rolling on into Aerosmith's spectacular autodestruction . . . our headlong highway to hell (cheers, Angus!). . .

Midnight lady Situation fetal Vaccinate your ass with your phonograph needle . . . Ridin' on the wheels of hell Smokin' up our axle grease

and concluding with a wish for the acid rain to stop . . .

Rock and roll Junkie whore Got my foot inside the door Knock knock, knock knock, knock Nobody's keepin' score Bad times go away Come again some other day

Side two—remember when albums had two sides?—had some great songs on it: "Three Mile Smile," "Reefer-Headed Woman," and "Bone to Bone." The last track, "Mia," I wrote about my daughter, because I missed her and I was missing in action most of the time.

Rock-a-bye sweet lady gypsy blue Ooh, the nightingale's singin' her song in the rain Hush-a-bye sweet lady soft and new Ooh don't you cry, the wind she's a-screamin' your name

There was a little room onstage behind the amps, behind the curtains, off limits to crew, where no one except the band was allowed. That was where drugs were laid out on the table so that we could step behind the curtain during the show and get a snort of cocaine or heroin . . . whatever flavor of ice cream we wanted.

We'd run out of blow a lot and we'd be *writhing*! What a great fucking word, w-r-i-t-h-i-n-g. A snakelike word, sounds like what it is. Like the word *sheath*. Sheath your weapon! Ooh, it's sexy! *Sheeeaaaaaa-th*! It's a delicious word, it's like eating a grape and eating a cherry, a nice hard one, just ripe, and making sure you bite down just enough to break through the skin, but not to hurt your teeth on the pit inside.

Drugs were just part of being in rock 'n' roll then. Nobody knew the downside of years and years of cocaine abuse and we could care less. It was the thing to do. Everybody laying it out for you, even the cops.

Oh the backstage is rockin' and we're coppin' from the local police That's right the local police Or the justice of peace

Promoters would have it backstage. There would be a deli platter and a mound of coke. So even if you didn't want to get high that night, even if your nose was falling off because it was raw and bloody from all the snorting, you ran into it at the next gig. *Boo-hoo!* That was just the climate. I never flew without having some blow on me.

By the end of the seventies, some nights I was so out of it our road manager, Joe Baptista, would have to carry me onstage. The promoter would be sitting there in the dressing room with a look of horror on his face. I'm almost comatose, he's hyperventilating. He thinks he's presenting the legendary cash cow Aerosmith, and now he's going to lose his shirt because the lead singer's down for the count. Is he dead or alive? What am I going to do? "You'd better get him on that stage. I don't know how he's going to do this show, but we've got too many kids out there."

Not to worry. The minute my feet hit the stage, I'm off and running. I don't know how it happens, but hey, you get up there in front of twenty thousand people and it's a high in itself, it's a charged space.

Still, the train kept a-rollin' and we kept getting high until one night in late '78, I don't know where we were, maybe in Springfield, Illinois, I blacked out in the middle of "Reefer Headed Woman."

I got a reefer headed woman She fell right down from the sky Well, I gots to drink me two fifths of whiskey Just to get half as high When the—

and then I hit the stage like a fish out of water.

I rarely went that far, but the few times I did, it was due to a little matter of not having the right combination of rocket fuel and booze. You drink something and you go onstage on an empty stomach and because you're jumping around and sweating and the lights are hot, you get fucked-up fast. When you're sitting there, it usually takes twelve, fifteen minutes for a skin

pop in your ass to get in your system. But a runner doing a marathon, because he's inhaling and exhaling so hard, *ah-huh-uhhuh-uh-huh-uh-huh*, and his blood pressure's rising rapidly, he'll get off probably in three minutes flat after you stick a needle in his ass because his metabolism is racing.

What happened is this.... I was up in Portland, Maine, got drunk. This was around Christmas 1980 and I was waiting for Bebe to come. She was living up there and it was very emotional seeing her again. She'd gotten pregnant in Germany and we'd somehow broken up after the tour. I guess I was in denial about it being my child, and she'd had just about enough of me and decided Todd Rundgren would be a better father. Bebe showed me pictures of baby Liv and we both cried before I went on. And, like all nights, I would order two double Beefeater martinis. I would down them in five, and chew up the olive really quick as I could, swallow it and not throw up. That is kind of where I was at in January 1980. I would drink two of those and if I had enough blow, I'd be good onstage, but on this particular night I didn't have any blow. Happened twice in my career that I was so soused and so dizzy that I became a fall-down drunk. Well, rather than fall down drunk in front of the audience and act like a pathetic idiot for an hour while they throw apples at me, I said, "Fuck this! Please, let's fold the show, man, and get me offstage!" But I knew they'd never stop the show just because I was drunk, so I lay down and didn't move, as if I'd fainted. And to make it look convincing I twitched my foot spastically so they'd look at the twitch and go, "Look, he's twitching! Holy shit! He's having a seizure!"

I really did it good, and Joe Baptista dragged me offstage. Now, on my children's life, this is the truth of what happened. The band all said, "He fainted and we took him offstage." The official account. But don't mind me just because it *happened* to me. I recovered in the dressing room, slept it off at Tom Hamilton's house, and the tour got postponed for a week. *

After Joe left he formed the Joe Perry Project. Brad played with us for a while, then he, too, took off in '82 to form Bradford St. Holmes with Derek St. Holmes, Ted Nugent's ex-vocalist. Fuckin' great! If you were to ask Brad, he'd probably tell you he had to leave, he couldn't take it. He'll tell you he had to wheel me out and prop me up and hope something would happen.

I replaced Joe with Jimmy Crespo because he looked just like Joe, and played really good, too. Nice long hair, skinny fucking guy, I thought, hey, bingo! What do I need fucking Joe Perry for? But then, think again.

Our producer, Jack Douglas, found Rick Dufay to fill in Brad's spot. Rick was a big tall guy, long hair, great character but a little out of his mind. I asked him, "How did you get in the business? What did you do?" and he said, "Well, once I got out of the loony bin...."Turns out the windows had that metal lattice over it, so he took his shirt and kept sticking it in the keyhole of the lock on the window and turning it and it finally just opened the window and he jumped three stories down, broke both his legs. That kind of stuff.

He'd walk into the Leber-Krebs office and say, "Come on, hit me real hard!" He'd lie down on the floor and say, "Come on, give me a boot right in the face!" And I'd say, "Get outta here, Rick! What the fuck are you doing?" He would want you to beat him up. Jack Douglas would smack him. Rick used to wrestle with me, and one day he knocked me down and to this day my elbow is still puffed up. He knocked me down and I landed on the floor of my apartment and I said, "Fuck, get the fuck out of here!" And that was it. Within a year or so he was gone.

I was stoned for about a year after that and not doing too much, just being a stoned, out-of-it guy, living in New York in my drug-

alogue. I got deeper and deeper into drugs, and conveniently Richie Supa had amazing drug connections—always useful. We had the same taste in drugs and women. I got blow from Richie for ten years, and my heroin. I'd go to Richie's house and he would sell me a T—a tenth of a gram of heroin, a chunk, a rock—and it was *so* strong I could chop it in half and put it in a needle, it would just dissolve, and shoot it in my ass and then lick the spoon and I was *gooood*, man, for four, five, six hours. I'd be strung out and shaking at four or five in the morning *so* many times. I'd call him and say, "Hey, man, I'm really sick." I'd get in a cab—I had no money, so I'd just jump out of the cab and run, run into the entrance of his building, with the cabby yelling, "Hey, come back here!" I'd knock on his door and he'd always have something for me. He was so fucking great, Richie. He always had the good stuff.

Richie had girls, drugs, and a recording studio—everything I wanted in one place—so I would go to his apartment on First Avenue and Eightieth Street, hide from the world, and just get crazy. I'd go there, buy a hundred dollars worth of cocaine, and then snort five thousand dollars of it while I was at his house. We would stay up for days on end. Like many drug addicts, our dopey motto was "BETTER LIVING THROUGH CHEMISTRY."

We were so blatant with drugs in this period. We thought we were invisible, but all the time there were those beady little eyes watching. Richie got a phone call one night that somebody in the band was about to get busted. "You need to clean your apartment," the voice said and hung up. I don't remember quite how the scenario went down, but we found out that this was coming from somewhere up in Boston. Still, it's not good politics to bust rock 'n' roll stars. It wasn't the thing to do. I mean, look at Keith Richards up in Montreal with pounds of heroin in a bath salts jar. I've been frisked years back where they actually put their hands on the package and let it go by, like, "Oh, well, no, *that's* not it."

Richie and I were at the Coconut Grove Hotel in Florida

one time. I was dope sick but I knew Richie had some stuff for me. He'd hidden the heroin in his underwear under his balls. I was jonesing, I was sick, and I got to the hotel. I banged on his door. *Thank god, he's there*, I said to myself. "Richie, open the fuck up, I'm desperate." He goes, "Wait a sec I gotta take a leak." He went to take a piss, but he was so stoned that the thing fell in the toilet and as he flushed he saw the package go down the drain. And then we had to spend half the night going out to cop. But he knew people, so by four o'clock in the morning I got straight.

If there was no freebase left I'd smoke just about anything kitty litter, cottage cheese. Richie nicknamed me "Spider" because I would crawl on the floor looking for a piece of freebase that I thought I'd dropped but probably already smoked. I was always looking for things that weren't there.

And then the very drugs that made me ecstatic and godlike started to turn on me. I began looking for things—things that weren't lost and people who weren't there. Things invisible to the naked eyeball, but that *you know* are there. Looking, looking, looking . . . Searching under the bed, examining under the door, looking out the windows—investigating. I was convinced I was under surveillance, believed I was being watched. By whom? By the IBI, of course, the Imaginary Bureau of Investigation, my relentless paranoia-induced pursuers.

And the IBI was not all that I hallucinated. One time we were up two or three days in a row and Richie found me standing in the doorway with a mop and a pail.

"Where are you going?" he asked me.

"To wash my car," I said.

"Give me the mop. Give me the pail."

"Oh, no, no, no! I gotta go clean my car."

"Steven, get real, we're on the fifteenth floor of an apartment building in Manhattan." I didn't know where I was. Or care.

I was stoned out of my mind on drugs almost all the time. I moved out of my house in Sunapee and into Jack Douglas's

apartment in New York in the winter of 1982. Then I got an apartment in New York and started to work on the next album, *Rock in a Hard Place*, with Jimmy Crespo, Rick Dufay, Tom, and Joey. Our cocaine was written into the budget—as twenty-four-track reels of tape. Even if you were out on a yacht or an island somewhere recording on a mobile unit they'd fly drugs out to you in seaplanes.

I wrote the songs on Rock in a Hard Place with Rick Dufay and Jimmy Crespo. Two of these songs-"Prelude to Joanie" and "Joanie's Butterfly"-are about a hallucinatory horse with wings and feathers. I bought some opium from a dealer named Reinhart, a tongue of opium, black and thick, about three inches long, half an inch wide, and half an inch thick. I didn't smoke it; I'd roll it into balls and swallow it. I'd eat it and it was like, fuck! The best high on the planet is opium. I remember being so high one night, one of those nights when you can't sleep, you're in this wakeless, sleepless place, and a story came over me. I was in a barn, in a stall, there was a lot of hay, and this horse gave birthwith the waters of life pouring out of her. It was a beautiful white horse, and its baby was this kick-ass rocking horse-that's what I called it-it had wings and feathers. I couldn't figure it out. How would a horse have feathers? But that was the fantasy. I wrote two songs around this opium vision. "Prelude to Joanie" told the story . . .

At first we three thought 'Twas the biblical cord of life Then noticing 'twas connected To his head How strange Not to be believed I reached out to feel And the pony's eyes they opened The cord got hard The head looked around And you know who pushed and gushed The waters of life First two hooved feet Then the shine of his fur But at first to my eyes only Feather—feather—wings

The second song was "Joanie's Butterfly," which I named for a vibrator in the shape of a butterfly. Women strap it on and it stays right here and it goes, ZzzzzzzZZZZZZZZZZZZZ But for whatever reason, that's what I called the song and took the dream poem into a hallucinated journey...

What a stormy night, when I met the pony It was so dark that I could hardly see It smelled so sweet, you know who and Joanie So many butterflies, one could not see . . . We all could feel desire, took off in flight It was hotter than fire, then came the light I smell the heat, the dancing pony Unwrapped his wings, to dry off Joanie The pony he grew in size, the thunder and rain And finally realized what it was, what it does, and what it come to say

We put some freaky effects on *Rock in a Hard Place*. I used a vocoder—essentially a frequency phaser or oscillator that had been used by Pink Floyd and Wendy Carlos. I was talking to one of the recording engineers and he said, "I can create this interesting audio hallucination if you're interested." "Oh, yeah?" I said. "Let's do it." He explained that it was a bizarre effect you can create using two stereo speakers in which a third sound appears to be coming from behind you. And I thought, *Wow, that is so cool.* So on "Prelude to Joanie" I hit an African drum with my elbow and it made this *oooouuum!* sound. You

can hear it on the song really loud if you put your speakers in two corners of the room facing you. Suddenly you'll hear a sound that appears to be coming from somewhere behind your head. People listening to the track would get up from the record in the middle of the song when they heard the drum beat and go to the door behind them to see who'd knocked. We could really fuck with people with this device. I got sold on it and bought it, but little did I know that it doesn't work unless there's music playing as well; that's what throws the knock out of phase.

Brimstone, my heroin dealer, also had the best coke and weed. One day he brought over this girl he was dating—Lisa Barrick. She was gorgeous but so obviously not interested in me it kind of pissed me off, so I asked her, "Are there any more like you at home?" "Well, yeah," she said, "I have an identical twin sister." "Awright!" Her sister, Teresa, worked at a restaurant that served exotic dishes, like buffalo burgers. I had a hippopotamus steak the night I went there. We talked, and I told her how odd it was that I would ask Lisa this corny question and how it turned out she really did have an exact copy of herself at home. I was in love. We were making out in hallways and behind closed doors. I was still married to Cyrinda when I first met Teresa in 1978, but things between Cyrinda and me had already gotten worse and worse. The fights were horrendous.

Cyrinda could provoke me to violent reactions more than anybody I've ever known—with the possible exception of Joe Perry. Cyrinda wasn't gay, but she'd adopted the grandiose gestures of a queen. "Uhnk! Oh, what are you FUCKIN' tawkin' abawt?! Oh, Jesus Cher-ist! You stupid fuck! Jesus! Get him the fuck outta heah! Oh, what a cunt! Oh, Jay-sus!"That kind of high-camp verbosity. Huh-hoo-ahhh! Cyrinda's vicious put-downs were like getting slugged. I couldn't take it after a while, because when I'm sober I get quiet. I think I'm such a fuckin' bore. *

Over a period of, say, twenty-five years I've gone to a bunch of different rehabs. I don't remember the exactomongo timelines. So, to rehash—*ha-ha-ha!*—all my rehabs (maybe we can crush one up and share it, *heh-heh*): (1) Good Samaritan Hospital in New York way back in '83, then (2) Hazelden to (3) East House (and back to East House) to (4) Chit Chat in Wernersville, then (5) Sierra Tucson, then (6) Steps in Malibu in 1996 to (7) Las Encinas in 2008 with Erin, and (8) Betty Ford in 2010. Whatever it takes.

The first rehab I went to was back in '83 because I was so fucked-up I was too wobbly to walk down the sidewalk. One of the reasons I wanted to go to Good Samaritan was that I'd heard they did tests on heroin there. *I'll go!* I thought. "Well, can I be one of the guinea pigs for the heroin? What do we get, uh, a shot every day? I'll do it!" NOT! That was Good Samaritan. Their motto came from the Bible: "THE SPIRIT OF THE LORD HATH SENT ME TO HEAL THE BROKENHEARTED AND RECOVER SIGHT TO THE BLIND," but as Saint Augustine said, "Please deliver me from my sinful life, O Lord—but not today."

While I was on tour with the Jimmy Crespo-Rick Dufay version of Aerosmith in '83, David Krebs had sent a psychiatrist, Dr. Lloyd Moglen, out on tour with the band to see what could be done, but—poor man!—he was aboard the ship of fools and their rabid pharmaceuticals. Lost souls! We were dazed and confused, divers in the murky depths of drugs and our din. We were down below the five-hundred-foot line—we couldn't come up for air or we'd get the bends. The doctor threw up his hands: "There's no saving them," he cried. "The band is broken and cannot be fixed."

Cyrinda and I were in Florida around this time and I got into a vicious fistfight with her. She may have looked like Betty Boop but she could pack a punch like Sonny Liston.

Hey Betty Boop you got me droolin' I'm buzzing round your hive tonight You play the hooky stead of schoolin' Son of a bitch put out the light

The fights with Cyrinda became so violent that David Krebs sent another psychiatrist to come get me. He brought me out to Saint Something's Hospital in San Francisco. It was a mental institution. They put me on a gurney, wheeled me into a room. I was kicking like a mule, my feet were twitching. I'd been up for days, I needed sleep. I drank on the plane, but you can't sleep on booze, you've got to pick it up and drink again after three hours. They put an IV in my arm. "Um, Doctor," I pleaded, "I need some more Valium." The fuck *promised* me he'd give me Valium. "All right, Steven, here it comes, look!" And I'd watch him hook up the tube. But it wasn't Valium. They were dripping saline solution into my arm. Some junkies are *so* bad that they go shoot water into their veins because they want to shoot something. But I'm not that kind of junkie. I never liked to shoot heroin. I did it once in my vein. Mainly I shot it in my ass.

Cyrinda and I were really bad drug addicts. We spent *years* shooting cocaine. After that I went with Cyrinda down to Saint Martin, and we got into another *raging* fight. We had bought all this blow from everybody before we left. The cops knew what was going on and they threw us *off the island*! We got deported from Saint Martin. You can imagine how outrageous you'd have to be to get deported from a Caribbean island for being rowdy. There were insane, uncontrollable fights; she'd hit me in the face and I'd slap her back. "You mean, Steven, you were *hitting* a woman?" Oh god! Yeah!

Cyrinda was driving away during this one horrific fight and I became so enraged I took my man bag and *smashed* her windshield—I jumped up on the hood of the car and whacked it and it shattered into a hundred pieces. Cocaine in*sanity*! She got out of the car and came over and a violent, uncontrollable fight erupted. We were punching and scratching and we fell over and rolled on the ground. I yelled, "Stop! STOP !!!" What was this fight about? What they were mostly all about: drugs. "Where's the fuckin' pills?" "I don't know!" "What do you mean you don't know? You had 'em last!" She came over and smacked me in the face with her bag and the bag fell open and all the pills fell out onto the floor. "They're in your bag, you fucking cunt!" She was fucking hoarding them. "Okay, liar, give me the bag," I screamed at her and ripped the bag out of her hand and in it were bottles and bottles and baggies full of pills. What kind of codependent fucking drug-addicted behavior is that? When I had drugs I'd always share-Cyrinda was more like Joe and Elyssa in that way. They would have pills or coke or heroin, but they wouldn't part with one pill or one line of it even when I begged. I would get dope sick and still have to get out there and sing. "You gotta give me a little something, man, I've got to go onstage tonight." And I would have to go on and perform fucking strung out! Do you have any fucking idea what that's like? I barely got through, barely made it to the end of the show. As bad as things got-and they got insanely ferocious-I never hated Cyrinda; I love her to this day. May she be in peace wherever she is. I loved her dearly, and when I went away for drug rehab, I wish she'd have come, too.

The beginning of the end with Cyrinda came about in an odd way. I took Teresa and her sister, Lisa, to eat dinner at this restaurant called the Twins—it's on the East Side, and only twins eat there. It's a really funny scene. I'm in the middle of a tour, the band was cooking, and some guy spots me and goes, "Hey, Steven Tallarico!" And next thing I know it's in the paper, Cyrinda hears about it, and wants to sue me for divorce, to serve papers. So that blew that night . . . ruined everything. I guess she loved me, but she didn't know how to do anything for herself. A love story could be written about how she loved me so much that it hurt her that we fought all the time and she became distraught. I'd like that to be the case, but that isn't really our story. We

STEVEN TYLER

fought in person, we fought on the phone, she'd yell at me, I'd yell at her—another song inspired, a couple years down the road, from *Done with Mirrors*, "The Reason a Dog"...

Yak yak yak Lord, you give me the bends Heads and tails You're all out of love Like the reason a dog Has so many friends He wags his tail instead of his tongue

It was "You know what? Well, fuck you! You better come up here and—" I'd say, "Cyrinda, you gotta calm down—" She was just a little too overbearing and over-the-top for me, not that I'm exactly a soft-spoken shrinking violet. We clashed, we fought like cats and dogs, and in the end, it just fell apart. I would tell her this on the phone: "Honey, I don't think it's going to work out, so let's get a separation and see, okay?" And finally that's what we did. She didn't like that I was seeing Teresa—naturally. She was jealous and and and and and ... What more can I say that will make my side the truth and hers not?

I was married to Cyrinda for twelve years. That's a long time, although we probably only spent three and a half to four years physically together. I was living in New York . . . Cyrinda stayed up in Sunapee. When she came to New York with Mia, I'd have Teresa hide behind the refrigerator and stuff like that. Things were very bad between us. I was trying to get sober; she was still getting high. Our divorce became final in September 1987. A year later Teresa and I got married.

By then Elyssa was gone, too. Joe's new squeeze was Billie Paulette Montgomery—I introduced her to Teresa. They liked each other. Hey, this could work. *

But I'm getting ahead of myself. Rock in a Hard Place only made it to number 32 in the charts in the fall of '82. For the first time in two years we went out on the road again, with Jimmy Crespo and Ricky Dufay, but it was a disaster and I ended up in rehab at Hazelden. Four fucking hellish nights of withdrawal. I knew what those fucks were up to. I called David Krebs: "Get me the fuck outta here. I've seen those movies. Fiendish scientific experiments! Spirit possession! Hypnotic trances! They're exorcising my demons, the precious demons that brought me my power, my drugs, world-renowned narcissism. How do you expect me to write lyrics without demons? They have machines here to siphon off your creative juices and sell them to the Japanese!" I so desperately missed that drug high I would spin and spin until I got dizzy just to feel that narcosis starting to set in, to feel that tingling in my cerebellum. Five hundred dollars and a fast horsethat's what I always need.

Not surprisingly, Hazelden didn't work—I didn't get it. It was years and a few more rehabs before I would get it. All I got was people experience. I'm a performer; I know how to work a room. While I was in Hazelden, Teresa came to visit me and brought me shooters from the plane. I snuck out and drank them all. It was the worst drinking bout I ever had. You could smell the liquor on my breath and I was ashamed to go to class. I didn't get busted for it, but still I felt so mortified that I had disgraced myself.

My god, by 1983 I had no money and no future except getting further into the pit. I felt I could hear the Voice of Doom saying, "I'm sorry, man, you've sung your aria." I'd done everything I said I never would. Back in 1976, when I read stories about guys who lost everything and blew a million bucks snorting all they had, I used to say, "That'll *never* happen to me." But in the end I blew twenty million. I snorted my Porsche, I snorted my plane, I snorted my house in that din of drugs and booze and being lost.

David Krebs told me I was broke and put me on twenty dollars a day, presumably to curb my drug intake. The way I got around that was to give the limo driver a two-hundred-dollar tip. He'd keep fifty and I'd get the rest to spend on my drug of choice, which increasingly was heroin. I was so out of it that when I got mugged—the guy stuck a pistol in my mouth—I didn't care whether I lived or died. I was half dead anyway.

Eventually I moved into the Gorham Hotel with Teresa. Teresa would go down to Alphabet City-the East Villagedaily and get me dope. Then I met one of our security guys, and he said, "What, are you crazy, man? You can get it right on Ninth Avenue." I said, "Bullshit!" He goes, "Ninth Avenue. What're you kiddin'? Ninth Avenue's where you score smack. Everybody knows that!" I said, "Well, I don't know it! Show me!" I got in his Corvette, he got me a bag, we drove back to the hotel, I dumped it out on the mirror, and it was a fucking pile! For twenty bucks? Twenty dollars' worth of this stuff was more than you'd get in five bindles from downtown. A bindle was just a little bit, and you were lucky to get high off of two of them. It was too good to be true. I snorted the stuff from Ninth Avenue and went, Uhhhgorrrrhhhhl! I spun right there. I got sick. It was fucking great shit! So for about a year, we got bags from there. Five, sometimes seven, mostly six, from the same guy. It came in a big white envelope. Forty weeks we lived at that hotel. We saved the envelopes, and when you ran out you could dump them out on the mirror, and when you scraped it all up you got a nice pile. Enough so that Teresa and I wouldn't get dope sick. The brands of heroin all had these great fucking crazy names: Poison, Fat Boy, Hot Girl, General Westmoreland, Toilet.

I remember in the midst of my din, hearing from fucking Alice Cooper that Joe was going to be his guitar player. I went, "*What?* You've got to be kidding!" My soul mate . . . I was so fucking pissed that I called Joe up and asked him, "Are you joining Alice Cooper? Are you seriously going to fucking be his guitar player?" And he said, "Yeah," like the prick he is! I said, "What the fuck? That's the dumbest fucking thing I ever heard! Just stop. The shit's over. Why don't you just come back with Aerosmith? How could you go be with Alice Cooper? We're Aerosmith. We have something so big THAT WE CREATED OURSELF! You're gonna join a power that is already there . . . be a little piece of it. Whereas YOU ARE the power in this band! We gotta get back together."

On my children's lives, that's what happened. I called him ... he didn't call me. This is not ego-speak. I hadn't spoken to him for more than two years, but it felt like way longer. This wasn't in *Walk This Way* and needs to be said. I'd push him, he'd scream at me ... we'd almost come to blows. Joe is passive-aggressive. He'd say heavy words, but say them quietly. You're always hurt by the ones you love, right?

Joe was really pissed off at David Krebs for holding him hostage. Supposedly Joe owed all this money, an eighty-fourthousand-dollar room service tab. Why was David charging Joe all that money? I know Joe couldn't afford to pay it. Considering all the money he was making from us, don't you think David at that point could have said, "What the hell. Fuck it!" He's a ruthless guy. Then there was this other little matter with Leber-Krebs, who were both our managers and our accountants. Not that we weren't fucked-up, fried, and filleted, but the whole business about Joe and me as the Toxic Twins, if you really did some digging you might find that it wasn't all that coincidental that it started hitting the media right around the time Joe was getting ready to sue Krebs over those room service charges.

The press loves catchy phrases and cute headlines and they latched right on to the Toxic Twins. When I fired Joe, the come shot was: "Band Breaks Up Over Spilt Milk!" Ha-ha-ha-haha-ha-ha-HA! Now all the journalists in the world get these little stars for being ASSHOLES! They're not telling the truth 'cause they assume nobody wants to hear the truth! Headline:

"Tyler on Drugs!" That should do the trick. The picture shows me holding a bottle of pills. Then in the second paragraph it says, "Those are the aspirins that he bought after he came out of rehab." And you go back and you say, "Wait a minute! But it said "Tyler on Drugs!" And then it clicks, "Ah! That's how they got me to read it!" 'Cause if it said, "Tyler Safe," no one would read it. I'd have to be an icon like Madonna to get a headline with my name and aspirin in the same headline. "Madonna Now on Aspirin."

During the years that Joe and I were broken up I realized that I wasn't half the musician I thought I was without him. But whatever was going to happen with Aerosmith, Joe would not deal with David Krebs again. Since we'd split up, Joe had met a manager named Tim Collins. I met him for the first time with Joe at a French restaurant in New York near Fiftyeighth Street. We had hamburger à chevalle, with an egg on it. Tim said, "Why don't you just come to Boston?" "Nah, I don't think so." That's when he said, "What if I gave you a gram a day?" And he did. That's how he got us up to Boston, me and Teresa. He had his guy Monkey bring us over a gram at the hotel every morning at the Howard Johnson's in Cambridge. He wanted to keep me there while he tried to put the band back together.

Tim played the game all managers play—he'd tell me Joe was interested in getting the band back together, that he'd really missed playing with Aerosmith, blah-blah-blah, and then he'd go back to Joe and tell him I wanted more than anything to reunite the band, that Joe was the essential element and without him, *da-di-da-da-da*—which was true, but it was all done through innuendo and manipulation. And that's how Joe and I started to work together again.

Managers are predatory, they troll the stars—and we got trolled, used, and abused more than once. Not long after he'd got us, he was down at a club in New York, at a party, drunk out of his mind, bragging that he's got Aerosmith, and this guy he was talking to said, "Aerosmith? Good luck! I used to book them. . . . You'll never manage those guys, they're too stoned. And by the way, the only thing that'll get them outta that is AA." And Tim went, "Huh? What the—?" But that stuck in his mind and it would resurface a few years later when the band was totally fucked-up again and he needed a way to pull us out of free fall.

I went to see the Joe Perry Project perform at the Bottom Line, then Joe came to the Worcester Centrum in the spring of 1983 to see an Aerosmith concert. We did a few lines of heroin in the dressing room—just for old times' sake. "Joe, check this shit out, you're not going to fucking believe it! See what you've been missing?" And then I fell down. I just got too high. That's only happened three times in thirty years. So drunk or so stoned that everything was spinning so much I couldn't stop it. This was at the height of my addictions and whatever the fuck. When you're in that state, even when you lie down on your bed the room is still spinning around you. Anyway, we do a bunch of lines and I get onstage at the Centrum and I realize I'm lost. I can't function at all, it's like, "Oh, God, please help me!" Those few times when I got so fucking drunk or high that I couldn't stand up we had to cancel that show.

I think it was the third song (it takes about fifteen minutes for whatever's in you to really take hold) when I realized I was in serious trouble. "Oh, dear God, my God!" I stumbled over to the drum riser. I put my hand out, slipped, and missed it. It was totally fucked-up—a great way to reintroduce Joe to the band. But as Joe always says, it's good to see a train wreck onstage—it means there's something going on up there. Fallible fuckups, not the click-track machine flawlessly reproducing its iPod hits. But in my case, it was getting a little too close to a demolition derby.

In early 1984 the band got back together at Tom's house. That was great. The old machine was rollin' n' tumblin' again and stumbling and mumbling and falling down and disintegrat-

ing. For the first three years we were back together, everybody was so fucked-up! Eventually it reached critical mass and at that point Tim Collins recalled what the promoter had said to him when he first got the band: "It's never going to work. These guys are alcoholics and drug addicts. Your only hope is AA." It was time to get Aerosmith clean and sober. Not everybody in the band, of course. Since I was the Designated Fuckup I was the first one to get sent away. I wound up at East House, a rehab facility at McLean Hospital in Belmont, Masschusetts, in February of 1985. I put it in a song called "My Fist Your Face":

Wake up, baby, what you in for Start the day upon your knees What you pissin' in the wind for You musta snorted too much bleez East House pinball wizard Full tilt bozo plague Second floor trekkie makin' warp speed out the door Julio Afrokeluchie He the only one who stayed Counting up the days Please, no more

Naturally, I wasn't exactly ready to give everything up on the spot, either. While I was in there, Teresa went to get me some blow from the only dealer she knew, a place in Queens. Now, as it happened, a friend of Tim Collins's was there at the same time getting blow for Tim. Joe heard about it, called Teresa up, and said, "I'll break your fucking legs if you give Steven any cocaine!" Meanwhile, Joe had gotten the okay from the Vatican master, Tim Collins, to carry on, drink, do whatever he wanted.

They figured as long as they got *me* sober, the band would be fine. I had to be straight in order for Aerosmith to work. Gotta get Steven straight! So it was back into East House at McLean a second time in the fall that same year. At McClean I met a therapist named Bob Hearne and for the first time I began to think about another path to enlightenment other than drugs and booze. The problem is that rock 'n' roll is a fantasy life and part of that fantasy is being high. Like most rock stars I suffer from Terminal Adolescence. I'll never grow up. The animated twelve-year-old thing—without that you wouldn't get up onstage in the first place. In rock you never have to grow up because you're so insulated, you never have to deal with any-thing. Everything's done for you . . . you're surrounded by staff and crew and managers and promoters and PR yentas. How do you rent a car, buy a plane ticket, reserve a hotel room? Oh, you've got to *call* them first?

In rehab they have all these theories: "No, no, no, Steven, don't paint with your right hand! Paint with your nondominant hand!" "Why? Because I don't know how to play with my left hand?" "Yes, that way you may come up with something that you don't know was in there!" *Rrrrr-ight*.

And even if I—through prayer, abstinence, and superhuman strength of character—were able to forswear the demons of dope and alcohol—what about my mates? Of course I'd call Tim from rehab from time to time and say, "Where's Joe? When is Joe coming here?" "Oh, Joe's down in the islands." Tim let Joe go to an island, where he was drinking paregoric, that baby for the gums, and he'd dip a cigarette in it, smoke it, or drink the bottle, and you can get so stoned on a bottle of paregoric. Trouble with me, the Designated Patient, was that everyone else in the band and all the people around us were still using—massive amounts—so naturally, it didn't take.

Tim's theory of keeping the band straight on the road was farcical. Basically, Therapy 411 . . . He would have his secretary dial information for AA meetings in the towns where we were playing. Dial tone. Start counting . . . one chimpanzee, two chimpanzee, three chimpanzee, four chimpanzee, five chimpanzee. CUE Lily Tomlin switchboard operator: "How-may-

I-direct-your-call?" "Yes, L.A., downtown Los Angeles, AA, please? Thank you, I'll wait." Nasal Directory Assistance Operator's voice: "The number is . . ." I mean, that would take one minute, wouldn't you say? Two? You dial the number for AA in L.A.: "Hello. What's the address there? Do you have meetings? What days?" That was Tim Collins's plan for keeping Aerosmith clean on tour.

Tim Collins found an apartment for Teresa and me in Beacon Hill, Boston, and another one for Joey. Then we moved from that apartment to a better one in Brookline. Teresa and I started going to a methadone clinic in Kenmore Square to try and get clean ourselves. This is fall 1986. I got down to five milligrams a day at the methadone clinic, because I didn't like the way things were going. There was too much blow and too much heroin and I knew if I didn't do something it was going to be The End. Who knows if I'd have made it on my own, but I was on my way down. No one told me to go to the methadone clinic. Teresa and I just did it. We were going to get married, we were going to have kids; we needed to change our lives.

One day Tim called me and said, "There's a conference call to Japan tomorrow morning, so you gotta be over early. Be at the office no later than seven A.M." Drag myself out of bed, get down there, and what do I see but the entire band, on time (suspicious in itself), and all looking very serious, all sitting at a round table, and presiding over the round table is High Lord Doodle Dum . . . the therapist Lou Cox. He singles me out and points his finger at me! What'd I do now? Or, let's rephrase that: what'd I do that everyfuckingbody in this band hasn't been doing up until this morning-and I'm not even sure about that. But they're all looking fucking smug, because it's Steven that's to be burned at the stake. It's pretty intimidating when your band members, your manager, and this self-important authority on mental health are sitting there in judgment, and I'm shaking and jonesing. Your own band the firing squad! Aerosmith & Wesson. Big-shot doctor from New York tells me this is an intervention, which turns out to mean I have to listen to all the fucking complaints about my behavior from everybody in the band and *I can't speak*.

"Steven, just listen to the guys in the band; they want to address some of the issues of your behavior. Is that okay?" Fuck no! But what am I going to say? He starts going around the room, from Joey to Brad to Tom to Joe. It was all that "when you did that ... I felt" shit.

"Steven," Joe says somberly, "I felt betrayed when I was playing my guitar and you nodded out at the keyboard at rehearsal yesterday—"

"What are you talkin' about? You gave me the dope! We both did the same shit. We crushed up a Dilaudid and shared it—and you fell asleep right after me!"

Therapist: "No talking, Steven."

Next up is Tom: "When you yelled at me last week I could tell you were doing too much blow. I got really angry with you—"

"What-? The fucking blow came out of your sock, you fuck!"

"Uh-uh, Steven, you can't speak."

Then Joey pipes up: "I got really upset when you started throwing stuff around at sound check the other day and I suspected you were doing blow."

"Joey," I said, "why would you need to speculate about that? We both did a line right before that!"

"That's what I mean, you've just become so blatant about it. Like when you did blow off my drums yesterday."

"What are you talkin' about? You gave me . . . it was your blow and *you* laid it out for me!"

"Steven, please! Let them talk."

Jesus, I've unknowingly slipped into Ratology 101! The study of "Why-is-the-rat-behaving-like-that?" First you shoot the rat up with adrenaline . . . then it runs into a wall and breaks its neck. Conclusion: that rat's behavior was clearly deviant—we must do something about this!

The big-shot psychiatrist is getting theoretical! He's got a

thesis! He's the authority (us lowly drug addicts know nothing). He's doing this whole examination of behaviors, but no one's allowed to know *why* the rat behaved like that. I go, "Excuse me, professor, do you think it had anything to do with shooting that rat up with adrenaline?" "Oh, no, no, no, it couldn't be *that*; don't you understand, it's that rat's *behaviors* we're studying here." Revive that rat and kill him again! That was me, I was the Experimental Rat, the deviant rodent whose behavior must be *modified*.

"Well, it's a big band and we figured we'd have you go one at a time. We thought if Steven got sober, the rest of the group would also get clean." How reasonable! How rational! But then they said, "Steven, if you don't go away, we're throwing you out of the band." What?! You're throwing me out of *my* band? I had to swallow that and suck it up.

Anyway, they allowed you to make one phone call—just like the cops—so I called Teresa and she said, "Don't let them do it." She goes, "They can't do that to you! What are you talkin' about? You did methadone. What do they want from you? I'm comin' right over!" And just then, I thought, *You know what? I get it.* So off I went . . . away to the bins.

But wait! You didn't think I was going to slink away from this farce without a peep, did you? Let's go into the Special Features of the Intervention Movie and listen to Steven's commentary, shall we? I could have gone . . . "Okay, now I get to talk. Well, fuck you, fuck your therapist, I'm leaving. Find another lead singer, and by the way, before I leave I'd like to ask this High Doodle Dum therapist of yours a few questions: 'Let me ask you, Dr. Cox, where'd you stay last night? You slept over at Tim's house? You stayed the night before this meeting at the manager's house?'"When I tell this to professional therapists they go, "What? That therapist stayed with the manager? Enmeshment! Wrong! Could have lost his license for that." Ha-ha! Bye! *Dingding-ding-ding*.

There's your movie! Ooh, it would have gone a little dif-

ferently. But I didn't. I didn't know how to say that back then. And, folks, that's why I'm angry today! What would Spock have done here? How would Spock have dealt with this? Or any respectable drug counselor, like, say, Dr. Steve Chatoff? Oh, you know what he'd have said: "Excuse me, Joe, so you're telling him you're angry at him for falling asleep, but wasn't it your Dilaudid?""Well, yuh . . . but I thought you said that we were to come here and this is about Steven.""Well, you see, I can't really point the finger at Steven if you gave him the drugs, so hold on here . . . are all you guys still using?" And the band in one noble, rousing cry would have said, "Hey, let's all go to a rehab. Maybe we shouldn't all go to the same rehab, but here's what we should do . . . we should all get clean." Now, that could have happened and, by the way, would have worked. A good, strong mental health worker-who saw my point of view-would have insisted on that.

Well, I came back from rehab and I said, "You know what, you guys? Therapists at the rehab said I'm gonna use if I'm around you, so you guys, if you don't get sober, I'm leavin' and I'm gonna start another band and use the name." I'd gone away to rehab, but none of the rest of the band did at that time. Brad never went. Joey never went. Tom never went. Joe carried on as usual. Tim Collins was afraid to come down too hard on Joe, and besides, he'd been in bed with Joe from Day One, because Joe and his girlfriends know how to makey-makey with the manager-manager. Tim Collins, because he'd become tight with Joe while Joe was broken up from Aerosmith, let him stay at his apartment, and Joe proceeded to empty his entire bar. Eventually Joe did go into rehab at Bournwood Hospital in Brookline, Massachusetts, after his son Tony was born in October of '86.

Another notable fucked-up onstage incident happened in Springfield, Illinois, on the Back in the Saddle Tour in the late summer of 1986 when partway through the show I just stopped singing and then sat on the edge of the stage and tried to tell jokes to the audience for about an hour until the show got canceled. It was the end of the line. Again.

I went into detox at Chit Chat in Wernersville, Pennsylvania-a fabulous rehab-in the fall of 1986. No mood-altering drugs to come down, they give you Clonidine. Cloni-fuckingdine lowers your blood pressure. You don't want to move; you're so lethargic that you're never going to stroke out, which is a major concern with people coming off drugs. Benzos-Valium, Xanax, etc.-are the absolute worst to come off. I never even told anybody I was on benzos. I thought it was the heroin I was doing before I went in there. I'd got myself down to five milligrams at the methadone clinic in Boston, but I was still doing the benzos, massive amounts, snorting them, filling a Coke bottle full. I didn't tell them what I'd been doing and I was tweaking out, but with the Clonidine I was chilled. They give you a patch of Clonidine. I was just mrrr-vrree-mrrr, in a hypnotic state. I couldn't wake up, I couldn't sleep, I had no energy, I would bang into the wall just trying to walk through a doorway. They also gave me Seroquel and Neurontin, which are nonnarcotic antipsychotic meds for people that are coming off drugs. I put a blanket on me and cocooned. There still was the Steven Tyler factor in there, but I didn't care if the other patients stared at me. Fuck you! Fuck off!

Coming out of that din with an absence of feelings and emotion, your periphery opens up more and more. They said, "No food in your room." But of course I've got to break every rule. I brought an apple, a pear, a banana, and a peach and I put them by the side of my bed. Your smeller goes away when you're doing hard drugs. The deeper, innermost things abandon you. How can you smell when you've got a snout full of drugs? When I noticed my sense of smell coming back, the musty, sweet aroma of the apple and the pear and the peach and the banana, it made me cry. While you're going through detox, you've got to believe in something other than a pill craving and fuck me and fuck you and I've got to have it. You can knock the idea of some Higher Power, but you've got to believe in *something* or you're just going to sink back into the muck. You've got to try and see things from a different place. I'm now thirty light years away from that person I was then, yet twelve years later I still had to get tweaked again.

Drug addiction, therapy, relapse . . . going through the hell of detox. "God, please take this pain away, I'll do fucking anything, God, please, no more!" I was in rehab with all the shit that entails, the great epiphanous moments. We're back in the superior vena cava, heading to the heart. We're heading to the ocean!

Then one day in the hallway I saw this poster. It told the story of a man's going through a nightmare journey and his epiphany at the end of it. I so identified with this story. I put myself in the guy's shoes. He's up on a mountaintop in a blizzard, snow and hell. He keeps on walking, pushing on grimly. He thinks he's going to die and cries out to God to save him. Somehow he gets down from the mountain and finds himself at the beach. It's warm and sunny, he's walking along, thanking God for saving him, but when he looks down he sees there's only one set of footsteps. He goes, "God, why have you forsaken me?" All of a sudden God appears and tells him, "I didn't abandon you, those are my footprints. I'm *carrying* you!"

When I read that I went to my room and fucking cried. We all need something to carry us: your mother carries you, falling in love, then rock 'n' roll. Drugs did it for me for almost twenty years, got me the fucking candy store, didn't it? My wives did it for me . . . so did my band.

Enough about God (for the moment)—let's talk about another religion we don't understand . . . Aerosmithism! Everybody

cleaned up—for a couple of years, maybe three. Then certain people in the band started using again, but it wasn't to the extent of the excesses of the past—it was often so low-key I didn't even know they were doing it. All I know is I got twelve years out of it.

And then in 1987 we made *Permanent Vacation*, the best album we'd made in ten years—and the first one we ever did sober. It had "Rag Doll," "Angel," "Magic Touch," and "Dude (Looks Like a Lady)." We knew we were back, opening it up with my "Heart's Done Time"—my Trow-Rico Indian war cry and wailing inner-city sirens on top of two real killer whales, Highach and Finna singing, recorded at the Vancouver Aquarium. *Oh, yeaaah!*

We were working on *Permanent Vacation* and I was talking to Toby Francis, our soundman at the time, about a sampler. You hit the button, and whatever goes into it gets sampled for a few seconds, then you can truncate it, manipulate it, and do whatever you want to it. Joe and I were all for it and decided to buy one. The next day Toby brought one in and tried to show us how to use it. I hit the "record" button, and Oh, my god, it's recording! I blew a raspberry, Bllllllt-. Stopped and saved. I played the drums, it grabbed the snare, went into my keyboard . . . played a few notes, and it grabbed that, too.

Joe started riffing on his guitar and I grabbed another bit with the sampler by mistake. I hit "play" and it went "*she-mah-mat*," and that was perfectly in time. I said, "Save that. That's a great fuckin' noise!" God is in the details.

I told Tobby to save the piece and make sure it didn't get lost, maybe we could put it on the album somewhere. He did, we did, and the rest is history. For better or worse it sounds like "banana," that little fun thing in the beginning of "Dude Looks Like a Lady." I had Bruce Fairbairn assigned it hard left and right and glue it into the font of the song. It was super stereo ear candy and so beautiful when the band comes in full tilt.

243

I began carving out lyrics, "cruise," "rused," "floozed," to fill in the blanks. I had a phrase. It started out as "cruising for the ladies." Yeah right, as if . . . I could never sing that in a song. I could take any scat, "here's looking up your old address" and make it fit. Of course it works best if there's something to hang my fuckin' hat on, like a Joe Perry riff, some kind of a hook. I tried a few things and then, a moment went by . . . I was sitting there with Joe and I came out with, "Dude looks like a lady." Once I tapped into the insanity, the song wrote itself.

That was the remembrance of the time the word *dude* first penetrated my brain. That dudeness came from the first time I heard that word used repetitatively, percussively. "Yo, dude, yeah, dude, yeah, dude!" I was friends with Mötley Crüe. We were all staying at the Trump International in NYC and they wanted to go down to a club. I went, "Yeah, come on, let's go!" We piled in the limo, and we had a blast. It was 1991, the year of the Dude. The "dude" thing was just starting to take off in NYC, like a virus. It was "Dude! He-ey, dude. Duuuude." "Dude, man, you are the fuckin' shit!" "Dude, man, dude, I gotta tell you, dude, your clothes.""I don't have words for you, dude!" Everything was "dude" and I thought that is the funniest, motherfuckin' thing! I couldn't, you know, believe it. In my era, it was "cool" and "boss" and "groovy" and "let's get down" and "let's get it on." "Dude" was really juvenile but very let's drop in the half pipe and radical. I mean my mother at the age of sixteen wouldn't have used such a jive expression.

Anyway, we went to the club, they got hammered—I didn't—and that was that. A couple of months later, the dude thing was ingrained, imprinted on my brain.

I'd be writing songs with people and they'd say, "But that doesn't rhyme." But there are all kinds of rhymes; there's soft rhymes, like "share" and "*Fair*port Convention." Now, that rhymes. I would also try things like "All I want is a room somewhere / in a bra and my underwear." That works, because there's a picture being painted: the bra and my underwear jolts. I'd written with the band and I'd written with Richie Supa, but Richie and I were best friends. Desmond Child was another matter altogether. He was a songwriter brought in by the record label. John Kalodner, the A&R man from Geffen Records, loved the band, so he threw everybody he could at us. Desmond was from Cuba, so dapper and with a mustache—he'd been in Desmond, Child & Rouge. And so began a long and involved songwriting career with other people.

I loved writing with Desmond Child because we always got into arguments. When I first met him, I'd written all the lyrics to "Dude (Looks Like a Lady)" *except* the first verse. I got kind of annoyed at myself for not finishing it. I could not find that first verse. I did not have an in. I said, "Hey, Desmond, I just don't know how to get into this." There were a couple of words here and there he threw in, but he got me into that first verse. He said, "Pull into a bar by the shore," and I went, "Oh, god! Here we go!" I never started a song like that. And I said, "Well, now, I'll give it a try, how about 'Her picture graced the grime on the door.'" And he goes, "Oh, that's great!" And "she was a long-lost love at first bite" rather than "sight." And then he wanted me to sing, "I threw my money down on the stage / and, well, I didn't care." "Are you serious, you want me to say *that*?" I didn't want to say, "Oh, that's too fey for me to say," so I said, "Well, that doesn't rhyme."

"Dude looks like a—" why would you sing that? Do you know a transvestite? I've actually met quite a few. "Dude looks like a lady" means nothing OR it means SOMETHING. I go, all right, in a commercial world, it's good, and not only is it good, but it gets under the hood of what everyone hides: the gay thing.

When Desmond started throwing things at me that I didn't know how to use, I should've said, "Nah! I can't sing that." But it took me a couple years before I could voice my objections that strongly. Just like when I got sober, I could not go into a bar and order a soda. The bartender would ask, "You want a beer? Can I get you a drink?" I couldn't say, "I'll take a ginger ale!" Could not

245

say it. Because there was so much shame behind it—why would I be ordering a ginger ale? "Gimme a Jack on the Coke." Now that was my natural mode of bar talk—I drank a bottle of Jack with my eggs! It was the norm.

At my first AA meeting, I looked around and felt right at home. I got in touch with whatever me had been there back then. I got to meet this fantastic woman who conducted guided imageries. The sessions took about an hour. And in that place you would learn to slither like a snake or-if you couldn't swim-project yourself swimming across a lake, or saying good night to a child that died years ago. You sit there quietly and the therapists talk to you: "Okay, imagine the sun is going down, you smell the warm summer air. Where are you right now? You're at your back door, you're in a chair by your back door." There's a whole room full of people tuned in-guided imagery. "Here comes your dog, bend down and pet your dog." And in your mind you're petting your dog. Some of the guided images were so beautiful, so heart-rending, people would begin crying. "Picture your mom, can you hear her calling you for dinner." After ten minutes of doing that with your eyes closed you are in a very vulnerable state.

How sweet is that! Envision a cat that you loved so much, or get on a boat that once sank. Now you're on the boat again, go out to your favorite fishing spot, you're rowing. People would actually sway back and forth while envisioning the images. In their mind they were rowing. The therapist might talk to you about your first sexual experience, and you'd get an erection but the erection would be in your mind.

How would you describe purple—grape juice maybe. What does black taste like? Licorice, I guess. I'm trying to think of a color that you can't associate with something that tastes good. Orange—oranges. Yellow banana. How would you describe what pink tastes like? Pink . . . pussy!

STEVEN TYLER

And that's what I do with songs. I navigate through images.

Sometimes I feel like I'm so fucking boring in sobriety, but you've got to remember, when you take drugs you're just spinning in your own head . . . *so up in your own Kool-Aid*, you know? Up in da Kool-Aid, mon, but you do not know de fla-vah.

CHAPTER ELEVEN GETTING LOST ON YOUR WAY TO THE MIDDLE

day in the life on the road—*Oh yeaaah!* The Permanent Vacation Tour's going to last seven months, easy . . . more likely a year. You wake up, you leave Boston, you're going on fucking tour, baby. This is the first true (more or less) clean and sober tour, 1989–1990—and Joe and I have gone from the Toxic Twins to the Detox Twins.

Still, it's hardly the Goody Two-Shoes Tour, so you've got to watch your step when temptation beckons—and trust me, *it beckons*. Why the need for caution? Because there's wives and girlfriends on this tour; you fuck someone, and even if *your* wife isn't on this leg of the trip, you know only too well, one of those bitches will be the first to get on her cell phone to your wife or significant other and tell all. "That Steven! He's incorrigible! Will he *never* grow up?" "My dear, I shouldn't be telling you this, but . . . what *was* he doing backstage to that slutty piece of jailbait? The silly boy tried to explain the bizarre pose he'd got himself into—'She's interviewing me for her high school newspaper.' Yeah, *right*." If you're on tour for a year, you're not fantasizing about drugs and booze and hot chicks so much as you're dreaming about falling into a comfortable bed at the end of that endless day. If you stay at the best hotels, then just scrape a million dollars off a tour because that's what you end up paying for eight guys in the fucking Four Seasons, deal or no. The tour manager is wheeling and dealing so he can stay in there for free because he brought Aerosmith. *A-heh*. Oh, yeah!

We stopped staying at the Days Inn in 1977 because we'd wake up in the morning with our backs twisted, thinking about feather beds. It was the era of *enough*! Plus there were fucking fans next door banging on the wall, *bam-bam-bam-bam-bam-bam*! "You're the fucking BALLS! You're the FUCKIN' BALLS!!!" At the Four Seasons you had security, and who gives a shit if it's a million dollars off the top.

The best tours are the ones that are propelled by hit singles, like the Pump and Permanent Vacation Tours. *Pump* had "Love in an Elevator" and "Janie's Got a Gun." *Permanent Vacation* had "Angel" and "Rag Doll." So when we went out on tour I knew we were four deep in hits. I knew it, oh, I *so* knew it! The tour's the surfboard, the wave is your popularity, how you're getting played, and if you are, you're going to go through the tunnel. It's a wave from the backside of Hawaii twenty feet tall and you're riding that fucker as long as you can ride it.

You leave Boston with a wistful heart. "Bye! Uh, we're going! Sniff!"

We'll be back in Boston in four months, and that's when the family comes to see the show and they start getting their guest list together: the doctors, the lawyers, and the candlestick makers, the fucking guy that gave me my canoe, the schoolteachers, the pharmacist, the caterer, the manicurist, the yoga teacher.

You get on the plane, the first gig's in Dallas. You get to your room, you lay out your clothes. You're going to stay in Dallas and do that hub thing, so imagine we're in the middle of a wooden wheel with these big spokes leading to the different cities we're

Just married, me and my beautiful wife, Cyrinda Foxe, 1978. Mia and I lost her on September 7, 2002.

The other Aerosmith in the 1980s: Tom Hamilton, Barry Gibb Kramer, me, Rick Dufay, and Jimmy Crespo.

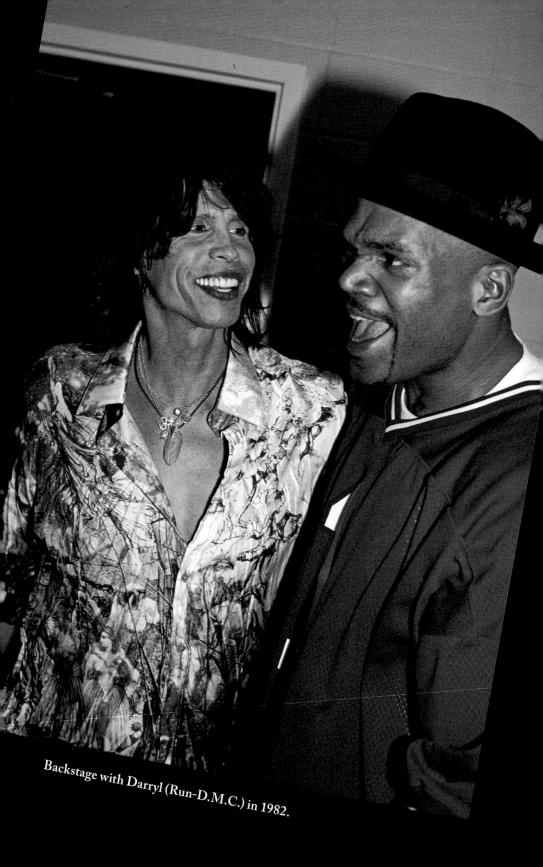

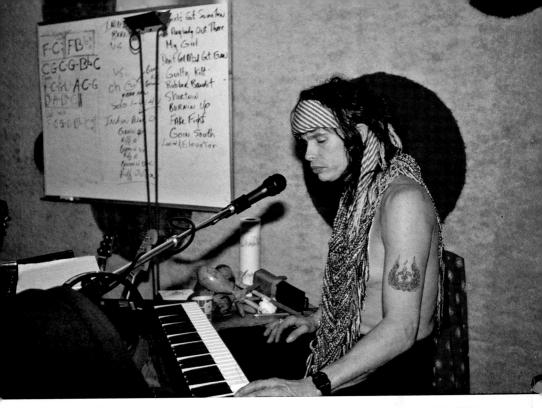

Pre-production for *Pump*, Rik Tinory's Studio, Cohasset, Massachusetts, 1989. Writing the lyrics for "Love in an Elevator."

Writing "The Other Side" on the floor at Little Mountain Studios, Vancouver, B.C., 1989.

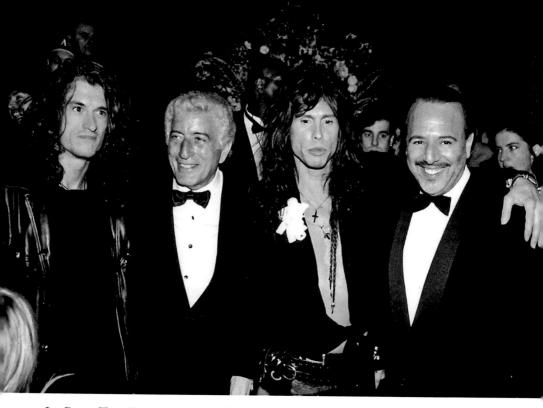

Joe Perry, Tony Bennett, me, and Tommy Mottola the day we signed with Sony, 1991.

Millenium Show at the Osaka Dome, Japan. The end of the world? My ass!

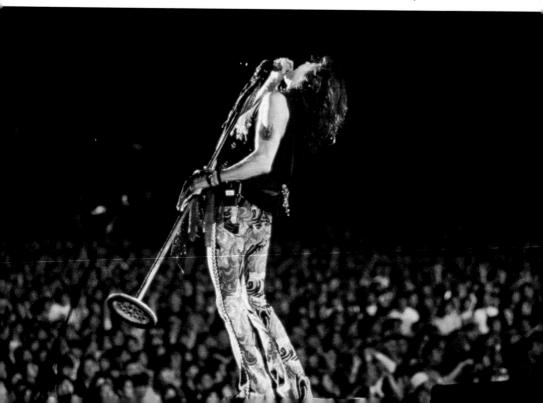

RIGHT: A gift from Willie Davidson for playing at the 2003 Harley Davidson Year End Bash.

BELOW: Me and me at the Rock 'n' Roll Hall of Fame in Cleveland. This is the head they made of me for the video of "Pink."

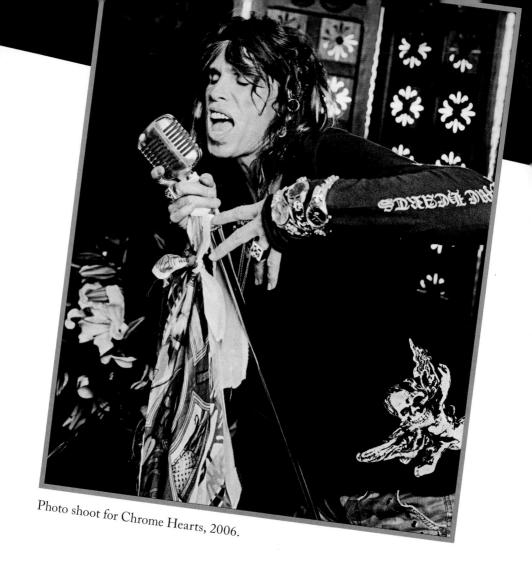

Taj, Mia, and Chelsea watching Pink perform at Aerosmith's MTV Icons show, 2002.

Laurie from Chrome Hearts took this picture of Chelsea and Daddy in 2006.

Backstage with the gorgeous Pamela Anderson on the Get a Grip Tour, 1994.

A quiet moment with Erin before the storm of the next show, 2006.

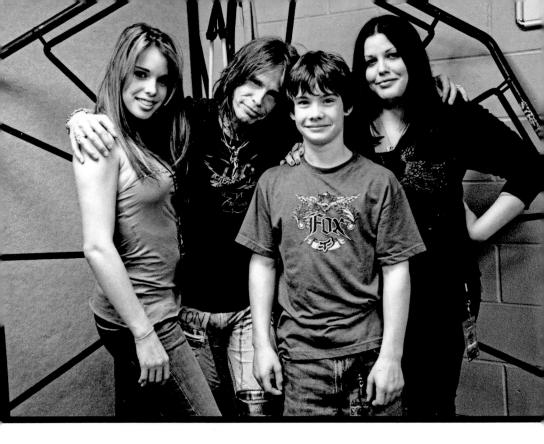

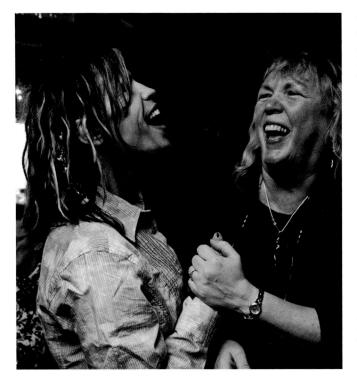

Chelsea, me, Taj, and Mia backstage in Boston, 2006.

Me and Lynda at Christmas, 2006.

RIGHT: Chelsea Anna Tyler Tallarico on our rope swing, Sunapee, New Hampshire, 2008.

BELOW: Liv on the cover of *Interview*, 2007.

BELOW: Clyde and his ride (Honkin'), 2010.

авоvе: My last drink, 2009. Go big or go home.

RIGHT: Me and Mick Fleetwood the night he loaned me his balls at the Roxy, 2010. The second second

LEFT: Anything for a good shot . . . 2010. Out of the closet, but still in the drawer.

BELOW: Johnny B. (Joe's guy and road manager extraordinaire) and me, London, 2010.

Me and Billie Perry raising the bar... the band and Bar Rafaeli 2007 RIGHT: "Chairman of the Bored," 2010.

BELOW: Me and Erin meet the Obamas at the Kennedy Center Honors, 2010.

TOP LEFT: Chelsea and Victor the Cat, 2011.

TOP CENTER: Mia mine, 2010.

TOP RIGHT: Taj and Ranger, fall 2010.

ABOVE: Me and Bebe Buell, Liv's mom, 2010.

LEFT: Milo Langdon, my grandson, 2010. I'm a grandpa . . . O yeah!

ABOVE: Me and Milo, 2011. Grandpa—spaced out.

RIGHT: Teresa and Ranger, as a puppy, fall 2009.

BELOW: My mother's final resting place.

Me and my dad, 2010.

My favorite Aerosmith pic of all time—Verizon Wireless Amphitheater, Irvine, California, July 29, 2010.

249

going to play. We were there for a week, Four Seasons. You wake up the next morning around nine, eat a little something by ten. At eleven you go to the gym, take a shower, you're back in the room by twelve, get your room in order and have a little lunch. By one, one thirty, there's a lobby call.

Your assistant says, "You know what? I was just downstairs, there are a bunch of people outside, so I talked to the manager, he says we can go to the second floor, we can walk down a set of stairs and go out the back way, *or* you can go out front. Either way, there'll be a car waiting, whatever you choose. There's about twelve people out front right now." I know if I want to sign autographs, say hello, and run real quick it'll take me about six minutes; that's what I want. Signing autographs for twelve people, you're talking six minutes, twenty people, ten minutes. But security has to know what I know. What if someone has a gun there? John Lennon got blown away by a psychotic fan. What if? And I walk into those situations all the time. I've got five bulletproof vests at home.

Two o'clock, you're down in the lobby. You ride back to the airport. Two thirty you get on the plane, a plane you rentedthat's going to cost you another two million dollars by the end of the run, scrape that off the top. You get in that beautiful plane of yours, you claim your seat-mine's on the right, up in front. I put my pens and papers there and scrawl my initials on the table with a Sharpie. To the left of me is a five-foot bench along the side of the plane. There's one seat across from me where my significant other will sit. Joe is to my left, and then Joey, Brad, and Tom are back there behind me. It's a ten-seater: five of us plus tour manager, security, the stewardess, girlfriends, etc. Stuff it all in, luggage stowed, we leave at three and head off to the first venue. The tour manager books it so we fly for an hour; sometimes it's an hour and a half, sometimes two, but not often. Generally an hour and fifteen minutes. It's the tour manager's job to set a tour up around a hub. You're flying at four hundred miles an hour. An hour and a half gets you to, say, Omaha.

You get out of the plane at four thirty. At the FBO (Flight Base Operations), you ask if there's a bathroom. You hope that your tour manager has enough brains to have called ahead and checked this out. We don't get in the cars and go right away—we take five to ten minutes, say hello to the cops, talk about *guns*, the tour manager can talk to the guy at the venue. "Do you have a shower there?" No. Okay, now you have to figure out some other way to take a shower before the show. As you're leaving the airport, you see a motel. The tour manager says, "Hold on!" and you pull the motorcade over. You stop at the motel and say, "Look, can we get a day room?"

By five o'clock you're in your dressing room at the venue. The place holds twenty thousand people. You're ready for tonight. You shoot the shit and bullshit for a while. It's six o'clock, time for your meet 'n' greet, shaking hands with people from the radio station, fans who have won tickets by being the fifth caller or the dude looks like a lady or whatever they do to get their tickets. They're all there in the room with you, asking you questions they already know the answers to. Backstage nepotism runs wild. Deejays and their kin. It's the announcer, it's the morning jock, it's the nighttime jock, it's the five jocks gacked on coffee in the morning, the morning-show guys, the night show, the five o'clock sideshow-they're all there with their wives and their best friends—so it's a room full of fifty to sixty people. You meet 'n' greet till seven. Around seven you ask the girls that do the backstage, "What time'r we goin' on?""Nine fifteen!"I have to eat two hours before I go onstage, so at seven o'clock I get the cook to come in. He makes me salmon. I have salmon every nightit's got to be wild-and steamed broccoli. I eat that at seven, I'm done by seven thirty or so.

People are still walking in and out, guys from the opening band. Shooting the shit with Kid Rock. "Where's your girlfriend?" Pamela Anderson comes walking in, "How goes it?" I said. I remember the first time I saw her at the MTV Europe Music Awards at the Brandenburg Gate in Berlin. She was going out with that guy in Poison, Bret Michaels. She was hot so I lied and said, "What the fuck are you doin' with that jerk, you knew I was going to be here." So *pretentious*, so *rock star*, but then again I'd drink a gallon of her piss just to see where it comes from.

It's now, like, seven thirty, my assistant goes, "ST" and she points to her watch. "Come on!" Nine fifteen we go on, so eight o'clock's the lockdown in the dressing room, lock it out, no one comes in. I set my timer for an hour-when it stops, it goes Brrr-RRRR-rrrr-RRRR-rrrr-RRRRRR! It's my fucking time, because I can't keep time to save my life. Pamela comes in again. We're shooting the shit! Some people are still pulling on me, going, "Steven!" I sit down and do makeup. Makeup takes twenty minutes. Hair I do myself. After that I do a little exercising, get on my StretchMate, get on the floor and do a little yoga, stretch those muscles out-if I don't, I know I'm going to feel it later on. Work out with my twenty-pound weights on my board. Now it's getting around eight fifteen and I've gotta warm up, singing, so it's Ay-aay E-eeee I-iiiii O-0000 Ay-aay E-eeee I-iiiii O-0000 Ewwww Ay-aay E-eeee I-iiiii O-0000 Ay-aay E-eeee I-iiiii O-0000, all the way up to the top, so you can't go any further, then all the way down to the bottom. Just watch that episode of Two and a Half Men and you'll know what I do. I'm the one the guy next door is complaining about when I practice my scales.

Then I get the countdown—they call out to me to give me the time I have left till I have to go on: "Fifteen minutes!" That's when I first get that "Oh, shit! I gotta go onstage!" jolt. Any bug that I got flies out of my body 'cause it knows deep down inside it's going to be two hours of *insanity*. I'm throwing a party for twenty thousand people. I *love* it, I'm addicted to adrenaline. "Five minutes!" someone calls out. We walk down the side of the stage and the tape rolls—it's a five-minute film. I got my big burly friend K. C. Tebo and his wife to take pictures of us that we could project on the screens in the back during the show. K.C. made an Aerosmith film with a voice-over in the style of the old newsreels: "And defending the nation is...." We found the reporter that used to do them, got his voice, and put it on the tape. It shows us at various places on tour. "And we stopped in Berlin!" We could be in Berlin on the European tour, we could be in Prague, we're going to France. It's projected behind us on an LED screen.

The LED screen is forty by sixty feet. When you hear LED you think a flat screen, but this thing is five inches thick. It's set up every night, hi-def Aerosmith. We used to have a camera showing us coming out of our dressing room and walking up to the stage. *Bor-ing!* Been there, done that. Not cool. This new montage of scenes K.C. came up with out of his head—he's brilliant, great director. He did the whole European tour with us, but because he stayed with me and filmed me, some people in the band got a little jealous and knew that I was doing a movie. If I die, K.C. has explicit orders to make all these clips into a movie and put the thing out, so the world can see what goes on with me.

My ex-wife Teresa is there, my girlfriend Erin is there in the dressing room. Dan Neer is interviewing me on a boom for XM Radio, I'm getting my face done by the makeup girl, the pitcher from the Red Sox is there with his wife. There I am ogling girls, philosophizing, chewing people out, hanging out with the Make-A-Wish Foundation kids. I go around the corner real quick because I have to pee. Dan says, "Do you mind if I come?" I haven't warmed up yet, and my cell phone rings, it's Al Gore! So there's all this stuff going on while I'm taking a leak. I tell the makeup girl, "You can look if you want." When you're not married, there's all sorts of things you can do, stuff I could never do when my wife was around. I can't *tell* you what *joy* that is. Because with wives you can't joke! That's part of the bargain. It's all on film, a day in the life....

Curtain drops, Aerosmith's on, two-hour show. The show takes us from nine fifteen to eleven fifteen. We're supposed to be off at eleven fifteen—that's a state curfew. If we go over it, we gotta pay them a couple of thousand dollars a *minute*; sometimes

253

it's *five thousand dollars a minute* if you're in New York at Madison Square Garden; it's ten thousand dollars every five minutes in L.A. And we *always* go over it. Makes you wonder what Axl Rose paid on his tour. Okay, so we get offstage at eleven, eleven fifteen, an hour backstage taking showers, meeting people, talking to girls, twelve thirty we're at the plane, we fly back, an hourand-a-half flight.

Like they say, the woman has to be in the mood, the guy just has to be in the room—and that—being in the mood—goes for the lead singer, too. You have to get it up, you have to get up there onstage and flaunt your petals. (You're asking yourself, *What is he saying? Where is he going with this? Is he on drugs again? Better call Tim Collins.*) Onstage, who takes the brunt in Aerosmith? ME! When your audience doesn't respond to a song, who feels worse about it, who owns it the most, the guitar player or the lead singer? No wonder I got Lead Singer Disorder.

And what is the leading cause of LSD? Guitar players! They drive lead singers crazy! Guitar players can put their amps on 10 and have a roadie change their strings.

Thank you! Onstage, no one's going to hear if Joe's guitar is out of tune-it's been out for years, it was out for most of the seventies. Now we have really good guitar techs. Still, it slips. Stuff happens. Joe plays so hard, his guitar still goes out of tune. I always wondered, Is it just me? How come only I notice it? It bothers the hell out of me onstage, but the audience doesn't hear a thing. They're stuck on the image of Joe being there, the cool cat they saw on the back of the album. Oh my god, it's him and it's live and there he is! Steven Tyler-live and in person. Well, I got news for ya, if I for a second sang flat "I could lie awake just to hear you breathin'," Oh, whoops! In the press, in the paper: "His voice was all right, but he kind of missed a couple notes." And they would put their finger on what note it was. "Steven Tyler looks good, but his voice is slipping. Maybe old age and years of drugs, maybe drug rehab-" Oh, they'll look for anything! They speculate like crazy. That's why, in my

Italian mind, that lawn's got to be mowed and good. It's got to be raked—or I ain't going to the beach! So if I don't sing really good and be all I can be in the Aero Army (ha-ha) they'll be on my case like white on rice.

You're in a band, you make it, you're let in the door; then you have to be realer than the realest real for people to relate to when fans are standing on their feet for three hours to come see you. They need to see a show that evokes something extreme in them. So you've got to, telepathically, and through body language and song, *reach* them profoundly, visually, electrically, do something that changes their Everything. The song you sang once touched something in their life, something that they can totally relate to. They heard you first on the radio *without* seeing you; now they're one-on-one with you by being there.

We're onstage, and during the last song, I hear in my ears, "Steven, we're doing a runner, the cops are waiting, go right to the car, stage left, stage left." We run out that way. That's when you put on the bulletproof vest, when you hear that goofy cartoony voice saying, "*Ex-it staaage left*." I snap into the vest, I'm so hot and just, like, *hoo-hah-hoo-hah*. I need to sit in the car in just my underwear and a towel with Erin. She gives me a little something to drink, we get in a police motorcade, the police siren goes off, *BaroooOOOOOoooooOOOOOOoooooo!* It's *so* loud! The noise! Trying to talk over the noise of the police siren, the plane's engines on the runway.

Around twelve thirty we're back on the plane. The pilot's complaining because he's got to fly so much—and we just came offstage! I guess it's all relative, because we all think our problem is the worst until we see someone else's. I'm bitching because I've been onstage for two hours and I hurt. Meanwhile somebody else was building the fucking pyramids.

The next morning, you don't have a show that night, but you're fucking dragging your ass. How do you fix a sore back? Back in the gym. You got to stretch that shit out. I learned that early on. But no jogging—those guys that run every morning

have fucked-up knees and legs and feet—just like I do from working out onstage for thirty years. We wear out, and that's a secret that nobody knows. The best exercise for anybody is keeping your hand away from your mouth—food is kind of a drug addiction itself. I did drugs because it made me feel good, beginning, middle, end of story. People eat because they got a lot of time on their hands and want to satiate the body. It's fucking great, I love to eat! Being off the road now, I love to eat, but I can't just indulge.

Two o'clock we're back in Dallas. Two thirty, we're dragging our fucking sorry asses into the lobby. What time did we leave? C'mon, try and keep up! It's a twelve-and-a-half-hour day. I first noticed that about seven years ago. I always just took it for granted, "Ah, it's three o'clock! We've gotta get to bed!" We never do two days in a row. In the past my throat was ripped, and after years of that I finally went, "You guys, fuck you. I'm doing dayon, day-off and I don't care how much money you think we're losing, that's what I need for my voice." Joe's guitar tech takes his sorry-ass worn-out guitar and strings, changes them, sets the guitar up for the next date. I don't have anyone to change my strings.

Three o'clock, I fall onto my comfortable bed at the Four Seasons and go to sleep. Nine o'clock my alarm goes off, I get up, order breakfast, go to the gym.... And that's my life.

CHAPTER TWELVE WHERE YOU END AND I BEGIN . . . AGAIN (THE GODDESS)

should be alone, without girlfriend or significant other, and when I need my love, go to a fair. Go to a mall! I used to say to my wife, "Jesus Christ, I get more love from a fuckin' stranger on the corner than I get from you—are you *tired* of me?" "Oh, I'm just tired of you always being angry." "Tired of me being angry? I'm angry for a reason!" "You always have reasons." True. But I'm supposed to turn into a Stepford husband? "Good morning, you look so beautiful, I'm glad you have such nice hair, and your teeth! That face! You look so good. Lovely to see you again! Bye." *Ding!* Next morning: "Hi. Wow, you haven't changed a bit, you look so young!" *Ding!*

It's easy to get accolades from kids on the street, but from your exes—forget it, even when they weren't exes. Instead it was "Why do you look at the women like that?" "That's what I do for a living." I've never had a relationship with a woman who really trusted me. I'm this guy onstage with an outrageous, larger-thanlife persona, a persona designed to be over-the-top, out there and *nasty*. Any woman who ever acknowledged that would have put the fire out. Immediately. If they'd said what they knew to be true: "I knew you were gonna fuck all those women." Never did they ever acknowledge that side. Ever. But if I fucked *anything*, it was the fucking inquisition. Even when I just kissed another girl.

"You're disgusting! Why did you kiss that girl?"

"I kissed her on the cheek."

"Oh, why would you do that?"

"Cause out there, I was in the moment." Do I have to explain every single thing I do in my performance? Should I explain yet another thing I do out there so that you can try and take the piss out of my performance at night? "I didn't fuck her, fer chrissakes!" But even at fifty, after going through two marriages, I didn't have enough brains to go, "Wow, well, this is so over!" and end things with Teresa. I had beautiful Chelsea and Taj, and I wanted the dream to go on.

I've been in a band most of my life, and if you live like that you don't have normal things happen to you—like *weekends*. Rock stars don't get weekends, time when you can stop being the guy on the lip of the stage. When I had kids at home I'd think, *I've gotta get up early like other fathers—mow the lawn, take out the trash*. When I'd fuck up I'd feel bad and call Joe Perry, who doesn't get up until one o'clock. "I'm a rock star," he'd say. "Have you forgotten who *you* are?"

Compared to most men who come home every night to their wives and their kids and all that delicious everydayness of normal life, I'm at a disadvantage. Oh yeah! The whole rock star business—combined with the basic male impulse of wanting to fuck anything that moves—does put a kink in the ideal of domestic bliss and the till-death-do-us-part thing.

I would goggle down at the girls in the front row in the tight tank tops with their nipples sticking out like rocket boosters,

STEVEN TYLER

because that's *my job*. My job onstage is to be sexy, that's what I am! It's the equivalent of me saying to my wife, "Why are you such a whore in bed?" To which she'd say, "Well, it's only in the bedroom." "Well, with me, it's only onstage!" "Well, no it isn't! You're looking at them like that out here in the parking lot, too!" "I am?" So now I'm bad for being naughty onstage, bad for flirting with girls at home, bad for arguing with her about it...

Everything to do with women is a negotiation, because it's based on sex. Your boss can tell you, "Show up, suit up, shut up." But you can't exactly say that to the woman you want to fuck tonight.

In this world, you know, it's "size doesn't matter" and "sex isn't everything," but then why is cheating in a marriage the final straw? (And by the way, *fuck* is no longer one word. It's *Fuuuuuuuuuuk*! Or FUCK, you're gorgeous! It is so expressive, it's *Fuuuuuuuk*!)

It's funny. Getting married, it's all "I, Betty, take Joe . . . better or worse . . . death or sickness." Excuse me? Did you say better or worse? And then you divorce him? Didn't you take a vow? Weren't we supposed to learn compassion and forgiveness from the Pope? Didn't the Pope once go visit the guy in the hospital who shot him? So how come I can't get none?

Why would a man and a woman who call themselves soul mates ever leave each other over something as frivolous as sex? The wife, in a high-pitched voice, says, "Well, 'cause it's deeper than that, Steven. It's really a trust issue." And that means if I fuck around, you can take all the money out of my account and sell all the animals? Excuse me, but what does a hand job have to do with my bank account? Suddenly they've forgotten everything except that laundry list of what they don't like about you?

As soon as I left my Teresa I became sexually active. Sad to say, but everyone said, "Wow! You seem so happy now!" And I thought, *Hell, yeah*! I can go to character breakfasts at Disneyworld now. Whereas in the past, *someone* didn't want to go. Or whatever it is you like to do and she doesn't. Or vice versa!

Your girlfriend, your wife, they're supposed to be your soul mate but you really never know. When you're in therapy you find out that you often do things in life out of necessity. Naturally, I didn't want to hear that. There comes a time in a man's life when he realizes he's not getting any younger—I think I'll marry this girl. And if you tell her she's your soul mate, she'll love you even more. Hey, we like to raise goats together, live in the country, eat brown rice, pet the old donkey. And isn't it funny how we found out that we both like—?

And then one day she catches you fucking somebody else and it's "I never did like that fucking donkey! You and your fucking donkey. You and your fucking chickens. I never fucking liked them and I'm bummed out that you never *sensed* that I didn't like them [*sniff*]."

And you go, "Oh my god, but . . . I thought that we were soul mates."

"Fuck you and your soul mate shit." And in a second, they're gone.... In a fucking heartbeat. Any guy that's caught fucking, suddenly everything that the wife loved him for ... gone!

Behind every great rock star there's the rock star's wife, drop-dead gorgeous, walking around in a thong—the kind of gorgeous woman you jerked off to in *Playboy*, but after two hours in a room with her you'd lose your mind. She's belittling the rock star, humiliating him, you wonder how that rock star could be with her. Because men are imprinted. They just want to get laid. It's a slammin' thing. Why does a guy who's the president of the bank want to suck on a high-heeled spike while she's smacking him on his ass with a riding crop that's leaving welts?

I'm half man, half woman. Most men are 80 percent man, woo-hoo-woo-hoo-woo, like an ape. There's not a lot of female emotion evoked in most males. My generation grew up in a John Wayne world, the macho cowboy or the GI going, "I don't want anyone to touch my bitch! I don't want anyone to touch my female!" What a crazy fucking thing is that? It's all male ego run riot. Gzooom!

I like to jerk off, I like to come! Who gives a fuck what gets you off? Gays love me! I walk into a roomful of queens and go, "Oh, you found me!" Still, I got to tell them, "Don't even think about hittin' on me. I'm a breeder and you know it." Gay sex just doesn't do it for me. I tried it one time when I was younger, but I just didn't dig it. The idea of some guy pulling my hair back, biting my ear, and shoving his cock in my ass doesn't appeal to me.

Sex is the strongest force in the universe. Forget about the Grand Unifying Theory, Stephen Hawking, I'll tell you what it is: women. Aren't women the strongest sex? What force is more magnetic than that? It's not just pussy. We're attracted to women for their energy. We're attracted to their fluidness, their ability to nurture a baby without even knowing how, to be able to put up with screaming and crying and colic and shitty diapers where men would go, "I'm fuckin' outta here! I'm gonna go kill me a saber-toothed woolly mammoth an' bring it on home to eat tonight. *Wa-haaaaaa!*" We don't have tits; we couldn't nourish a gnat.

Hooo-hoooo! Based on testosterone alone, guys are fucked. Most women are—can be—a little nuts upstairs, but they're basically nurturers, and we are, used to be, were created to hunt. We're created to be Ted Nugent. For a million years we did the hunting. We didn't sharpen our spears and sign a *contract*! Kill the fucking animal! Blood, guts, blurt. That's why women crawled to the back of the cave and had their babies. So the male wouldn't *eat* the baby. Animals do it! We're not far from that. There's something going on: in all of our fightings, we have not been able to find that cranial capacity to go from the monkey brain to ours. It kills me. I just *kills* me. Very rarely will you find a compassionate man who'll say, "I'm sorry," or cry. Hell, you join the women doing that! "What're you, a faggot? You're gay? Be a man!" I mean, wow! I'd rather be gay, if that's what gay is: smell the flowers, like to suck on my thumb, cry, smile big.

We keep the vagina hidden. It's too strong in our society. Jesus and Mary Magdalene—it says "and he kissed her" and the

261

rest is scratched out. He kissed her *what*? Her lips, her hands? We all know what the Holy Grail was, it was a vagina. Now that really is mystical. Those guys, the Knights Templar, are looking into the chalice—like that scene in *Basic Instinct* where Michael Douglas can't look at Sharon Stone's pussy—and they go into a swoon. What do you mean the chalice was gold with rubies. Please! Whatever the God force is, it certainly isn't in a golden box! Gold *we* made. Heaven and hell, we invented. Put *that* in the gold box.

Fucking-A women are different. They can have babies. They can nurture. Nurturing is part of a woman's DNA. But what about remembering anniversaries—is that part of their genetic makeup, too? Even tough chicks like my girlfriend, Erin Brady, get sentimental and pissed off when you don't remember. Last time I was in England with Erin, I got in trouble for that. We were doing the English equivalent of the Grammys. Oasis was playing that night. Well, unfortunately, this big night was also Erin's birthday or our anniversary or something. See? I'm already in trouble because even now I don't remember which one it was.

Whatever it was, I realized it along the way or someone told me. A little red flag went up in my mind. "Oh, my god!" So I called the hotel and said, "Give her some flowers." But she got it in her head that I took the flowers off a counter or that they otherwise hadn't actually come from me, which in a way...

"Erin, you gotta understand. I'm getting ready to do the Grammys, my head is in the clouds, I don't know *what* I'm doin', let alone to say Happy Birthday." Or was it our anniversary? Hey, I probably even messed up on the apology. "Listen, I miss my own kids' birthdays," I told her, "never mind what *day* it is."

"Well, not with me!" I think she said.

Finally I go, "Oh, *o-kaaayyyyyy*." We only broke up for ten minutes that day.

When I started to make money I said to Teresa, "You know what, honey? Go buy whatever you want." And she said, "Really, I can? Can we get, like, a *house*?" Oh, they forget all that! And then when I come home and say, "Look, honey, I was a little nasty on tour," it's "What-do-you-mean?" "What do you mean 'what-do-you-mean?" "Why did I tell her? Because I'm a fucking idiot. Oh, I know what happened. I was in rehab, I was sober, I was trying to be honest about everything. In rehab they were telling me, "Well, you should tell her, but it's not me that's sayin' you should." I took their advice. Unfortunately.

It's that word *but*. When they said to me, "*but* it's not me that's telling you to do it," I should have known better. *But* is a scary word. It'll get you every time. You know what my uncle said about the word *but*? It stands for "the basic underlying truth . . . is to follow." So when you go, "I didn't tell him, *but* . . . ," it means you did tell him. And when you go, "I told him, *but* . . . ," it means you didn't tell him.

Isn't it a crazy coincidence—or is it fate?—that my ex-wife Teresa was a twin and my girlfriend is also a twin? Hmm, maybe those seven-year-olds from the choir had something to do with it. When I was younger, if I ever ran into twins I'd say, "How about me and your sister getting together?" By the way, if I were on *Oprab* right now, I'd say, "Is there anyone out there who's got twin sisters? E-mail my Web site tomorrow, let me know." Oh, yeah, I don't do e-mail.

Of course, me being me, I did ask Teresa about having a threesome with her sister Lisa for years and got so smacked down. I may have asked Teresa's sister Lisa one too many times! But honestly, don't you think twins get that a lot? It's the thing to do, no? I once wrote a song about Teresa and her sister. It's called "Push Comes to Shove." "Lookey here, baby I'm talkin' bout you without a doubt. Your sister's lookin' mighty thin, me and the boys know where you been." I sing it like Tom Waits.

Women love me because I sing good, because I'm a rock star, because I'm Steven Tyler. You may say, well, hell, what's wrong with that? What's the big deal about being loved for yourself anyway? And at the end of the day, does it matter that I got laid tonight because the girl's known about me for ten years and loves Aerosmith? "Dream On" is her favorite song so she fucked me. Unfortunately, she's home telling all her friends, "Guess who I fucked?" And sometimes that sucks. Of course I'm not going to get any sympathy in that department.

I just have no life! I didn't even have time to see Chelsea and Taj, let alone go visit. I couldn't, because there was *so* little time and because I do this: *AaaaAAAAaaaaaah*! Every show my throat gets strained. My skin, my feet, my back is pulled and twisted. I am the whirring front man of Aerosmith, their golden goose! At the end of the night, I ache, I can't talk. The rest of the band, they can wake up and they're fine—they don't use *themselves* as an instrument. They can claim aches and pains so they can be in the Aches & Pains Club, too, once I start squeaking. Hell, everyone likes to bitch about how wasted and sore and shattered they are, but they can go home on the day off. My wife would see Joe home, call me up: "Why didn't *you* come home?" And once that starts, it's the beginning of the end, because I do day-on, day-off to rest my voice. And when I start to explain to her in my creaky voice, does she melt and say she understands?

I'd be in the Midwest and call home and say, "Guess who's here tonight? Jimmy Page!"

"Yeah? And I'm *here* alone. Hope you're having fun!" I'd kick the phone and go, "Fuck!"

They say that the female brain is different from the male brain and I can fucking believe it. Sometimes I'm ashamed to be a male around women. Men are FM—fucking and money—and women are, you know, psychosexually multitracked. We're still in mono—that's why they're all confusing to us. I mean, we're just sort of, like, "Hey, I like that, I want that!" But they can be both sides of the same question within two seconds. It's like David "Honeyboy" Edwards, the old Mississippi blues singer, used to say that you can't ever win an argument with a woman.

Dogs don't remember, they act by rote, they don't even know why they're doing it. When we're in a roomful of pussy, do guys instinctively go "*Ugghh*" like the Neanderthals we were? Do we? I mean, I don't know.

I want to talk about women, I want to sing to them. I'll do my lounge lizard act, anything to get through. To her, the one, the girl that I've missed: decipher this, baby!

Ridin' into town alone By the light of the moon I'm looking for ol' Sukie Jones She crazy horse saloon Barkeep gimme a drink That's why she's caught my eye She turned to give me a wink That make a grown man cry

I feel the vertigo of being alone. I'll be working a room, talking to people, joking, telling them stories—they're looking at me, and what they see is this Steven Tyler entity. I began to think of myself in the third person—which is a kind of existential hell. And everybody I know said the same thing except the one person that I wanted to say it to me, and she left me. So it's really lonely being who the fuck I am.

CHAPTER THIRTEEN

TROUBLE IN PARADISE (LOSING YOUR GRIP ON THE LIFE FANTASTIC)

y the fall of '91 I had six years' sobriety, but, for whatever reason, I wasn't getting along with my band. I'm Italian, I really look at what's going on. So I thought I better go check in someplace and get this sorted out.

Around that time, Marko Hudson was working on a Ringo album and put me on the phone with him—never mind the fact that it was the first time I'd ever spoken with Ringo, one of my heroes (an actual Beatle), and to say the least I was beside myself. Mark had told me the day before that Ringo had just come out of rehab and was sober. So, I got on the phone.

"Richard," I said, "I've been butting heads with my band for just about every fucking album we've done."

"I can relate to that," he said.

I thought to myself, if I'm having problems with my bandmates and you're in the Beatles, I can only imagine what you went through. The funny part is that we spoke for almost an hour about all this stuff and he ends by saying, "Well, good luck man . . . enjoy your sobriety."

"What do you mean, 'sobriety,'" I said to him. "I've been sober for six years—I thought you knew. Didn't Marko tell you?"

"Well, what the fuck are you going *there* for?" he said, meaning rehab.

"I want to make peace with my bandmates," I said, "so we can write like we did in the old days. I'm following the old adage that you can attract more flies with honey than vinegar. The only problem is who is the honey and who is the vinegar?"

So off I trekked to Arizon-i-a and checked into Sierra fucking Tucson (for codependency) to try and find out what the problem was. Now then, how to juggle band and family at the same time? Mmmmmnh! I wanted to see why my relationship with the band was so fucked . . . so up and down . . . and not in a good way. In part it was because of something I hadn't yet grasped-and wouldn't for many years to come: that Tim Collins and Joe Perry had been in bed together micromanaging the band since Day One. I would tell Joe something and he would tell Tim, and in many instances by the time it got back to me, it was the exact opposite. It was a triangulated version of the telephone game. Say Tim had it in his head for some reason to want to do something, but instead of working it out between us he would call Joe and tell him I was out of control-and then call me and tell me Joe was out of control. Since Joe and I were now not speaking to each other Tim could tell the band that Joe and I were fighting. All this happened in the middle of a yearlong world tour for the album Get a Grip-talk about "Livin' on the Edge"... WTF! But that's how it was-and obviously not just in this band. How about Keith and Mick, Dave and Ray Davies, Jimmy Page and Robert Plant, and John and Paul. How is it that the best of us can be so manipulated? Fuck, we did turn out like our heroes, but not in the way we thought. Joe and Tim were to Aerosmith what the world percieved John and Yoko to be to

the Beatles—without a doubt. What with the band members, the wives, and the managers . . . all in bed together. Talk about fucked. That's the heroin of it all! To find out that we'd spent years turning reality into a dream and watching it turn into a nightmare. *That's* death by heroin.

I spent three weeks at Sierra Tucson, a multipurpose attitude-reconditioning facility or whatever. First day I'm there the therapist asks me, "So, uh, Steven, we start with some questions: Ever had an outside affair?" "Well, yes I-" "Okay, send him to sexual therapy. Next, have you ever had a member of your family die when you weren't there?" "Well, you see, my grandmother-" "Grief counseling!" "Have you ever had problems at home with your wife and children?" "Well, see, I'm often on the road for months at a time and don't see-" "Family orientation group." After I left there, I had six or seven isms hung around my neck: drug addict, alcoholic, sex addict, codependent, family concerns, anger management, rhino clit, dwarf cock, whale watcher, bee keeper, oh, and did I mentin compulsive narcissism? Oh yeah, I had a full range of life issues. The bad news: how did they know? The good news: the last week of any stint in rehab, you have what's called family week, and as I have two families-my biological family and that other one . . . the band . . . guess who came to dinner?

Of course, there's all these therapists with their fucking theories. John and Yoko went to Arthur Janov for scream therapy. Let's see, if people scream when they're really scared, what if ... No, no, wait! What if we get them to scream indoors when they're *not* scared? That way, maybe they won't scream when they *do* get scared—and we'll have invented a *new emotion*! Yes! That's it! Hungry, angry, lonely, and Janov!

It took me a good three weeks to get any love from the counselors who were constantly trying to label me and figure me out . . . to make me recognize shame—feel *bad* about my bad self. They said leave Steven Tyler outside and bring Steven Tallarico inside. And never the twain shall meet? As fucking *if*! They tried

STEVEN TYLER

to make me wear my clothes-in disarray as they said-inside out and put a patch on me that said "No talking to females." All that did was attract the freaks. He was a bold man who ate the first oyster, and they were about to get to know him real well. Meanwhile I'm still waiting for that counselor to tell it like it is. So, on family day we (the band, plus management) go around the room and then they get to Bob Dowd, who was hired by management primarily as a "drug cop" to keep the band sober (imagine that). This guy was a real Nevada trooper who knew little about human interaction and nothing about rock stars' evil ways. And Tim goes and makes him Aerosmith's fucking tour manager?!?! Bob would sit with us, keeping an eye on us while Joe and I were trying to write songs. I'd say, "You know, Bob, we don't write so good with people watching us. You're blowing the vibe." Of course, that would be translated into, "Steven's causing trouble; he wants me out-he must want to do drugs."

So at the session I laid into him, "I don't appreciate you following us around like a cop. Stay out of it. Besides," I mumbled to myself, "your arm's too short to box with God, and you don't know anything about addiction!" Tim, in Bob's defense, looked at the counselors, and said, "I hired him to make sure no one was using, leave him alone. And, by the way, that's the way it's gonna be." The counselors looked at Tim in astonishment and said, "You may be the sickest one here." The tension was beyond belief. That's when I screamed. "Halle-fuckin-lullah!" I took some boxes and pushed 'em together in the middle of the floor of this room of mucho agidacion. I grabbed my giant scarf from the corner of the room and threw it over the boxes and said, "From here on out I dub thee the Shroud of Touring, and we shall take it with us as a good luck sign to never forget this moment." And with that, I grabbed my coffee cup, poured it into a goblet, and made a toast to the band: "Here's to hell . . . may we have as much fun there as we had getting there."

The manipulation never stopped with personal management, money management, and the addiction counselors. One day after the Tucson incident, and neck deep in the *Get a Grip* album, they all came to my house (and wouldn't you know these cretins all came from the Malibu Home for the Recently Alright). Apparently they had concerns about the way the album process was going. They said, "Look, we feel you're really not writing the way you did before. So, we think, you know, it would really be all right to get a blow job once in a while." These were words of wisdom coming from the total Aerosmith management package.

And I said, "Wow! That's great, you guys. So, does that mean you'll bring me a beer once in a while, too—and which one of you guys are gonna blow me right now? Don't you know one drink is much too many... and a million's not enough? Let's see, do I want to be a dancing bear here? Do I want to give up that easy? Do I really want to keep the right ones out and the wrong ones in? Or do I want the world to think that I'm mysterious and dark and that I get my lyrics from the De-vil's Den? Hmmm, let me think."

In 1992 we were recording *Get a Grip* with the band. I was working on "Fever" with Joe when I hit on one of the best lyrics I think I've ever written. I was so proud of it and thought it was so funny that I brought it to the band with such a frog-eating grin that Tom said, "What's the matter? What do ya got?" And so I said, "Check that shit out."

The buzz that you be gettin' from the crack don't last I'd rather be O'Din' on the crack o' your ass. Yeah, we're all here, 'cause we're not all there tonight

Silence . . . crickets . . . a blank look and then Tom turns to me and says, "Are you gonna sing that lyric on the song?" "Excuse me?" I knew where he was going with that because he's hit me with that same type of sideways getting-into-something shit before.

"Steven, I was just, um, wondering . . ."

"What, man, what?" Knowing the other shoe was going to drop. "Well, just fucking say it, will ya?"

And Tom says, "That's not going on my album."

"That's one of my favorite lines of all time, Tom. And by the fucking way, what do you mean 'that's not going on my album'? I wrote the fucking song, not you. If it wasn't for this internal mental fucking backwash I wouldn't have the inspiration to write the next song," I said.

If I could have bottled the anger I felt in that moment I would have quit the band and bought Madrid, and hung out with the lemurs for the rest of my life.

Oh well, and speaking of anger, when you get into bed with A&R men . . . that all-time adage is so true: can't live with 'em, can't live without 'em! Or maybe it's, "If you lie down with dogs . . . "Nah . . . but do they really do a band good? Did the infamous A&R diva, John Kalodner John Kalodner, really help us out? He insisted that every time his name was put on the back of an album it be written twice. I guess he subscribed to my point of view that anything worth doing is worth overdoing. Actually it was a good luck thing in the end. And so I think the best thing John Kalodner John Kalodner ever did was to challenge us, to bring us around as real songwriters. The truth to the secret success of our marriage was that we let him in to begin with. Saying fuck it, just try it, that was my credo (okay, maybe some Tibetan monk living in a cave with yak butter in his hair said it first).

Kalodner's input as far as what a song should be and where songs should go was antiquated but all the same very effective. But his instincts were godlike. What he did do, however, was say in his nasal whine, "Steven, that's great! Don't bore us—get to the chorus. And it'll be a hit single if you put strings on it." Kind-a-like, if a tree falls in the woods and there's no one there to hear it, does it still make a sound? And would that hit be a single? Or if a man has an opinion and a woman's not there to hear it, is he still wrong? Yeah, I like that better. Sometimes Kalodner would hear different choruses after songs were already written. Once, when we were out of songs for *Permanent Vacation*, I grabbed the guitar and started playing the riff to "St. John," which at the time was a shell just waiting to be filled in. "That's fucking great," Kalodner says, "your instincts are right. You always write the best songs under last minute pressure."

Of course, I hated hearing him say that, but it was true.

I was in Vancouver in a hotel room by myself, gnawing the furniture, trying to come up with songs for *Get a Grip*. John Kalodner didn't like the lyrics to "Cryin'" and for a month the walls of my room were covered with Scotch tape and scraps of paper—*covered*. I rewrote the lyrics to that song till I tore a hole in my brain—three, four times—and after the month I went, "Fuck it! I'm singing the original lyrics."

There was a time When I was so brokenhearted Love wasn't much of a friend of mine The tables have turned, yeah 'Cause me and them ways have parted That kind of love was the killin' kind Now listen All I want is someone I can't resist I know all I need to know by the way that I got kissed

That's the first verse and it sets up a beautiful story.

And it sang so good. *That's* what Kalodner was leaving out of his equation: *sing-ing*. He was hearing it literally and I was singing between the notes. He didn't understand that it doesn't matter *what* the fuck I sing if it ain't got that thing. I would be scatting, which sticks to your soul:

It's down on me Yeah I got to tell you one thing

It's been on my mind Girl, I gotta say We're partners in crime You got that certain something What you give to me Takes my breath away Now the word out on the street Is the devil's in your kiss If our love goes up in flames It's a fire I can't resist

... but he was looking for meaning and understanding, which you ain't gonna find in that verse 'cause I didn't write it that way. It just sings so good with the melody I wrote that it's irrefutable.

When he called me unreasonable, I always rubbed it in his face. What was written on the subway walls....John, there's a very famous saying by George Bernard Shaw that goes something like this: Reasonable people adapt themselves to the situations they find themselves in. But the unreasonable man insists on trying to make the world see things his way—therefore, it's the unreasonable sons of bitches who are always the catalysts for progress.

I was cryin' when I met you Now I'm tryin' to forget you Love is sweet misery I was cryin' just to get you Now I'm dyin' cause I let you Do what you do—down on me

Now there's not even breathin' room Between pleasure and pain Yeah you cry when we're makin' love Must be one and the same You can ruin anything by overintellectualizing it. I want my lyrics coming straight at you—I don't want everything explained, rationalized, sanitized, and homogenized. I'm writing "Deuces Are Wild" and Kalodner the fucking momaluke says, "What are deuces? No one plays cards anymore." He was right (back then, before TV poker became all the rage in the 2000s)... but deuces, when I'm done with them, are sonic dice. I'll make those bones dance.

I love you 'cause your deuces are wild, girl, Yeah, a double shot at love is so fi-i-yine! I been lovin' you since you was a child, girl, 'cause you an' me is two of a kind!

It had nothing to do with deuces . . . it had everything to do with gambling as a metaphor for love, betting everything on the hand you're dealt. Love, gambling, romance, games of chance. And by the way, "Deuces Are Wild" is on the side of the fastest funny car in the world. Do they look at it and go, "Huh? What does that mean?" They'd know what it means: deuces are wild, the car's fucking fast. So what? If a girl came out naked and she had e = mc² on her tits, do you think no one would lust after her because they didn't understand it?

Salieri in the film *Amadeus*—that fucking prick! You know who he really was? Mozart's A&R man! Salieri the sycophant . . . who agrees with Emperor Joseph II, who agrees with the Music Director that there are "just too many notes" in Mozart's opera. A&R men, that's the way they talk: "Start with this. . . ." "Put that in there!" The critics, too, can drive me crazy.

Their style of dissecting things rubs me the wrong way. However, remaining open to criticism can take you to places you may never have gone to on your own. Thank you, John Kalodner, you're a genius and I love you . . . no one can wear a dress better than you, including me. Dude looks like the bearded lady.

Can you sing? Can you dance? Tim Collins couldn't clap twos and fours to a click track to save his life—but he saved ours.

Wait! I know what they'll say: Salieri was integral—if it hadn't been for Salieri making Mozart mad, he wouldn't have written his *Requiem*. And they would have a point. Whenever somebody said, "You can't do that!" it just made me want to sing it even *louder*! Because that's what the sixties were all about: hatred of rules, regulations, the accepted way of doing things. Now it's all fucked. Now it's nothing but mock rebellions, it's all "Why, I'll show you! I'll do a reality show and . . . shit on the table! Yeah! That's it."

Give me the freaks, the geniuses, the confused, the Daltons, the great unwashed, and the ones in doubt. All great art will tip the cart—and I'm not, by the way, claiming Aerosmith is the fucking Sistine Chapel—why no . . . no great art was ever created by playing it safe. Now, in the new gigabyte, iPod apps, 2.0 U.S. of A.'s, they're all cloned, certified, and convinceified. There are automatons out there! It's like a Universal horror movie except instead of giant ants oozing nuclear snot, it's the professionals, lawyers, doctors, shrinks—and A&R men!—with their learned, conditioned responses, their stock answers to every fucking thing. A little-known secret? Listen to the things they're not saying and you'll find out what they are really saying. "Well, you see, if I were in your situation, given the parameters of the . . ." "Professionally speaking, if you were to ask my canned opinion . . ." Shut the front door.

Lawyers were brought into the folds of the band to advise us how to handle ourselves in the case of stalkers and how to talk to female employees. For example, if we ever get stalked by a twisted fan, what not to do. Never talk to the person. And since no one in the band ever does talk to fans, what's the problem?

"Just don't talk to that person if you sense they're stalking you." That was their blanket statement. Thank you—and bye! "How much was that, Mr. Manager, sir?""Oh, well, that was only fifteen grand to bring in the lawyers again."The band looks at me and says, "It's all your fault. You talk to everyone!"

275

And then Joe and Billie started having stalkers, and then came the beginning of the end.

Here's a case in point: I'm vacationing at my summer home with all my kids for the first time. I'm cooking breakfast, and I see someone jump over my fence. My ex-wife, Teresa, says, "I'll take care of this," and starts walking toward the door. And I say, "No, you don't, I got this one." So, this guy is standing at my backdoor pushing the doorbell. I said, "Ehh, what's going on here? What are you doing jumping over my fence? This is the last place I can go to get away from people like you. You could get shot jumping over my fence like that. What are you doing here?"

"Well, my mother said you wrote a song about me." Looking in his eyes, I could tell he was on something or off his meds. I was standing close enough to see his hands so I'd be able to stop him if he went to grab for something.

I said, "I write a lot of songs about a lot of people. How do you know this one's to you?"

"Well, you sang, Tommy now it's untrue."

And I went blank. "Tommy? No, no, it's actually 'tell me,'but it could be Tommy. Yeah, if you want it to be Tommy, it could be Tommy." I didn't correct him. I asked him, "Where's your mom?"

"Well, she died when I was three. She left a note to me in a letter." So that was his connection with the mother—I'm not going to take that away from him.

So, I said, "As far as I'm concerned, it's 'Tommy.' From here on out, I'm gonna sing it like that. Now get outta here!" with a wink, "and don't ever climb over the fence again."

I could have called the cops, but I diffused it myself. Half the people in the world who hear your music own it anyway. And it's exactly what you want them to do.

Marko Hudson told me a story about when he was hanging out with John Lennon and the Hollywood Vampires during the *Walls and Bridges/*May Pang Kotex-on-the-head moment in 1973. You gotta see this picture: Marko buzzing around Lennon's hive (me thinks a bit too much). Lennon let Marko ask him ONE question about the Beatles, so he asks John about the lyric from "Happiness Is a Warm Gun." "The image of the velvet hand and the lizard—it meant so much to me," said Marko. "Can you tell me where it came from and what it means?" Lennon, Marko's greatest hero in life, replies (imagine thick Liverpudlian accent), "Doesn't mean nothin'. Sounds good comin' off me tongue. I just write the words . . . you make up the meaning." My best friend was both crushed and liberated. But it points back to interpretation. . . .

People ask me all these questions about "Dream On." "What does it mean?"What do you mean, "What does it mean?" It means Dream On. You figure it out. You're the one listening to it . . . make up your own meaning.

While I was working on *Nine Lives* I was clean and sober, I was high on life, but Tim Collins was convinced I was using. How could I be that jacked and on the natch? I think Tim wanted to catch me doing drugs in the worst way.

I went to Tim Collins's office. I could tell by the smell of sulfur in the room that he was working on something diabolical, the monster. Dark deeds were afoot. "Steven, we're going to send you to a retreat in Big Sur for a week, we think it'll do you good." Whenever I hear that something's for my own good brrraaaannnng!—alarms go off in my brain.

"I'm gonna go to a retreat in Big Sur? With who?"

"A men's group from New York—all professional guys, captains of industry—you'll get on with them famously," Bob Timmons, Tim's weaselly minion, chimed in.

"Oh, that sounds like Fun," I said. "It'll be five minutes of silence and the rest of the week it's going be, 'Uh, dude, man, what was it like singing "Dream On," man?' Or, 'I gotta tell ya something, man, I got laid to your fucking records last week.'"

You know what that would be like for me at sixty with another bunch of sixty-fucking-year-olds? "Do you know that my wife and I made love to your song and we got seven good children out of it."

That marked the beginning of my communication breakdown with Tim Collins. In my head I was going, *Na-na-na-na-na-na-na-na-dun-da-DA-na-na-na-na-na*. Ha! I was covering my ears so I couldn't hear this crap. There was no way in hell I was going. Taj was four and Chelsea was eight. And it was hard enough being away from them for so long, but to come back from making a record and go to a fucking men's club in Big Sur! With a bunch of, you know, sober testosterones? Bad enough going to a fucking bar and talking to those guys! Sober it's ten times worse! They're going to remember every epiphanous moment they had in their teenage years when they were watching porn, getting stoned, and listening to "Sweet Emotion" while fingering the girl next door.

"I'm not going, you fucks!" I said. "I just got back from finishing a fucking record—and it turned out great, by the way, thanks for asking." They'll tell you they were only *suggesting* I go, but it's like the Pope suggesting to the Boston cardinal that he better change the subject matter of his sermons or he's going to go away for a year to a retreat in the Azores! Because when I objected, Bob Timmons said, "No, you have to go, we've already booked it." And the sleazy duo started trying to talk me into it. I got really angry. "I haven't seen my wife in over two months. What are you guys thinking of? Enough of your fucking control issues! Wait a fucking minute—it wasn't all that long ago, back when I was in Tucson, Arizona, that you were telling me I could get a blow job. And now you're telling me that I should go away? For *what*?" I said, "Fuck you! I'm not going there." I walked out and slammed the door.

Now, keep in mind, this is a guy that helped massage and facilitate our sobriety. He was a strong advocate for us, but all along he was taking sleeping pills, anxiety medication (necessary apparently because he's managing Aerosmith!), and binge eating. He's up in his hotel room eating cheeseburgers, there's three main entrees on the room service trolley. That's a drug, too. Still, I intended never to return. The era was over. He knew it. So he gathered the band to Boston, in the basement situation room, for an emergency meeting and told them, "Steven's out of his mind. We gotta get his wife on the phone."

He went upstairs and proceeded to call my wife. Pure vindictive crap. Joe was shocked that he'd actually done it. He said, "You did *what*? What the fuck?!?!"

Actually I was almost a year sexually sober, so if they told me to go fuck myself I couldn't even have done that. All this while Sly Stallone was trying to hook me up with the most lascivious, sweetly sweaty, Floridian pulchritude known to man. I would go to clubs three times a week with him. Girls all over the place, boobs and thongs just like in *Girls Gone Wild*. Everywhere. The most I would do is say good night to them. "You're leavin' us, baby?" "Well, ladies, you can walk me back to the hotel if you like." "Okay!" And three or four of them would walk me to the corner across the street from the main entrance of the Marlin Hotel. I would say, "Okay, girls, you have to stay here. I'm going in there alone. So I can get back to writing lyrics to stories yet untold." A saint, I tell you.

After leaving Tim's office I stomped out the door and drove to Sunapee to open up the house for my kids, wipe the flies out of the windows—my favorite thing to do. On the way back to Boston I stopped at a tollbooth, pulled over, and called Teresa. She was crying hysterically. "Baby, tell me." I said, "Why are you crying?" "Well, I'll tell you why," she said. "Tim called and told me you were fucking other girls and you're still on drugs, and that's why you went up to New Hampshire alone." That's how good he was—those devious little details! She just freaked. He had her on the phone for twenty minutes, screaming at Teresa. I had been married to her for eighteen years by then.

When I hung up the phone with Teresa, I called Bobby Hearn (my sponsor in AA). I said, "Bobby, you better meet me at my house in Marshfield and get rid of all the guns or I'm gonna fucking get my gun and shoot Tim Collins. I am so fucking furious!" I mean, I totally went off! I don't allow myself to get into that state anymore 'cause there's no one in my life I let do that to me.

Now I had to deal with my wife. It took me two weeks, every day, to get rid of the anger.

Tim called the band into the office after I said it was over. Joe and I had been writing songs without them, so the guys in the band were already angry at me and this gave Tim the power to get the rest of the band on his side.

The next day, I walked into our rehearsal space and said to my partner, Joe, "You fuck! Why didn't you ask me if I was high? Like we used to talk in the early days." Oh! See how angry I get now just thinking about it? Wait, it gets better!

When I saw the guys in the band again, I asked them, "What were you guys thinking when you let Tim call my wife? All this stuff he told you, it's all just fucking hearsay from some friend of Tim's." And it was all particularly galling because it was one of the few times in my life that I was not drinking, was drug free, and sexually abstinent.

When I asked the band why they believed I was fucking everything that moved they said. "Oh, Steven! What did we know? Tim convinced us...."

"Fuck you! What if I called up your wife and said, 'He's fucking this chick in his tiki hut?""

Tim Collins would get people going with his insinuating little sayings like, "There's trouble in paradise." That's the fucking letter he wrote to my wife. *Trouble in Paradise*. Tim Collins was famous for starting rumors, stuff that he made up himself. He was the fireman who sets the fires. He would go to Joe Perry's house, light a fire at night when no one was looking, go back to the firehouse, wait for the alarm, rush over there, really quick, quicker than any other fireman, and put the fire out. So he could be a hero. He did that time and time again. And then when the fire was out, he'd say, "I saved your life."

The very next day he went up to Sony with Bob Timmons to

see the president. "So, Tim," Donnie Ienner asks, "you're telling me Steven's back on heroin?"

No hesitation. "Yup. But don't worry, sir, I'm gonna get him back into rehab, and in a month or two, he'll be all right again. I'll get him in the studio, do an album, and everything'll be fine. Goddamn him! I tried!"

Oh, and it doesn't stop there! Then he went to *Time* magazine and *People* and *Rolling Stone*. "Aerosmith Lead Singer Back on Heroin!"

Shortly after this I'm out to dinner with Ienner at an Italian restaurant eating capozzelli di agnelli. Capozzelli, that's a dish of lamb's head. They bring the whole head out after it's been in the oven. I'm sitting at the table and I said, "Did Tim and fuckin' Bob Timmons come down here and tell you I was on heroin?" And he got quiet and he goes, "That's exactly what they said." "And you believed him?" "Well, now, Steven, I don't want to cause any trouble here." I said, "Don't worry about that. We just fired him." "Well, to be honest with you, I was thinking this was a little fucked." "Oh, really? A minute ago you wouldn't say anything because you didn't want to start any trouble." "Well, Stevie, ya see, I'm one of those people that—"Oh, fuck you and the horse you rode in on!

While all this was going on my daughter Mia called me up crying. She goes, "Daddy, I'm so scared! Are you on drugs again?" I was stunned to hear her so upset; Mia never cries. I took her out and told her, "Mia, I'm not on drugs and I'm not hiding. I haven't gotten high in nine years." We hugged, and she's crying in my arms. We turn the corner and I open my eyes for a second and there's that motherfucking paparazzi with a lens from here to Connecticut. I thought, God, does it never stop? "Mia, here's what we're going to do. Hold on a minute." I went into a hardware store we happened to be walking past, and asked, "Do you have an umbrella and a can of spray paint—in white, preferably?" I took the can, shook it up, and wrote FUCK YOU! on the umbrella, opened it up, put it behind us, and we walked down

281

the street! Let 'em get a shot of that—all day! I did see it in a few stupid rags, but that was all right.

Tim Collins put a spell on me. Svengali, that's who Tim Collins was. He would deliberately say whatever was on his agenda in front of groups of people to intimidate them, that way nobody would dare contradict him. It's like if you had been sitting around with a friend of yours the night before and the next morning you're reading the newspaper and you go, "Oh, my god, a woman's decapitated body was found in the woods," and just then your best friend walks in with a shrunken head. Now you're going to be real fucking careful what you say about that best friend of yours, not to mention he ain't your best friend no more.

As I walked out of Tim Collins's office for the last time, I could see and feel the waves receding like the backwash of a speedboat on a calm lake. I turned around and said, "This is the last fucking time I'm coming here or I'm ever gonna utter your name." I fell into the wormhole of consuming anger. I could feel the weight of hatred welling behind me. It was like standing at the back of the *Queen Mary* and watching the waves that it throws off.

I didn't talk to him again until three years ago in the elevator at the Mile High stadium in Denver.

"Mr. Tyler," he said, "so good to see you. There's something I've been wanting to say to you for a long time."

"I know what it is. You want to ask my forgiveness for that remark."

"How did you know?"

Oh, I knew. When I had last confronted him with all the outrageous things he's done, he simply said, "I'm sorry, you must have mistaken me for someone who gives a shit."

I had been devastated. I loved Tim, I trusted him, believed in him, and he let me down. Abandonment and betrayal by managers has been an ongoing thorn in my side my whole career. But why should I be any different from any other performer?

CHAPTER 13.5

THE BITCH GODDESS OF BILLBOARD

iv called me and said she got offered a part in a movie with Bruce Willis and Ben Affleck. And she wasn't sure if she wanted to take it because it was too commercial. "In what way?" I said. Her taste in movie roles was more off-beat and indie, like *Steal*-

ing Beauty and That Thing You Do, which she had already done. So she says, "In the opening scene Bruce Willis is teeing off an oil rig and trying to hit the Green Peace boats. And then they go up in space to shoot down an asteroid." I said, "Are you kidding me?" She said, "I think it's too mainstream and commercial, Daddy." "Take it," I said. "There's nothing wrong with being a household name, baby."

Meanwhile, *Nine Lives* came out in '97—that was such a fucking great album. I remember walking around with the finished cassette in my back pocket—felt like a bar of gold. But look at the goop around it! We all got sober. Looking back, I think if we'd have stayed stoned, the band would never have come back and gotten its grip again. I was sober for twelve years. Joe had four. Brad maybe had eight. If he was drinking wine, doesn't matter. Tom, who knows what he was doing? Joey's the only one that stayed sober through the whole thing. He's the only guy in the band who stayed the course.

Some of the lyrics I wrote on the *Nine Lives* album was my rant, my rage. Maybe Tim Collins, Bob Timmons, and all the other sonsofbitches stuck in my craw had to come out.

How can a good thing 7 come 11 Slip into a fare-thee-well And how can one man's Little bit o' heaven Turn into another man's hell

But in the end I came through all the turmoil philosophical and with eyes wide open:

In the old game of life, best play it smart, with love in your eyes and a song in your heart, and if you've had problems since way back when, did the noise in your head bother you then? You know, I hope you see it as clear as I do. If you've been a problem since way back when, did the noise in your head bother you then? Forget "fuck me," "fuck them," "fuck you," does the noise in my head bother you? Are you fucked no matter what you do? No. If your life's been a lie then ask 'em true, does the noise in my head bother you?

That one I wrote at my kitchen table up in Sunapee. I love tongue twisters, word games, and shit like that:

Well well well I feel just like I'm fallin' in love

STEVEN TYLER

There's a new cool Some kind of verbooty It fits me like a velvet glove . . . yeah And it's cool Shoo ba pa du ba She's talkin' to me juba to jive . . . yeah

My divorce from Teresa years later, in 2006 (wait, it's coming), put the song "Hole in my Soul" into my heart's perspective . . .

I'm down a one-way street With a one-night stand With a one-track mind Out in no-man's-land (The punishment sometimes don't seem to fit the crime) Yeah there's a hole in my soul But one thing I've learned For every love letter written There's another one burned (So tell me how it's gonna be this time) Is it over Is it over Is it over 'Cause I'm blowin' out the flame

That kinda defines getting laid out on the road. I finally put into words how fooling around on someone you love back home could kick back on you. The one thing I've learned from being a singer and a poet is that it's often not what's been said . . . but how you lived it.

I wrote "Hole in My Soul" with Desmond Child. It's one of my favorite songs. I came to him with the chorus, then went to the band and said, "Tom, what if you played this on a fretless bass?" I asked him to please, *please* get one. "*There's a HOLE* in my soul that's been killing me forever . . ." What a chorus that is. With every album we ever did, I tried to dig out the parts with the other members of the band to perfection. Listen to Tom's bass and Joey's snare and foot from *Pump* on up. I pushed the rhythm sections up louder than they'd ever been. I worked on parts for Tom that I knew would pop out, and when it came time to mix, I pushed those parts out and added 3k to them, so they stuck out like the hard nipples that were about to listen to it.

While we were tracking *Nine Lines*, the end of "Hole in My Soul" was playing . . . Chelsea and Taj walked into the studio with Teresa. I looked over and I said to them, "Good night, Chelsea. Good night, Taj." It's whispered at the end of the track.

Ten years prior to making Nine Lives I'd been listening to the sound intro on the THX commercial that always plays: "The audience is listening." Joe had bought this fucking guitar that would tune itself. It was a computerized Les Paul or something. So I took the guitar and I untuned it, all over the fucking planet. I said, "Put that over on the left side of the studio," and he hit the button and it went wwwooowwww trying to retune itself and wound up back in the key "Taste of India" started in. Then I said, "Can you control the time it takes to get to the chord . . . slow it down?" And he goes, "Oh yeah," so we slowed it down to this intro, ten seconds, and I took that guitar, detuned the whole thing again, and put it over on the right side . . . then we did it again and panned it over to the right side, and when we played 'em altogether we got this incredible sound that was the equivalent of shuuuu, the audience is listening but even better than the commercial THX. Then we added this loop that producer Glen Ballard had lying around from Alanis's Jagged Little Pill and I went, "CAN I USE THAT?" And he said, "It's yours (if you pay for it)." We added a track of this Indian singer, and that's the music behind the opening verse of "Taste of India."

God I love the sweet taste of India Lingers on the tip of my tongue Gotta love the sweet taste of India Blame it on the beat of the drum God I love the sweet taste of India Lingers on the tip of my tongue Gotta know that what's gotten into ya Any cat man do when it's done Now she's got that kind of love incense That lives in her back room And when it mixes with the funk, my friend It turns into perfume

Then you get to the next verse and listen to what the drums do . . . EXPLOSION!

When you make love to the sweet tantric priestess You drink in the bliss of delight But I'm not afraid when I dance with a shadow (BOOM!)

I went to an antiques store and I found this little red church about a foot high and half a foot wide. It had a crank on the side of it and I went, "What's this?" The shopkeeper said, "Crank it." It had three harmonicas and a bellows. We used it at the end of "Full Circle."

Time Don't let it slip away Raise yo' drinkin' glass Here's to yesterday In time We're all gonna trip away Don't piss heaven off We got hell to pay Come full circle

DOES THE NOISE IN MY HEAD BOTHER YOU? 287

On the next track, "Something's Gotta Give," I took two trash cans, drumsticks, turned the cans upside down, and played 'em. First song Joe and I ever wrote with Marti Frederiksen. Next track . . . a ballad, "Ain't That a Bitch."

Up in smoke, you've lost another lover As you take a hit off your last cigarette Strung out, burned out Yeah you're down on your luck And you don't give a huh! Till the best part of you starts to . . . twitch Ain't that a . . . bitch

"The Farm" is Marko Hudson! He wrote most of that. One of his finest fucking moments. He arranged the orchestra, too.

Buckle up straightjack Insanity is such a drag Jellybean Thorazine, transcendental jet lag, Sanity I ain't gonna feeling like a piñata Sucker punch Blow lunch motherload, pigeonhole I'm feeling like I'm gonna explode TAKE ME TO THE FARM

I wrote "Pink" with Richie Supa at the Marlin Hotel down in South Beach, Florida. I'd be writing and go, "Fuck." I'd turn the lights on when the sun went down. I turned the lights off when the sun came blasting through that big bay window. I loved writing lyrics at night—it was more mysterious than in the day, and I could evoke my demons when no one was around to bother me. The only problem was when normal people got up, like our producer Glen Ballard, who was also a cowriter on "Pink," they would expect me to go in and do my vocals later that morning, when what I really needed was some shut-eye. So most days at the old Marlin, we

STEVEN TYLER

started recording at about 1:00 P.M., which left me five more hours of daylight before I sat down at the table again to turn the light on—this went on for five months until I started growing neon hair.

Pink it was love at first sight Pink when I turn out the light, and Pink gets me high as a kite And I think everything is going to be all right No matter what we do tonight

Pink you could be my flamingo Pink is the new conni lingo Pink like a deco umbrella It's kink—but you don't ever tell her

I threw in that line "It's kink" because Richie Supa thought I should call the song "Kink." I said, "Richie, we can't call the song 'Kink.' My life is kink. I am kink!"

When I got hungry and thirsty for some South Beach sustenance, I would go down and have a carrot, an apple, a beet, a stick of celery, and a plug of ginger juice—and as I was told by the young Dave Dalton, who used to be English, that's what they would stick in a horse's ass to get its tails in the air and to prance in dressage. So when I drank this concoction that I got from the juice man, it made my ears stick out. What in the what the!!! Anyway, more often than not I would write and sing a scat where there weren't lyrics yet, *Isha, boo-da-lee-ga / a-moo-shoo-bada / gee-da-la-a-zoo-ba / oobi-doobi-aba*—thank you for the inspiration Louis Armstrong, and fill up what the scat sounded like with lyrics (didn't often make sense—but who gives a fuck'cause it's only rock'n' roll). I sang that over the chorus line one day and I went, "Oh! Fuck!" *Hel-loo!* I'm home!

I—want to be your lover I—wanna wrap you in rubber

As pink as the sheets that we lay on Cuz pink it's my favorite crayon, yeah

Pink it was love at first sight Pink when I turn out the light Pink it's like red but not quite And I think everything is going to be all right No matter what we do tonight

Veni, vidi, vici. We came, we saw, we needed a Kleenex! Get the fuck out of Dodge! Songs are stories, didn't all troubadour stories turn into songs and didn't all the tales lead to the same thing? Saving the queen? Getting the girl? Wrapping her in rubber?

Glen Ballard started as producer on Nine Lives, but Joe Perry eventually threw him out because Glen was working on tracking and vocals and wasn't paying attention to Joe's leads or working with him on guitar sounds. I said, "Why don't you talk to Glen? Ya know it's your guitar . . . get your own sounds." So along comes Kevin Shirley, who won Joe's heart by turning his amp up to 11 and who swore he'd rock the album like it hadn't been rocked before and needed to from the beginning. Kevin loved his rock 'n' roll so much and his style was so sawtoothed that he was dubbed the Caveman . . . just what Aerosmith needed. The version of "Pink," bits and pieces of vocals, and miscellaneous trackage was still there from the Florida sessions with Glen Ballard. I had to scrap all the vocals and start over, which didn't come easy for me. Joe and Tim had talked Sony into thinking the album was jinxed by Glen Ballard since Tom, Brad, and Joey hadn't come to Florida yet. We were neck deep in the writing process when Glen hired Steve Ferrone to do the drum tracks. So we planned to layer in the guitars once they came down-unlike any other album we'd done yet. But no, I'd already sung all the vocals and harmonies to the album and I was being told we were going to have to

rerecord the whole fucking thing . . . *and Joey's having a nervous breakdown?* Joe couldn't get his guitar sounds and since Brad and Tom weren't on it yet, what the fuck, let's just scrap it and rerecord everything.

All the songs on *Nine Lives* would have been great except Ballard's guys, who were in the studio during the early recording sessions and looked like zombies because they'd been up all night fixing Joe's timing on the tracks. Glen had a reason to his rhyme and wanted the stuff put to grid and the last thing Joe wanted was to be told what to do. Another reason why he had him ousted. The funny thing is, Jack Douglas had been adjusting Joe's guitar timing all the way back to the seventies. It's what producers did and still do.

I walk around like a woman during pregnancy when I'm working on an album. I don't listen to anyone else's music, I just want to marinate in my own creativity. A song is constructed like a tree—from roots to branches, and when it's done you hope it bears fruit. You need a first verse, next a second verse, then a prechorus, which is the titillating foreplay, then the cum shot the payoff—being your chorus line. Then comes the bridge, which should bring you back to the chorus line, then *boo-ya*... SCORE! It's outta the park. So satisfying, because that chorus, when it works, epiphanates everything you ever thought of in your life (or whatever that song made you think about).

You think you're in love Like it's a real sure thing But every time you fall You get your ass in a sling You used to be strong But now it's ooh baby please 'Cause falling in love is so hard on the knees

It's got to pay off so deliciously that you just can't wipe it off! A little something that gets inside of you and changes your everything—that's always been my aim. And by the way, there are nine others on that album that are also out of the park. No one can catch you—they're on the hood of a car on Forty-ninth Street from Yankee Stadium. It went *where*?

While writing *Nine Lives* at the Marlin Hotel, Bono and Larry from U2 came to visit. We played the tracks for them and they were blown away—nice to have a solid wall to bounce your ball off. During the sessions, one of the finer producers on the planet, Tom Lord Alge, was in the studio in the basement of the Marlin Hotel diddlin' around with a song called "If It Makes You Happy," which it did, extremely, after hearing it. That night Joe and I went upstairs and wrote "Kiss Your Past Goodbye," which was a premonition of the coming breakup between Collins and me. When I listen to it now it's very eerie.

It's later than a deuce of ticks Your broken heart, it needs a fix You're feedin' off a high that would not last

And people they don't seem to care And sorry just don't cut it, yeah It seems to me you're gettin' nowhere fast

So kiss . . . your . . . past Or kiss your ass good-bye

I can pull a rabbit out of a hat by pulling a song out of scat. I hear lyrics in my sleep, little embryonic words poking up out of the scat plasma. This is a pretty different approach to the way a professional songwriter like Diane Warren works. Diane sits down at the piano and out come the words and melody together fully formed, the way you might build a chair...

STEVEN TYLER

I could stay awake just to hear you breathing Watch you smile while you are sleeping While you're far away and dreaming I could spend my life in this sweet surrender I could stay lost in this moment forever.

I'd hear one of her songs and think, "How many affairs does this woman have to have to know how to put it so brilliantly? Oddly enough, she's married to a parrot named Buttwing who keeps repeating, 'That's *brilliant*!' and 'I *love* it!'" Whereas my songs come out of the muck and mire of the muddy stream of consciousness—or, as I like to say, the stream of *un*consciousness.

I think my way of writing songs comes from when I first heard hymns and organ music in church when God was still there under the pulpit in a box covered with red velvet. I grew up Presbyterian, I've walked with God all my life; you know, I always said my prayers. The music was so profound and stimulating, a cosmic harmony pouring into the soul of the congregation. That's why the organ is so powerful. People hear God in a song because music infuses your mind with melody . . . it floods your brain like the fluid in the placenta. So, in church, hearing those giant organs sweetly playing swelling chords and melodic soaring hymns, I just fell into that angelic sound. And at home, from age one or two, I was lullabied to sleep with the notes of Debussy and Schubert. Looking for God? I did not come here looking for God, I brought Her with me.

Diane wrote "I Don't Want to Miss a Thing," and that song, by the way, has one of the most *brilliant* front lines ever. If you're in love and your significant other ever says to you, "I could fall asleep just to hear you breathing," you're going to drop and give her twenty right there on the floor. Or nestle your head in her neck and believe that you wouldn't be able to live the rest of your life without her. We've all been there, haven't we? Songs are nothing but air and pure emotion, but they have intense effects on people's lives. When people relate passionately to a song, all that goes on in their lives gets attached to the song—and the music never stops. All they want to do is tell me how that was their wedding song, or what they played at their wedding.

How about the two guys who created the BlackBerry they came up with the idea while smoking pot and listening to "Sweet Emotion." At the Kennedy Honors, a prominent democratic politician told me she had made love for the first time listening to "Sweet Emotion." Half the current government of the United States has made love to Joe Perry's licks.

John Kalodner introduced me to Diane Warren—it was an A&R man's equation: big band, big money, big really talented songwriter—big band needs big hit. I'd written a bunch of things with her before. When I was working on "Devil's Got a New Disguise," I went out to her house in Malibu. She has a piano that looks out over the ocean and I said, "So, we're gonna write a song. How do we start?" "Well, I'll play you something." She played me a couple things, mostly ballady and it wasn't working. That's when I sat down and carved out that beginning piano live and *voilà!* "Devil's Got a New Disguise" started to take shape. Some years later, the song was completed. . . .

Sweet Susie Q she was a revel No angel wings, more like the devil She was so hot, so cool and nasty Believe it or not, here's what she asked me... If you need love with no condition Let's Do the Do, honey, I'm on a mission

The girl's so bitchin', my backbone's twitchin' 'Cause down in hell's kitchen The devil's got a new disguise I'm on a mission, a proposition It's intuition 'cause The devil's got a new disguise

And so that was "Devil's Got a New Disguise." Another song Diane wrote that we recorded was "Painted on My Heart."

And I've still got your face Painted on my heart Scrawled upon my soul Etched upon my memory, baby

"Painted on My Heart" was going to be taken by Johnny Hallyday, the French rock star. I gave him the stem mixes, I gave him my vocal, but at the last minute he didn't do it. A stem mix is the basic track. You put your vocal on it so the band can play behind it. It's a little like Guitar Hero, where you have the backing tracks and you leave space for the kid to play Joe Perry.

Some time in 1997 I got a call from Jerry Bruckheimer saying he'd like to put four or five Aerosmith songs in an upcoming movie. We were all for it and that's when John Kalodner played me Diane's "I Don't Want to Miss a Thing." Little did I know that Kathy Nelson, who was picking the music, would put it in the same Jerry Bruckheimer movie, *Armageddon*, that Liv was talking about.

Okay, let's get into the what-it-is-ness of Diane Warren. Diane had written the song already and got a Celine Dion singa-like to make a demo. Diane put it on a cassette with her band doing it on synthesizers, all done in her studio. I listened to it in the car with John Kalodner and said, "It's fuckin' great, but where's the chorus? It's a hit single without a doubt, but there's no chorus."

A couple days went by, and Diane comes to the Sunset

Marquis to my room where there was a grand piano. She sits down and starts playing "I Don't Want to Miss a Thing." And because of the way she was singing it, I finally heard the chorus and I went, "Oh, my god," and I started to tear up. It was just that tonal difference between the Celine Dion wannabe version—and the way she sold it—and the way Diane sang it, forget about it. It was a perfect example of *it's the singer, not the song.* The way she sang *"I don't want to close my eyes"* made a believer out of me and the rest is history.

In Diane's office, a room that she's used for the last twentythree years, there's the same piano, cassettes from thirty years ago, and thirty number one singles on the wall. She walks around with that little green African parrot on her arm, Buttwing, and never leaves home without it. That little fucker will live a hundred years and it'll be singing "I Don't Want to Miss a Thing" on the space shuttle to Mars. Damn if Buttwing doesn't get there before me!

"Hey, Diane, everyone's fucking to your songs," I said. "Do you ever get laid?" She laughed shyly. "I get it," I said, "you take all the angst from not getting it—and put it in a song." She goes: "You got it! I'm just a frustrated romantic."

Okay, I was hitting them out of the ballpark, but unbeknownst to me I was cursed, cursed as Cain, doomed as Captain Ahab. The seven plagues of Egypt . . . all fell on *me*! What did I do to bring this on myself? Did I desecrate the Pharaoh's tomb? Did I violate some dire taboo? Is there someone somewhere putting pins in a voodoo doll?

Or . . . was it the Faustian bargain I made with the Bitch Goddess of *Billboard*, when she whispered in my ear, "Steven, baby, how would you like a hit record?"

"That'd be sweet."

"How about a *number one* hit record?"

"Fuck, yeah! Honey, I'd do anything to get a number one record."

"Anything? Are you sure, Steven, because, you know there may be a price to pay...."

"Hell, bring it on!" said I recklessly. "Whatever it is, I can handle it."

Oh, yeah? Did I really say that? I should gone to see the gypsy, because before too long I found myself in a world of trouble and pain. *Nobody knows the trouble I seen*. Gimme an E! Heavy is the head that wears the motherfucking Mad Hatter's hat. Thank you, God, may I have another?

We would soon get our hit with "I Don't Want to Miss a Thing" came out in August 1998, stayed number one on *Billboard*'s Hot 100 for four weeks—but before that happened the price to pay prophesied by the Bitch Goddess of *Billboard* came horribly true.

My litany of maladies, misfortunes, and woes began in the Year of the Rat. It started out uneventfully enough. The band had a day off, we were in the Allegheny Mountains. I called Joe's room and told him I wanted to lease a llama and fill our backpacks with crunchy peanut butter and jelly sandwiches, and climb to the top of Pikes Peak. We hiked five miles up. Unbeknownst to Joe, I had a copy of "I Don't Want to Miss a Thing," the version with the strings on it. So I brought my CD player and *two* sets of batteries, because I'm on to Murphy.

We were on the edge of a cliff. Joe's sitting on top of the mountain eating his sandwich, and I walk off, about a hundred feet away. I looked over, found a little place to sit down, and listened to "I Don't Want to Miss a Thing" under the headphones, with that orchestra welling up and me watching eagles soar for the first time in my life, and I wept like a baby. And then I knew that we really had something. Just like the time I listened to "Love in an Elevator," going "*Whoops!* This is gonna be a hit!" I *knew*. The crying part of "I Don't Want to Miss a Thing"—*dub*-

da-duh-DAHN-N-N!—it was, like, *fuck*, wait'll they hear this! Never mind "Is it gonna be?" I don't want to jinx anything, but guess what? I know what's on the radio—this is *better*!

The first Demon of Excruciating Pain visited me a week later. We were on tour in Alaska playing the Sullivan Arena in Anchorage on April 29, 1998. We'd never done Alaska, so I said to management, "If that's the only state in America that we haven't played, we've gotta do it." So we're up there in Anchorage, and we're doin' "Train Kept a-Rollin'." At the end of the song, during Joey's drum bit, I do this thing where I jump in the air, do a spread eagle split, and at the same time swing my scarf-festooned mic stand around. The bottom of the mic stand weighs around four pounds, and as I go up in the air I accidentally whack the inside of my left knee with it. It's like hitting your funny bone with a four-pound hammeryour knee will go all tingly with electricity, so for a moment you can't feel your leg. And that's what happened to me. I landed, but because my knee was tingling and numb, I didn't have any sensation in that leg when I hit the stage and the ACL in my left knee shredded, ripped right out. Your ACL is a ligament inside the knee. Anterior crutiate ligament-it's what holds your knee on.

And this happened not in midconcert or midsong but *right* at the end of the show, "Train Kept a-Rollin'," our encore song. In other words, I fell down at the conclusion of our show, providing an unintended climax. I'm lying there, writhing in pain, going, "Aaaaaaagggh!" No one realizes what's just happened to me. I played it like it was part of the show. And I looked back at my tour manager and I mouthed the word ambulance.

He went, "What?" He didn't understand yet. But I knew that I'd hurt myself beyond any pain I'd ever felt before. I could tell something really bad had happened. The ambulance came, they gave me a shot of what I love—I didn't know what it was, but I could hear the opening line of "Strawberry Fields" floating through my head.

At the hospital, they said, "Here's what you did: you tore your ACL. It's going to take two weeks for the swelling to go down before we can go in arthroscopically to look around and see what the damage is and take care of it. Two weeks. And here's what you've got to do: ice it every day and get that swelling down." Fuck! End of the tour. Wrong time to make the doughnuts—and right into the video of "I Don't Want to Miss a Thing."

After that we went somewhere in the Midwest to do the video for "I Don't Want to Miss a Thing." I'm still in a cast, packed in ice, and if you watch that video, you'll see that they only shoot me from the waist up—just like Elvis. The director created a futuristic scenario using two hundred cones, geodesic shapes and stuff. The stylist had Betsey Johnson make me a very freaky coat, as I found out later, out of human hair—I instinctively knew what to do with it, so I fucked with it, used it as a prop just like I did with the mask at the beginning of "Cryin'."

Right after that video we had a number one single. What are the fucking chances? Well, I kinda sorta knew we would. Later that fall I ran into the Bitch Goddess of *Billboard* at a convention in the Bahamas. "What are you looking so glum for, baby?" she asked with a crooked smile. "Didn't you get your number one with a bullet?"

"Are you kidding? That stuff with the ACL, that wasn't funny," I said.

"Ah, well, honey, we all gotta pay our dues," said she. "And by the way, baby, there just might be a little more of that to come." Before I got a chance to ask her what she meant, she'd vanished.

Got home, had to ice my knee another week before I went in for the operation. And when I came out of *that* wormhole, it was pretty fucking paralyzing—even though they did it arthroscopically. That means they drill a little hole in your knee and go in with a scope so they can see inside. They fill the inside of your knee with water, then flush it out so they can observe what's going on in there with a miniature camera. On the camera are little scissors and they cut the ends of the ACL off—it looks just like spaghetti.

They take out your torn ACL and put in someone else's; it's called an allograft. When they take the ligament out of your other leg, that's called an autograft. I said, "Fuck that, pass the cadaver, doc. I'm a creature who lives onstage, I need *both* legs, and I need all the help I can get." He said, "Well, we got a freezer in the other room full of knuckles from people who died, and we can use ligament from one of those, because knuckles are like ACLs, they take little blood supply, and you don't have to worry about rejection." So they cut a ligament from this sixteen-year-old kid's knuckle and used that to replace the ACL in my knee. Every night when I say my prayers, I say them twice and I thank that kid who gave me the ligament for my knee.

Got home the first day after they screwed my new ACL in and iced it. Second day, I get into this machine. You Velcro your foot into it, it has a slow-moving motor that moves your foot straight out, and then it goes up to a bend while the ice bag is on. It goes *mmmmmmmmmnnnnnn*, moving your leg up s-1-o-w-1-y and then back down. That's the first two weeks. Did that hurt? Oh, fuck, yeah!

I was on painkillers, but still . . . it's what you have to do to get out—the only way out is through. It took four months, but after that I was in pretty good shape. It still hurt, but my knee was well enough for me to go on the next Aerosmith tour. We had to go right out, because by that time "I Don't Want to Miss a Thing" was number one, and all these opportunities came up. We played Madison Square Garden again.

I brought a girl out on tour with me, she massaged me three times a day: iced it, massaged it, iced it. When they massage a scar, it goes away. That's why I don't have any scars. I wore a leg brace onstage for six months after that. When I first got it, it was mummy white. I said, "Paint it black!" I cut all my pants off at the

knee and it looked pretty cool. Steven, the bionic man. We had to tour, so that was that.

In December 1998, I went to the White House with the band, and fuck me if President Clinton wasn't being impeached *that day*. The Senate broke, they called him up, and said, "Mr. President, you're going to be impeached; we're on our way over." So all the trucks were there from the news media (as you can only imagine). We were all at the Secret Service shop in the basement. There's a firing range down there and a major tunnel with a train that's propelled through a pneumatic tube. You strap yourself in and it goes *ptchoooo-oooo!* to some DUM (Deep Underground Military) facility. America's full of DUMs. But enough about our managers.

We're getting walked around, given little gifts-Secret Service golf balls! Clinton's press secretary comes down and goes, "Steven, do me a favor, can you come upstairs, please?" I said, "That's fine with me, but we're playing tonight." "What time do you need to be there?" "Six, and the gig is three hours away." "No problem, we'll get you there." They took us upstairs to a waiting room to hang out till Bill Clinton could come meet us. And where do you think they put us? The Situation Room-I'm sitting in the president's chair looking around at all the monitors. We met with Bill (briefly-he was kinda busy that day, ya think?). Then we were escorted quietly out of the White House. We were walked out to a police escort-off to Quantico, FBI headquarters to stroll down a street with full-on machine guns. They let me shoot dummies at a practice range there that's mocked up to look like a city block. Animatronic figures pop out at you as you walk around. The head of a terrorist leans out and you shoot at it, then an animatronic little girl leans out with her doll-ooops!

*

"I Don't Want to Miss a Thing" was nominated for an Oscar for best original song-it was the theme song for Armageddon-which was especially sweet since Liv was one of the stars of the movie. I was going to perform it at the Academy Awards. I peeked through the curtain and looked down and there's Eric Clapton and Sting and Madonna and all the people from my era, sitting in the front row. Just before the curtain opened my keyboard player kicked a cord out and it took out my ears so I couldn't hear the mix. When the performance starts I'm supposed to be up front with the guy playing the cello for the opening line of the song. They went "Sixty seconds!""But, wait," I said, "I can't hear anything! Is that mic on?" I walked back to my production man and told him, "Don't let them open the fucking curtain yet, I have no ears. Do not open-"They did it anyway. And so the song started and I was twenty feet from the cello player. I wasn't about to run up to the front of the stage; everyone in the place would have laughed, "A-HA-HA-HA! Look at Steven, he lost his mark!" I'm a little more professional than that. I walked up real slowly. But by the time I got to the cello player-probably thirty feet away-the first verse was gone. I blew the first verse. Live TV at the Oscars! Oh, man.

We'd got our number one hit record, been at the Grammys, and still had a half-a-Grammy left, sung at the Academy Awards. So I had to go through a few rough periods—but it was all worth it. Aerosmith was at full tilt. I was happily married to Teresa with two beautiful children, Chelsea and Taj, plus my Liv and Mia. Life was good and I had nothing to worry about. Or so I thought...

CHAPTER FOURTEEN

HOLY SMOKE, QUEST FOR THE GRAND PASHMINA, AND THE BIG CHILL OF TWENTY SUMMERS

found myself making snorting sounds: *fffueh-ffub-ffuh-ffuh-feu-feu*. Snuffling like an armadillo in search of fire ants. My nasal passages were completely clogged. No, not from the coke! Fuck, no. I stopped in 1980. I stopped smoking. I stopped everything, well, for X number of years anyway. To this day, no damage to the nasal passages. No, the snuffling was from the way I slept (I used to sleep on my back) and the fog juice. My sinuses had mutated, become an alien life form. Thirty years of breathing in the damn oil-based fog juice, that's the stage smoke they use to enhance the beams of light. The smoke makes everything look bigger and more dramatic. It's HOLY SMOKE! You see more colors.

This is how it works: the guy doing the lights hits a foot switch that activates the smoke machine behind the drum riser and up comes this apocalyptic fog juice. It's blowing out onstage and I'm inhaling it, taking a deep breath to launch into the song: *"I could lie awake"* . . . you know . . . *"just to heh-heheh-heh-hear you bruh-breathing!"* and I'm going, *ah-heh-ah-hehh-ahh*. It's like being a fucking monkey in a lab experiment. A demented researcher is saying, "All right, let's fill this room full of smoke, get the little chimp to sing at the top of his lungs for twenty years, and then we'll run some tests."

If I get sick I've got to cancel. And when Aerosmith cancels a show it's a million dollars! I tell you, the worst time in my life is when I'm taking a shower or sitting in my room, it's one o'clock in the afternoon and we've got a gig that night, and I go, "Fuck! I can't do it." My voice is gone from laryngitis. Either I have a high raspy whine or a deep, bullfroggy honk, but either way I can't sing. I hate that, I lose it, knowing that there's twenty thousand people on their way to the concert. They're high and happy, thinking they're going to get laid tonight, and now they're going to find out over the radio that the concert is off and they're all going to go, Awwwww shit! I feel for them. Now someone like Axl Rose, on the other hand, will handcuff himself to the toilet at the hotel and have people wait four hours for him to show. Why does he do it? That's just how Axl is. He'll say, "The marbles were thrown and the color red didn't show up, so I can't get there tonight." Some astrologi-theosophical omen like that and he won't move.

We have to take out eight million dollars in insurance in case anything goes wrong with Steven the singing monkey. Anything could happen to anyone else in the band—unless they break a leg—and the show would go on. So once again Steven's the designated patient. Rather than the band spending insurance money if I get sick, I take a shot of a type of cortisone to reduce the sinus inflammation—it's called the Medrol Dose Pack, and it shrinks them.

After years of inhaling fog juice I had a serious case of sinusitis. Gunk dripped down my throat like a slow-running faucet. They had to operate. Roto-Rootered my sinuses, stuffed them with cotton. I'm lying in bed that night after the operation and I wake up 'cause I'm going *glllk-glkkk-gulpgm-glllk*. Like I'm swallowing in my sleep, going, "What is that warm mucuslike gunk?" I reach over and turn the light on and—oh, my god!—blood is pouring out of my nose! Dripping like that thin stream of water out of the faucet when you're trying to fill the little hole in your water gun. Except it wasn't a faucet, it was my nose. And it wasn't water . . . it was blood.

I freaked out. I said to my wife, "Teresa! Quick!" She went in the other room and got a wad of toilet paper. After a minute it was soaked. More toilet paper: soaked. With blood. When a human sees that much blood, it's "Call an ambulance!" Ambulance came, took me to the hospital. I'm lying there; nobody's doing anything. "You guys! I'm bleeding to death here!" That hospital didn't have the capabilities to do anything about my bleeding, so they stuffed me up with cotton and rushed me down to Mass General. They cauterized my nose at one o'clock in the morning, and the bleeding stopped. Two hours of hell! Blood all over the place! I had an operation, then everything was fine. My nose is still fine, thank you. No schmutz in my lungs, either: *bhub-bhub-bhub-bhub-bhub.* Did you hear anything?

When I first blew a tire, so to speak, in my throat, people started saying, "Steven Tyler has cancer!" What I actually had was a broken blood vessel in my throat. When I had throat surgery the doctor said, "No talking for three weeks." Now how was I supposed to do that? I went back to see him and he said, "You talked!" I got deep with it, I said, "What are you talking about, Doc? There isn't a soul on this planet who can shut up for a day, never mind three weeks. Unless I tape my mouth up, there's no way. We're humans, we're primates—we talk—and talking is my life. People talk in their sleep, they talk to themselves, and personally I suffer from being vaccinated with a phonograph needle!" "Steven, another week!" he told me and he did that three times. It went on for five weeks—it was a fucking nightmare.

The way they treat a broken blood vessel in the throat is just astounding. They put a tiny camera down my throat with a laser attached to it. On a computer they draw a line around the spot with the green laser beam and then they delete it the way you would a sentence in a word-processing program. They tap on the spot and it gets rid of it. Dr. Zeitels is in there with a green laser and he's going, "Gone, gone, gone, gone—" The green laser eats the blood under the skin, evaporates it, it's gone! *Star Trek*. I watched it back on a monitor, it was unfucking-believable.

While Dr. Zeitels was working on my throat I told him, "I have an idea. We're playing in Minneapolis. Why don't you fly to the gig with me, bring your gear, that way you can film me before a show, during Joe's solo, and after the show. You'll get to see what it's like to be me." Flew him out, he did it. All the way, I'm going, "Doc, I mean, what if we went public with this?" "Well, you see, no one's really done this operation on film before." "So, let's do it. I'm a lead singer—what more dramatic candidate for this operation could you get?" We thought about it for six or seven years and then we simply took the film footage of him zapping the blood vessels with a laser, some performance stuff, and they began to put the sequence together.

I thought they should get me singing "Dream On." As he was going down my throat, I said, "Oh, shit! If you're going to film me singing 'Dream On' while I'm in the chair, I wanna caterwaul the chorus, 'Dream o-on!' I couldn't do that if he went down my throat, so he went down my nose instead. He put the microcamera in and I really slammed it out, 'DRE-am o-ONNNN... YEee-AH!'"

The footage ended up on National Geographic's The Human

Body. When they did the show you heard me singing in the chair, the doctor talking, and all that stuff, and when I sang that, they could cut to me onstage singing it for real.

While I was at MIT Dr. Zeitels give me a tour of the lab. They put me in a red jumpsuit and took me down to the lab to see rats growing human ears. What they're doing there is pure science fiction. They paint organic webbing with human skin on it and attach it to the rat, so now it's getting a blood supply, it's absorbing it—it's called osmosis.

The whole *National Geographic* special was interesting because it was about the physics of singing, how your throat functions as a musical instrument, and how that instrument can bend, melt, twist, and wring emotions out of words. Sung words are mutations of written words. You come to a phrase in a song, your brain gets altered—words behave very strangely when they're fused with music. What *is* music anyway? And how does it go from *bom-da-bom-bom* into a song? When we sing we convey emotion by raising the pitch; the notes change the form of the words. Tone determines emotion: praise, stop, pay attention, comfort. A melody with a rising tone keeps a child calm; a minor second is jarring. Music literally touches you. Sound is touch at a distance; it touches your brain.

Monotone speech is robotic. In tone languages, words take on meanings from different pitches. In English we don't depend on tone for meaning, but in Mandarin Chinese, for instance, tone determines the meaning. Depending on the tone you use, *ma* can mean "mother," "hemp," "horse," or "reproach." The Chinese are very adept at using different pitches to indicate meaning, but *perfect* pitch is very rare: like having a tuning fork in your brain. Everything has a voice and a key: a car horn is an F, bells are between D flat and B. One person in ten thousand has perfect pitch. Mozart, Bach, and Beethoven all had perfect pitch.

I've spent my life listening to singers and realizing which ones could sing really well and are still lousy. It has nothing to do with perfect pitch or music lessons. Thousands of people sing great, with well-trained voices. The ones that have character in their voices are rare. Fucked-up voices with a ton of character-that's my idea of a great voice. My first album, people were going, "Steven, I know that's you singing, but how come it doesn't sound like you?" "Well," I tell them, "I didn't like my angelic voice so I did it in my fake ghetto voice." It was then I realized that I needed to fuck it up good. Like the great ones, like Janis: "Whoa Lor-ord woncha buy me-eh a Merrrcedees Benz!" That rusty, ornery, bar-at-closing-time voice. She could fuck up a song brilliantly. She had a raspy, croaky voice, she was born with a raspy voice. She had vocal chops that no other singer had. She wasn't the perfect American girl. She was skinny, had long fucking thick-ass hair, R. Crumb running out of the pages. You know Angel Food McSpade? She was her fucking white counterpart.

What about:

I got a reefer headed woman She fell right down from the sky

Lord, I gots to drink me two fifths of whisky Just to get half as high?

How epiphanous is that to a camp song? You know

Froggie went a walking one fine day a-woo, a-woo Froggie went a walking one fine day Met Miss Mousie on the way a-woo, a-woo

Ridin' into town alone By the light of the moon

... "a-woo" is the same fucking, happy, in-your-face yelp as the chorus to "She Loves You."

With Aerosmith we do so many different flavors: "Game On," "Shank After Rollin'," "Seasons of Wither," "Nine Lives," "Taste of India," "Ain't That a Bitch." We do down-home Delta blues, sleaze boogie, anthems, mandolins, steel-drum calypso, wailing sirens, cat-in-heat yelps, sentimental ballads, metal, Beatles covers, mooing killer whales, and the Shangri Las. You can't put your finger on what we do, because we do a lot of different kinds of music, unlike Metallica, which does only one genre. Have you ever heard a slow Metallica song? Is there one that you could dance to at a prom? If you asked them, they'd go, "Why would we?"

You can know all the technical stuff of singing, but it doesn't matter in the end because it's too over the heads of the audience anyway. Once you learn the nuances of music, you've got to take it somewhere else. There comes a point in most great musicians' evolution where they no longer hear all that underpinning. They only know the words that are thrown over the music: *"Every time that I look in the mirror . . ."* You take off from that. You don't know what you're singing or what chord it is.

Animals don't have brains like ours and are easily impressed

309

by big fake-outs. If you hold a blanket up to a bear, it'll run away. They tell you, "Lay down." Yeah, so it eats your ass?! No, you should go "*Arhhhh!*," jump up and down, scream, grab a blanket, a big branch. Because an animal doesn't know the branch isn't you. Long ago humans found out how to extend their egos: If I build a building, it will be an extension of *meeeee*. People know it's not you, but in some way it *is* you. Just like a song—that's my feathers, my proud plumage.

It was March 2001 and I was on a quest for the Grand Pashmina-otherwise known as how a European tour almost got canceled on account of a six-hundred-pound garden ornament. I was up in Sunapee closing up the house. We had a week before going on to Europe to begin a tour. I was trying to lift a six-foot black feather lawn ornament made out of wrought iron. There was still permafrost in the ground, and in trying to move the fucker I pulled both sides of my back out. I couldn't get out of bed without excruciating pain, and the thought was looming in my mind that we might have to cancel. The gear's already on its way over there on a steamship. Just to get out of the bed, I'd have to roll on my side and then get on my hands and knees and then slowly get up. It is the worst pain on earth-the muscles were ruptured. I was under a cloud, just a looming sense of doom reawakening my fear of abandonment, the overwhelming feeling of I-know-not-what.

I went over to Europe anyway—to do a tour promotion. There I am in Munich, freaking fucking out. We get to the hotel and there's the classic promoter's assistant. They're always a hoot. Sometimes you can play them like an old 45—right before the chorus, you lift off the needle because you know what it's going to be: the thieving, lying voice of the promoter. You try to weasel under the thread of their spiel and get into whatever is actually going on. But on this trip it wasn't drugs I was after—I was in search of the Grand Pashmina.

It's a soft, woven cloth made from the underbelly of goats up in the Himalayas. Every night when the stars shine, their fur glistens with tiny sparks of light. I bought one for six hundred bucks. It was about three feet wide and six feet long, so it could cover me completely, and when I pulled up on it, it was like empress chinchilla, softer than the folds of a clit. And that took my pain away for a minute, and then it all came back horribly, gruesomely, and I finally broke down and said to the promoter's assistant, "Look, I'm in agony, I can't move, I won't be able to perform. My back is fucking killing me." And she goes, "Ah! Shtop right zere!" She knows about everything in München: legal, illegal, hookers, drugs, record albums, Americanisch food. "Ach, geh scheiss in deinen hut!" she said. Literally, "Oh, go shit in your hat!" But basically, fuck off! And I said, "Really? Thank you!" But then she took me to this doctor who took care of the Munich football team, huge guys who play in the games against England's Chelsea Arsenal and all that. I walk in and there are six blondes from hell, German blondes. I went, Fuck! In the doctor's office I'm lying down on the operating table and I say, "Doc, are you fuckin' kidding with these nurses? How do you work with these gorgeous women?" He goes, "Vell, you should see my vife." "No, but really, what's goin' on with them? Is this-? Are you-? If you're not careful I'm going to throw'em in the back room in a few minutes and-""Nein, das ist not so good to do," he says. "Dis is vat I got here for you." And he shows me this concoction that he's going to use to take care of my pulled back. "I deal vith dis all za time. In two ho-wars it vill be all ofer." I said, "What?" "Yah, two ho-wars. I just came from America doink the seminar and I showed zem za procedure but zer insurances wouldn't allow it, because ve do injections in your backbone. Zere, zere, zere, zere, und zere."

He's pointing to the bottom of the spine, on each side of the spine, close to the spine itself. You put a needle in a quarter inch, because the spinal cord's *inside* the bone. There's a little divot there before it goes to your rib cage, a little bit of meat. I'm a little scared and I say, "Can you show me the bottle?" "All right. Read zis." So he goes out and takes care of another patient, and ten minutes later I've read the whole back and it's a bizarre concoction, a mixture of ground-up liquid rooster comb, shark cartilage, stuff like that and another chemical, butopinexopropophine or something. Shark cartilage, rooster, whatever, but that fleshy substance—that's the shit! People swear by shark cartilage here in America. Buto-whatever had helped me out for a while, it's a supplement for cartilage, for back pain, knee pain, joint pain, basically a joint pain supplement. But now I'm getting the great kahuna of all supplements: the cockrilcombsharkcartilegebutoprophine shot. I was scared shitless.

I was very much in the middle of should-I-do-it-or-not, and just at that moment I said, "All right, fuck it, do it!" He comes in and he gives me a series of twelve shots, on either side of the backbone, like L-9, L-10, whatever. A shot of Novocain first, then the injections after. Then they brought me into another room that was like a closet with a really soft doctor's table and a bottle hanging from the ceiling. "What's this?" "Oh, don't worry. It's amino acids. It helps in healing." Well, that's *another* thing America doesn't do. A half hour, forty-five minutes later, I'm peeing in the bathroom and I noticed my back was still a little tight, but it didn't hurt. Back to the hotel room, watched some TV, went to bed, woke up the next morning . . . pain gone. I'm telling you, *gone*.

Back problems seem mild compared to our days of yore, the Aerosmith days of rape and pillage through Europe. I remember one time in the late seventies when we so destroyed a hotel in Germany that Interpol was waiting for us *in the next country*. We were in Rotterdam and it was "What seems to be the problem, officers?" "*Us*, international fugitives? What do you mean?" Send lawyers, guns, and money. . . .

No back problems among the savage roadies in those days, either. Once when we were in Paris the crew were caught in a

traffic jam with a bus full of gear. A Citroën had overheated and was smoking in the middle of Rue Foche or some such froggy place, so the roadies just lifted the car up bodily, put it on the sidewalk, and proceeded to the concert site without missing a beat.

Of course in those days they were superhuman, fortified by chutzpah, lust, and pharmaceuticals. When a doctor came backstage at an Aerosmith concert in those days, they'd say, "Trapper's here!" And a handful of the crew guys would go over to him, get their teeth taken out quick, and go, "Oh, man, my tooth fell out yesterday!" Bloody their mouth up a little and get OxyContin prescriptions! They're a fucking bunch of carneys, me included. But I'd get the bill and it would be for six hundred bucks.

What's right down from Russia? Ukraine? No, Keep going. Toward England. Yeah, Finland. "*Hello Finland*!" We played Helsinki and a bunch of other provinces around there. In the Eastern Bloc, I'm looking around and it's like girls from hell. High cheekbones, blond hair, natural blondes—dirty, but not sewn in and not stripperlike. Real dirty blond hair with rug to match and you just wanted to get down and root for taters. These girls were *gothic*.

There's a name for a girl that shaves her puss because she's that sexually active and it's called "Please, Will You Marry Me." It's the ones with the tattoo down there, the tramp stamp, the Aerosmith logo with the wings, that are really hot to trot. Or else that have a tattoo with Chinese characters that you don't know what the fuck it says. *Harder*, maybe?

If someone did a study of rock stars . . . Perhaps I should create a chair of Rock Star Sexual Studies at some university. Have them write papers on the sexuality of Keith Richards, Slash, Mick Jagger, Jimi Hendrix, Janis. The boys that Janis loved—and the girls. You'd find that all these rock types have a certain kind of overzealous DNA, a bug-eyed hairy monster gene that leers out of their mom's pussy the moment they're born. Hey, we grew up on R. Crumb. We have that head space.

Everyone wants to see other people naked. I just don't want

313

to see my schlong on YouTube. I have a guy, Juan, do my dressing rooms because there's a camera in the wall somewhere waiting till I take my pants off. Fuck yeah!

Okay, put on our next CD . . . Just Push Play.

It's 2001—the new millennium, the New! Improved! Aerosmith! I'm writing "Jaded" with Joe. I'm in Joe's basement, recording, and I ask him, "What're we doin' this weekend?" Now, Joe, because he doesn't get thick into lyrics and write melody, says, "I'm taking a break. My wife and I are going to the movies." And I think, well, shit, Teresa is going to be fucking furious with me because we're *not* going to the movies. I can't just stop writing lyrics in the middle of a song. I can't sing, "*Hey, jaded, you got your mother's smi-ile, but your*"—and then answer the phone and just resume what I was writing: "You've got your mother's style, but you're yesterday's child to-o *me-e, so jaded*...." It's like climbing a rope out of a well—do you stop halfway to answer your cell phone with your foot?

When you're in a train of thought like that, you want to keep going. So I went up to Sunapee with my friend the songwriter Marti Frederiksen and left Joe and Billie at home to go to the movies. Then I have to deal with Teresa yelling at me about if they're taking the weekend off, why don't you? There's a little bit of that sideways anger I have toward Joe and his wife leaking out. But it's just what I have to walk through to get that song out.

I'm with Marti Frederiksen, we're out on the lake in a canoe, and we're writing "Jaded." Monday we come back, we start in with the band again, and Joe realizes that I've written the song without him. Marti was staying at his house and someone in the family read Marti the riot act for being a traitor and writing a song when Joe wasn't there. But, you know, behaviors can be forgiven and you got to forgive them, they were high.

Little did I know at the time that Aerosmith's fate depended on that song. According to Donny Ienner, if we hadn't come up with that hit, Sony was getting ready to drop us. Period. He said those words to me: "If you hadn't had that song on *Just Push Play*, we would have dropped you." That's pretty heavy. Shit. But stop me! I can't write from anger. I'm trying to be the lovely *sober* Stevie that's glowing, the placenta waters pouring over me.

With songwriters, when one of you comes up with a line, a riff, the other guy doesn't go, "Oh, shit, he's getting all the credit for this." Someone picks a little bit of inflection that you said and says something that you would have never thought of, and that propels you, the song builds, you climb up another rung. You're a man possessed! You can't even stop to wee-wee! Writing "Jaded"—was it out of anger?

When you write a song with somebody you're evoking the spirits of a moment in time, flecks of words, tunes, riffs hovering in the air, trip wire, seconds where you sing. When I heard Joe play that riff, I knew where to hang my hat.

Hey j-j-jaded, you got your mama's style But you're yesterday's child to me So jaded You think that's where it's at But is that where it's supposed to be You're gettin' it all over me X-rated

My my baby blue Yeah I been thinkin' about you My my baby blue Yeah you're so jaded And I'm the one that jaded you

Cyrinda died on September 7, 2002. Let a song go out of my heart.

When bad things happen, people tend to go, "God. It's God. God did everything. There are no coincidences, and every-

thing that happens happens for a reason." Well, I sure don't think Cyrinda should have died from a brain tumor! Was it me? Should I have made my first marriage last, no matter what, till death do us part? Should I have made that work? Well, sad to say I'm not a good candidate for saving a bad marriage. I could barely keep my head above water myself in those days. Or should I have, when I was in rehab, forced her to go into rehab with me? "Your toothbrush is packed and you're leaving tomorrow." That one really haunts me. I told her, "I'll send the plane," but Cyrinda did not want to go. Who does? I should have gone and gotten her myself. That might have worked, but I don't know. Until people are ready to stop, it doesn't work. And even then it rarely works.

When I found out she had cancer, I tried to help, but it was too little too late. I got my doctors together at Sloan-Kettering to check her out, a room at the Grammercy Park Hotel, and bahbe-dah-bah. Such a sad end, so unfair for someone who had to put up with me for too much of her life.

In 2006 I was at the clinic at the Beth Israel Deaconess Medical Center in Boston and Dr. Sanjiv Chopra (he's Deepak Chopra's brother) said to me in his *the-monkey-knowest-not-the-taste-ofginger* voice: "It is time, Steven. Go in for your hepatitis C treatment now; neither time nor the Ganges waits for critical matters such as this. You know what I am telling you: if this bad business is happening all the time to you, only worse will come of it."

I'd known I had hep C for years, because a few years before this a doctor had told me, "You know, Steven, you've got something weird in your blood." I would do blood tests three times a year and see my viral levels. I was asymptomatic, meaning no symptoms, so who gives a shit? People who have hep C are usually lethargic and tired. But I never get sick on tour, because on the road my subconscious functions on another level from that of other humans. It's as if when I'm about to get sick,

the flu, or whatever, it goes, "Oh, shit, you're *going onstage*? I'm fucking outta here!" I had hep C for four years and it never stopped me.

"Now, Steven," Dr. Chopra said, "I am very pleased your subconscious is so obliging and you are asymptomatic and so on and so forth, but veritably, it is time."

"Time? For what, Dr. Chopra?"

"Time the band took a year off."

I went, "Oh, shit!" But wait, it gets worse. . . .

I was staying at my brother-in-law Mark Derico's house because at the time we were in the process of fixing my house, rebuilding Taj's and Chelsea's rooms, and a lot of other stuff. Teresa would be over at the site during the day, and occasionally so would I. The main part of the house was cordoned off with tarps. Mark is not only my brother-in-law, but when he's not bulding houses in the New England area, he's my partner in crime in Dirico motorcycles. But later for that. He's been building houses for the last thirty years—some of the finest homes in all of New England, the kind of houses that will still be standing two hundred years from now—double insulation, commercial standard heating and plumbing, all that stuff. Mark had a troop of twelve guys doing major reconstruction, when one of them caught Teresa's eye.

So the band took the year off. We're rebuilding the house and there's these roofers and sheetrockers from hell with no shirts and pierced nipples and they're climbing all over the house like red ants fixing it up. Chelsea and Teresa would be over there checking on the progress—but little did I think that they were looking at these construction workers *like that*. Teresa had told me that there were some hotties over there and Chelsea was buzzing around—she was fourteen, fifteen—but stupidly it didn't occur to me that my wife had her eye on one of the guys, too, and that he was making eyes at her—just as I do on the road with hotties in the front row.

I said to Sanjiv Chopra, "You know what? Send a couple of

nurses out and show me how to do it." So they came out with a month's supply of needles, which come in a box. There's four in a box, they look like darts and they're filled with interferon and you keep them in the refrigerator. The ampoules are loaded, you pinch the fat on your side, which everyone calls love handles, but I don't have, stick in the needle, and go *pkkkkt!* into your skin. *Pkkkkt!* Monday *Pkkkkt!* Tuesday. *Pkkkkt!* Wednesday. My joints ached. I tossed and turned . . . I couldn't sleep.

The nurses gave me a month's supply of interferon and a bottle of ribavirin pills—that's this system called Pegasus for treating hep C. I'd been put on interferon ten years ago, and my viral levels actually went up—and that's not good. But I was reassured that that had frequently happened in the past but that the FDA had done new tests and released it as effective, mixed with the pills. They claimed this new regimen would kick hep C's ass 70 to 80 percent of the time.

Dr. Chopra told me to do it for nine months—I did it for a year. I walked the distance. But the interferon not only kicks hep C's ass, it kicks *your* ass. You take three pills in the morning and two at night. Your muscles ache, you can't get out of bed, you hurt all over, your hair starts falling out, your fingernails turn yellow, your toes turn orange and purple. You feel like you're dying, and that's what it is meant to do: trick your body into thinking it's dying. Your immune system goes, "Oh, shit! I've gotta get it together and knock this thing out of my system or we're both gonna croak!" If there's anything threatening your body, your immune system revs up, kicks ass, and kills it. The hep C virus lives primarily in the liver. But you can't inject the liver; whatever you put in there doesn't stay, it gets pissed out. So how else to deal with problems connected with the liver than by putting your whole immune system in jeopardy?

Several times in the night, I would have to move over to the other side of the king-size bed because there would be a huge wet spot—and not from the reasons I would have loved. I'd go through four T-shirts a night, I'd wake up all clammy and

wring them out. Your body's sweating, thinking it's dying. I did the whole process for a year, but after the third month, I said, "Fuck this, I can't stand the pain," so I went to the doctor. I told him, "I'm not taking anything. I'm a drug addict and alcoholic and proud of it, and I'm not gonna!" And Dr. Chopra in his allknowing-all-seeing voice, says, "Well, I don't want you to suffer." At which time the addict in me responded, "All right, Doc, give me whatever ya got." I'm on half a Vicodin in the morning and half at night. This could be a litmus test for addicts: if you give five people Vicodin, four will fall asleep and one will stay up and clean his room. That would be the addict—and that would be me. So now I need a sleeping pill to get me outta my room. Oooh, my addict loves that!

So it's the third month into the hep C treatment, and I'm back on the drugs. My wife decides to leave me (let another song go out of my heart!), I've got both the kids in the house. I've been diagnosed with a brain tumor, and on top of it all, the doctors say I'm in a clinical depression. Ya think? I'm a fuckin' mess (who wouldn't be). Oh, God! What next?

What the hell! Was there a snaggle-toothed witch somewhere cackling over a Steven Tyler doll made of wax?

Where shall I stick this pin next, my pet? In the heart or better yet, Liver, knee, toe, or spleen? For Steven Tyler shall not rise again.

Is that my phone beeping or is it my brain? Does the noise in my head bother you?

For five months I was a weeping, crying mess living in the other side of my house, sleeping in a room with my son, Taj, who at the time was eight. He's worried about what's going to happen to his mom.

"Mom's gonna be fine," I'm telling him. "Don't worry, everything's gonna be all right," as I hold back the tears. I never cried in front of the kids when it came to me and their mother. I loved her then as I love her today. And I would never let them think that I didn't.

It was the first time the band took a year off in thirty years. They went to Florida, bought cars and fucked and ate ice cream, and I went through hep C hell and lost my wife. Alleged friends of mine, people reading some crackpot book, would say to me, "Steven, dude, it's your karma, you had it coming." I-don't-thinkso. After the hep C treatment, I was doing half a Vicodin twice a day and all that. I had twelve years' sobriety when all that shit hit the fan.

And so the hep C treatment went for a year of that, and then I doubled up on the pills: I took three in the morning *and* three at night. I locked myself in my uncle Ernie's room in the back part of my house and lived there. I was off and running with the drugs. Most people stop the hep C treatment. They start doing it and they go, "Fuck this, I can't go to work!" Luckily I didn't have to go to work. Killing the hep C was my job. I persisted. And now I'm durn near down with the flu. . . . My toe got sick and my liver too. Oh, man, I'm beginning to sound like a Luke the Drifter song:

The hogs took the cholera and they've all done died The bees got mad and they left the hive The weevils got the corn and the rain rotted the hay But we're still a-livin', so everything's okay

And ten months, twelve months later, nondetectable in my bloodstream! Done! *Ding!* Over. I did it. Wife's still gone, but we go back on tour. I was lucky for the diversion but still brokenhearted.

Teresa left me for this young guy with pierced nipples who was building our house. Why she did it I don't know. Everyone's got

STEVEN TYLER

their reasons—even Hitler had his reasons! "You were gone for ten years," she told me. It killed me. I may have cheated on her, but I was home every night I wasn't touring. You have a marriage, you got kids, you bring millions of dollars home. It doesn't make any difference. You had an affair! You cheating, adulterous, sonofabitch! And to her I was that guy.

If a woman marries a rock star, doesn't she know that women are constantly throwing themselves at him, and being a man, what is he meant to do? How about if I was married to Pam Anderson? Would I be surprised if last time she visited Kid Rock they slept together that night? Fuck no! I could be completely wrong here . . . but she's a sex symbol and I'd have to understand that. Sex symbols attract sex and they get off on the interplay. It's the drama of it, and that's how they derive their sense of power. True or false? I've heard this over and over and I tend to agree. But in the end I hurt her and I so regret what I did.

We could've worked it out. "You'd rather leave me than work through it!" I said. Of course, I made the mistake of going to her and telling her I'd had an affair. My friends would say, "What'd you tell her for? You goddamn fool!" And they'd be fuckin' right. When I was younger, for guys it was "Lie till you die." There *is* no telling a woman. *Especially* if she says to you, "Just tell me the truth, I won't be mad."

In August 2008, my daughter Mia had a book out called *Creating Myself: How I Learned That Beauty Comes in All Shapes, Sizes, and Packages, Including Me.* She called me up: "Daddy, I'm going to be on *Good Morning America* with Matt Lauer and talk about the book. I just wanted you to know." When I saw her talk about her problems I was mortified. She was telling the world that she's a cutter—still cuts herself when she's stressed. It really hit me hard, because I wasn't there for her when she was growing up. Oprah and everybody watching who gets the big picture is going to go: "What a bitch of a father! She must have been crying in the empty house and in a desperate state and turned to cutting herself." And that's what I knew when I read her book.

Like father like daughter. Mia had drug problems as a teenager—drinking, diet pills—but I didn't know about her cutting herself. At one point I tricked her into going to rehab, saying I was sending her to a spa in California. My heart broke thinking that I had anything to do with her drug addiction. In the end I told her about this old AA slogan that I'd heard in the halls, where a lot of people vent their woes: "A lot of your problems have my name on them, but most of the solutions will have your name on them."

Not long after that I was walking along the beach, I dropped to my knees, I began crying because I realized that I'd gotten sober, but I hadn't done it for my kids, or even my own health. I hadn't thought about them when I was using, so why would I have gotten sober for them, either. Drugs robbed me of my spirituality and compassion, only later to find I'd lost Liv and Mia as well—I cried when they forgave me for my past behaviors but I'll be working on it for the rest of my life.

What would I say to my children? We may have picked the key but they are their own song. We don't own them, they only pass through us, as Kahlil Gibran says in *The Prophet*, they don't owe us anything, either.

Your children are not your children,

They are the sons and daughters of Life's longing for itself.

They come through you but not from you,

And though they are with you yet they belong not to

you . . .

For their souls dwell in the house of tomorrow, which you cannot visit, not even in your dreams.

STEVEN TYLER

In the end, all I could do was write a song for her.

On na na . . . na na na na na na . . . On na na . . . na na na na na na . . .

Hush-a-bye my baby soft and new Oooh loveliness gypsy dance in the rain Hush-a-bye my baby what'cha do Oooh the baby cry The wind she's callin' your name . . . (Mia) Ooooh . . .

Where you came from you ain't alone Live and loved from the old jawbone Oh don't you cry you're home sweet home

Rock-a-bye sweet lady gypsy blue Oooh the nightingale's singin' her song in the rain Hush-a-bye sweet lady soft and new Oooh don'tcha cry the wind she's a screamin' your name... (Mia) Ooooh...(Mia) ooooh...(Mia) Ooooh...(Mia) ooooh...

Come too soon that sunny day You give your heart away No divorcée or repouise'... yeah... yeah (Mia) Ooooh... (Mia) ooooh... (Mia) Ooooh... (Mia) ooooh... (Mia) Ooooh... (Mia) ooooh... (Mia) (Mia)

Last year I told the band we should call our next album 20 Summers. They all went, "Oh, 20 Summers, man, that's so great." Pause. "What the fuck does that mean?" "Well," I said, "you know . . . that's all you got left." And everybody gasped. People don't like to think about it, but like the Irreverend Steven Tyler said:

Ladies hold the aces And their lovers call it passion The men call it pleasure But to me it's old-fashioned

Times they're a changin' Nothin' ever stands still If I don't stop changin' I'll be writin' my will

It's the same old story Never get a second chance For a dance to the top of the hill

Me running the loop in Sunapee passing a jogger running the other way,

Female voice: Hey, I know you.

Me: Ya think?

I walk off the set of *Good Morning America* after I've done another phony intimate interview. I go into a bathroom and some little shit has followed me in there. Christ! I'm pissing at the urinal, "Hey, man . . . ?" And, right there, it cuts off the flow. I mean how am I expected to pee when the guy standing next to me is hemorrhaging internally, his fucking urine flow ain't going nowhere either. My nerves have somehow pinched it off and nothing's come out of me, so I head off to a toilet stall to finish the job. I close the door, and it's like *Aaaaab*, a shiver goes down my backbone because finally no one's staring at me, no

one's trying to get at me. I'm alone in my wild lonesome in that room . . . and for that one blissful moment I think to myself, *Finally, you're in peace.* Then, here it comes from over the top of the stall, a woman's voice, "Can I have your autograph?" I turn whilst still in midstream and piss all over her pumps. And for one wild moment and while we're stewing in my own juices, I realize life's a pisser when you're a-peeing.

The aloneness-it's a world in and of itself.

Bitchy Female Fan: Boo-hoo!

Bitchy Female Fan's Best Friend: Let him finish. This is a riot!

It's the yang of yin, if I may put it like that. It's the other side of frivolous, kinetic, sparking energy! It's a deep void, the silent play square. In that anechoic chamber of my own brain, anything I want to come out can, because it's not being interrupted by other ignorant motherfuckers—otherwise known as the precious children of God.

And the media, my darling . . .

Bitchy Female Fan: Jaysus! He's not going to play that tired old number, too!

Bitchy Female Fan's Best Friend: Shut *up*! They all have to bitch about the press, while at night they pray on bended knee to the Whore of Babble-on that they'll be mentioned on Page Six.

Me: Ninety percent of everything you read about me in the press was made up. Every rag in England disseminates utter bullshit. "Look," I say, as sweetly as possible, "before we start, do me a favor, let's not talk about drugs this time."

Montage of Announcer's Voices: The drug-addicted Tyler Perry gave us an interview the other night.... The ex-drugaddicted rock star ... The sixty-year-old Tyler ... The Jaggeresque Tyler ... The just-divorced Tyler ...

Me: It all has to be that or they wouldn't have their jobs. It's the oldest game in the book.

But wait, why have I never been on the cover of *Wonder*land magazine? I'll dial my press agent. Evan Dando and Rachel Wood get themselves cover stories. I mean, darling, if they can make the cover of *Wonderland*, why can't I? So many choices! Should I suck cock or should I suck pussy? Dando or Evan Rachel Wood? I just don't know...maybe I'll not suck cock and instead I'll write a song with Evan Dando and I'll just stick with Julianne Moore and Evan Rachel Wood as far as pussy goes. *Yeeeeesss.* I mean, really, darling, if they can make the cover of *Wonderland*—is it worth my tongue on their gynies?

Well, of course, absolutely.

Female fan: Hey, are you Steven Tyler?

Me: I think so.

Oh, fuck the book, you have no idea what *movie* this is! Get the picture?

STEVEN TYLER, an aging but well-preserved rock star moodily stares into space, wistfully looking out at his twelveroom tree house from the terrace of his eccentric compound in Marshfield, Massachusetts. He's talking into a digital tape recorder, which he barely knows how to operate.

STEVEN TYLER: (anxious but defiant) "I know you're not going to have a lot of sympathy for what I'm about to tell you, but it's my fucking book and I can say what the hell I want, can't I?" [Click!]

He shuts off the tape recorder and begins again.

STEVEN TYLER: (Cont.) "It's never again going to be the same way for me as it was before I was twenty-five . . . fuck, is this just *too* self-indulgent?" [Click!]

But if I'm too self-deprecating it's gonna sound just like all those other fucking candy-ass autobiographies out there.

(He resumes dictating into the tape recorder.)

"I sometimes have to put myself back in that head space of when I was twenty-two just for my own sanity, because it really sucks. I can't tell you why, but it doesn't feel good knowing that people already know all about me. They know my cat's name, my father's name, they know where I grew up. I'll be with people, and after a couple of hours of hanging out they'll ask me out of

the blue, 'Oh, so do you still have that cat?' That's what it's like for me to be with a girl in a club. I never have to bring up my exwife, or my last girlfriend; they know my story; and I'm as tired of it as they are.

"People like to tell stories; they'll tell me stories about *myself* . . . they'll tell me stories about Joe. 'Joe Perry, he's outta control, man. Yeah, I was with him the day he shot himself in the foot.' 'Oh, yeah?'You ask, 'Joe shot himself in the foot? When was that?' And at the end the story is that he *almost* shot himself in the foot."

"I go to people's houses who work for me and the guy will take me aside and go, 'Hey, tell the kids that I was your backstage guy, 'cause that's what I told them.' And I do it! 'Your dad, he was the guy... Without your dad, Aerosmith woulda..."

"I know all about this because I did it myself. Like when I told that story about Mick, that I was his brother. And imagine! I said we played with the Yardbirds, too. This is when we all carried each other's equipment from the cars. We drove up to the stage at Staples High School in 1966 with the Chain Reaction. So now people do this stuff about me.

(Reading a poem from his notebook, "Famous Stains." Clears throat.)

You're born then you die, do you think that's what life gets?

Then you're cheating yourself if the sun never sets.

If truth is the truth and you make it your friend

Then there'll always be a beginning, a middle, and an end.

The truth that went on that some like to squash Of the dirt that went into what came out of the wash.

Because Aerosmith, we're the dirt, we go through the ringer and we come out of the wash! My line used to be "I snorted half of Peru." Don't know where I got that from. Zircon-encrusted tweezers—that's got to be Zappa. We all get little bits and pieces from the ether, so you got to grab on to something and hold on to it. 'Cuz if you don't stand for something you'll fall for the anything, and to me Aerosmith always stood for something. In my book, it would be the three M's: money, music, and *mmmm* (pussy). Did I just say that?

I sleep with one eye open. I'm hypervigilant. I overfocus and overanalyze things. I've always been that way. That's part of the insanity of being me. I'll walk along the sand and will not leave until I have turned over every stone on the beach. I'm obsessed to a fault, and so you couple that with being ADD and we're off! I'll start with A, D, C, then I jump to Z.... Oh, and by the way:

Twas brillig, and the slithy toves Did gyre and gamble in the wabe: All mimsy were the borogroves. And the mome raths outgrabe.

"Uh, what was that again?" "What do you mean? WHAT DO I MEAN?!"

If I quit Aerosmith tomorrow, I'll just go paddle my own canoe. I love canoing so much that I brought mine to Maui and married it. It's the only place they let you marry an inanimate object as long as you do the sacred kiawe (*kee-ah-way*) dance.

Steven's Secrets of Life #9: Get Nekkid. I'll tell you, this year Erin and I got back from a ride from Sturgis one night. Took a shower and walked nekkid out in the backyard, as it was 92 degrees, while smoking a cigarette. I said, "Oh, my god! This must be what it's like in paradise, to be walking around naked outside this house, as Donovan must have imagined when he wrote 'Wear Your Love Like Heaven'... he just called me to say hi. Adam and Eve, man, they *knew*."

STEVEN TYLER

Even Eve in Eden Voices try deceiving With lies to show the lady the way At first I stopped and stared and tried to walk away....

Yeah, she ate it Lordy, it was love at first bite Yeah, she ate it Never knowing wrong from right

Most of what happens in life is based on electromagnetism. Each of us generates a specific type of electricity, our own frequency. We each have a unique aura, and auras are connected to each other by the electromagnetism that comes out of your personality. If you're a sex addict and you walk into a room full of people, without saying a word to them, you can make contact, they know who you are. "They smell ya!" as my friend Ray Tabano would say.

Energy is an almost psychic property. I remember Mouse McElroy and his girlfriend when we lived in the old gray clapboard house in Sunapee. Mouse was a keyboard player, and right out of the blue—*vrrrr-vrr-vrt*—he would go into seizures. Grand mals! And right before this guy would go off, go out, you could feel it thirty seconds before. He'd be still looking around the room, but you'd feel this surge of energy emitting from him like silent lightning.

I'm, what, sixty-three now? I've been to Maine, Spain, Spokane, seen goats fuck in the marketplace, but it's taken me sixty years to realize I don't know anything. I've come to find that out after going around and through all this—I really don't know what the hell it's all about . . . and I like that.

Wait! Stop! I'm not finished! Are you crazy, this isn't the end of the book! I have more to say, you fucks! Turn the fucking page!

CHAPTER FIFTEEN

TO ZANZIBAR AND BACK

The man said, "Why do you think you here?" I said, "I got no idea." AMY WINEHOUSE, "REHAB"

he press are always there, like jackals, hanging around at the gates as the latest celebrity drug addict drags his sorry ass into a waiting limo. When I came out of the Chit Chat rehab in Wernersville, Pennsylvania, in 1989, it was for the last time—I'd hoped. The press asked, with their fake sympathy, "So, how *was* it, Steve, getting through all that?"

The thirty days? Or the forty years it took me to get here? I think thirty days is a small price to pay for the rest of my life. "If it helped you find your soul again," I said, "then how can you not owe it your life?"

And then I began to explain, in the way the recovering addict is expected to do, with the required contrition and shame. And then you give them the promised fairy-tale ending, renewed faith in life after the nightmare of addiction and willful selfdestruction. All true—I wasn't just mouthing pieties about my road to recovery—but there was something I wasn't saying, not because I was hiding anything but just because it was so weird and intimate and ultimately unexplainable. Some of it I missed, some of it I got. The fairy-tale links I understood.

As a child I lived in the woods and I saw where the sap to make maple syrup came from, and later on I sought it out. I went and got some heroin because I wanted to feel what it was like not just to taste the sap from the tree, but to feel it coursing through my veins, opium from Mother Earth, the resin of the poppy plant. The gooey nectar of the earth—roots, tendrils growing out of the damp, humid soil. Unconsciously I connected the pine trees, the unearthly silence of the woods I had played in, with the opium I numbed myself with—as if the two linked a secret passage back to my childhood.

But my romance with opium and heroin and drugs of all kinds was over. Or so I thought. Though I lived on the tail of a comet and though I came from a town called Euphoria. In 2007 I left my home for a world tour. Everything was fine. I was feeling no pain. Why? After twelve years of being straight, I'd started using painkillers again because I was in terrible pain from my feet.

On May 31, 2007, we played to forty thousand people at the Dubai Exiles Rugby Club stadium in Dubai, Saudi Arabia. It was so hot there we couldn't play until eleven o'clock at night when the temperature had gone down to eighty, eighty-five degrees. I greeted the crowd in Arabic. Okay, one word, *marhaba!* (welcome), but still . . .

The day of the concert, Erin and I went out into the desert with Sand Dune Explorers, camelback tour rides. We rented five trucks and took along a bunch of people from the hotel, security, and a truckload full of camera gear and stuff for a photo shoot. The SUVs were *flying* up and down the dunes, some thirty feet high, like we were surfing great sand waves. They have to let the air out of the tires to get traction on the sand. We drove for twenty minutes into the great unknown of sand and sand and more sand. It was 110 degrees out there. If I'd been left out there

I wouldn't know where in hell I was. It's just a sea of sand, like being in the middle of the ocean. Sandstorms in the desert come up out of nowhere and hit so fast, they're tsunamis of sand, and when that happens you're not only lost, you're blinded.

A group of Bedouins was crossing the dunes on camels. I was curious about how they found their way around out there, so we drove over to talk to them. Some of these camels cost more than a Lamborghini. One of the Bedouins told me that the camel he was riding on was a dromedary of a very high strain and worth two hundred thousand dollars. There are racing camels worth over a million dollars. I asked him, "How do you know where you're going out here, with no landmarks, no signs?" And he goes, "Well, the camels know—if you're lost the camel will take you back." "Ah, no wonder the price!" I'd pay it, too; it's fucking life-threatening out there.

And not only do camels have their own GPS sensors, they also invented butter. Yeah, they did. When the Bedouins carried milk across the desert in goatskin bags, they found that it had turned into a solid—butter—when they got to the other side. But I prefer the account of the invention of butter in *Little Black Sambo*, a book my mother read to me (it wasn't as politically incorrect when I was growing up as it is today). They were fantastic tales and great fun. Sambo was a little boy from India. Four hungry tigers are pursuing him, and in order to avoid being eaten by them he has to give them his colorful new clothes, his shoes, and his umbrella. Each one of the jealous, conceited tigers wants the clothes and umbrella for itself, and they begin to chase each other around a tree, going faster and faster until their orange and white stripes begin to blend and they end up a pool of delicious butter.

I've often wondered if I could be turned into something like that when I pass away. Instead of burying me in a family plot somewhere they could scatter my ashes all over the sand of Big Beach in Maui. That way after I'm dead I'd still be getting into girls' bikini bottoms.

We came offstage around two in the morning—all I wanted to do was decompress. I was looking forward to walking around the town, going to the marketplace in Dubai, just being somewhere I'd never been before. I get back to the room and go to bed. The next morning I wake up and I *hurt* like hell. I'm in excruciating pain from *my feet*. My feet are screaming at me, "What the hell were you thinking last night? You trashed us!" The night before I'd been running, leaping, levitating onstage for two hours as the pointman for Aerosmith—but the point was I trashed my feet, and now, the day after, I'm paying the price. And we still had concerts to play in Sweden, Germany, England, Ireland, Latvia, Estonia, Finland, and Russia—not to mention twelve dates in Canada and the U.S.

On June 2 we played India! We had always wanted to play India, and in 2007 we got to do a concert in Bangalore. India has been a huge part of my life. I named my son, Taj, in part for the Taj Mahal. I wrote "Taste of India" in 1997, simply because . . .

It's like your first taste love of vindaloo That sets your heart on fire And if you let her stuff get into you It will be all that you desire

When you make love to the sweet Tantric priestess You drink in the bliss of delight But I'm not afraid when I dance with her shadow

This time I'm gonna get it right She's gonna whet my appetite Just lookin' for a little taste, taste of India She'll steal the smile right off your face

I love Indian food, Indian incense, Indian printed fabrics onstage at Bangalore I wrapped myself in yards of batik print shawls (leather pants and a black ganji top, for the fashionistas). One of my favorite books is Rudyard Kipling's *Kim.* Snake charmers, levitating yogis, many-armed blue gods and goddesses, roaming elephants with silk towers on which maharajas ride, temples covered with statues of couples caressing, copulating, doing the wild thing in a thousand yoni positions. And the *Kama Sutra*—the bible of sex! And in honor of Shakti, Hindu goddess of love and the unknowable feminine, I stripped halfway through the show to bare my stomach, on which I'd written "LICK ME!" in Hindi. I think it meant more to me than it did them.

I discovered the erotic origin of yoga while reading about Tantric sex some fifteen years ago when I was into meditation. And it turns out that yoga was originally created so that the maharaja could stay harder for a longer period of time so as not to let any of the harem girls down. He had seven or eight beautiful girls in his harem. The first girl, whom he'd got when he was younger . . . was now the taskmaster to the other girls, and with a gold-braided whip she trained them to do things to excite the maharaja's pleasure. They had to adopt ways for the marahaja to exercise. He had to stand on his head for hours in the hot sun just to be able to meet them adequately with his manliness. His temple guards saw him doing this and thought there is an easier way. They knew just what the maharaja liked: the perfect plump ass, nice firm breasts, a tight sweet yoni-but as we know, it goes deeper than that. All is good in the palace, but after five or ten years of this life, with all these women at his beck and call, his back is killing him from servicing all the palace *punani* . . . and what is he to do? Well, one day, the maharaja was sitting under a palm tree eating a date when his old teacher, a wise and horny old sage appeared, a Sufi master bringing some hash and the special dates with the almonds in the middle-whatever exquisite treats it takes to get through to the maharaja and not get your head chopped off. "Ah, Babu," he says, "just the man I want to see!" "I hear you, oh great panjandrum, and I have just the thing: yoga. If you follow my practical asana exercisings-the Cat-Cow stretch, the Downward-Facing Dog pose, the Awkward Chair

pose, and the Half Lord of Fishes pose—you will be able to fuck all the girls till kingdom come and you will not have a single twinge in your spine." And the maharaja was well pleased with this advice and said, "We could have a chain of yoga centers in the United States of America and make a fortune with this silly business and the confused seekings of the baby boomers!"

We arrived at the Bengaluru International Airport in Bangalore, India, and were greeted by a thousand Indian fans who took us by surprise. We were whisked into limousines and headed off to the hotel. But as we were to find out it was much more than a hotel. When we arrived, a ten-foot gate opened to reveal a full-on hundred-piece Indian marching band complete with giant elephant for us to ride to our rooms.

The elephants dropped us off, and Erin and I walked into our room. There was a big bowl of mangoes and papayas and anything your heart desires awaiting us. Beautiful arrangements of tropical flowers, a prince of a man is standing outside our door to be ready at our beck and call to fulfill our slightest whim. "Steven" is embroidered on the pillowcases, I kid you not. "God," I said to Erin, "pinch me. When are we gonna wake up?" She said, "The way things are I hope we never do."

We got to the Palace Grounds for the sound check. That's where the concert was to take place. Once outside the hotel, the scenes were horrifying: mobs of desperate, hungry people milling around with begging bowls asking for coins, people pooping in the street and dogs eating the poop.

"So sorry but sound check delayed," said the promoter.

"Why is that?" I asked.

"Well, you see, we are just now testing it for you."

"Testing *what*?" He pointed to the stage. So I walked down and looked underneath the stage: sticks! It was just a great mass of sticks, twigs no bigger than your thumb. It was stronger than it sounds because they were lashed together like a geodesic dome. It was never going to break, but it was scary-looking and we had a ton of sound and lights and equipment.

The promoter of the Bangalore concert was even more ruthless than your average scummy promoters in the United States. He confiscated water, booze, and food from everyone and then made them pay ten dollars for a bottle of water and there's eighty thousand people at the concert—so do the math. The worst part was that he didn't offer to cut me in! The guy said, "I make beer. I own all alcohol here in Bangalore Province. We take all the bottles away before they come in." There's a ton of booze and water bottles piled up in a huge heap. I said, "What do you do with all those bottles?" "Oh, we dump them." "What about all the destitute people walking the streets outside our hotel like zombies at four in the morning, barefoot, in loin cloths, with no food?" "As Ramakrishna says, 'When an elephant is in trouble, even a frog can kick him.'"

Three hours later, we're back in our room, Erin turns on the TV, and there's an Indian announcer in the singsongy voice describing our room as the camera pans around to the bowl of fruit, the bed (without us in it), but the pillows with "Steven" stitched on them, my bathrobe, and the towels (also with "Steven" on them). We sat up, "Whoa! Is this camera in here *now*?" They'd been in the room the day before and filmed everything.

Onstage, Joey's always tied to his drums, and Tom, Brad, and Joe are all ferociously focused on their fret boards—they can't be running around like maniacs—so it's up to me to put on a show. I'm the designated kinetic animal, the leaper, the somersaulter, the jack-in-the-box, the March Hare driven to mad extremes by the manic artillery of Aerosmith's heavy-ordnance rock. And my poor feet having had to bear the burden of all these acrobatic antics for thirty-six years finally said, "NO MORE! If you don't treat me good the way you should, you won't have a leg to stand on." Okay, I get it! What was wrong with my foot? It sloped to one side, it looked oddly reptilian, like it had turned into an alien pod. I dealt with it the same way I've always dealt with pain—I self-medicated. It took me a while to get around to having my feet examined (I should've had my head

examined, too). When I finally went to see an orthopedic specialist, Dr. Brian McKeon at the Boston Sports and Shoulder Center, he said, "Son, what you got ain't good!" What he actually said was something like "It's an enlarged nerve that usually occurs in the third interspace, between the fourth and fifth toes. Problems often develop in this area because part of the lateral plantar nerve combines with part of the medial plantar nerve here." Okay, stop! I've heard enough! It had a nasty-ass name: Morton's neuroma. It sounded bad and it was.

My feet were crooked and broken from years of wearing tight shoes and high-heeled boots—Beatles boots—and slamming around onstage. That's why I walk this way. It's one thing to walk around all day in high heels like women do, but to traumatize your feet onstage for two hours every night for thirty years is quite another. We played *thousands* of shows, my feet and I. After every tour, my feet weren't just inflamed, they were *in shock*.

In February of '07 I was a busy boy. We'd gone to London to perform at the Hard Rock Cafe, where I put on one of John Lennon's jackets. We were there to promote our upcoming world tour and to rip the Hard Rock another asshole with our badass selves. It was the first gig Tom played after having recovered from throat cancer. The show was fucking great and I was on fire from hanging out with the Bert and Ernie of England, our photographers, Ross Halfin and Classic Rock magazine's Peter Makowski, who I later had dinner withalong with Jimmy Page. Not only do I have to perform, I have do BBC One and BBC Two interviews: "Now, tell me, Steven, how are you and those drug addictions doing? Are you and Joe still the Toxic Twins?" Where have they been? Fuck, they missed my whole sobriety thing. What! Twelve years of me clean, sober, drug free, and reasonable (well, okay, maybe that's going a bit too far) and you missed it, you fucks? On to the inevitable Mick look-alike questions and the more recent taunt, "By the way, how old are you?" I just went, "You sensationalistic motherfuckers. I don't mean that in a bad way." They

just laughed; they loved it. I was, after all, a visiting dignitary and it was all really sweet.

At the Brit awards I was asked to copresent the Best International Group award to the Killers, along with Sophie Ellis Bextor. Amy Winehouse, my sister in the art of self-destruction and abuse, showed up to greet me. The guys from the Red Hot Chili Peppers came to my dressing room and I felt bad because most of them were clean and I was still crusin'. "How're you doin'?" I asked Anthony Kiedis, and he goes, "Well, I'm still ridin' the sobriety train." And shamefully, I blurted out, "Yeah, me too!" but I was snorting Zanzibars at the time like there was no tomorrow. I did an absolutely manic interview with the Brit classic rock magazine *MOJO*. I raved on about God, gorillas, talking dogs, and sex in trees.

The thing about my feet was that I knew they were going to require surgery and that it was going to be fucking painful as hell, because I knew the band would force me to rush my recovery in order to get back out on tour in a timely manner. My doctor works on all the Celtics' and Bruins' knees and shoulders and feet, and he put me in Larry Byrd's room. I was in the hospital for a week-plus while I had the foot operations. What they had to do was to cut some bone and take two knuckles out of my feet (they're in a similar position to the knuckles in your hand). If you bend your thumb above the nail, that's one knuckle, the next knuckle back is where the thumb attaches to the hand, and that was the joint in my foot that had to be sawed in half because it was bent. They also took out a ganglion of nerves. The nerves that are in your feet are small as a dime, but mine were the size of a quarter, big and bulbous and traumatized to the point where they had to be taken out. Morton's neuroma is the nerve center in the feet. That's where they took the nerves out, so now there's just phantom pain there, like a guy who gets his arm cut off and still feels his fingers. Whatha? So there's phantom pain plus my brain is sending electricity down to the feet thinking that Nerve Central's still

there. What Dr. McKeon did was to take the Grand Central Station of nerves in my feet out.

Even four months later I was still walking on those incisions; it's something that I need to do because it makes nerves spark and come back to life and return life to my foot again. The doc said that in a year it should be just plain all right. I've got a couple of places that are creaking and hurting still and I don't know why. Love may be hard on the knees, but it's also hard on the vocal cords and the feet—and my ankle muscles aren't back, either. I'll be in pain for the rest of my life. Hey, what else is new?

When I got out of the hospital I kept my feet elevated and got a little roller device to do my orthopedic exercises on. I also got a scooter on four wheels that I'd kneel on and scoot around the house. I put a horn on it so I could blast everyone as I zoomed around the house. But because it's my feet and because of who I am, you can only imagine, after a month and a half, I climbed up the stairs on my *knees* to go take a tub. After sixty days of climbing up the stairs on my knees I moved my bed from downstairs into my living room in Marshfield.

Then I tried to find a live-in nurse to give me my drugs so I wouldn't have to touch them myself because of my past history. I called up the Nurses Society at the hospital near me in Marshfield and left a number. A woman called back, very excited about doing it. I hung up and went, "Oh, god, I *know* that name. Who is it?" Susan, who was working for me at the time, said, "That's the fuckin' stalker girl! *Ach!* That's that stalker bitch down the street, who drives by and we duck all the time!" And I went, "*Wha-a-a-at?*"

I could hear her in the echoing recesses of my addled brain saying in her crazy scary lady voice: "Steven, love, I followed you back from Sunapee, I'm going to make you well . . . I will never abandon you."

Whoops! So this nurse is another stalker woman off her meds who's now moved to Boston, moved near me. I got a restraining order, but all she did was to move *farther* down the block and become a nurse, a fuckin' nurse, Oh, *nuuuuuuuuse!* They're very sweet, nurses, and overweight—like in the movie *Misery*. Maybe women who satiate themselves with food have a need to take care of everyone else but themselves! I told Susan, "Ah! Get rid of that number!!!"

So, now I was forced to bring my own drugs home. And needless to say, I was back in my element. I wasn't taking the pills, I was grinding them up and snorting them. Eyes pinned, mind numbed. I wasn't the only one buying drugs from the dealer on the street. Everybody was doing OxyContin, Joe more than me. Oh, sure, we had our reasons, um, excuses. Joe's knees and my fucked-up foot. Ya gotta take something for that severe pain. Unfortunately, those were the only things that worked for us.

For the first month I needed serious painkillers-for the second month, I should have started weaning down, and the third month, been damn near off the drugs completely. But these are my feet and I'm walking on the surgery so by the end of three months, I was hooked but good. I still couldn't walk and the pain was excruciating. One day one of our road crew came down to visit me, and knowing what he did on the road, I asked him if he had any you-know-what. I was already taking it so why not do a little more. And I would have, had a dear friend not bought it all off him an hour before. Within a month I was one of his regulars. I'm glad he did it, but after I came out of Las Encinas a lot of my friends began saying, "That motherfucker! He's fired!" Well, I didn't think he should be around me and I didn't want him working for the band, but I never had any bad feelings about him. Shit, I was in a lot of pain and he was trying to make me feel good!

I couldn't get enough narcotics to dull the pain in my feet. I had whole jars full of Xanax. Not the cute little pills your mother gives you, but these monster things—pills so big they got named Zanzibars. They're slammin', they're great—I got them from Mexico—I didn't know about the online stuff back then. Xanax,

Librium, Valium, etc., commonly known as benzos from their basic chemical compound, benzodiazepine. Now, in rehab, if you came in really strung out on benzos, some counselors would take you off to one side and whisper in your ear, "Go out and get yourself hooked on heroin, instead, because the benzos take a year to kick and are so much harder to come down from. And heroin only takes two months to get off." Go figure.

But the painkillers and tranquilizers weren't the only problem. One day a friend of mine came over and he said, "You wanna do a few lines?" I said, "What? You have blow on you now?" I mean, those were the words. I leaped at it. I said, "You have it on you now?" He goes, "Yeah, I got it.""Well, could I have some of it?" God, and I was shaking like a leaf. I hadn't done blow in fifteen years.

This drug binge went on for a month . . . or two . . . or three. Then, at the end of March, John Henry, who owns the Red Sox, called me at the house and asked if I would sing for the opening game. And it was "Let me see. Okay, yes." So on April 4, 2007, I went to Fenway Park and sang the national anthem. I'm in the midst of singing "The Star-Spangled Banner" and I'm high as a kite. The words are melting like candle wax against the blue sky.

But at a certain point I said, "This shit's gotta stop!" So I went to L.A. and got even more fucked-up. The ostensible reason for going out there was that during the third month after my operation, Guitar Hero was doing a version of their video game with Aerosmith. I had to get out there and do stuff, on pain meds *and* in a cast for my foot. Early in the fourth month I'm out of the cast—walking around pretty good wearing a sneaker with the toe cut off. I have some pretty impressive insulated socks and a toe condom I wear onstage.

I was so into Guitar Hero. I love cartoons, comic books. When I was a kid up in New Hampshire at Trow Rico, my comic books were *Archie* and *Scrooge McDuck*—and it was pretty cool stuff. It was sweetly demented, but who knew? Whoever wrote that shit? Scrooge McDuck diving in his pool of dimes and nickels, coming up with his lucky dime.

I've always wanted to be a comic book character. Now I was going to get my chance. A cartoon of me! Tylertoons! "How are you going to make me come alive on Guitar Hero?" I asked. "Well, we'll draw you." "But you draw me based on what?" "We put you in an outfit with balls attached to it and the camera reads those outlines and creates a two-dimensional figure." I had to dig a little to find out that the guy who did the characters in all the other Guitar Heroes was going to be doing me. That's when I went, "Whoa! You mean you're going to have some guy do my character?" The director took me aside and said, "If we had known you wanted to this-"I said, "Didn't anyone tell you I was coming here?" "No, management said they didn't think you'd want to do this." You might say, well, it's Guitar Hero, it's about guitar players, they don't really care about lead singers, but I knew better. Whatever they were going to show was going to be called "Aerosmith," and I've been known to be the lead singer from time to time. And I thought all the moves that Joe and I had come up with onstage for the last forty years that we were known for would have been the perfect thing to take the game over the top and represent like no stunt doubles could ever have thought of doing. The interactions between us that millions of pople love to see would have been priceless for the game. At Activision they thought we'd have been happy to have someone other than us do the performance because that's how they'd always done it. It didn't occur to them that maybe Steven would want to front the band, playing himself, in the video game. Let the bars come down on the video screen and there's Aerosmith. It's a guitar-driven video game with a fret board and everyone's playing that color-coded toy guitar, but people are also going to be looking around at the other members of the band, aren't they-including maybe the lead singer-especially if they happen to be singing along while following the guitar leads? I mean when people are playing "Dream On" on the Guitar Hero game,

do you think anybody can even *hear* the guitar part through that vocal? *"Every ti-ime that I look . . ."* It's like on "Satisfaction," there's a guitar playing the opening chords. But do you think anyone can pick out what the rhythm guitar's doing on that song if there even is one?

So in the spring of '08 I went to the Neversoft's motion capture studio to get myself turned into an animated cartoon. For four weeks I jumped around in an outfit with tracking balls stuck on it so that I could be digitized. They even attached them to my mouth: my upper lip, my lower lip, my grin—that alone took an hour. When it was done I pulled the balls off my face, put them in a bag, and snuck out with them. I figured if I could get out with my balls intact management would never get a chance to break 'em again. Managers have a way of being really truly mean.

Aerosmith Guitar Hero turned out so great, what could be better—it's like a cartoon biography of the band—and you get to be Joe Perry. Although I do know Joe tried it out and couldn't get beyond the first level! Ahh, heck, he's always playing with himself anyway. It's a sort of biorama as well as a video game. You can catch Aerosmith from start to finish—or at least up to 2008. You get to see us at Nipmuc High School in Massachusetts, where we played our first gig, Max's Kansas City in New York, where we got signed, the Orpheum Theater in Boston. It's like watching your yearbook on DVD. You see the girl that you took to the prom, and you go, "Omigod, look at what *I* look like. What's with the hair—and the Prince Valiant haircut?"

We got into the whole Guitar Hero thing when they put "Same Old Song and Dance" on Guitar Hero III: Legends of Rock. That sold a whole lot of copies and we started thinking, *Hmmmm . . . now*, *what if the first Guitar Hero built entirely around one group—was us!* It seemed like a great idea, especially since we hadn't put out a studio album of original material since 2001, and people were starting to say, "When are you guys gonna put some more shit out there?"

I'm only bummed that it wasn't Lead Singer Hero—but they'll get around to it. Ya think? I think that the *face* of a song is whatever the lyrics are, wouldn't you agree with that? You know what's going to happen? In about three years they're going to come out with a video game featuring the Stones or some other group with a great lead singer, and when that happens they'll have someone miming the singer and you'll get a microphone with the game and sing along with it like karaoke.

Having been clean and sober for so many years it was a crying shame the state I was in after I got my feet fixed. I was bumping into people, doing crazy stuff. "Man, you were fallin' asleep last night right in the middle of dinner," people were telling me, and I was saying, "You saw me do *what*?" I was just, "Oh, Jesus, this is fucked-up, I wanna live." But ya know how my girl Amy sings it . . .

Hence the drug addiction rumors in the press once again. I didn't respond. I was full-on with the OxyContin and the Xanax. I was crushing the long fat two-milligram Zanzibars and inhaling them.

I went to the annual MAP Fun Benefit Concert honoring Alice Cooper and Slash. I presented Slash with the From the Heart Award for his support of MAP's program: access to addiction treatment regardless of your financial situation. Slash had been clean and sober for three years and here was I still high. *Aaach*!

I was high on drugs during that 2007 tour, so high on Xanax I let little things really get me over the top. Oh, god! I thought, *Here I am again in that place again, being a fucking drug addict.* I began to panic. *Am I going to go out like this?* I'm thinking to myself, *Am I gonna go out like this?* I have this running thing with the band about death, the deadline.

I went off the deep end out in L.A. After a while of being

absolutely insane, I decided to get off everything, but I wanted to do it by myself—never a good idea. My plan was to get myself a suite in a hotel and have a doctor—using other meds than the ones I was taking—wean me off my drugs of choice.

I happened to know Justin Murdoch, whose dad owned the Westlake Four Seasons—he's the other Murdoch, David Murdoch. He owns Dole, and he's the largest landowner on the island of Lanai in Hawaii, my favorite place on earth. I'd met Justin a few years earlier at Koi, a restaurant in L.A. Outside the eatery was a car, a Shelby Cobra, no paint on it, just the body, and I went, "Aha! This is interesting, I wonder who that belongs to." I walked in, it was, like, after hours, not many people there, and I asked, "Who's fuckin' car is that?" This guy stood up and it was Justin Murdoch. We've been best friends ever since. Justin's got more money than God. He flew me over to Lanai in his father's plane while I had hep C and introduced me to the doctor who invented a cure for addiction.

So Justin got me a room at the family hotel, the Westlake Four Seasons—with an adjoining small room where the nurses would sleep. The idea was that my doctor would come see me every day and I would detox there. The doc and the nurses are coming in at night, I'm doing my meds while I'm sleeping. It was a good setup just with the drug he was giving me for my feet at home, Subutex, an alternative to heroin. It's a drug that fools the nervous system. It's a narcotic, different from heroin—almost as hard to get off. A month and a half and a *hundred and forty thousand dollars* later, I'm out of there. I was off the narcotics for a time, still doing an occasional Oxy-Contin, you know, four times eighty milligrams a day, and still doing Subutex.

While the doc was detoxing me, three weeks in—I went, "Stop! Doc, will you come to Boston with me because Joe is at home and just had a knee replacement and I know he could use a tweak. We gotta help him." I got on the plane with Erin and

my doctor and we all flew to Boston first class. Doc stayed at my house, and the next day I called up my brother Joe and for a moment he was into it, too. "All right, come over," he said. The doctor went over and told him, "If you want to get out of this cycle of dependency I can help you. Come to L.A., and I'll do for you what I've done for Steven." Next day I jumped back on the plane with the doc, went back to L.A., was in the same hotel, started the regimen again, and after that I don't exactly know what happened. But I didn't hear from Joe again for months. A week later I fired *that* doctor because I was still as strung out as I was when I went it. I was singing Amy's song before she wrote it. But I began to seriously think about rehab.

Erin had left me the month before, went off with her girlfriend, started going to some meetings, and then checked into the rehab at Aurora Las Encinas Hospital in Pasadena. Unlike most rehabs it's on a huge estate, twenty-six acres. It was started in 1901 to treat alcoholic movie stars. The doctors were so rich and the place so prosperous back then that they were able to landscape it in the most picturesque style. They planted exotic and indigenous trees on the grounds. Trees from Africa, India, South America. It was like an arboretum. A lot of the Hollywood stars of the twenties, thirties, and forties would go there to dry out—that was before they knew that alcohol was a disease and to get them off the booze, they'd give them *morphine*. While I was there I slept in the house W. C. Fields died in. Slept like a baby.

I went to visit Erin in Las Encinas. I was going to take her to the movies, but she didn't want to go. I was sitting in her little cabin at the outpatient clinic chatting with her and looking around and saying, "This is pretty nice! Hey, what's up here?" And at that point her therapist came in, took one look at me, and said, "Steven, maybe you need to stay here tonight."

And I went, "Oh, god! Are you going to try and talk me into going through rehab?"

"Yes, Steven, I think that would be a good idea."

I went into the bathroom, took my bottle of pills out, and dumped it in the bottom of her wastebasket, came out, and, given my impetuous Italian sensibility, I said, "That's it! I'm in." Because I knew that I couldn't do it on my own, and they had an intensive detox program. So I went for the real rumpypumpy, baby.

A week and a half later: *Ahhhh!* I was in there and God had put this guy named Joe (Yo in Spanish) in with me. He was from Mexico, right across the border. I thought I was in bad shape! I'd been doing, like, four Zanzibars a day, two Zanzibars during the night. I'd wake up every two hours, snort a half, go back to sleep, and sleep forever. This guy is lying on his back screaming *at the top of his lungs*, holding the backs of his legs, kicking up in the air, going, *"Ahhhh! Ahhhh!"* Sc-reaming. They're shooting him up with shit, but *nothing* worked. He finally settled down after two weeks and when he was in good enough shape to talk I got to hear his story. He'd been eating six eighty-milligram OxyContins a day for ten years.

I always wondered what I was gonna be like at fifty, and here I was sixty and fucked-up. Give me a fucking break! It was all going too fucking fast! Although time never slows down as much as it does in rehab. Going through detox you look up at the clock and say, "Fuck, it's only *one o'clock*? Oh, god, it's going to be a *long* fucking day!" And they get you up at six! When you're in there detoxing at sixty it's *very* humbling. You tell people, and they go, "*What*?! Muchacho, you don't *look* sixty!" Or they say, "You telling me, my brother, that you *bought* that shit, you eat *shit*!"

But, you try to protest, these were *prescription* drugs, man! Of course, that's just the problem. Prescription drugs are the new plague. There's career drug addicts like me—and just about every other person in America who's on some kind of meds. Half of the people reading this book are going to be on pharmaceuticals, on legal meds. It's a pharmaceutical world, baby. "Take when feeling anxious, when you can't sleep—or just whenever you want to experience that mellow Swannee River mood," reads the tiny Courier type on the label. Why would I go out and get drugs from a dirty low-down dealer when I can just go and get a script from my sweet old family doctor. "Uh, Doc, do you have anything that'll, you know, attack the higher centers of pain because, see, I really need something that'll get me through the night, through my divorce, I've just been laid off and I need to get rid of this pain in here. . . ." That's why all my friends are cops, or dead.

Have you looked in any of your friends' medicine cabinets lately? You don't have to go down to Avenue Z and score, no, you can get your drugs from your doctor and hide them from everyone. But trust one who knows from bitter experience, it will start to dawn on you, maybe not until you're forty or fifty, that you're hooked. Sooner or later the benzo fiends will come and bite you on the ass, your little sleep aids will turn on you. You began taking half an Ambien to go to sleep and now you're up to *six* a night? But those prescription drugs just won't come through for you.

Wait a minute, what am I saying? Am I going to turn people off? Are they going to say, "I'm not reading this damn book! This sonofabitch is preachin' to me and I just got myself a big bottle of benzos." Well, actually, you already bought the book, right, so what the hell?

And that's how I got into all this shit in the first place: helpful doctors and accommodating dealers all trafficking in the same Mephistophelian meds. I just couldn't stand going through twelve years of pain and suffering and not being able to sleep at night! Not my sleep, doctor, not sleep *that knits up the raveled sleeve of care*, for god's sake!

Erin was at Las Encinas, halfway through her rehab. When you get through detox you go into residential units—just a hundred feet away. Nice cabins. There was a tree growing over my cabin roof. I would hear this *plick-plick* sound above my head.

Hard little shell-shaped purple flowers falling on the roof. I put a sleeping bag on the bench outside my cabin and brought my pillows—and purple flowers rained down on my head. In the morning the ground was covered with purple flowers. I sang "Purple Rain" every day!

Erin and I had been *flying* on this stuff for two years, Xanax being our drug of choice. I didn't like the me that was me on benzos, and coming out of that din was a revelation. It was now you're here, front and center, present. It was easier for me to do because I'd had practice. I'd come out of the din four times before this.

But after a few days I went, "Oh, my god, what is this?" You're in there for benzo addiction, and at the clinic they start telling you, "It takes months to get off that stuff." I said, "Oh, yeah? That's bullshit!" to that, as I do to everything. One of the things I hated (you're in there with this Dr. Blum-Barry Blum, head of the Chemical Dependency Program, along with Dr. Drew Pinsky) is the forced damn cheeriness-"Good morning, Steven! How are we today?""Hey, Dr. Blum, I'm feeling just great!" You see him every day and he has to be sure you really are cheery—but not too cheery (that would be suspicious) and not slipping into despair, depression, and suicidal gloom. So, because of the tendency toward morbid depression and desperation, Dr. Blum would see each patient every daythe more critical would be visited by one of the staff every fifteen minutes-because everyone's detoxing, hitting walls. I couldn't sleep for the first four days: "No one's gonna die from no sleep," he tells me. "But maybe we should up your Seroquel." So they gave you Seroquel and Neurontin to sleep. By the time you've finished this book you'll all have degrees in psychopharmacology.

Seroquel is a nonnarcotic, antipsychotic med for people who are coming off stuff, especially benzos. They gave me a patch of Clonidine to lower my blood pressure. Clonidine is used to treat hypertension (high blood pressure), alcohol abuse, nicotine withdrawal, and dependency on benzos. "Nah," I said, "I'm not takin' them. I've been through that and I'm not going to start banging into walls and doors again like a rag doll." "Well, Steven, we're here to help you. Why don't you just try one." Look, I can be reasonable, so I said, "All right, I'll do *one*." And this time it was bearable. But in the other rehabs I was in, they had me on *four* patches or a bunch of pills. I was the living dead. I was grunting like a stoat, making ungodly noises: *mrrrvrreeeeeee*. I couldn't wake up, I couldn't sleep or get up. I had no muscle control.

I'd been on this stuff before at Chit Chat, that rehab in Wernersville, Pennsylvania. I got sober there the third and last time in rehab—or so I thought. Now we're up to four rehabs: Hazelden to East House to Chit Chat to Las Encinas. I've been in so many rehabs they're like my alma maters. My foot has been in rehab, for chrissake. In 2001 I got a wing of the Roxbury rehab clinic in Boston named for me. I did a "Got Milk?" ad—which was pretty funny given my reputation. I would even have done one for a rehab if they'd asked me—they could have used "The Farm"...

There's a cockroach in my coffee There's a needle in my arm And I feel like New York Cittay Get me to the farm

Whatever it takes—like I said, I'm just such a good drug addict. But this time I knew, because I'd been through it so many times before, that it was now or never. I was sixty, and if I didn't stop now, when was I going to do it? Stop everything, including the Xanax, and Xanax was the killer. By comparison it was pretty easy getting off the narcotics. I couldn't sleep at night—the anxiety I felt coming off Xanax was extreme. A benzo nightmare. Benzodiazepine, *ach*! But to be honest, benzos were the shit and I loved them. It's just that I can't be anywhere near them. I know I'm a drug addict. "Hi, my name is Steven and I'm an alcoholic,

drug addict, coke freak, and benzo demon." It's insidious stuff. Benzo is Beelzebub's latest brew and I'll tell you why. You, even you, reasonable reader, I will tell you what you do without even knowing it: you open your bottle of Xanax or Valium or Librium, you take out mother's little helper and slip it under your tongue and wait for that feeling to hit. You know just what that buzz is going to be when it stings your central nervous system like a pharmaceutical viper.

And you'll say to me, "No, not really, Steven. I only take it to go to sleep or when I have a panic attack." Uh-huhn. But I *know*. When people take those drugs, even nonaddicts, they wait for that mood-altering brain fog to kick in. They go, "Yeah, I love it when it hits, I get that warm, woozy feeling, and that's when I know I can go to sleep." And I *cry* when I hear that, real chemical tears—*a-heh-heh-heh-he-heaoaooh, ah-ha-haaaaaa*—because I love that, too. I just can't do it!

One day I'm at Las Encinas on my way to the lunchroom. I'm stumbling around banging into things because they put me on Seroquel, and to get to the lunchroom you had to go through the bipolar clinic. That was really fun. As I pass through, a heavyset guy looks up at me and smiles. I see his teeth are all sharpened like Dracula. Remember that? That was a bit of insanity that was all the rage right before shaving your head became a craze. I said, "Hey, how ya doing?" And he goes, "Oh, real good. I love your music!" It was all very relaxed, as relaxed as it could be with people going through serious mood swings. I was glad it was all so casual and informal. Weren't we all on the same ship of fools, all suffering, deluded creatures, all the same under the eyes of God and Dr. Drew Pinsky? But I forgot that I was still in the United States of Amnesia, where everything up to and including mental illness is subject to the overriding law of sensationalism, gossip, and innuendo. Paris Hilton: New Sex Tape! Nick Nolte's Cocaine and Booze DUI! Lindsay Lohan Back in Rehab; Blames Astrologer.

As I'm walking through, trying not to stare too much, I see a

guy playing a guitar. "Woo, give me that," I say. I don't really play guitar, but I watch my fingers and I'm strumming away, and suddenly there's a huge crowd of people around me and everyone's got their cell phones out, taking photos, recording. I looked up and went, "*Aiiiieeeee!* Fuck! You know, I'm not supposed to be in here!" Word got out that I was in Las Encinas and I heard the tabloids were offering a considerable amount of money for a picture of me in there looking as fucked-up as possible. So after that, they put police out front—not to prevent homicidal psychopaths from breaking in and attacking their old shrinks, but to stop the paparazzi from sneaking in to catch me drooling on the floor.

When you won't answer their dopey questions—"Give us a full accounting of why you're in there and what it feels like to be back in rehab for the *fourth* time"—they'll go ahead and write what they want anyway. They did that with my divorce, Aerosmith breaking up, and Erin punching out the girl in the bar in New Orleans.

I called Slash up from rehab and said, "Slash, I got somethin' to tell you, man." He goes, "So do I!" I go, "No, no, me first." He says, "What? What?" He thought I was going to say, "I'm trashed and I'm here with my friend, I'm in—" but instead I said, "Slash, know where I am?" And he said, "Oh, I *know* where you are." "You sonofabitch," I said, "what do you mean?" And he goes, "Well, you know Steve's in there with you." I said, "Excuse me?" He said, "Yeah, Steven Adler's right there in Las Encinas. He's back in detox." "*What?* Steven fucking Adler's in detox again?" Steven Adler, the original drummer from Guns 'N' Roses was in there with me at the same rehab and I didn't know it.

The poor guy. Talk about an appetite for destruction! He got fired from Guns 'N' Roses in 1990 for being too fucked-up to play drums, ODed on smack in his car in 1995, a year later had a stroke and went into a coma after doing a speedball (cocaine and heroin), and after a second stroke ended up with a speech impediment.

Slash asked me to go over and say hi to him. Detox was

right down the hill from my cabin so I walked down. Steven was a total wreck. He was slurring his words so badly I could barely understand him. "Uh hiyaaah, Steeeveeeen, aaahm noot stoooned right nooow, I juss taaalk liiike thiiis. I've haaaaaad twwwwwo ssssssstroooooookes, heeee, huhhh." I was stunned. "You sound good, man," I said. "Nice goin'!" And I walked out. I wanted to throw up. He's had two strokes, slurs his speech, and he's a mess. And because he's like that, he's never going to come back, and he'll just never not be on drugs, and he'll never be in the band again. So there's part of his brain that knows that and goes, "Fuck it! I'm gonna go get high right now!" And I get that. I actually get it. I hope I'm wrong.

Two weeks later I found out that the reason he was there was to do Celebrity Rehab, a reality show on VH1 hosted by Dr. Pinsky about famous people in recovery. They don't film it there at Encinas, they do it in a hotel. They wait until the celebrity gets detoxed and then get him to reenact his former fuckedupness-which is pretty fucked-up, actually. Later on I heard some assistants from the show prepping Steven Adler for the Celebrity Rehab episode. "Here's what I want you to do," they were telling him. "Tomorrow night, just as soon as the sun goes down, we're going to put you in an ambulance, we're gonna take you over to the hotel. When you get there, fall out onto the ground and go, 'Oh, my god! Where am I?" They wanted him to act out his own messed-up state when he entered rehab. It was ghoulish and unreal. They gave him thirty grand for the episode, he snorted it all, crashed his car, and he ended up in iail detox.

It didn't seem to me all that ethical using actual fucked-up patients like Steven Adler in a reality show, but who am I to say? Not to mention getting trashed celebrities to mime their own self-destructive nosedives, which they then sensationalize on a melo-fucking-dramatic reality show, which so traumatizes them they end up in worse shape than ever—from the drugs they bought with the money from the show. *Oh nurr-se!* Well, here's how Dr. Drew does it: he gets people in and then he has an announcer explain in a smarmy, therapeutic voice what the patient's paradigm is, his traits, his innermost feelings, how it was, how it is now, and how it could be in the future with positive affirmations spread over the top like butter on new bread. That's how they get away with it. All delivered under a veneer of sanctimonious concern. Like the corrupt state senator who goes on the air with that stone-casting voice, "Yes, I was there, she was a prostitute . . . regrettable incident." With no response . . . just that flinty smile. John Lennon read that type brilliantly . . .

There's room at the top they are telling you still, But first you must learn how to smile as you kill, If you want to be like the folks on the hill

Every Saturday morning, there was a "What's Up, Doc?" session with Dr. Barry Blum, where significant others and family groups could come and talk and ask questions. Then on Saturday afternoon Dr. Drew would give a talk, and the room was packed. If everyone had inhaled at the same time the windows would have imploded, there were that many people. His talks were so interesting because he would expostulate about his theories. He had some curious poses and stances, which he delivered as psychopharmacological dogma. Such as that addicts have especially sympathetic receptor sites for narcotics-we all do, actuallyand that's why they're drug addicts. Drug addicts, in other words, have the drug-addict gene. Well, if I have that gene, what did the conquistadors have, the El Dorado gene? And what about Magellan, did he have a global-navigation gene? "Flat? Did you say the world was flat? Get in the boats! We're goin'!" Anybody that's got any balls at all, are they the ones with the gene or without? Dr. Pinsky would claim that there's a certain paradigm to our behavioral traits, but his argument is bullshit: "Well, I get why he would try drugs; he's predisposed to them." Which, of

course, makes me wonder why *wouldn't* this hypothetical person take drugs out of curiosity to see what they're like? Are there genes for people who go up to the wall? Or do other people have a gene that suppresses adventure, risk, and curiosity? Shrinks don't even go there!

It's interesting that Dr. Pinsky never came up to me, never made any advances; he certainly didn't ask me to be on his celebrity rehab, because—at best—I would have gone, "Are you *fucking* kidding me?"

I come out of any detox a wreck, but benzo detox is the worst. After five weeks, your skin is crawling, because they stifle your nerves. People take Xanax and other benzos because they're having a *nerrrr-vous breakd-d-down*. It's a great drug for masking. In a really laid-back, jive-talking voice you'll tell yourself, "Hey, I'm really comfortable now, so what the fuck are you tellin' me, dude, lay the shit on me, because I don't hear you...."

When you're coming out of that benzo din you get to see what life has to offer again. Oh, that's what mango smells like, that's the color of a peony....I'm ecstatic to be sober again now and coming up a wormhole. I'm ready to change the channel.

The more spiritual side of me tends to get lost behind the stereotype of the Sex Addict, the Toxic Twin, the Screamin' Demon, the Terror of the Tropicana. But if you listen to "Dream On," a song I wrote in 1969, you might see me in a different light...

Half my life's in books' written pages Live and learn from fools and from sages You know it's true All the things come back to you

Sing with me, sing for the years Sing for the laughter and sing for the tears Sing with me, if it's just for today Maybe tomorrow the good Lord will take you away

DOES THE NOISE IN MY HEAD BOTHER YOU?

I don't even know where I came up with that shit! I may be a monster, but I'm a *sensitive monster*....

I went to church, I had a sister, I'm Italian, and I've probably seen the sun set and rise as many times as anyone. I liked cutting the umbilical cord at my son Taj's birth. I liked smelling the placenta. I like the act of making love rather than saying, "I fucked you!" If anybody wants to see the spiritual side of Steven Tyler, well, it's fucking there!

Erin got out of rehab two weeks before me—she'd started earlier than I had—but the day I got out, my new life started unfolding *that* day, while I was making *wild* love to Erin, talking about how we were so *fragile* coming from the rehab, like coming out of the womb, with all these feelings of newness and astonishment. Feeling the wind blow, the sun on your face. When you're high, you're numb to everything. We had been taking so much OxyContin and Xanax for so long our feelings were deadened. When you reemerge, everything affects you wildly. The mildest cool breeze and you're freezing, you're so vulnerable. Somebody says something negative, the slightest thing, and you're devastated. We came out of that cocoon, and even two months later, we were still reclaiming ourselves, recovering from the din of addiction.

Colors! I'm so into colors now. I want to eat *food* that's different colors. I can feel the wind blowing against my face and hear the woods, the woods that were *mine* when I was a kid.

Back in Sunapee, I took off my shoes and felt the cool green moss on my feet; I smelled the pine needles, the pungent, earthy odor of decaying leaves. For a moment I stood alone in a clearing, listening to that muffled silence.

CHAPTER SIXTEEN

FALLING IN LOVE IS HARD ON THE KNEES

got out of Las Encinas in the summer of '08 and went home to be with my mom before she passed. I was not on drugs and got to spend a couple of wonderful months with her.

My mom went over to the other side in July '08. I was sadder than I'd ever been. And I left my body as I cried. I wailed, "Oh, God, how can my mommy die? God, oh, God, please, God." I cried when Mom was lying there. And I hugged her and held her. We each got to sit with her. I got to sit with her after her soul left her body and talk to her and tell her things I had not told her. It felt as if she was still there with us as we spoke to her. I knew she could hear what I was saying. And felt as much there as she was before. We each said good-bye. Kissed her and wept.

My mom, Susie, was somebody who wanted to make her own life. She was a real tomboy, which was hard in an age when women were supposed to get married, have children, stay at

357

home, and be a housewife. Susie never was that, she wanted to go out into the world. She carried to the grave a regret that she hadn't done something great with her life. But she had us, loved us, loved my dad.

She painted, played the piano, made pottery, loved to finger paint with me, and read Rudyard Kipling's *Just So Stories* to me when I was three. She was beyond talented. I could feel her living vicariously through me as I was growing up—from jumping out of trees . . . to barefoot skiing . . . to falling in love . . . to screaming and arguing at the dinner table . . . to screaming at a hundred thousand kids onstage. Toward the end she talked about a piece of her life that she felt was missing. But, ya see, that's the piece that she gave to me. And no one can deny that I have lived a double life.

When I was ten, my mom would say, "Yo, where are you going?" (Yes, Mom said "Yo!" She was ahead of her time.) And I could talk to her about anything. I tried to get her to smoke pot instead of cigarettes. It was her idea for me to be in music. "I'll drive you to the gigs in the station wagon," she said, and drove me and the Chain Reaction to the County Center in White Plains to open up for the Byrds.

I have this indelible image of my mom the way her brother, my uncle Eddie, described her as a young woman: jumping into a Buick convertible, her long hair streaming in the wind behind her—and *vroooooommmmm*! She was off in her element. She loved that. She was like a thoroughbred horse that just jumped the fence and was running free across the fields. With Susie it was always just, "Let's go!"

My mom passed away and so did my sobriety. I started using right after that. That went on for another half a year. I would spend nights at home thinking about going on tour with the band and I just couldn't do it; I couldn't dance. The pain was so excruciating just walking around and I had moments when I shed tears thinking, *I really can't do this*. While I was in Las Encinas in the spring of 2008, I got a call which pulled me out of my melancholy mood. Erin had just left and I was there all by myself doing Neurontin, a beta-blocker used to prevent seizures. Then on my twenty-sixth day there which already felt like an eternity—Henry Smith of the Living Myth called me and said, "The Yardbirds are thinking of getting back together and they're wondering if you might want to be the lead singer." Well, hell, yeaaah! I would. I'd always had this dream that someday the old Yardbirds would re-form and I would somehow be part of it, and, damn me, if it wasn't happening. The Yardbirds was the band that had been Aerosmith's greatest inspiration, and, outside of Aerosmith, that would have been the group I would most want to be in.

Four months later I'm on the phone with Peter Mensch, Jimmy Page's manager. "Peter, let me ask you something . . ."

"You know I'd do anything for you, Steven," he said. "Besides you gave me my first job."

"I did?"

"Don't you remember, I was your tour accountant. Hah! Anyways, what was it you wanted to ask me?"

"I'd heard that Jimmy was thinking about re-forming the old Yardbirds and I—"

"Hold on, Steven, he's right here," and he handed Jimmy the phone.

"Steven," said Jimmy, "would you consider coming over to the UK and giving it a try?"

"You know I'd really love to do that—it's been a fantasy of mine since I was seventeen."

I wanted to do it because I wanted to say I did. Everybody's dying to hear Led Zeppelin again, with me—or someone—especially Robert—singing lead. So, in September 2008, around the twenty-second as I recall, Henry, Erin, and I flew to London to see about doing some dates with Jimmy, John Paul Jones,

359

and Jason Bonham, "Bonzo," John Bonham's son. Henry and I went to the studio in Putney and all went pretty well, I thought, but unfortunately I was getting high. The first day I was there I got a migraine. Friday we played Led Zep songs all day. Fuckin' heaven!

But I soon realized it wasn't going to work. Not that I couldn't sing this stuff, I could do Led Zep in my sleep, but I wasn't Robert Plant, and Robert wasn't anything like me. Fans want to hear "Percy" wail on "Whole Lotta Love," "Communication Breakdown," etc. It never would have been the same. Aerosmith tried it when Joe and Brad left in the early eighties and it never worked without them either. I was flattered that he'd asked me, but it would be like trying to replace Bonzo—it's not going to happen and maybe it shouldn't. The way a band works is chemistry—and you can't substitute for that. I blew it, but even though it didn't work out, the kid in me was dying. I got to sing every song from "Black Dog" up and down. I called Jimmy and told him, "I'll never forget the experience of singing with you as long as I live."

I just didn't think a band like Led Zeppelin needed a singer like me. They already had the best; they were the best. Robert used to say, "I think I could sing and shear a few sheep at the same time." I can think of a few things I could do while singing but that ain't one of them. Maybe that was the problem.

Anyway, I was already missing my own band. I hadn't given up yet. I'd been trying to get them to do an album for four years and this detour made me more determined than ever.

To tell the truth, one of the reasons I tried to do the thing with Jimmy Page was because I was feeling bereft. My mother had just died; Joe, my brother, was mad at me for working with other songwriters. I felt he was trying to get back at me by doing his own album. And then he disappeared off the face of the earth. I couldn't find him under a rock and no one would tell me where he was. I called Truly Mean, who was our manager at the time. All she'd say is, "Joe's unavailable." Un-fucking-available!

STEVEN TYLER

Then a few months later I heard my own band was trying to replace me, and I was like, what the fuck! They don't get it. It's all in the fucking mix. Robert's banshee wail synchs with Jimmy's plaintive Gibson EDS 1275 to make that high octane Led Zep sound. With us it's the Screamin' Demon's howl from hell and Joe's raunchy blues grind that makes Aerosmith's 150 proof moonshine—pumped out by Brad, Joey, and Tom. It's the collective vibe of four or five people tuned into each other that makes the bee sting and the honey drip. I knew what I had to do—gotta fly back to my hive, talk that jive, and hit the road again with that beautiful, dirty Aerosmith liquid hydrogen snarl that makes the liver quiver, the knees freeze, and the booty shake. And that's an understatement!

But my feet were still writhing in pain. I could barely walk, and if I was to go out on tour I needed to prance. The band wanted to tour—and Aerosmith was my first love, a fucking gift from God—but I questioned whether I could even be onstage. The band said, "Aw, come on out, anyway, Steven, you can sit in a chair." In a chair? In a fucking chair? Who did they think I was, Lightnin' Hopkins? I'm a dancer. I can't even sit still under normal conditions—so onstage, fuggedaboutit! I ground my teeth in anger at my brethren. You fucks, to discount my pain and think only about the money! So I was given the option: either I could sit in a chair and sing (yeah, right!) or . . . guess what?

In the spring of '09 I went to see Dr. Brian McKeon again. He's going to know how to take care of my problem, I figured. He treats athletes, and they're all crippled at forty, all on some kind of painkiller. He did prescribe something really effective, something that attacked the higher centers of pain, so I could at least get onstage without being plunged into the hell of screaming skulls.

Effectively medicated, I went on the Aerosmith-ZZ Top tour (the so-called A to Z Tour), which began in Maryland Heights, Missouri, on June 10, 2009. It wasn't long before I began abusing my meds. On the list of side effects—sleeplessness, nausea, sweating, headaches—they should add: "may cause patient to respond in an inappropriate manner to the horseshit of others." I wanted to explain to the band why I was on drugs. It wasn't—as many cynically believed, "Oh, that's Steven" wanting to get high. It was me trying to get through the pain. And I fell hard because it was hard. I sacrificed my sobriety and my sanity! And I did it all for them! Sob!

The tour was going fine. . . . I was planning to work on my book—the very thing you hold in your hands!—but Dave Dalton was sending me huge chunks of manuscript and I was having a hard time reading that many pages. I told him, "Only send me twenty pages at a time." But did he? Not that it would have made that much difference because—on serious doses of Lune-fucking-esta and the Suboxone—I was in the way-outa-sphere and not really up to reading twenty fortune cookies, never mind twenty pages of Steven-fucking-ography. It's not that easy to revisit your checkered past while snorting long lines of Lunesta—which I was spending too much time in my room doing.

It's funny. After all the drugs that I ever did, all the coke and the rest of it, now I am on Lunesta? Lunesta! The least of the sleeping meds. But I just needed to do it... I was flying on the wings of Lunesta, and that along with the Suboxone that I was taking, supposedly one of, but by now I was up to two or three. Suboxone is used to treat opiate addiction—but it has a morphine derivative in it, so... But never the day of the show!

August 5, 2009, Sturgis, South Dakota, the Sturgis motorcycle rally. It's a big day because my brother-in-law, Mark DeRico, and I were building our Red Wing motorcycles, and Red Wing was going to be named bike of the year there. Sturgis is biker heaven and I was getting nicely loaded. I was there with my friend Justin Murdoch. Justin's downstairs with me and Erin, and Mark and the family were upstairs in the hotel. The night comes, we play the gig, I fall off the stage and suddenly everybody is on a witch hunt for Justin. They just assumed he was the

STEVEN TYLER

one who had given me the drugs. Now Justin's like my father he can't drink more than one beer, two beers tops. No one gave me any drugs! I was using—if you can call it that—doing the Lunesta! And instead of eating the three pills prescribed me I was snorting them, too, at night. That's all! Compared to what anyone who went to see Hendrix swallowed, or smoked at a Be-in or Woodstock . . . Lunesta? What the fuck! That's like ...smoking banana peels! After all my running in the seventies, eighties, and nineties, I'm smoking banana peels? You know ain't nothing in that. It's like what the fuck?

Here's what happened that night moment-by-moment in Tylerama: The night of the show, we're backstage, we're waiting to go on. There's a terrible thunderstorm. Lightning puts out the electricity on half the stage and the floor is flooded, soaking wet. They're trying to mop up the stage and consequently the show is held back an hour. A fucking hour! Anyway, we get out there and we get to "Love in an Elevator." Suddenly the sound goes out, my microphone is dead. I walk back to Joey and go, "Can you hear?" No response. So I make a T sign for time-out and he runs his finger across his neck like he is slitting his throat, signaling, "No, I can't." I begin walking slowly back down to the front of the stage to start singing "Love in an Elevator," but half the PA system is out in the front of the house and just to keep the audience entertained I do one of my Tyler moves-and I fall off the side of the stage. I zigged when I should have zagged, and I fell eight feet ten inches. Right then and there I knew the world was gonna know I fell off the stage and what they were going to think. And there it was, the whole thing on YouTube as soon as I got to the hospital, twenty minutes later. I just figured, What the fuck? I'll say, "Yep, I was high," and just call a spade a spade. Tyler falls off stage. Tyler fucked-up on drugs. I could've sidestepped the whole thing by saying, "I zigged when I should have zagged."

Backstage they laid me out in my dressing room on a gurney and only Brad Whitford came back to see how I was. Only guy in the band. When I fell off the stage, a soon-to-be band mem-

ber's wife yelled at my manager, "You know what happens when you let him hang out with drug addicts?" So, after falling off the stage everyone got so mad at me no one in the band called me for twenty-seven weeks. I'm not sure how deep I would want to go with this, but it's just fucking ironic, isn't it, that not one of those fucks came to see what was going on with me, and when I asked them a couple of months ago, "What the fuck?" they said, "Well, we were angry at you!" Angry? They were angry at me for falling off the stage? That was the best that they could come up with.

After falling off the stage, I started the healing process and twelve weeks later I went out on the road to do a few makeup gigs with the band-San Francisco, Honolulu, Maui-or we'd have been sued. I did them, but I still wasn't talking to the band. I had my manager get me a Winnebago so that I wouldn't have to go backstage and see any of them. Not once did I talk to any one of those pricks. I got out onstage that first night in San Francisco but not one word did I speak. I shot daggers at them, smiled, put my arm around Joe, thinking, You fuck! I remember looking at Joey-he and I had always had a laugh together-but I just stared him down. I read a book by Og Mandino called The Greatest Salesman in the World, where it says if you tell yourself when you're angry at your friend, that you love him, he'll feel it. It works. But at that moment I looked at Joey and said silently to myself, "I hate you, you fucking piece of shit." I didn't know what else to do. And . . . it was one of the best shows we've ever done.

I got chastised for falling off the stage high. That I may have done. I guess some are yet to fall off their own stage. I see people in this band who drink and fuck up, fuck up and drink, and if I ever point that out to them they always say, "Yeah, but I didn't do what you did." The hypocritical finger-pointing shit. "I don't have a problem." Yet. And then, lo and behold, what do I see not so long ago but one of the guys in the band mid-snorting, there was a fucking luger at the end of his nose. I saw the picture! It was taken by a Fan Club Girl, Amanda Eyre, of a certain member of the band with a fucking stalactite hanging out of his nose.

It was a high def image so we zoomed in to see what the fuck color it was so we could figure out what drug he was snorting.

When those gigs were over, I went to New York, got an apartment on the Upper West Side, and worked with Keren Pinkas who was helping me organize my book. During this time the band was scouting for other lead singers behind my back and putting out rumors that I was leaving Aerosmith—that I had quit. On November 10, 2009, I was at dinner with Erin Brady, Mark Hudson, Mark's girlfriend, and Keren Pinkas in New York and there was a phone call from Paul Santo, Joe Perry's guitar player, saying, "Hey, we're playing down here at Irving Plaza, blah, blah, blah. . . ." And I thought, hold on a minute, let's go get a limousine, we'll ride downtown to the theater and wait outside until he's about to do his encore, then I'll run in and get up onstage and tell the world what happened.

We orchestrated it like a movie where you go in, you go out, and no one gets hurt, like the scene from Oh, Brother Where Art Thou? I was going to go in and fucking take over. We put our plan into action. We called the limousine company. I said, "Keren, look up on the Internet, find out what Joe played at his last show, and then we'll know exactly what song he does before he comes back and does his encore: "Walk This Way." Then we sent Keren into the theater as our satellite, as our mole. Keren went and stood right in front of Joe. Right away, she texts me, "Oh my god, I can't believe it, there's barely two hundred to three hundred people here.... It's half empty." Poor Joe's in there playing to half an audience! Then Keren texts me again, "I think this is his last song." We run in, I meet the guys at the back door, and they recognize me. I tell them, "I gotta get onstage right now!" They go, "Okay, okay, okay, Mr. Tyler!" We're like a snake, running through the crowd, this way and that. I see Billie Perry, she sees me and goes, "Joe! Joe! Steven's here!" She starts freaking. It's Elyssa Perry, the Wicked Witch of the North again. Billie, Elyssa, same woman. If you ever meet guys who have had three, four wives, you know they keep getting married to the same woman over and over. They pick a new woman

365

who's just like the old one every time. Nothing else will do. If you're a sex addict, you're not gonna go look for a date in a library!

So I go backstage, Joe's just come off, and I walk in the room and go, "Hey, Joe, what's going on?" He goes, "Nothin." I say, "Havin' a rough night?" He doesn't answer me. I say, "Joe, let's go up there, I want to do 'Walk This Way' with you." He introduces me to his lead singer, some German kid named Hagen Grohe. I say, "I know I heard you up there. How you doin?" and shake his hand. Joe says, "Here's what's going to happen. My guy Hagen's gonna take a verse then you take a verse." And I go, "Well, now you know that just ain't gonna happen!!" I should said, "FUCK YOU I'm singing it. What are you gonna do about it?" Just like when I was growing up, the guys in the gangs, that's what they did. "Fuck you, I'm stealing your date, what are you gonna do about it, prick?" That was the kind of words that went down in Yonkers among the Green Mountain Boys. But instead what I said was, "Come on, Joe, let's go, let's go do this thing." There was tension and an ominous silence that you could cut with a knife. It was bullshit. I said, "Joe, come on, man, they're waiting for you." I walked out and he had to follow me. I grabbed the mic and the place was roaring. They gave us a standing ovation for at least a minutethat's a long fucking time when you're up there-it seemed like two minutes of whistling, clapping, and hollering. I got them to quiet down. I said, "All right, here's what's happening. I'm going to sing with Joe tonight. The rumors about me quitting the band aren't true. And Joe, you're a man that wears a coat of many colors. But I, motherfucker, am the rainbow."

I thought, where the fuck did I get that from? You get these moments when you know how the movie's going to go. I said, "Count it off, drummer boy!" And we did the song and when it was done I jumped off the stage, into the crowd, went out into the limousine and went, "Uh, what just happened?"

Eventually I moved into my daughter Liv's brownstone in the Village-she was off doing a movie. During Thanksgiving I drank, did some blow again, and then Christmas was coming up so I had a guy bring me an eight ball of coke and a bunch of pills. And those deliveries got through Erin a couple times. But by December, the last package arrived and Erin saw it and said, "What is this?" I said, "Gimme that!" I pulled it away from her and the package ripped. Cocaine went all over the place. I went back later that night and snorted it all up, off the counters and everywhere, and got a nice fucking rail out of it. It was pretty cool. It's interesting how fast you can go back to romancing your drug. I got laid the first time on coke. I've done every fucking drug under the sun. I've smoked combs, for chrissakes! You'd buy a nickel plastic comb in the men's room at a gas station, cut all the teeth off, stick one in the end of a cigarette, and smoke the plastic. Pure poison. But, like they used to say in the Renaissance, Dosis sola facit venenum, which translates to something like, "Only the quantity makes the poison." A very cool saying by Paracelsus, a sixteenth-century alchemist and doctor: "All things are poisons," he said, "for there is nothing without poisonous qualities. . . . It is only the dose which makes a thing poison." I love it. Anyway, amo, amas, amat, and December 14 rolls around, and I'm laying in bed, wiped out from arguing all day with Dave Dalton. I've been having a shitty week, which got a whole lot worse after Erin found my shit. Four A.M. she wakes me up and says, "Guess where you're going? Betty Ford."

I called my friend Frank Angie who sent his plane for me. The guy loves me—he'll do anything for me. We flew out to L.A., then flew over to Palm Springs where I made a brief pit stop to grab a double double In and Out burger—where they bake the fries in the bun—for my last meal in civilian life.

Oh, you know what I forgot to say? We have to put it in right here. Just before that tour where I fell off the stage, I was in New York. I was up here on the West Side and went to this little restaurant where I met my new manager Allen Kovac, who I'd met through his partner at 10th Street Entertainment, Eric Sherman. I told him about my problems and what was going on with the band.

The day before I went to Betty Ford, I said to Allen, "Get me something else, something besides the band. I need to have some backup plan outside of Aerosmith." My father used to tell me: "Always have a backup plan, something you can fall back on." Aerosmith wasn't exactly a sure thing anymore; they were looking around for other lead singers—and I was getting calls from Lenny Kravitz . . . who was wondering if I was really quitting the band.

I knew I was going to be all right after the second day at Betty Ford. I went from detox to the community, having, ironically enough, come to Betty Ford high on the very same drug they wound up giving me to deal with my addiction: Suboxone. They let me out in a day, only to be greeted by this guy who said, "Hi, I'm the Kings of Leon's dad." His kids didn't like the way their dad was behaving. He'd remarried and they hated his new wife, he was getting drunk all the time, running trucks and buses off the road (he was the band's tour manager)—just fucked-up shit. So they sent him to rehab, and so I spent the next month in the best of company with the Kings of Leon's dad.

After detoxing and spending a month at Betty Ford, I was talked into spending two more months there. After the first month at Betty Ford they put you in what's called the lane. It's a house in a cul-de-sac. I lived there with four other guys—three rooms, two guys in each bedroom. The first day I was there I went, "Wait a minute, you guys are doctors?" "Yup." One was shooting fentonyl, a potent narcotic painkiller, and the other was delivering babies and stealing all the drugs he could get his hands on. They all had to submit to random urine tests—or they'd never get their licenses back. There was a pilot there who flew a route from England to America. On the day of the flight he was dead drunk and fell out of the truck taking him to the plane he was about to fly. His best friend, thank God, grabbed him and sent him into rehab. Can you imagine what would have happened if he'd taken off and flown the plane bombed out of his mind? That's who I was in rehab with. I decided I'm just going to do it, too—the random urines and whatever. I don't give a fuck. At this stage of the game, you're kind of a little like I will follow the program wherever it takes me, I will do whatever it is to get through this.

I knew that after the first month in rehab that my not calling anybody in the band was really fucked up. It was one thing for those suck-asses to not call me for twenty-seven weeks; it was quite another thing when I didn't call them, because when you're in rehab, you look at your own side of the street. It was then that I realized that I loved the band, regardless of a guitar player that's a loose canon and doing a solo record and angry at me for doing stuff he'd done half a dozen times himself. And suddenly I'm Peck's Bad Boy? There's the pot calling the kettle beige.

After I'd been there two months I was told I could go home for a week, which I did. . . . I had a meeting with the band, at which time I begged their forgiveness and sincerely apologized for my behavior. Looking around the room I realized that although we had all allegedly gotten sober in the late eighties, some of us didn't exactly stay with the program. Some of us never did get sober. I did, Joey followed . . . but not everybody cleaned up and that's the sad truth. Naturally I'm always the identified patient. If you get Steven sober, then you'll have a band. You need the lead singer, you can't lose him! I begged their dodgy forgiveness and said, "Let's go out on tour when I get out of Betty Ford."

When I got out of rehab, that day on the fifteenth of March, there was a song that needed to be written for a million dollars. The next day and the day after that I'm writing that song with Marti Frederiksen and Kara DioGuardi who was the judge from *American Idol*. We came up with a great song called "Love Lives" for a Japanese movie called *Space Battleship Yamato*.

Then we're on tour again. After a month of rehearsing, we hit Caracas, Venezuela, May 18, 2010. "Caracas of Your Assus" was the running joke. And it was one of the best tours we'd ever

done. It was a bit ironic and a thorn in my side, but not worth getting angry over after spending three months in rehab, that I came back to a band where someone was still using. I don't give a fuck. I live for this band, but the world needs to know.

South America, Europe, the United States.... Where are we going to go with this? Oh yeah, Caracas of Your Assus . . . Some of the districts there were beyond the Third World, they were more like the Fourth World. They were selling incense and papaya, goat's heads, sugar skulls, and monkey meat . . . anything you can imagine. While I was there I went downtown to the area where they used to torture people, looking for an AA meetingmy own personal inquisition. Where is it? ¿Donde es? Oh, it's up there. You climb up the spiral steps of this building in the middle of downtown. It was the old hellhole jail . . . and you walk into the interrogation room-that will sober you right up fast-that's where all the bad shit happened . . . and it's an AA meeting. Two fucking hours. Drinking nothing but black coffee with tons of sugar in it in these little plastic cups. Not one word did I understand, but I picked up on their passion. They were doing Caracas drugs: opium, heroin, drinking....

When we go on tour to a new place, I like to get to each gig two nights ahead of the band 'cause I like to walk around, get a feel for the town, and get a good night's rest before the first show. I brought a sober companion with me, Chappy, one of the stars on *Brotherhood*—very funny guy at the beginning of the series with a huge cock, I mean clock . . . dock.

The J. Geils Band tried to throw their lead singer, Peter Wolf, out, too. I had had a nice long talk with him. I said, "These fucking guys, they're trying to find a new lead singer because I'm in rehab, can you believe that? While I'm down on my knees, at my lowest ebb, what do I find? My old band of brothers is auditioning lead singers to replace me . . . as if that were even possible! Forty fucking years of brotherly love, knockdown fights and drug hoarding . . . did that mean nothing to them? And now they want to replace me . . . and all because I fell off a stage.

The exact same thing Joe Perry's done five times before I did it. Wait, wait! I need a witness, can I get a witness? Isn't that why they called us the Toxic Twins, because of . . . ?" Peter Wolf looked at me like Mr. Natural saying, "What else is new?"

June 29, 2010. We were on tour in France, when Kara Dio-Guardi texted me asking if I've ever thought about being a judge on *American Idol*, because apparently she didn't want to continue doing it. I didn't know. Like a dummy, I went, "Does it still have high ratings?" She's going, "Oh, yeah!" So I said, "Well, I'll get back to you."

Early July I'm on a plane coming back from England to start the American leg of the tour and there's an in-flight movie called the *Back-up Plan* playing. There'd already been rumors and grumblings about my doing *American Idol*. My own internal interrogator is going, "Can you do it, Steven? Do you want to do it, lad?" I said, "You know, yeah, I do."

Three weeks later, we're getting ready to begin the American tour down in Florida. And that's when I said, "You know, I'm just gonna fucking do it." And I signed the papers. I hadn't told the band yet.

When we get to Vegas, Joe barges into my dressing room and accosts me: "What the fuck's going on?" And I, all innocent, said, "What?" "Well, how come I'm finding out about this in the press? Why didn't you tell me?" And I say, "Well, c'mon man, two months ago you were trying to throw me out of the band, so I got myself a job, that way I've got something steady while you guys are trying to figure out what you want to do." It's all water under the bridge now. It's all this bullshit that happens because bands' wives get to talking to the guys in the band. When we're onstage, none of that shit's there. But when they're off the road, their wives start pecking them to death.

The day I came out of rehab is the day the rest of the band should have gone in. Nevertheless, the tour was beyond successful and we end up August 15, 2010, at Fenway Park on a double bill blowout with J. Geils—twin bad boys from Boston—selling

out the stadium. The last show on the tour was September 16 in Vancouver, and then . . .

Next stop: *American Idol.* Hey, like my dad said, make sure you have something to fall back on in case your day job doesn't pan out. And, boy, what a day job I got!

CHAPTER SEVENTEEN

TAKE A WALK INSIDE MY MIND . . .

h, yes, it was the best of rhymes it was the worst of rhymes....

I've been mythicized, Mick-icized, Eulogized and fooligized, I've been Cole-Portered and farmer's-daughtered, I've been Led Zepped and twelve-stepped.

I'm E to the Z ew tweedle-dee, I'm a rhyming fool that weren't learned in no school—me, Fritz the Cat, and Mohair Sam are the baddest cats....What *is* what *am*.

Every time that I look in the mirror All these lines on my face getting clearer The past is gone It went by like dusk to dawn Isn't that the way Everybody's got their dues in life to pay

373

"Dream On"—I wrote that when I was seventeen, and sometimes I feel like that young kid, this seventeen-year-old who just wormholed himself into this sixty-year-old man. The voice seems fine, but then there's my feet, my knee, and my throat. But when I hit the stage, something miraculous happens. I go on tour and after a month I turn into Peter-fucking-Pan. The band is my happy thought and then I get my wings again. It's my fountain of youth. I get so strong from the workout that I'm zapped back into being a twenty-year-old. And it's not that I *feel* that way, but it *is* that I *am* that way.

Janis, Jimi, Jim Morrison, Keats, and Brian Jones, didn't they all die at twenty-six or twenty-seven? It's that weird doomed age. And I always wondered, since we all shared the same lifestyle, would I live past that glorious age. And guess what? I've been lucky; I've lived long past that. I was born on March 26, so I always wondered what I'd look like when I was twenty-six. It's funny, when I was a teenager and way before Aerosmith, I would dry my hair after a shower with a blow-dryer and search for my face in the foggy mirror—because I couldn't see my reflection. ... I aimed the dryer at the clouded glass. There I was at ninety, and then the slow melt back to nineteen ... "Every time that I look in the mirror" Gee ... sounds familiar! But the singer didn't arrive until the song was written. Life is like a roll of toilet paper, the closer it gets to the end, the faster it goes.

Erin and I were sitting on the lawn in Sunapee, New Hampshire, one morning and the phone rang. It was Billy Joel. He asked me if I'd like to play the final show that Shea Stadium would ever see. I told him I saw the Beatles there in 1965 and that I'd love to do it. He sent a plane for us and we were on our way. Jump to . . . I'm backstage in my dressing room when Billy Joel walks in, saying his hellos. He introduces me to Tony Bennett, who to me is a god . . . second only to Frank Sinatra. . . . and I'm sharing a dressing room with him. HUDDA THUNK? Tony then introduces me to his son who asks me, "Do you know whose jacket this is?" It's in my dressing room so I'm thinking,

it gotta be mine, but no, I tell him, "It reeks of Sgt Pepper." At which time he says, "Yeah, and it's Ringo's . . ."And he lets me try it on. Turns out, he's one of the largest collectors of Beatles memorabilia in the history of memory. So, here I am, sixty days sober, sixty years old, sixty thousand people in the audience and in the house. . . . Sir Paul fucking McCartney, as the extra special guest, flown in from London that evening, who's closing the show with "I Saw Her Standing There." Forty-three years since I heard the Beatles open up with that at the same stadium back in 1965. We flew back to Sunapee that night and sitting out on the lawn in the dark, the same lawn where we had been that morning, I asked myself, "What just happened, what did I just do?" Living on the tail of a comet, it's all so fast. It's such an age of supersonic travel, transcendental or otherwise, and instant everything that life can become a blur for me.

When we tour we often hub in Minneapolis, fly to Detroit after that . . . and two hours later we're back in the same hotel, hitting the sheets by four and thinking, "Where were we tonight?" When you rattle it back and forth . . . memories of what *that* tour was like, it all blends together: plane, limo, lobby, backstage, encore, limo, lobby, dressing room, plane. It's just a big fucking *blurrrrr*.

Sometimes it feels like . . . all I'm doing is rearranging deck chairs on the fucking *Titanic*. And then I wonder why I don't dream anymore—my subconscious must be saturated.

What I've seen, faces that remind me of faces, places that remind of other places I've never even been to yet . . . It's just another example of vooja de. I could talk to you forever about the people I've met in the shadows of time, in the vibrations between musical fifths, even in the spaces between the words you're reading right now. But when I zero in, things come into focus. When I went back and looked at my yearbook, seems like everybody I ever knew was there in those twenty small pages. Different people maybe, but then one tends to morph into another. Those forty or fifty kids in your graduating class, you never thought their faces would bleed into the future. . . . And so now I realize after peering into my own yearbook that the guy who was sitting next to me in wood shop looks exactly like the president of Sony. Where am I going with this? Whatever happened to a good melody? Maybe to be the headline speaker at the Alzheimer's convention with speech in hand . . . to an empty house that forgot how to get there. . . . Gasp! Only to wake up in front of President Obama, Oprah, and Paul McCartney singing the last four songs of "Abbey Road" at the 2010 Kennedy Awards. And you tell me I'm not living the dream.

One day, after my mom had passed, my dad sent me an e-mail which said: "Don't wait until it's the last minute to make the phone call. And use one of the quarters I gave you for these calls as a kid." So I wrote him this little poem:

Once upon a dime I felt so alone, So I first made a call on the last pay phone; Something so strange inside of me stirred, So I knew I'd be the first to get the last word. I screamed "Oh, Lordy, is this my time? I feel like the first at the back of the line. So it's all your fault and it seems to me, I was on the last pay phone in NYC."

Along with everything else that's happened, life is good. And I've learned that if I shoot an arrow of truth, I must first dip its point in honey. I've learned the ancient lesson of apology— OWN IT. It puts out every fire you may have walked through in life. People, too, often miss the silver lining because they were expecting gold. I've seen the sun go down only to be swallowed by the ocean! Only to rise again in the morning.

I fell in love with Bebe Buell, and on July 1, 1977, my first baby Liv arrived. I married Cyrinda Foxe, and soon Mia was born on December 22, 1978. Then I married Teresa, and along

STEVEN TYLER

came Chelsea, and two years later my man child, Taj, was born. Fatherhood changed me forever. I wept when I heard Chelsea sing in kindergarten. I burst with pride when Taj graduated high school. My heart broke from the honesty that Mia put in her book. And how Liv dazzles me in her movies. . . . And now I'm ever so humbled by the way she loves Milo.

Some of the marriages weren't so happy for everyone, but most of the times we had were great. There wasn't a woman that I had a child with that I didn't love, but there were always two trains running: my family, my band. Sometimes toward each other and other times away. And a lot of the women in my life couldn't understand that. Seems like the light at the end of the tunnel may be you. You write a song with somebody, and it's like having a child with them. . . . The songs are my spirit children. You're evoking the spirits, conjuring up moments in time, ephemeral seconds where you hear that O YEAH sound in your head and catch the scat on the wing. Or it's gone.

I now live in Laurel Canyon. I can't believe I live where all my idols once lived, the very houses I'd drive by and wonder what fantastic scenes were going down in there. Jim Morrison lived one house down from me, Mama Cass three doors away, Chris Hilman of the Byrds two houses away from her, Frank Zappa and the GTO's, Joni Mitchell and Carole King lived across the street from the guys in Buffalo Springfield, John Mayall, the magus of the Bluesbreakers lived there briefly, as did Jimi Hendrix in Errol Flynn's old house.

It's hard to tell who I am by the trail left by my musical career. I am the Demon of Screamin', the dude that looks like a lady, the rag doll that married Lucy in the Sky. But I'm also something more than the rock 'n' roll junky whore who got his foot inside the door. Sure, we're the sum of our experiences. If you listen to that song I wrote in 1969, "Dream On," you might get a different view. I may not have been quite sure of what I was doing, but I was on to something. Just sayin'....

ACKNOWLEDGMENTS

Aeroforce One, Robert Agriopoulos, Arthur & Pats-Dee and Artie, Peter Augusta, Amanda Ayre, Ken Backman, Kevin Baldes, Richi and Moe Balsbaugh, Jobete Baptista, Frank and Helen Barrick, Jeff Barrow, Roderick Bates, Beechy, Debbie Benson, Michel Berandi, John Bionelle, Uncle Eddie Blancha, Sandy Blancha, Scott Blancha, Todd Blancha, Kelly Blancha, Aunt Sonja Thomas, Holly Thomas, Felix Blancha, Grandma Bess, The Blue Army, Bert Bodel, Mike Boschetti, Charles Boyd, Erin Brady, Terry Brady, Judy Brady, Steve Brady, Els Brady, Jerry Bruckheimer, Bebe Buell, Helen Burnett, Andrew Caster, Roberto Cavalli, Kevin "Chappy" Chapman, Ellen Chiquita, Christine Ciavarro, Lauren Cohen, Meghan Cole, Tanner Cole, Kiley Cole, Derick Cole, Frank Connolly, Eileen Cope, Jimmy Crespo, David Dalton, Coco Pekelis Dalton, Mike Darnell, Clive Davis, Stephen Davis, Paul Deluca, Johnny Depp, Mark Dirico, Lisa Dirico, Jack Douglas, Rick Dufay, Dennis Dunn, Ralph Eaves, Jim Ebdon, Jill Elsworth, Peter Emspack, Steve Erle, Jimmy Eyers, James Eyers, Lisa Fasano, Randle Feagin, Tony Fedewa, Rich Feldstein, Virginia Fernando, Josh Flaherty, Mick Fleetwood, Betty Ford Center, Sylvia Fortune, Cyrinda Foxe, Jeff Frasco, Marti Frederiksen, Lonn Friend, Cecile Frot-Coutaz, Chris Furlong, Frank Gangi, Keith Garde, Julia Halcomb, Ross Halfin, Anita Hall, Cheryl Hall, Daniel Halpern, Tom Hamilton, Bob &

Donna Hansen, Dick "Rabbit" Hansen, Apple Mike Harnois, Matt Harrell, Matthew Hasz, Deron, Christy and Iris Hasz, Julia Hasz, Johnny Hertsberg, The Hoffman School, Abigail Holstein, Marko Hudson, David Hull, Donny Inner, Russ Irwin, Randy Jackson, Elton John, Brad "Burt" Johnson, Dorothea Johnson, Robin Joseph, Bob "Kelly" Kelleher, Denise Kirby, Gene Kirkland, Josh Klemme, Allen Kovac, Joey Kramer, Linda Kramer, April Kramer, Julia and Spiro Koulouris, Lenny Kravitz, David Krebs, Mike Ladge, Jonny Lang, Dina LaPolt, Francine Larness, Don Law, Lee Leipsner, Steve Lieber, Ruth Lonshay, Jennifer Lopez, Marc Anthony, Bruce Lundvall, Nigel Lythgoe, Billy Macdonald, Melissa Mahoney, Kenneth Malament, Andy Martel, Rick & Teresa Maston, Robert Matheu, Augie Mazella, Kevin Mazur, Paul McCartney, Brian McKeon, Truly Mean, Sabrina Ment, Pete Merrigan, Jay Messina, Larry Mestel, Ed Milano, Mike and Gail Milian, Justin Murdock, Guy Napolitana, 5610 Neatherland Avenue, Willy Nelson, Marc Nevins, Magee, Heidi and Jeff North, Aaron Notarianni, Johnny O'Toole, Stevie Panaminto, 100 Pembrook Drive, Joe Perry, Billie Perry, Adrian Perry, Aaron Perry, Tony Perry, Roman Perry, Keren Pinkas, Jeff Plourde, Stephanie Pohl, Lisa Queen, Robyn Quivers, Michael Rees, Peter Rice, Loree Rodkin, Ron Ross, Carlos Santana, Paul Santo, Ryan Seacrest, Barry Shapiro, Eric Sherman, Sherry & Philip, Lynn Small, Chris Smith, Henry Smith, Kari Smith, Don Solomon, Liz Stahl, Peter Stahl, Laurie and Richard Stark, Howard Stern, Alan Stohmayer, Rorie Suda, Joseph Sugarman, Richie Supa, Ray Tabano, Susan Tabano, Tommy Tabano, Lucy Tabano, Victor Tallarico (Dad), Lynda Tallarico, Liv Tyler, Mia Abigail Tyler Tallarico, Chelsea Tyler Tallarico, Taj Tallarico, Milo Langdon, Uncle Ernie Tallarico, Laura Tallarico, Aunt Phyllis Tallarico, Teresa Tallarico, Giovanni Tallarico, Pasquale Tallarico, Dominic Notarangelo, Ray Taviccio, Casey Thighbolt, Dutch & Boone Thighbolt, Simonida Tomovic, Emanuel "Bisou Bisou" Tomovic, Jim Vallance, Elizabeth Vargas, Heidy Vaquerano, Diane Warren, Ken Warwick, Jimmy Weiss, Hannah Williams, Brad Whitford, Kim Whitford, Donny Whitman, Debra Whitman, Tori Whitman, Steven Zeitels.

PERMISSIONS

"Adam's Apple" Words and Music by Steven Tyler. Copyright © 1975; Renewed 2004 Music Of Stage Three (BMI). Worldwide Rights for Music Of Stage Three Administered by BMG Rights Management (US) LLC. International Copyright Secured. All Rights Reserved.

"Ain't That a Bitch" Words and Music by Steven Tyler, Joe Perry and Desmond Child. Copyright © 1997 EMI APRIL MUSIC INC., SWAG SONG MUSIC, INC. and DESMOBILE MUSIC CO., INC. All Rights Controlled and Administered by EMI APRIL MUSIC INC. All Rights Reserved. International Copyright Secured. Used by Permission.

"Back in the Saddle" Words and Music by Steven Tyler and Joe Perry. Copyright © 1976, Renewed 2005 Music Of Stage Three (BMI). Worldwide Rights for Music Of Stage Three Administered by BMG Rights Management (US) LLC. International Copyright Secured. All Rights Reserved.

"Bright Light Fright" Words and Music by Joe Perry. Copyright © 1980 Music Of Stage Three (BMI). Worldwide Rights for Music Of Stage Three Administered by BMG Rights Management (US) LLC. International Copyright Secured. All Rights Reserved.

"Cryin" Words and Music by Steven Tyler, Joe Perry and Taylor Rhodes. Copyright © 1993 EMI APRIL MUSIC INC., DEMON OF SCREAMIN' MUSIC PUBLISHING, JUJU RHYTHMS, UNIVER-SAL MUSIC CORP. and T. RHODES SONGS. All Rights for DEMON OF SCREAMIN' MUSIC PUBLISHING and JUJU RHYTHMS Controlled and Administered by EMI APRIL MUSIC INC. All Rights for T. RHODES SONGS Controlled and Administered by UNIVERSAL

PERMISSIONS

MUSIC CORP. All Rights Reserved. International Copyright Secured. Used by Permission.

"Deuces Are Wild" Words and Music by Steven Tyler and Jim Vallance. Copyright © 1993, 1994 EMI APRIL MUSIC INC., DEMON OF SCREAMIN' MUSIC PUBLISHING, ALMO MUSIC CORP. and TESTATYME MUSIC. All Rights for DEMON OF SCREAMIN' MUSIC PUBLISHING Controlled and Administered by EMI APRIL MUSIC INC. All Rights for TESTATYME MUSIC Controlled and Administered by ALMO MUSIC CORP. All Rights Reserved. International Copyright Secured. Used by Permission.

"Devil's Got a New Disguise" Words and Music by Diane Warren, Steven Tyler and Joe Perry. Copyright © 2006 REALSONGS (ASCAP), EMI APRIL MUSIC INC., DEMON OF SCREAMIN' MUSIC PUB-LISHING, and JUJU RHYTHMS. Exclusive Worldwide Print Rights for REALSONGS (ASCAP) Administered by ALFRED MUSIC PUB-LISHING CO., INC. All Rights Reserved. Used by Permission. All Rights for DEMON OF SCREAMIN' MUSIC PUBLISHING and JUJU RHYTHMS Controlled and Administered by EMI APRIL MUSIC INC. All Rights Reserved. International Copyright Secured. Used by Permission.

"Don't Want to Miss a Thing" Words and Music by Diane Warren. Copyright © 1997 REALSONGS (ASCAP). Exclusive Worldwide Print Rights Administered by ALFRED MUSIC PUBLISHING CO., INC. All Rights Reserved. Used by Permission.

"Draw the Line" Words and Music by Steven Tyler and Joe Perry. Copyright © 1980 Music Of Stage Three (BMI). Worldwide Rights for Music Of Stage Three Administered by BMG Rights Management (US) LLC. International Copyright Secured. All Rights Reserved.

"Dream On" Words and Music by Steven Tyler. Copyright © 1973; Renewed 2001 Music Of Stage Three (BMI). Worldwide Rights for Music Of Stage Three Administered by BMG Rights Management (US) LLC. International Copyright Secured. All Rights Reserved.

"Dude (Looks Like a Lady)" Words and Music by Steven Tyler, Joe Perry and Desmond Child. Copyright © 1987 EMI APRIL MUSIC INC., DEMON OF SCREAMIN' MUSIC PUBLISHING, JUJU RHYTHMS and UNIVERSAL—POLYGRAM INTERNATIONAL PUBLISH-ING, INC. All Rights for DEMON OF SCREAMIN' MUSIC PUB-LISHING and JUJU RHYTHMS Controlled and Administered by EMI APRIL MUSIC INC. All Rights Reserved. International Copyright Secured. Used by Permission. "Everything's OK" © 1950 Sony/ATV Music Publishing LLC. All rights administered by Sony/ATV Music Publishing LLC, 8 Music Square West, Nashville, TN 37203. All rights reserved. Used by permission.

"Falling in Love (Is Hard On the Knees)" Words and Music by Steven Tyler, Joe Perry and Glen Ballard. Copyright © 1997 EMI APRIL MUSIC INC., DEMON OF SCREAMIN' MUSIC PUBLISHING, JUJU RHYTHMS, UNIVERSAL MUSIC CORP. and AEROSTATION CORPORATION. All Rights for DEMON OF SCREAMIN' MUSIC PUBLISHING and JUJU RHYTHMS Controlled and Administered by EMI APRIL MUSIC INC. All Rights for AEROSTATION CORPORATION CORPORATION CORPORATION CORPORATION CORPORATION CORPOLITION. All Rights for AEROSTATION CORPORATION CORPORAT

"Fever" Words and Music by Steven Tyler and Joe Perry. Copyright © 1993 EMI APRIL MUSIC INC. and SWAG SONG MUSIC, INC. All Rights Controlled and Administered by EMI APRIL MUSIC INC. All Rights Reserved. International Copyright Secured. Used by Permission.

"Full Circle" Words and Music by Steven Tyler and Taylor Rhodes. Copyright © 1997 EMI APRIL MUSIC INC., SWAG SONG MUSIC, INC., MCA MUSIC PUBLISHING, A Division of UNIVERSAL STU-DIOS, INC. and T RHODES SONGS. All Rights for SWAG SONG MUSIC, INC. Controlled and Administered by EMI APRIL MUSIC INC. All Rights for T RHODES SONGS Controlled and Administered by MCA MUSIC PUBLISHING, A Division of UNIVERSAL STU-DIOS, INC. All Rights Reserved. International Copyright Secured. Used by Permission.

"Hole in My Sole" Words and Music by Steven Tyler, Joe Perry and Desmond Child. Copyright © 1996, 1997 EMI APRIL MUSIC INC., SWAG SONG MUSIC, INC. and DESMOBILE MUSIC CO., INC. All Rights Controlled and Administered by EMI APRIL MUSIC INC. All Rights Reserved. International Copyright Secured. Used by Permission.

"Jaded" Words and Music by Steven Tyler and Marti Frederiksen. Copyright © 2001 EMI APRIL MUSIC INC., DEMON OF SCREAMIN' MUSIC PUBLISHING, EMI BLACKWOOD MUSIC INC. and PEARL WHITE MUSIC. All Rights for DEMON OF SCREAMIN' MUSIC PUBLISHING Controlled and Administered by EMI APRIL MUSIC INC. All Rights for PEARL WHITE MUSIC Controlled and Administered by EMI BLACKWOOD MUSIC INC. All Rights Reserved. International Copyright Secured. Used by Permission.

"Janie's Got a Gun" Words and Music by Steven Tyler and Tom Hamilton.

Copyright © 1989 EMI APRIL MUSIC INC., DEMON OF SCREAMIN' MUSIC PUBLISHING and SHACK IN THE BACK MUSIC. All Rights Controlled and Administered by EMI APRIL MUSIC INC. All Rights Reserved. International Copyright Secured. Used by Permission.

"Joanie's Butterfly" Words and Music by Steven Tyler, Jack Douglas and Jimmy Crespo. Copyright © 1982 Music Of Stage Three (BMI) and Stage Three Songs (ASCAP). Worldwide Rights for Music Of Stage Three and Stage Three Songs Administered by BMG Rights Management (US) LLC. International Copyright Secured. All Rights Reserved.

"Kemo-kimo" Words and Music by Dwight Latham, Moe Jaffe and Jack Berch. © 1947 (Renewed 1975) COLGEMS-EMI MUSIC INC. All Rights Reserved. International Copyright Secured. Used by Permission.

"Kings and Queens" Words and Music by Steven Tyler, Jack Douglas, Tom Hamilton, Joey Kramer and Brad Whitford. Copyright © 1980 Music Of Stage Three (BMI) and Stage Three Songs (ASCAP). Worldwide Rights for Music Of Stage Three and Stage Three Songs Administered by BMG Rights Management (US) LLC. International Copyright Secured. All Rights Reserved.

"Kiss Your Past Goodbye" Words and Music by Steven Tyler and Mark Hudson. Copyright © 1997 EMI APRIL MUSIC INC., SWAG SONG MUSIC, INC., UNIVERSAL MUSIC CORP. and BEEF PUP-PET MUSIC. All Rights for SWAG SONG MUSIC, INC. Controlled and Administered by EMI APRIL MUSIC INC. All Rights for BEEF PUPPET MUSIC Controlled and Administered by UNIVERSAL MUSIC CORP. All Rights Reserved. International Copyright Secured. Used by Permission.

"Last Child" Words and Music by Steven Tyler and Brad Whitford, Copyright © 1976; Renewed 2005 Music Of Stage Three (BMI). Worldwide Rights for Music Of Stage Three Administered by BMG Rights Management (US) LLC. International Copyright Secured. All Rights Reserved.

"Lord of the Thighs" Words and Music by Steven Tyler. Copyright © 1974; Renewed 2002 Music Of Stage Three (BMI). Worldwide Rights for Music Of Stage Three Administered by BMG Rights Management (US) LLC. International Copyright Secured. All Rights Reserved.

"Make It" Words and Music by Steven Tyler. Copyright © 1973; Renewed 2001 Music Of Stage Three (BMI). Worldwide Rights for Music Of Stage Three Administered by BMG Rights Management (US) LLC. International Copyright Secured. All Rights Reserved.

"Mama Kin" Words and Music by Steven Tyler. Copyright © 1973; Renewed 2001 Music Of Stage Three (BMI). Worldwide Rights for Music

PERMISSIONS

Of Stage Three Administered by BMG Rights Management (US) LLC. International Copyright Secured. All Rights Reserved.

"Mercedes Benz" By Janis Joplin/Michael McClure/Robert Neuwirth. Copyright © 1970 Strong Arm Music (ASCAP). Admin. by Wixen Music Publishing, Inc. All Rights Reserved. Used by Permission.

"Mia" Words and Music by Steven Tyler. Copyright © 1979 Music Of Stage Three (BMI). Worldwide Rights for Music Of Stage Three Administered by BMG Rights Management (US) LLC. International Copyright Secured. All Rights Reserved.

"Movin' Out" Words and Music by Steven Tyler and Joe Perry. Copyright © 1973; Renewed 2001 Music Of Stage Three (BMI). Worldwide Rights for Music Of Stage Three Administered by BMG Rights Management (US) LLC. International Copyright Secured. All Rights Reserved.

"My Fist Your Face" Words and Music by Steven Tyler and Joe Perry. Copyright © 1985 EMI APRIL MUSIC INC., DEMON OF SCREAMIN'MUSIC PUBLISHING and JUJU RHYTHMS. All Rights Controlled and Administered by EMI APRIL MUSIC INC. All Rights Reserved. International Copyright Secured. Used by Permission.

"Nine Lives" Words and Music by Steven Tyler, Joe Perry and Marti Frederiksen. Copyright © 1997 EMI APRIL MUSIC INC., SWAG SONG MUSIC, INC., EMI VIRGIN SONGS, INC. and PEARL WHITE MUSIC. All Rights for SWAG SONG MUSIC, INC. Controlled and Administered by EMI APRIL MUSIC INC. All Rights for PEARL WHITE MUSIC. Controlled and Administered by EMI VIRGIN SONGS, INC. All Rights Reserved. International Copyright Secured. Used by Permission.

"No More No More" Words and Music by Steven Tyler and Joe Perry. Copyright © 1975; Renewed 2003 Music Of Stage Three (BMI). Worldwide Rights for Music Of Stage Three Administered by BMG Rights Management (US) LLC. International Copyright Secured. All Rights Reserved.

"No Surprize" Words and Music by Steven Tyler and Joe Perry. Copyright © 1979 Music Of Stage Three (BMI). Worldwide Rights for Music Of Stage Three Administered by BMG Rights Management (US) LLC. International Copyright Secured. All Rights Reserved.

"One Way Street" Words and Music by Steven Tyler. Copyright © 1973; Renewed 2001 Music Of Stage Three (BMI). Worldwide Rights for Music Of Stage Three Administered by BMG Rights Management (US) LLC. International Copyright Secured. All Rights Reserved.

PERMISSIONS

"Painted on My Heart" Words and Music by Diane Warren. Copyright © 1999 REALSONGS (ASCAP). Exclusive Worldwide Print Rights Administered by ALFRED MUSIC PUBLISHING CO., INC. All Rights Reserved. Used by Permission.

"Pandora's Box" Words and Music by Steven Tyler and Joey Kramer. Copyright © 1974; Renewed 2002 Music Of Stage Three (BMI). Worldwide Rights for Music Of Stage Three Administered by BMG Rights Management (US) LLC. International Copyright Secured. All Rights Reserved.

"Pink" Words and Music by Steven Tyler, Richie Supa and Glen Ballard. Copyright © 1997 EMI APRIL MUSIC INC., DEMON OF SCREAMIN'MUSIC PUBLISHING, COLGEMS-EMI MUSIC INC., SUPER SUPA SONGS, UNIVERSAL MUSIC CORP. and AEROSTA-TION CORPORATION. All Rights for DEMON OF SCREAMIN' MUSIC PUBLISHING Controlled and Administered by EMI APRIL MUSIC INC. All Rights for SUPER SUPA SONGS Controlled and Administered by COLGEMS-EMI MUSIC INC. All Rights for AERO-STATION CORPORATION Controlled and Administered by UNI-VERSAL MUSIC CORP. All Rights Reserved. International Copyright Secured. Used by Permission.

"Prelude to Joanie" Words and Music by Steven Tyler. Copyright © 1982 Music Of Stage Three (BMI). Worldwide Rights for Music Of Stage Three Administered by BMG Rights Management (US) LLC. International Copyright Secured. All Rights Reserved.

"Push Comes to Shove" Words and Music by Steven Tyler. Copyright © 1982 Music Of Stage Three (BMI). Worldwide Rights for Music Of Stage Three Administered by BMG Rights Management (US) LLC. International Copyright Secured. All Rights Reserved.

"Rats in the Cellar" Words and Music by Steven Tyler and Joe Perry. Copyright © 1976; Renewed 2005 Music Of Stage Three (BMI). Worldwide Rights for Music Of Stage Three Administered by BMG Rights Management (US) LLC. International Copyright Secured. All Rights Reserved.

"Rattlesnake Shake" Lyrics from Rattlesnake Shake by kind permission of Peter Green and Rattlesnake Ltd.

"Reefer Headed Woman" Words and Music by Steven Tyler and Joe Perry. Copyright © 1979 Music Of Stage Three (BMI). Worldwide Rights for Music Of Stage Three Administered by BMG Rights Management (US) LLC. International Copyright Secured. All Rights Reserved.

"Rehab" Words and Music by Amy Winehouse. Copyright © 2006 EMI MUSIC PUBLISHING LTD. All Rights in the U.S. and Canada Controlled and Administered by EMI BLACKWOOD MUSIC INC. All Rights Reserved. International Copyright Secured. Used by Permission.

"Same Old Song and Dance" Words and Music by Steven Tyler and Joe Perry. Copyright © 1974; Renewed 2002 Music Of Stage Three (BMI). Worldwide Rights for Music Of Stage Three Administered by BMG Rights Management (US) LLC. International Copyright Secured. All Rights Reserved.

"Seasons of Wither" Words and Music by Steven Tyler. Copyright © 1974; Renewed 2002 Music Of Stage Three (BMI). Worldwide Rights for Music Of Stage Three Administered by BMG Rights Management (US) LLC. International Copyright Secured. All Rights Reserved.

"Sedona Sunrise" Words and Music by Steven Tyler, Joe Perry and Jim Vallance. Copyright © 2006 EMI APRIL MUSIC INC., DEMON OF SCREAMIN' MUSIC PUBLISHING, JUJU RHYTHMS and SOME GUY SONGS. All Rights Controlled and Administered by EMI APRIL MUSIC INC. All Rights Reserved. International Copyright Secured. Used by Permission.

"Sick As A Dog" Words and Music by Steven Tyler and Tom Hamilton. Copyright © 1976; Renewed 2005 Music Of Stage Three (BMI). Worldwide Rights for Music Of Stage Three Administered by BMG Rights Management (US) LLC. International Copyright Secured. All Rights Reserved.

"Sweet Emotion" Words and Music by Steven Tyler and Tom Hamilton. Copyright © 1975; Renewed 2003 Music Of Stage Three (BMI). Worldwide Rights for Music Of Stage Three Administered by BMG Rights Management (US) LLC. International Copyright Secured. All Rights Reserved.

"Taste of India" Words and Music by Steven Tyler, Joe Perry and Glen Ballard. Copyright © 1997 EMI APRIL MUSIC INC., SWAG SONG MUSIC, INC., UNIVERSAL MUSIC CORP. and AEROSTATION CORPORATION. All Rights for SWAG SONG MUSIC, INC. Controlled and Administered by EMI APRIL MUSIC INC. All Rights for AEROSTATION CORPORATION Controlled and Administered by UNIVERSAL MUSIC CORP. All Rights Reserved. International Copyright Secured. Used by Permission.

"The Farm" Words and Music by Steven Tyler, Joe Perry, Stephen Dudas and Mark Hudson. Copyright © 1997 EMI APRIL MUSIC INC., SWAG SONG MUSIC, INC., UNIVERSAL MUSIC CORP., BEEF PUPPET MUSIC and DO DIS MUSIC. All Rights for SWAG SONG MUSIC, INC. Controlled and Administered by EMI APRIL MUSIC INC. All Rights for BEEF PUPPET MUSIC and DO DIS MUSIC Controlled and Administered by UNIVERSAL MUSIC CORP. All Rights Reserved. International Copyright Secured. Used by Permission.

"The Reason A Dog" Words and Music by Steven Tyler and Tom Hamilton. Copyright © 1985 EMI APRIL MUSIC INC., DEMON OF SCREAMIN' MUSIC PUBLISHING and SHACK IN THE BACK MUSIC. All Rights Controlled and Administered by EMI APRIL MUSIC INC. All Rights Reserved. International Copyright Secured. Used by Permission.

"The Sun" Words and Music by STEVEN TYLER, BARRY SHAP-IRO, DON SOLOMON, PETER STAHL and AL STOHMAYER. Copyright © 1966 (Renewed) WARNER-TAMERLANE PUBLISHING CORP. and WB MUSIC CORP. Exclusive Print Rights Administered by ALFRED MUSIC PUBLISHING CO., INC. All Rights Reserved. Used by Permission.

"Toys In The Attic" Words and Music by Steven Tyler and Joe Perry. Copyright © 1975; Renewed 2003 Music Of Stage Three (BMI). Worldwide Rights for Music Of Stage Three Administered by BMG Rights Management (US) LLC. International Copyright Secured. All Rights Reserved.

"Uncle Salty" Words and Music by Steven Tyler and Tom Hamilton. Copyright © 1975; Renewed 2003 Music Of Stage Three (BMI). Worldwide Rights for Music Of Stage Three Administered by BMG Rights Management (US) LLC. International Copyright Secured. All Rights Reserved.

"Walk This Way" Words and Music by Steven Tyler and Joe Perry. Copyright © 1975; Renewed 2003 Music Of Stage Three (BMI). Worldwide Rights for Music Of Stage Three Administered by BMG Rights Management (US) LLC. International Copyright Secured. All Rights Reserved.

"Working Class Hero" © 1970 Sony/ATV Music Publishing LLC. All rights administered by Sony/ATV Music Publishing LLC, 8 Music Square West, Nashville, TN 37203. All rights reserved. Used by permission.

Lines from *Two and a Half Men*, Season 4, Episode 2. Story by Chuck Lorre & Lee Aronson, Teleplay by Don Foster & Eddie Gorodetsky; Created by Chuck Lorre & Lee Aronson.

Kahlil Gibran, excerpts from "On Children" and "On Clothes" from *The Prophet*. Copyright 1923 by Kahlil Gibran and renewed 1951 by the Administrators CTA of the Kahlil Gibran Estate and Mary G. Gibran. Used by permission of Alfred A. Knopf, a division of Random House, Inc.

Kahlil Gibran, excerpt from *A Tear and a Smile*. Copyright 1950 and renewed 1977 by Alfred A. Knopf, Inc. Used by permission of Alfred A. Knopf, a division of Random House, Inc.

Review of Aerosmith. Creem Magazine, 1973. Used with Permission.

INDEX

AC/DC, 196, 209 Academy Awards, 301 Academy of Music, 43, 104, 105 Aerosmith, 9, 45, 61, 63, 66, 80, 86, 89, 91, 93-95, 98, 100, 103, 106, 108, 109, 112, 113, 115, 117-19, 121, 122, 139, 146-47, 151, 155, 157, 166, 171, 181, 185, 194-96, 198, 201, 211, 212, 217, 225, 231-34, 239, 248, 252, 253, 263, 266, 277, 301, 303, 308, 311, 326, 327, 332, 341, 342, 351, 358, 359, 360, 364, 367, 373 "Ain't That a Bitch," 287, 308 AIR Studios, 190 "All Is Loneliness," 48 "All for the Love of a Girl," 33 Allman Brothers band, 140 "Amazing," 214 American Idol (TV show), 138, 368, 370, 371 "Angel," 242, 248 The Animals, 43, 45, 69, 87, 157 Apostolic Studios, 58 Apple Records, 60 The Association, 65 Atlantic Records, 112 Ayre, Amanda, 363 Bachman-Turner Overdrive, 154

"Back in the Saddle," 175, 177 Back in the Saddle tour, 239 Band of Gypsys, 110 Baptista, Joe, 217, 218 The Barn, 29-30, 40, 42, 54, 77,94 Barrick, Teresa. See Tallarico, Teresa Barrick Beach Boys, 39, 59, 60, 127 Beatles, 9, 33, 38, 45, 52, 60, 64, 89, 97, 101, 107, 115, 117, 149, 157, 163, 175, 199, 200, 265, 267, 276, 308, 373, 374 Bell Notes, 53 Benson, Debbie, 30, 49, 51,52 Betty Ford Center, 225, 366, 367, 368 Big Brother and the Holding Company, 48 "Big Ten Inch Record," 164-65 Black Sabbath, 75, 145 Blancha, Eddie, 357 Bloodwyn Pig, 87, 115 Bluesbreakers, 376 "Bone to Bone," 213, 216 Bradford St. Holmes band, 219Brady, Erin, 225, 252, 254, 261, 327, 330, 334, 335, 345, 347, 348, 351, 355, 358, 361, 364, 366, 373 Bruckheimer, Jerry, 294 Buell, Bebe, 180, 181, 202,

218, 375

Buffalo Springfield, 376 The Byrds, 47, 53, 54, 61, 357, 376

Cactus band, 107 The Cenacle, 184, 185, 187, 188, 190 Central Intelligence Agency (CIA), 206 Chain Reaction band, 21, 42, 61, 62, 63, 75, 164, 326, 357 Cheap Trick band, 182 "Cheesecake," 213 "Chip Away the Stone," 214 "Chiquita," 213 Click Horning band, 123 Collins, Tim, 232-36, 239, 253, 266, 268, 274, 276-81, 283, 289, 291 Columbia Records, 112, 113, 173, 175, 214, 215 Connally, Frank, 107, 112, 113, 120, 156 Counting Crows band, 78 Cream band, 116 Credence Clearwater Revival, 98 Crespo, Jimmy, 211, 213, 215, 219, 222, 225, 229 "Critical Mass," 185 "Cryin'," 271, 298

The Dantes, 53, 66 "Dark Is the Bark," 58 Date Records, 60 Dave Clark Five, 46

INDEX

Davis, Clive, 112, 113 Deep Purple, 75, 184 Desmond, Child & Rouge, 244 "Deuces Are Wild," 273 "Devil's Got a New Disguise," 293-94 Dirico, Lisa, 172, 224, 227, 262 Dirico, Mark, 316, 361 Done with Mirrors album, 228 The Doors, 50 Douglas, Jack, 152, 174, 175, 176, 177, 184, 185, 189, 190, 219, 221-22, 290 "Draw the Line," 188 Draw the Line album, 186, 189, 190, 192, 198 "Dream On," 10, 44, 93, 106, 113-14, 115, 117, 120-21, 124, 125, 126, 128, 131, 263, 276, 305, 342, 354, 373, 376 Dream On (Buell), 202 "Dude (Looks Like a Lady)," 242, 243, 244 Dufay, Rick, 219, 222, 225, 229 Dunn, Dennis, 1 Edgar Winter Band, 104 Elvin Bishop Group, 155 Everly Brothers, 33, 74, 82,97 Federal Bureau of Investigation (FBI), 42, 206 "Fever," 269 Fleetwood Mac, 78, 87, 93 Foreigner, 199 Fox Chase band, 72 Foxe, Cyrinda. See Tallarico, Cyrinda Foxe Freddie and the Dreamers, 45 Frederiksen, Marti, 287, 313, 368 The Fugs (band), 87 "Full Circle," 286 Geffen Records, 244 Get a Grip album, 266, 269, 271

Get Your Wings album, 144-45, 151, 153

The Glitter Queen, 145, 146 "Got to Get You into My Life," 115 Grab Your Ankles tour, 207 Grateful Dead, 89, 187 Greatest Salesman in the World (Mandino), 363 Guess Who, 87, 145 Guitar Hero (video game), 340-41, 342, 343 Guns'N' Roses, 351 Halfin, Ross, 336 Hamilton, Terri, 209-10 Hamilton, Tom, 16, 77, 88, 91, 94, 108, 113-14, 131, 158, 167, 168, 187, 189, 210, 215, 222, 237, 239, 249, 269, 270, 283, 284, 285, 289, 290, 335, 336, 360 Hansen, Dick "Rabbit," 188, 200, 207 Hawkwind band, 145 Heart, 199 "Heart's Done Time," 242 Hells Angels, 108, 144 Hendrix, Jimi, 49, 58-59, 67, 68, 99, 107, 110, 115, 312, 362, 373, 376 The Highwaymen, 53 Hoffman School, 24, 25 The Hog Farm, 65 "Hole in My Soul," 168, 284, 285 Hollywood Vampires band, 275 The Hookers band, 97, 98 Hudson, Mark "Marko," 114, 154, 265-66, 275-76, 287, 364 Hull, David, 110 Humble Pie, 104 Huxley, Aldous, 9, 66, 150 "I Don't Want to Miss a

Thing," 125, 292, 293, 294, 295, 296, 297, 298, 299, 301

Intermedia Sound/Studios, 99, 103, 116 Isley Brothers, 116

J. Geils Band, 369, 371 "Jaded," 132, 313, 314

Jagger, Mick, 44, 45, 47, 66, 70, 80, 82, 99, 100, 115, 266, 312, 326 The Jam Band, 77, 94 "Janie's Got a Gun," 248 Jay and the Americans, 62 Jerett, Elyssa. See Perry, Elyssa Jerett "Joanie's Butterfly," 222, 223 Joe Perry Project band, 219,233 John, Elton, 9, 184 John Fred and His Playboy Band, 70 Jones, Brian, 45, 49, 50, 59, 62,373 Joplin, Janis, 2, 38-39, 46, 48, 66, 70, 80, 307, 312, 373 Journey, 209 Just Push Play album, 89, 313, 314 Kalodner, John, 244, 270, 271, 272, 273, 293, 294 Kansas band, 155 Kelleher, Robert "Kelly," 119, 133-34, 147, 154, 160, 165, 166, 183, 196, 199, 205, 206, 208 The Kettle of Fish, 49 Kid Rock, 250, 320 Killers band, 337 King Bees band, 66 The Kinks, 54, 74, 119, 153, 154, 157 Kipling, Rudyard, 7, 333, 357 Kiss, 145 "Kiss Your Past Goodbye," 291 Kovac, Allen, 366, 367 Kramer, Joey, 66, 88-91, 101, 103-4, 114, 120, 152-53, 161, 164, 167, 179, 189, 199, 202, 215, 222, 236, 237, 239, 249, 283, 335, 360, 362, 363, 368 Kravitz, Lenny, 367 Krebs, David, 107, 112, 156, 183, 184, 208, 214, 225, 226, 229, 230, 231, 232

Led Zeppelin, 61, 62, 64, 75, 87, 93, 94, 95, 98, 107, 140, 145, 358, 359 The Left Banke, 57, 58, 62 Lieber, Steve, 107 Lennon, John, 48, 97, 190, 249, 266, 267, 275, 353 Leslie West and the Vagrants, 62 Lick the Boots That Kick You tour, 207 "Lightning Strikes," 214 Little Richard, 38, 39, 63, 80,97 "Livin' on the Edge," 57, 266 Lonshey, Ruth, 18 Lord of the Rings (book/ movie), 19 "Lord of the Thighs," 153 "Love in an Elevator," 248, 296, 362 "Love Lives," 368 Lovin' Spoonful, 49, 57, 59 "Magic Touch," 242 Mahogany Rush, 199 "Major Barbara," 105, 117 "Make It, Don't Break It," 93, 105, 117 Mama Concerts, 192 "Mama Kin," 115, 179 Maston, Rick, 75, 213 Mazella, Augie, 29, 32 McCartney, Paul, 49, 97, 137, 181, 266, 374, 375 The McCovs, 104 McKeon, Brian, 336, 338, 360 Mean, Truly, 359 Messina, Jay, 176, 177 Metallica, 308 "Mia," 216 Mike Bloomfield's Electric Flag, 110 "Milk Cow Blues," 188 Montgomery, Billie Paulette. See Perry, Billie Paulette Montgomery Montrose band, 87 Monty Rock III, 51, 52 Morrison, Jim, 50, 51, 52, 373, 376 Mother of Invention band, 170 Motley Crüe band, 146, 243 Mott the Hoople band, 119, 122, 145

"Movin' Out," 92, 93, 101, 115, 118, 131 Murdoch, Justin, 344, 361 "My Fist Your Face," 234 "My Friend Today," 58 The New Yardbirds, 61 New York Dolls band, 107, 171-72,210 Night in the Ruts album, 213, 215 "Nine Lives," 308 Nine Lives album, 124, 276, 282, 283, 285, 289, 290, 291 "No Surprize," 112, 213, 215 "Nobody's Fault," 174, 175 Nugent, Ted, 139, 142, 153, 159, 199, 209, 219, 260 Oasis band, 77-78 "One Way Street," 105, 115, 117 O'Toole, John, 107, 120, 215 Page, Jimmy, 61, 62, 64, 94, 95, 99, 100, 120, 160, 167, 263, 266, 336, 358, 359 "Painted on My Heart," 294 Paul McCartney and Wings band, 181 Paul, Steve, 49, 104, 105 Pearl Jam, 78 Permanent Vacation album, 242, 248, 271 Perry, Anthony "Tony," 239 Perry, Billie Paulette Montgomery, 228, 275, 313, 364 Perry, Elyssa Jerett, 27, 78,

79, 101, 102, 120-21, 79, 101, 102, 120-21, 172, 182, 189, 191, 209, 210, 227, 228, 364
Perry, Joe, 21, 26, 27, 73, 77-82, 88, 90, 92, 94, 100-103, 105, 106, 108, 113, 114, 117, 120-22, 124, 131, 135, 140, 142, 148, 157-58, 163, 166, 174, 175, 182-83, 187-89, 191, 195, 196, 203-5, 208-14, 219, 224, 227, 230, 231,

232-35, 237, 239, 242, 243, 247, 253, 257, 266, 268, 269, 275, 278, 279, 282, 285, 289, 291, 294, 296, 313, 314, 326, 335, 336, 339, 342, 344-45, 359, 363, 365, 370 Peter, Paul and Mary, 194 "Pink," 124, 214, 287, 289 Pink Floyd, 75, 223 Pinkas, Keren, 364 Pinsky, Drew, 348, 350, 352, 353, 354 Plant, Robert, 266, 307, 358,359 Plaster Casters, 140 Playboy magazine, 78, 259 Poison band, 251 "Prelude to Joanie," 222 Presley, Elvis, 37, 40, 60, 298 The Pretty Things, 45, 65,93 *Pump* album, 248, 285 Queen, 154 "Rag Doll," 242, 248 "Rats in the Cellar," 177 "Rattlesnake Shake," 78, 80,93 "The Reason a Dog," 228 Record Plant, 200 Red Hot Chili Peppers, 337 "Reefer-Headed Woman," 216,217 Rich Kids band, 215 Richards, Keith, 46, 47, 49, 70, 71, 74, 79, 80, 82, 100, 104, 184, 188, 220, 266, 312 "Road Runner," 93 Rock in a Hard Place album, 222, 223, 229 Rocks album, 173, 195 "Roll Over Beethoven," 39 Rolling Stone magazine, 121, 163, 167, 181, 203, 280 Rolling Stones, 9, 43, 45, 47, 50, 52, 54, 58, 60, 64, 69, 74, 75, 87, 92, 93, 96, 97, 104, 115, 343 Run DMC, 90 "Same Old Song and

Dance," 152, 153, 342

INDEX

Santana, 199 Santo, Paul, 364 "Seasons of Wither," 10, 31, 72, 114, 115, 152, 175,308 "See My Way," 115 The Sex Pistols, 70 Sgt. Pepper's Lonely Hearts Club Band movie, 199 Sha Na Na band, 121 The Shangri-Las, 42, 62, 308 "Shank After Rollin'," 308 "Shapes of Things," 45 Shapiro, Barry, 53 Sherman, Eric, 366-67 The Sidewinders, 120 Simon and Garfunkel, 63 Sire Records, 60 Slash, 312, 343, 351 Sly and the Family Stone, 61 Smith, Chris, 54 Smith, Henry, 50, 54, 61, 64, 182-83, 187, 188, 204-8, 358, 359 Solomon, Don, 41, 60, 65, 68,164 "Somebody," 63, 91, 115 "Something's Gotta Give," 287 Sonny and Cher, 187 The Soul Survivors, 62 Stahl, Peter, 41 "The Star-Spangled Banner" (Tyler), 340 Sting, 301 Stohmayer, Alan, 41, 50 The Strangers/Strangeurs, 41, 46, 53, 59, 60, 61 "Strawberry Fields," 297 Studio 54, 200, 201 Studio A, 200 "The Sun," 60, 117 Supa, Richie, 213, 214, 215, 220, 221, 244, 287, 288, 327 "Sweet Emotion," 102, 168, 277, 293 Tabano, "Crazy" Raymond, 49, 52, 53, 54, 65, 91, 92, 162-63, 173, 188, 200, 328 Tabano, Susan, 200-201, 338, 339

Tabano, Tommy, 150 Taj Mahal band, 93 Tallarico Brothers band, 13 Tallarico, Chelsea, 9, 18, 111, 257, 263, 277, 285, 301, 316, 376 Tallarico, Cyrinda Foxe, 105, 172, 191, 192, 200-203, 213, 224-28, 314-15, 375 Tallarico, Ernie, 14, 15, 16, 26,71 Tallarico, Francesco, 13 Tallarico, Giovanni, 13 Tallarico, Lynda, 7, 8, 11, 16,29 Tallarico, Mia Abigail Tyler, 111, 192, 202, 213, 228, 280, 301, 320, 321, 375, 376 Tallarico, Michael, 13 Tallarico, Pasquale, 13 Tallarico, Phyllis, 16 Tallarico, Susan Ray Blancha "Susie" (mother), 2, 6-7, 8, 13, 16, 19, 24, 26, 124, 143, 156, 243, 331, 356, 357, 359 Tallarico, Taj, 18, 257, 263, 277, 285, 301, 316, 318, 332, 376 Tallarico, Teresa Barrick, 224, 227-30, 232, 234, 236, 238, 252, 257, 258, 262, 275, 278, 284, 285, 301, 304, 313, 316, 319, 375 Tallarico, Victor (father), 11, 14-15, 27, 362, 367 "Taste of India," 285, 308, 332 Ten Years After band, 65 10th Street Entertainment, 366 Thin Lizzy, 209 Timmons, Bob, 276, 277, 279-80, 283 "Tits in a Crib" (alternate title for "One Way Street"), 117 Tokyo Spiders, 188-89 Townshend, Pete, 48, 80, 99 Toxic Twins, 157, 209, 247, 336, 354

The Trampers, 108 Twitty and Smitty band, 63.123 Tyler, Liv, 129, 218, 282, 294, 301, 321, 375, 376 U2, 291 Vanilla Fudge band, 116 Velvet Underground band, 115 Ventures/Dick Dale, 40 "Walk This Way," 90, 159, 364, 365 Walk This Way album, 231 Walk This Way (Davis), 202 "Walkin' the Dig" (misprint title), 117 "Walkin' the Dog," 105, 110, 117 Warren, Diane, 291, 292, 293, 294, 295 "When I Needed You," 60, 63,75 Whitesnake band, 154 Whitford, Brad, 92, 102, 105, 108, 114, 167, 174, 189, 195, 213, 215, 219, 237, 239, 249, 282, 289, 290, 335, 359, 360, 362 The Who, 45, 52, 68, 75, 97 "Who Do You Love," 39 William Proud band, 50, 63, 72, 73 Woodstock Festival, 65, 66, 67, 68, 101, 362 "Write Me," 115 The Yardbirds, 43, 45, 58, 60, 62, 63, 64, 79, 82, 87, 93, 326, 358 "You Should Have Been Here Yesterday," 63, 75 The Young Rascals, 57

Toys in the Attic album, 90,

156, 157, 159, 171

175,297

"Train Kept a-Rollin'," 62,

79, 91, 93, 94, 153, 155,

Zappa, Frank, 169-70, 327, 376 Zeitels, Steven, 305-6

Born Steven Victor Tallarico on March 26, 1948, in Yonkers, New York, Steven Tyler is the iconic songwriter, composer, and voice of Aerosmith— America's greatest rock 'n' roll band—and is considered one of rock's most recognizable and dynamic frontmen. *Rolling Stone* magazine has cited him as one of the greatest singers of all time.

After coming together in Sunapee, New Hampshire, in the late sixties, five musicians made the decision to move to Boston, live together, and become the band we know today as Aerosmith: Tyler as frontman, guitarist Joe Perry, bassist Tom Hamilton, guitarist Ray Tabano, later replaced by Brad Whitford, and drummer Joey Kramer. The band has sold more than 100 million records across the globe and won numerous prestigious awards—multiple Grammys, American Music awards, Billboard awards, and MTV awards—and was inducted into the rock 'n' roll Hall of Fame in 2001.

Aerosmith has infiltrated rock history with their memorable appearances on *Wayne's World* and *The Simpsons*, at the halftime show at Super Bowl XXXV in 2001, and in their own Aerosmith version of Guitar Hero. Their number one single, "Don't Want to Miss a Thing," was nominated for an Academy Award® for best song for the movie *Armageddon*. In December 2010, Tyler performed for President Obama and the First Lady in a special tribute to Sir Paul McCartney at the Kennedy Center Honors. In January 2011, Tyler joined Jennifer Lopez, Randy Jackson, and host Ryan Seacrest as a judge on the Fox TV phenomenon *American Idol*.

David Dalton, a founding contributor to *Rolling Stone*, is the author of some fifteen books, including *James Dean: The Mutant King, El Sid: St. Vicious, Piece of My Heart, Mindfuckers, Painting Below Zero, Faithfull with Marianne, Been Here and Gone*, and *Bob's Brain: Decoding Dylan.*